American Genre Painting

ELIZABETH JOHNS

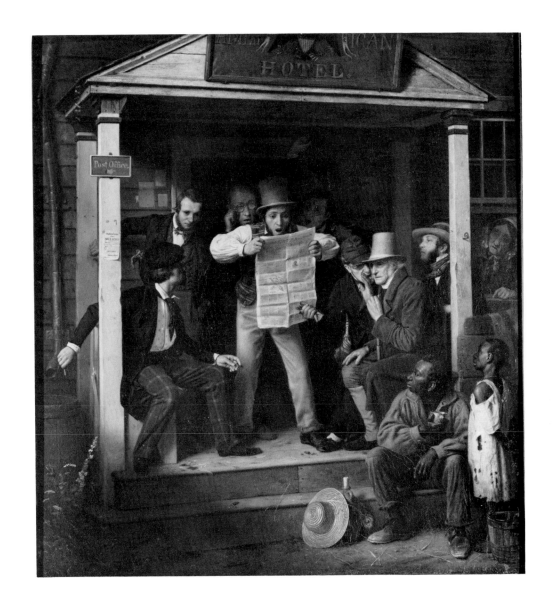

American Genre Painting

The Politics of Everyday Life

YALE UNIVERSITY PRESS NEW HAVEN & LONDON

Publication of this book is supported by a grant from the National Endowment for the Humanities, an independent federal agency.

Published with the assistance of the Getty Grant Program.

Designed by Richard Hendel.
Set in Baskerville type by
G & S Typesetters, Inc., Austin, Texas.
Printed in the United States of America by
Arcata Graphics Book Group, West Hanover, Mass.

Library of Congress Cataloging-in-Publication Data

Johns, Elizabeth, 1937–

American genre painting : the politics of everyday life/ Elizabeth Johns.

250 p. : cm.

Includes bibliographical references and index.

ISBN 0-300-05019-4

1. Genre painting, American. 2. Genre painting—19th century—United States. 3. United States in art. I. Title.

ND1451.5.J64 1991

754'.0973'09034—dc20 91-9613

CIP

The paper in this book meets the guidelines for permanence and durability of the Committee on Production Guidelines for Book Longevity of the Council on Library Resources.

10 9 8 7 6 5 4 3 2 1

FOR MAX

Contents

Acknowledgments, ix

Introduction, xi

CHAPTER ONE
Ordering the Body Politic, 1

CHAPTER TWO
An Image of Pure Yankeeism, 24

CHAPTER THREE
From the Outer Verge of Our Civilization, 60

CHAPTER FOUR
Standing Outside the Door, 100

CHAPTER FIVE
Full of Home Love and Simplicity, 137

CHAPTER SIX
The Washed, the Unwashed, and the Unterrified, 176

CHAPTER SEVEN
Inspired from the Higher Classes, 197

Notes, 205

Index, 245

Acknowledgments

A number of institutions and individuals have made this study possible. A Guggenheim Fellowship and a fellowship at the Woodrow Wilson International Center for Scholars in 1985 and 1986 and a research leave at the University of Pittsburgh in 1987 enabled me to formulate, research, and write early drafts of the book. Colleagues and students who heard short papers about segments of the work in progress were generous with their questions and emendations. At a colloquium at the Woodrow Wilson Center in 1986, Thomas Bender and Lois Fink made suggestions at a crucial time, and I was grateful at the center for the support and interest of Michael Lacey, director of the program for the study of politics and American society. Particularly helpful at the University of Maryland, College Park, were my colleagues James Gilbert, David Grimsted, Gordon Kelly, and Larry Mintz; at the University of Pittsburgh, Samuel Hays, Peter Karsten, Joan Weinstein, and Aaron Sheon; and at large, Michael Fellman, Wanda Corn, Jean T. Baxter, H. Barbara Weinberg, and John B. Bennett. Colleagues at archival centers have been of invaluable help, especially Bernard Reilly, curator of Prints and Photographs, Library of Congress; Terry Ariano in the Print Collection of the Museum of the City of New York; Georgia Barnhill at the American Antiquarian Society; Zed David, librarian at the Woodrow Wilson Center; the staff of the Rare Books Room of the Library of Congress; the staffs of the Print Room of the New York Public Library and the New-York Historical Society; and the staff of the Julian Library of the San Diego County Library system, where I spent a summer stretching to the limit the capacities of the interlibrary loan system. Research assistants made the staggering bibliography manageable, and I thank in particular Stephen Scott Epstein, Janet Marstine, Elizabeth Sargent, Jennifer Corrigan, and Andrew Kronenberg.

I would also give grateful tribute to the intellectual community that nourished me as I undertook this work: my students, especially my graduate students, at the University of Pennsylvania (and before that, at the Universities of Pittsburgh and Maryland) and faculty colleagues there and elsewhere who have rigorously questioned motives, selectivity, formulation, audience, and purpose in the studies of the history of art that we have investigated together. Perhaps the most important dimension of this community is our conviction that creating a tapestry about the social and artistic legacies of the present and the past is an ongoing process.

Beyond this supportive community, I would single out several individuals without whom the work could not have taken final shape. To Ann Abrams, Joan Weinstein, Alan Wallach, and David Lubin goes my deepest gratitude for their devoted readings of my drafts. To Judy Metro at Yale University Press my sincerest thanks for her unfailing graciousness, encouragement, and sense of humor; and to Laura Dooley at the Press my gratitude for her sensitive editing. I was particularly fortunate in the advice of two readers for the Press (Michael Kammen identified himself) although I could not always do their suggestions justice. Finally to my husband, Max T. Johns, to whom I dedicate this book, my unbounded gratitude for his devotion and sympathy over the long haul. He taught me the economic history of the United States long before I suspected that it had more than a slight relationship to art; I am fortunate to have had so charming, and so insistent, a tutor.

Introduction

This book studies American genre painting during its years of greatest prominence. For three decades, from 1830 until the outbreak of the Civil War, the socially ambitious and typically urban group of American citizens who were patrons of paintings and reviewers for cultural journals championed images of "American" subjects. Twentieth-century viewers have celebrated many of these antebellum works as evidence of a golden age in American culture and in American genre painting. Yet antebellum artists who created genre paintings from "native" themes experienced difficult and ultimately disappointing careers. The subjects that brought them success waned quickly in popularity, and patrons and other members of the viewing public transferred their loyalties to quite different types of painting. Within a short time after the Civil War, genre painting as an enterprise had been virtually abandoned. Genre painting would seem to have been, at least in the United States, a troubled undertaking. In this book I propose an explanation.

As I began my study, I wondered whether the art-historical definition of genre paintings as scenes of everyday life might not obscure their relationship to the complex social world in which artists created them. I wondered, in short, just what the ideology of "everyday life" has been over time—who has been represented as constituting it, with what activities, and for what purposes. Pictures from the genre tradition, whether seventeenth-century or nineteenth, whether Dutch, French, English, or American, are often funny, sometimes moralizing, occasionally sentimental, and almost always subtly patronizing of their subjects. Such images as a Flemish doctor studying a young woman's urine for signs of pregnancy, a young English aristocrat gambling away his substance, or an American riverman dancing on the cabintop of his flatboat stand out in this tradition. To characterize genre images as "scenes of everyday life" not only is inadequate but obscures the social relations that underlie this type of painting. Two simple questions underscore my diagnosis: "Just whose 'everyday life' is depicted?" and "What is the relationship of the actors in this 'everyday life' to the viewers?"

Genre painting might best be studied, I decided, as a systemic cultural phenomenon that develops in certain economic and social circumstances and meets social needs peculiar to a specific audience. I wished to analyze as carefully as possible the systems of social and economic relationships operating in the antebellum United States, especially since

the nature and production of genre painting changed so quickly after the Civil War. I wanted also to identify the relationship of the audiences to whom genre paintings were addressed—and the subjects that seemed to constitute the paintings—to this larger cultural network. I hoped to replace the generalization that has organized virtually every scholarly study in American art—that certain phenomena were "American"—with an identification and analysis of the interests of the *region* of the country where the paintings were produced and shown, the class of those who viewed them, and the classes and regions of the subjects.[1]

Thus, rather than focusing directly on either the style or the themes of the genre painting, I found it imperative to pay attention to the very function of representation. Genre paintings hide the artificiality or the contingency of their subjects with a realist mode. One major effect of realist painting is that as its viewpoint seems to be perfectly natural—that is, reportorial—the viewer tends to accept the ideological underpinnings of the painting in the very process of looking at, and coming under the spell of, the picture. The successful painter, therefore, could be said to be an entrepreneur of the viewers' ideologies. It is these ideologies, and the system in which they were generated, maintained, and challenged, that deserve investigation.

In seeking the relations among genre subjects, ideologies, and the supporting social networks in the United States, I wondered if the conditions that shaped the values represented in genre painting were not usually of a piece. Although I suspect that they involved the rise and flourishing of a free economy, artists typically produced genre paintings during times of great change, most prominently in the economic sphere, when within a broad middle class old hierarchical relationships were challenged and new ones forged. These changes both accompanied and promoted shifting political and social relations. Certain members of groups appropriating power enjoyed a sudden and exhilarating enlargement of their opportunities for economic success, political dominance, and social status. Their perception of this fluidity, indeed their determined seizure and continued creation of it, gave them energy and driving ambition but also tension over the newness of their circumstances, anxiety about their competitors, and contempt for those who were not successful.

The cultural construction of these social changes that seemed to bear most directly on genre painting—certainly this was the case in the United States—was the complex activity of typing. As anthropologists and students of popular culture have long known, typing is part of the larger process by which human beings assert, parcel out, and deny power to members of their communities. Typing often occurs from the apex down (that is, when initiated by those who would be at the top), but it is also undertaken by human

beings in middling situations and at the bottom of societies. People variously distinguish those around them by class, gender, age, intelligence, and manners and set up targets for satire or condescension that satisfy their need for superiority. To distinguish from one another, and from oneself, the village fool, the calculating tradesman, the pious peasant, the dashing military officer, the vainglorious preacher, or the sly farmer—as occurred in Western European societies in recent centuries—provided a social order for the ones doing the distinguishing. Among other things, it set apart some as "others," both those on the way up and those on the way down, and it posed some as vicarious figures who embodied the desirable qualities that citizens doing the typing thought they did not have time or perhaps even license to cultivate. In virtually every instance, it seems, typing was—and *is*—carried out as a harmless, natural activity. That is, persons doing the typing usually do not recognize the interests behind their constructions and at other times pointedly deny them and see the typing as perfectly natural.[2]

Typing in simple description and in more complex joke, story, dramatic presentation, and even moral exemplum created the repertory of characters that in turn appeared in genre painting throughout the 350 years of the tradition. Painters seem to have drawn on types for paintings whenever the emotional need to disdain or laugh at or explain others ran high. In painting for the market—and this was as true in the United States as it was elsewhere and earlier—artists tapped into the evolving, contested network of so-cial relations and prejudices already sorted out in typing (or being sorted out) that best satisfied the interests of their ambitious patrons. This was a complex process, however, one that was by no means overtly conspiratorial or that even established class hegemony. Because economic and political change took place in the antebellum United States with dizzying speed, social relationships were contested and shifted frequently, and this may well have been true in other social circumstances.[3]

Yet it seems accurate to say that genre pictures in the antebellum United States en-couraged viewers to invest in social hierarchies, in their convictions that certain "others" in the community were or should be revealed as deficient, and in their need to assert that a genuine community of warm feeling existed among (unequal) members of society. Genre paintings contributed to the sorting out of the citizenship that was a major fo-cus—some would say the fundamental concern—of public discussion. As white male citizens from the artisan to the entrepreneur dreamed of the personal empowerment made possible by democracy, as they schemed for their own interests and hammered out economic and political arrangements, the behavior of the individual citizen was a focus of tension, concern, optimism, and alarm. The specific emotions with which the general citizenry was regarded depended upon the economic circumstance, social class, and geo-

graphic provenance of the breasts within which these emotions were felt. Identifying these investments and analyzing their embodiment and temporary resolution in specific genre paintings comprise the undertaking of this book.

A word about the relation of this study to earlier scholarship. In recent years most historians of American art have made landscape painting their primary interest. Yet even earlier few published full-length studies of genre painting. The two general studies of the early 1970s—essential groundbreakers for anyone working on genre since—were surveys, arranged both chronologically and thematically. Other, more recent work includes a few monographs and articles that consider certain genre paintings as thematic groups. Most of these studies have focused on elements of biography, style, and typical iconography of the artists, with some attention to social context. All these approaches are valuable; I incorporate them into my work with varying degrees of emphasis.[4]

The study of context, however, posits a background that images in turn reflect. In contrast, what I wish to capture in my study is my conviction that background is never seamless. Paintings function in social spaces, working within the culture with the interactive and shaping power of jokes, plays, newspaper editorials, and political decisions. They, too, are created from and advocate positions of interest; they propose and undercut ideology. Thus I examine paintings as claims or assertions made within certain economic, political, and social contexts.

In this regard, I would say a word about the relation of my work to studies of the American past in other disciplines. Having grasped how to conceive this project from analysts of culture, I have learned how to materialize it from historians. In the past fifteen years there has been a virtual explosion of work by social historians on the competing groups—women, labor, early professionals—that determined the directions of the American experiment before the Civil War; by cultural historians on intellectual temperament, moral reform, attitudes toward urbanization, and institutions; and by new historicist literary historians on politics, the market, and reception. To all, I am grateful.[5]

Largely because of insights gained from them I study a wide range but selective number of genre paintings, which I have chosen with two criteria in mind: (1) they were perceived by contemporaries as major works and came before a large audience, and (2) in sequence they create a narrative of the relation of representations of everyday life to material and ideological forces. My book is an interpretive essay and not a monograph; much more remains to be said about American genre paintings, and a few well-known

works have a place only in the notes. I have invoked the essayist's privilege not only in deciding against comprehensive coverage but also in excluding certain categories of images altogether. To concentrate on citizens of the United States making claims about citizens of the United States, I have not discussed genre paintings about American Indians. Native Americans were written about by most Americans during the antebellum period as though they were beyond the pale of otherness, although citizens found certain aspects of this otherness attractive, and those formulations, as I shall show, were important in certain genre paintings of whites. Nor have I discussed literary painting (commonly, and inaccurately, I think, called literary genre). Painters who worked from literary productions keyed into very different constructions of social relations than those who worked from an ideology of everyday life. Even when authors constituted their characters from types already loosely identified in the culture, such as James Fenimore Cooper's frontiersman Leatherstocking, artists took as their territory a character and issues that had been defined, or mediated, by another intellect with his or her own interests and created, moreover, within conventions characteristic of the literary rather than the visual mode. Artists who painted from literature appealed to viewers at least partly with the social associations of the literary work itself—its tone, class assumptions, and reading audience, and the author's success and social status. This topic might fruitfully be discussed elsewhere, as might be the relation of genre paintings of Indians to genre paintings of white Americans.

Other convictions have also guided me. Ultimately, the production of paintings at any one *moment* is mysterious. Neither the painting nor its production at a particular time, and certainly not its reception, can be completely explained. However, I have looked to the past for patterns, and the bold outlines in artistic production that I have found are both significant and illuminating. In the conviction that a narrative, even given its totalizing effect, best probes relationships that developed over the passage of time, I have constructed one that sets in relief both continuities and disjunctions. Although I have been eager to assert the power of the art world or worlds, I have also emphasized the careers and decisions of individual artists in order to probe the intersection between the ideologies of groups and the agency of individuals.[6]

Finally, I would forthrightly declare the social convictions that have informed the art history of this book, though I remain perhaps too close to the work to have the advantage of hindsight. My interest in the social relations that gave rise to typing and in turn to genre painting in the antebellum United States devel-

oped in the context of my increasing concern about the destructive power of these currents in contemporary society, despite recent moves to make available to all groups the freedoms that many have long enjoyed. These currents are especially insidious in the imagery of popular entertainment and advertising. I hope that after studying this book my readers may look at many ongoing cultural practices with fresh eyes.

American Genre Painting

One *Ordering the Body Politic*

Playing to the visual appetites of his fellow Americans at a time of high political excitement in 1849, Richard Caton Woodville, painting in Germany, sent his small, intense picture *War News from Mexico*, 1848 (pl. 1), to New York to be exhibited. In the image, a group of eight white males gather around a figure who reads aloud from a newspaper. Young, middle-aged, and old in years, acute and thoughtful in expression, and fashionable, restrained, and even outlandish in dress, they congregate on a small porch above which is a sign displaying the American eagle and the words American Hotel. This is the citizenry of the United States. All seem to be devoted to getting ahead, from the plaid-trousered dandy on the front left to the spats-clad and top-hatted old gentleman on the right. Each face wears a look of speculation, even calculation, about the opportunities that this news might bring—chances for personal heroism on the battlefield perhaps, or for land speculation from afar, or for migration into new territory. The potential future of the young republic is portentous at this moment: this hotly contested war promised a staggering enlargement of national territory, an ominous—or luxurious—expansion of slavery, and fortunes to be made in commerce and manufactures and communication. But not all the figures in the painting occupy the special space of the porch over which the American eagle offers protection and opportunity. One man wearing a soft hat and standing just off the right edge of the porch seems either to strain to be included in the deliberations or to hold himself apart with some anxiety. A middle-aged white woman leans out of a window in the right background, consigned to the interior of the hotel and perhaps unable even to hear what is going on. In the most obvious separation of figures from the main group, a black man and a black girl in the lower right foreground look on with quiet uncertainty. They attend to the news with an air of waiting. To see after their own interests is not their prerogative.[1]

Offered to the viewing public at a time of public excitement and even uproar, Woodville's "scene of everyday life" invoked national politics, social differentiation, and the character of the citizenry. So popular when it was exhibited that prints made from it totaled fourteen thousand, the work identifies the crucial issues at stake in genre painting in the United States in the three decades before the Civil War: Just what kind of

social entity was this democratic experiment? Who constituted the citizenry? And how did these new men go about being sovereign?

Genre painting in the United States might have been about ordinary people, but it was not about ordinary matters.

For historical grounding, let us look first to the traditions in genre painting that these artists inherited, concentrating less on specific themes, characters, and activities than on the functioning of genre painting in Western societies. In what cultural circumstances were such paintings produced? Who were the audiences? From as early as the sixteenth century, it seems to me, such scenes depicted people within a large social fabric who were perceived by viewers as special in a condescending way—as different, amusing, threatening, or peculiar. As the situations and titles of the works indicate, the subjects of genre paintings were not individuals but types or representatives of social orderings, in characterizations that apparently first achieved permanency in jokes, anecdotes, and stories. And just as the people to whom jokes allude do not think of themselves as either typical or amusing, so genre paintings seem to have been produced for members of the society doing the joking or typing rather than for those being the brunt of it. Genre painting was most prominent in enterprising northern Atlantic societies, especially during periods of economic and social change. During such times—the seventeenth century in the Low Countries, for instance, the mid-eighteenth century in England and France, and the early nineteenth century in England, America, France, and Germany—new patrons and classes were coming into power and identifiable subordinate groups were on the move as well. The class structure in these societies was hierarchical but fluid, with a constant stream of individuals breaking across and falling through class lines. Although many of the newly arrived were exuberant, others were alarmed. With the conservatism typical of the freshly successful, they urged that economic enticements and social disarray threatened values worth preserving. Typing, anecdotes, and ethnic jokes received new impetus. Across the centuries—with early scenes of stolid peasants, and later of industrious craftspeople, sly lovers, and humble couples praying before meals, and then of a range of urban characters, including crooked politicians and destitute beggars, and finally, in the nineteenth-century United States, of farmers and rivermen and urban sharpers—artists, like the jokesters and storytellers before and around them, engaged their patrons' deepest social anxieties.

But I do not wish to suggest that the process of creating genre paintings was conspiratorial. Well into the early nineteenth century such pictures were called by many names,

including comic scenes, low subjects, cabinet pictures, domestic scenes, familiar life, and scenes of everyday life. This variety in nomenclature reveals not only that the images represented widely differing aspects of social relations but that they performed functions that artists and their audiences could not uniformly specify. The groups of patrons to whom the pictures appealed had varying class alignments, diverse histories of mobility, and distinct family heritages. At times these pictures that they applauded and bought seem to have masked social machinations, at others the images were overtly critical of the powerful, and at still others they highlighted a humble pleasure that seems genuinely to have been shared across class lines. Almost inevitably, however, these paintings embodied for their diverse viewers ideologies of an everyday life that was someone else's.

Perhaps because of their dependence on the humbler, less noble social relationships, genre paintings by whatever name they were called came to be regarded as enjoyable to look at but low in the scale of art. The unidealizing, indeed deflating, nature of identifying and formalizing difference meant that art theorists and academicians always ranked genre painting near the bottom of artistic endeavors. Unlike history painting, which called for the expression of intellectual principles and high thoughts, there was nothing necessarily intellectual or elevating in scenes of familiar life. History painting elevated the privileged and relatively secure patrons and their institutions to an ideal past with mythological or literary or allegorical scenes. Genre painting, in contrast, constructed aspects of the scene at hand and offered newly arrived patrons—not quite elite but not lower class either—the possibility of sorting out their place in it. In spite of its low status, however, genre painting was typically perceived as amusing and by some even as quite wonderful. The most influential theorist in English thought, Sir Joshua Reynolds, whose "Lectures on Art" had a powerful effect on American artistic expectations into the middle of the nineteenth century, criticized Dutch genre painting as inexpressibly low at the same time that he amassed a large collection of it.

How, then, did genre painting come to be constituted in the United States?

It is hard to ascertain patterns in the early years of scant production. Before 1830, although a number of artists created genre paintings, they did so sporadically, and they seemed to draw on two traditions—that of English and Dutch genre painting and that of the urban figured landscape, both of which, presumably, they knew through prints and copies. Many of these artists were portraitists, others were landscapists. Genre paintings served at least as a contrast to their other work, and perhaps also tested the possibilities for more variety in their patrons' demands. In Boston, Washington Allston, home in the early 1810s for an interlude from his work abroad as a fledgling history painter, painted small satirical urban scenes reminiscent of prints and small paintings then popular in

England. *The Poor Author and the Rich Bookseller*, 1811 (Museum of Fine Arts, Boston), for instance, a sharp contrast to Allston's landscape and history paintings, shows a young author humbly importuning a callous bookseller in his shop. Energetic landscapist and animal painter Alvan Fisher, who spent most of his career in New England, painted rural genre scenes that ranged in focus from a cornhusking celebration, with shenanigans among the young men and women in the foreground (fig. 1), to a humorous mishap among a well-to-do group of passengers whose coach has been fording a creek. In urban New York, the immigrant landscapist Francis Guy varied his menu of topographical landscapes with *Winter Scene in Brooklyn*, about 1816 (fig. 2), in which he presented for his audience's amusement recognizable figure types going about their routines in a snowy setting. Depicting a precise layout of the buildings, shops, and streets, complete with signs, Guy created an entire social world that included businessmen, children, and black laborers. Inspired by a variety of antecedents and keyed to local activities and landmarks, these images were not put forward as part of a focused cultural undertaking. They were, so to speak, trial balloons.[2]

Given the political and financial dominance of Philadelphia in the first years of the republic, it is not surprising that artists working there produced somewhat more genre paintings than can be accounted for elsewhere. In Philadelphia, too, however, with one exception genre seems to have served artists as a hopeful diversion. William and Thomas Birch, primarily landscapists, and John Neagle and Thomas Sully, both portraitists, occasionally painted scenes of children and of rural pleasures, motifs that were popular in England. Bass Otis and Charles Bird King, also pursuing careers in portraiture, painted a few scenes of local smithies and industry. The single artist in Philadelphia who pursued genre with consistency was John Lewis Krimmel, who, after training in Stuttgart and London, immigrated to Philadelphia and worked there as a portraitist and drawing master from 1809 until his death in 1822. During these years he painted more than a dozen genre images of characters and excitements peculiar to Philadelphia streets. Although virtually nothing is known about Krimmel's patronage, reviewers commented favorably on his works. The themes were accessible and entertaining: explicitly rural gatherings, such as a country wedding and a quilting party, which he modeled on prints after Jean-Baptiste Greuze, and gatherings in Philadelphia's public spaces. Election-day subjects seem to have intrigued him, perhaps because the suffrage spread across classes and gave him a variety of figures and incidents to draw on, or perhaps because he could moralize with obviously inebriated figures. *Fourth of July in Centre Square*, by 1812 (fig. 3), calls vivid attention to much else that Philadelphians discussed in the press—the new pumping station designed by Benjamin Henry Latrobe at the intersection of Broad and Mar-

Figure 1.
ALVAN FISHER
Corn Husking Frolic, 1828–1829. Oil on panel,
27 3/4 × 24 1/4 in. Gift of Maxim Karolik to the
Karolik Collection of American Paintings, 1815–1865.
Courtesy Museum of Fine Arts, Boston.

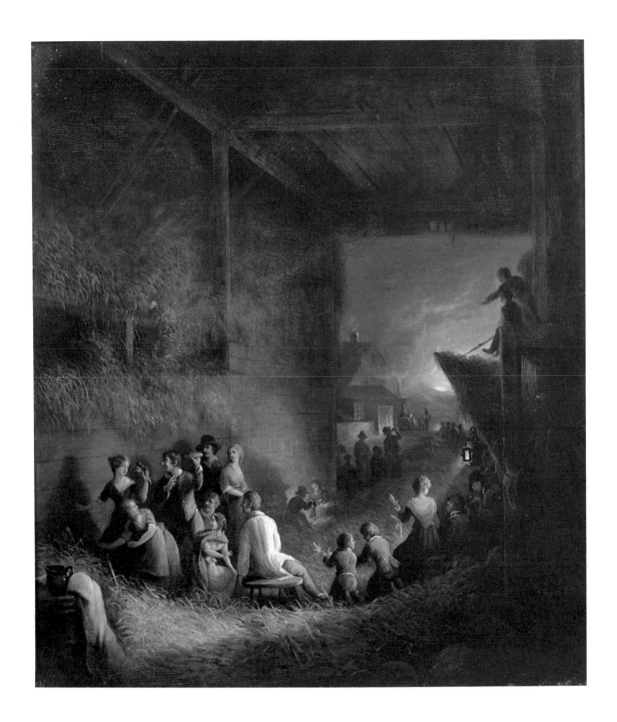

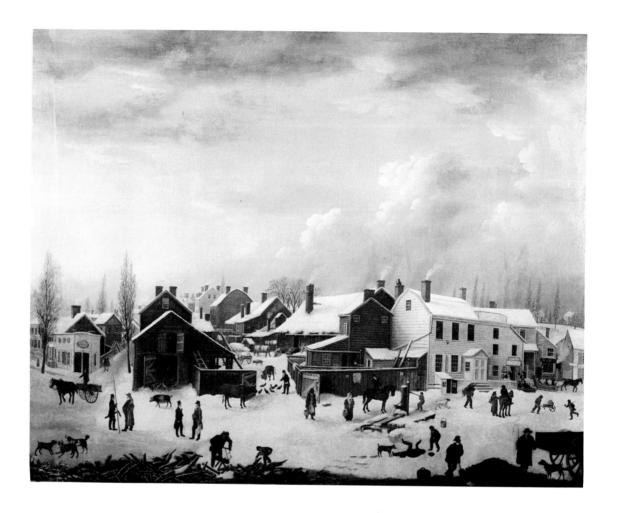

ket, the fountain and sculpture just completed by William Rush nearby, and the vast assemblage of urban and Pennsylvania types in public gatherings. Much as Krimmel was to do in his election day scenes, he included a broad cast of characters—male dandies, young women in the latest fashions, a solemn Quaker family, and an African-American couple in urban finery. The local periodical *Port Folio* enthusiastically approved of Krimmel's depictions as Hogarthian. Its critic also pronounced that genre painting in the style of David Wilkie, associated with images of rural simplicity, was "well fitted for our republican manners and habits."[3]

Just what a citizen who in 1812 pronounced genre painting Hogarthian and "well fitted for our republican manners and habits" had in mind is not clear. Did he see genre painting as a moral corrective? Did he see it as a device that subtly or not-so-subtly encouraged the maintenance of social distinctions? Other questions arise. Krimmel painted for only a decade, and one wonders just what contribution he would have made to genre

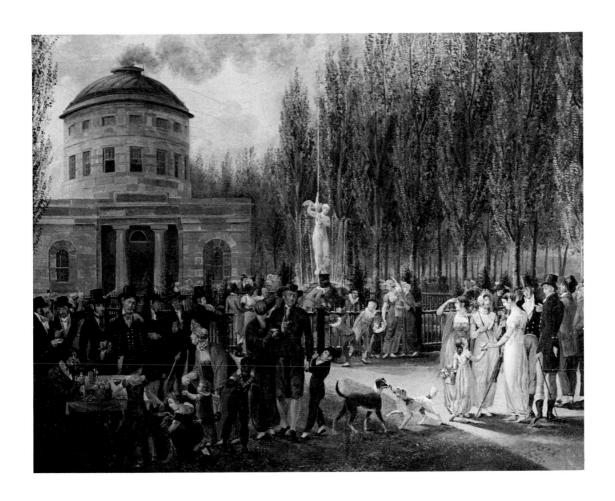

painting had he lived longer. Could he have moved beyond a cast of characters associ-
ated with Philadelphia to figures more broadly identifiable as representative Americans?
Or was Philadelphia a location already unlikely to foster paintings that viewers elsewhere
would consider national? During Krimmel's career, Philadelphia declined from its repu-
tation as the Athens of the West, and by 1825 New York asserted its economic dominance
over the nation. Not until the rise of New York to unchallenged prominence, as we shall
see, would "national" genre painting even be conceived as a project.

 In the meantime, a complex process necessary to the conceptualizing
of such painting had long been under way. Genre painting typically
drew on generalizations about social groups that developed during periods of intense
change. Fundamental to the formulation of genre painting in the United States—paint-

ing that critics were to hail as distinctively American—was the differentiation of the citizenry throughout the first decades of the republic by people seeking or in positions of dominance.

Driving speakers to make these distinctions was the rise to power of a heterogeneous and politically empowered citizenry. Even in the earliest days of the new nation, euphoria about the unique ideals of the Constitution began to be replaced in powerful groups with anxiety about the growing power of the "rest of" the population. In the perception of the elites, the spectrum of backgrounds in the body politic—a variety perceived primarily in terms of social class—meant that the social, moral, and religious practices that had unified their leadership in prerevolutionary society, and that they had assumed would sustain them in the new nation, would not prevail. Moreover, not only was their own dominance threatened, but the process of republican decision-making that depended on shared assumptions and on deference toward the wise was severely compromised. The alarm of these citizens was exacerbated by the increasing visibility of European visitors to the nation, whose social assumptions were usually their own and who wrote liberally on returning home about the typically disappointing character of "the" American citizenry.[4]

The "solid" classes defined their anxiety about the population's heterogeneity around two poles. The first was the potential economic power of individual (lower- and middleclass) citizens, both those who were clever and those who were inexperienced. As economic activity in the 1790s revealed, commercial power in the hands of the unscrupulous could be turned to deceit and speculation that destroyed not only social trust but the very economic stability on which the success of the nation depended. Throughout the period, even self-made citizens saw the economic opportunism of others as deplorable. Europeans, registering shock that so sacred an ideal as democracy was implemented within a rough-and-tumble economy, railed about Americans' devotion to making money. They assessed as frenetic Americans' preoccupation with the seemingly limitless land to be obtained, settled or exploited, and sold at a profit, and with money to be made in canals, railroads, and urban building. Foreign observers, as well as the more privileged participants in the new nation, found commercialization hard to take.[5]

Slowly, however, a certain irony began to pervade public discourse about economic democracy. Whereas early in the nation's life American conservatives expressed umbrage that the "lower sort" had no compunction to virtue in their financial dealings, as time passed and citizens of even the "better sort" got caught up in entrepreneurial ventures, the anecdotes of those already in comfortable economic positions revealed more tolerance. Successful merchants coined jokes half-celebrating and half-ruing the entre-

preneurial wit of humble citizens. Someone coined the term "wide-awake" to describe citizens' putative alertness to every advantage and their heedless rush for profit. In the terms of other vernacular inventions of the period, it was always someone else who was after the "main chance" or worshiping the "Almighty dollar." Alexis de Tocqueville, the foreign visitor identified with defining the essence of the American personality, noted in 1831 that the pursuit of money was so intense that every citizen took on the character of the merchant; even the farmer, he felt, was essentially a tradesman, always on the look-out to sell his land. Indeed, Tocqueville told his French readers, most Americans were never happier than when they were taking a risk in hopes of profit. In response, the matter-of-factness of at least one New York newspaperman about these complaints was typical: "Some travellers have pronounced the Americans a sordid people, wholly oc-cupied with the thoughts of gain, because no two men can be heard talking in the streets without using the word 'dollar'—as if people in the streets were accustomed to talk of any thing except what brought them there."[6]

The second pole around which alarm about the heterogeneity of the empowered body politic clustered was the implications of egalitarianism in the social sphere. This area of complaint was considerably more difficult to temper with good humor. Americans who claimed to be the better sort, that is, those of the upper and high-middle classes, and European visitors (even those with democratic leanings) accustomed to hierarchical class relations were shocked at manifestations of insistent egalitarianism. They simply did not expect that, in a republic founded on the presumed virtue of leading members who would somehow remedy the deficits of the lower orders, citizens would so literally trans-late the implications of republican "sovereignty" into expectations for and of themselves. A term originally associated with the limitless power reserved to a monarch, then with power entrusted to legislative representatives, and finally (but still carrying its full freight of "unreserved power") with the power of the individual in a democracy, "sover-eignty" in the formulations of Thomas Jefferson and James Madison was political dig-nity of the most profound kind. However, what sovereignty meant to "ordinary" citizens by 1830, complaints by the "extraordinary" registered, was social and political equality that others challenged at great risk. Even early on, dismayed leading citizens com-plained, inferior (lower-class) citizens took up the cry that they were sovereign, subject not only to no monarch but to no received structure of value, opinion, or social practice. In 1837 Philip Hone, former mayor of New York, was aghast at the disruption to the New Year's open house held by the current mayor, when, rather than the "gentlemen" who usually called, Mayor Lawrence's "doors were beset by a crowd of importunate *sov-ereigns*, some of whom had already laid the foundations of *regal* glory and expected to

become *royally drunk*." Males in the citizenry refused to take off their hats because the hat was a sign of empowerment; conversely, servants, policemen, and workers refused to wear uniforms because they indicated servility. America's most famous visitors made trenchant comments on the matter. Frances Trollope, mother of the novelist Anthony, comfortable in her English middle-class roots, was indignant at the "I'm as good-as-you" attitude with which she felt assaulted by "even servants" in every transaction. Charles Dickens commented wryly that "Republicanism will not tolerate a man above me, and of those below, none must approach too near." Tocqueville observed that of the two ideals that underpinned American democracy, liberty and equality, Americans held equality dearer. "[Democratic peoples'] passion for equality is ardent, insatiable, eternal, and invincible. They want equality in freedom, and if they cannot have that, they still want equality in slavery. They will put up with poverty, servitude, and barbarism, but they will not endure aristocracy."[7]

Men in positions of dominance—merchants, clergy, newspaper editors, and people of independent means in the upper class—came to use the term *sovereigns* ironically. Looking out at a citizenry fully devoted to the pursuit of its own interests and with no regard (as they perceived it) for the whole, they referred to ambitious (and lower-class) citizens collectively as "the sovereigns," or the "demos," assailing them as having political and economic freedom that they could not and did not want to use responsibly. As elite speakers saw it, the consequences for the community—and for themselves, where they wished the *real* power to be sited—were disruptive at the very least. Alarmed by practices all around them, self-designated Jeremiahs from this group published warnings that ranged from the fulminating epic *The Columbiad*, published in 1807 by the well-born Connecticut poet Joel Barlow (but begun much earlier), to the savagely comic *Modern Chivalry* by the low-born but entrepreneurial writer Henry Hugh Breckenridge of western Pennsylvania.[8]

Terrifying as was this vision, humor often prevailed. Expressing themselves in jokes, editorials, correspondence, and stories, citizens who were high and low, intelligent and unintelligent, sedately elite and aggressively middle-class, variously boasted or cringed about being situated in a nation of "go-aheaders." As the editor of the comic magazine *Yankee Doodle* was able to put it irreverently in 1846, "The lowly of to-day may to-morrow rank among the proudest; and from infancy the little Yankeedoodle is taught to look upon himself as a legitimate heir to sovereignty, and to 'go ahead' until, by pushing, driving, bargaining and persevering, he achieves what his country newspaper eloquently and weekly informs him is his 'inalienable right.'" Yet it was always "others" who put their own interests first, pushing relentlessly ahead of their fellow citizens and calculat-

ing just how they might stay there. Only Davy Crockett claimed to operate on what might be described as principle: "Be always sure you are right," he advised his constituents and friends, "then go ahead."[9]

An important effect of citizens' need to distinguish themselves from the economic, social, and political irresponsibility of others was their differentiation of the population by region, race, and gender. Such judgments materialized in the creation of specific types that deflected tensions between figurative neighbors. Even those who were by no means politically or economically dominant enjoyed casting aspersions on those who could be identified as different, making this a much broader practice than separating the citizenry into leaders and sovereigns.

Regional differences in the citizenry promoted stereotyping. That the earliest New Englanders and Virginians had settled with very distinct missions, religious beliefs, and class origins meant that almost two centuries of social relations were now entrenched. Distinguishing clergyman from tradesman from farmer, and planter from artisan from laborer, early settlers had implemented systems of class stratification in their settlements that into the nineteenth century were incontestable. New England, Southern, and Mid-Atlantic colonies felt such regional separateness that the first construction of the nation as a confederation was a failure, and so persistent were sectional loyalties that even under the Constitution a kind of cultural federalism dominated the attitudes of many citizens. Immigrants who came later to the middle colonies and inland areas, notably the Scots-Irish in the eighteenth century, brought to the citizenry yet other expectations of self and social place. And those who began arriving in the 1820s from Ireland and in the 1840s from Germany brought with them languages, class assumptions, and a Catholic religion that were at variance with the customs of citizens long settled. Secure in their Anglo-Saxon Protestantism, established citizens felt these new characteristics to be an unacceptable introduction of yet more heterogeneity that would lead to the nation's decline. Perhaps the most intractable historical circumstance was that the ancestors of a substantial proportion of the population, the blacks, had come involuntarily. The slaves and free blacks of 1830 had no acknowledged participatory voice in the American constituency, but they had an economic role and social presence that demanded attention from those who did. They were the most obvious "other" in a society in which white males in all class levels, despite their differences from one another, prized economic activity and social competitiveness. Women, too, of all social classes, both black and white, were an "other." Like black men, they enjoyed neither economic nor social power. The

sheer immensity of the United States meant that differences in the social constituency, or citizens' perception of them, endured and intensified. Extending in 1830 from Maine to Georgia, from the Atlantic Ocean to beyond the Mississippi River, the country was already many times larger than any European nation.[10]

Reifying these several kinds of differences, citizens began as early as the 1780s to categorize the social body—that is, all who were not the obvious elite—by inventing types that were singularly American: the Yankee, the Kentuckian, the black, the domestic woman, and the urban street child. These types constituted an efficient roster that served two functions. First, it was a cast of indisputably New World characters with which Americans of diverse interests ostensibly explained, celebrated, and excused American differences from Europe. And second, it was a mechanism through which speakers embodied their antipathies toward and fear of the potential power of others caught up in the experiment with them. These others were rarely members of their own class or group. Each formulation grew from basic tensions in the burgeoning constituency: that among regions (identifiable as New England, the Middle Atlantic, the Old South, the Southwest, and the developing West), between urban and rural, between free citizens and enslaved blacks, and between genders. As fictions that they created about one another, types and typical behavior gave pundits, storytellers, editorialists, and audiences across the regions quick points of reference. Yankee jokes were the staff of life in the South and in New York, where antipathies against New Englanders and fears of excessive commercialism were greatest; Kentuckian stories were their most popular in New York and New England, where urbanites recoiled at the manners of "wild" Westerners; anti-black stories were most prominent in the Middle Atlantic region and the South, where citizens needed constantly to justify slavery. Caricatures of women, who were on the margins in every region, were ubiquitous. Although some listeners or readers were offended, most entered into imaginative complicity with the storyteller, whose tales were always about someone else.[11]

Citizens' earliest formulation was to identify the American citizen as a yeoman. An agrarian who farmed his own land, the yeoman was theoretically the political and moral bedrock of the republic. At the time of the Revolution most Americans were farmers, and in spite of the steady rise of urbanism, commerce, and finance, farmers constituted the majority of the population until after the Civil War. But the ideal of the yeoman was not born in the singular circumstances of the American Revolution. The term had ideological underpinnings that began in seventeenth-century

England. The English aristocracy created the yeoman type both as a buffer between themselves and the peasantry and as a support in the rivalry between the aristocracy and the monarchy. A class of "solid" citizens, yeomen could be counted on to identify as their own the interests of the land-owning aristocracy. Although land-holding lords proclaimed that yeomen had sovereignty, or independent authority, in the government at no time was this sovereignty confused with social equality: yeomen were expected to defer to the gentry, their natural superiors.[12]

In America, Jefferson and others of the Founding Fathers drew prominently upon this heritage. Specifying the yeoman as the ideal U.S. citizen, Jefferson assumed several givens: first, that agriculture would always be the nation's fundamental productive force, second, that the agrarian way of life dependably bred virtue, and third, that yeomen could be counted on to recognize leaders of education and substance in their communities who were natural rather than hereditary aristocrats. In other words, the farmer was not only virtuous but knew his place. In the beginning years of the nation, as I have suggested, Jefferson's theory seemed to work: only property owners could vote, and most were also agriculturists. Those whom the yeomen elected to government were drawn from a privileged, and perhaps what could be called a natural, aristocracy. But as state legislators gradually extended suffrage to those who did not own property, and as more citizens became artisans and tradespeople rather than agrarians, the ideal of the yeoman lost concreteness. Ordinary rather than extraordinary men began to win political office. Before long the farmer was not the fundamental sovereign in determining election outcomes. Moreover, the exalted concept of sovereignty suffered a radical debasement by citizens who appropriated it to justify their economic and social ambitions rather than their political status and responsibilities.

A central incongruity in citizens' investment in the yeoman as a meaningful symbol was that urban citizens spoke of actual farmers in terms anything but reverential. Seeing themselves as vital to commerce and finance, and presenting this vision in the opinion-shaping newspapers and journals that they controlled, city dwellers often characterized farmers as remote from the up-to-date news of the city, stubborn in their routine, and fashionless in their practicality. Competitive in their every fiber, urban citizens contributed anecdotes to newspapers that presented farmers as lower-class, suspiciously like the ignorant English plowman who lived on for decades in jokes reprinted in American almanacs. As early as 1787, in Royall Tyler's *The Contrast*, American playwrights presented American farmers as naive fall guys, bent on making their crops and incapable of understanding the intricacies of manners or society. And even though patriots gave much lip service to the yeoman ideal, novelists in the 1820s and later who focused on American

subjects were attentive to the class associations of the English farmer. They avoided the type altogether for their leading men, using the farmer instead as a dull foil to a "gentleman" hero.[13]

And yet, while citizens might express disdain for real farmers and make jokes at their expense, during the more hectic moments of the era many invoked the yeoman as a standard of ideal citizenship. Alarmed about the ostensible materialism, lack of self-discipline, and immorality of urban citizens, newspaper editors and politicians began in the 1830s to hold up the yeoman as a reference point for what was being lost. Typical was an editor's exhortation in 1836 in the *Knickerbocker,* a general periodical distributed across the country: "It is to the agricultural portion of our community that we must look for the preservation of our liberties. The simplicity of their manners, and their isolated situation, enable them to think, and judge, and act for themselves. Uninfluenced by the power of sympathy with the many, and devoid of that restless excitability which places the populace of our cities in the power of every demagogue who harangues them from the polls or the market-place . . . this sober and independent body of freemen govern their feelings by their reason, and their actions by their sense of right."[14]

Ever more reverent of the yeoman ideal in the face of departure from it, citizens called the nation a "Farm," and citizens "Farmer" until after the Civil War. Caricatures of moments of crisis like Andrew Jackson's removal of deposits from the United States Bank depicted the bank as a corncrib and Jackson as the chief farmer. Throughout the century, presidential candidates ran for office as farmers whether or not they were, and on occasions of national ritual—presidential annual messages, Independence Day orations, and rural campaign speeches—the farmer was held up as the very repository of virtue.[15]

As opposed to the yeoman, who persisted as a national type, the Yankee was often a specifically regional type. Having appeared at the time of the Revolution, the characterization of the Yankee may well have been invented by contemptuous Englishmen to set off Americans as peculiar. Almost immediately, however, Americans appropriated the figure and interpreted it on their own terms. As a national type, he became "Jonathan," a little brother of England's "John Bull." In caricatures over the next half-century that depicted him as young and lanky, Jonathan exhibited a range of such positive qualities as independence, innocence, directness, and cleverness. It was with these characteristics that Americans set themselves off from citizens of the Old World. But it was in other manifestations, those through which Americans looked inward, that the Yankee had his real life.[16] In these, he was primarily (1) rural and (2) a New Englander. In the first capacity, he was an invention by urbanites who showed all the oddities that city citizens, particularly self-confident new Gothamites (Washington Irving's instantly popular desig-

nation of New Yorkers), attributed to their rural countryfolk: he was insular, socially clumsy, and peculiar in his dialect. In few manifestations did he actually farm. Newspaperman Seba Smith's popular rural characters in the 1830s, in fact—Jack Downing and his Uncle Joshua of Downingville, Maine—did almost everything they could to avoid farming.[17] The second allusive quality of the Yankee was more tendentious. Developed fully by New Yorkers in the 1820s, 1830s, and 1840s through countless anecdotes and almanac jokes, the Yankee was a New Englander whose characteristics ranged from covert to overt criticism of citizens of that region. Non–New England speakers gave to the Yankee such qualities as self-confidence in his virtue, a calculating nature, and suspicion of all things new, including politics, people, ideas, and gadgets. But New Yorkers were not the only Americans to project self-righteousness and calculation onto the Yankee. Early on, the type became popular in the South, where resentment of New England financial power and so-called moral righteousness ran high. Westerners complained that Yankees had so overrun Ohio that the merchants there were totally untrustworthy. The word *yankee* became a verb used widely, except perhaps in New England, that meant to cheat.[18]

The characteristics that New Yorkers and others projected onto the Yankee were those about which they worried a great deal in their own behavior. As the *Museum* expressed it in 1835, "The history of the Yankees is the history of the republic; the character of the Yankees has influenced, and continues to influence, that of every part of the nation; and their name, from a provincial designation, has become among foreigners the popular appellation of the whole people. . . . The other states are becoming like the Yankees." In the incarnations of the Yankee as Downeaster in such characters as Smith's Jack Downing, the Yankee was suspicious of Democratic politics—in which New Yorkers were leaders—but ultimately gave the Democrats his loyalty. In the interpretations of the Yankee as peddler by actors George Handel Hill, Dan Marble, and others on the New York stage (with such characters as Marble's Solomon Swap), the Yankee was the bearer of New Yorkers' anxiety about the blatancy of their own economic drive. The New England peddler, who in real life journeyed as far as New Orleans and Detroit selling tinware, clocks, and notions, became a national symbol of commercial exchange conducted quickly, under pressure, and probably deceitfully, by a seller who had traded his integrity for a lust for gain. By the 1840s, Thomas Chandler Haliburton's character Sam Slick the peddler, who tricked his way across the American countryside in stories published over the next two decades, was praised by enthusiastic readers as the incarnation of ongoing Yankeeism. It had become a commonplace to refer to the United States, with a mixture of apology and amusement, as The Universal Yankee Nation.[19]

As a construction called on for all sorts of differentiating occasions, the Yankee—and Yankeeism—combined humor, reflection, and self-criticism. In the Yankee farmer's or peddler's or Downeaster's self-confident and self-interested ingenuousness, and in his convoluted, inventive vocabulary, he embodied what seemed to make the yeoman tick and, moreover, what might enable self-satisfied citizens to accept the deplored "masses" as laughable and thus at least partially redeemed. From almanac jokes to the proliferating versions of Charles Mathews and other Yankee actors onstage, the Yankee "reckoned," schemed, misspoke, and triumphed over European visitors, urban merchants, Washington politicians, and social sharpers alike. To many in urban society, as the nation grew ever farther away from the domination of New England values and ideals, the Yankee farmer, the all-too-actual incarnation of the yeoman ideal, was both a celebration and a satirical target against which they simultaneously examined their own behavior and exempted themselves from its implications.

While the Yankee was being explored as a type within which citizens could release their resentments of farmers as well as of New Englanders, express their anxiety about economic transactions, and materialize in characters of another region their fears of being provincial and peculiar in European eyes, they explored projections of the Dutchman as well. Early slurs by New Yorkers of the Dutch burgher as stupid or blundering culminated in Washington Irving's characterization of them as such in his *Knickerbocker's History of New York,* 1809. Irving presented a vast canvas in which the dreamy burghers were out-thought and out-traded by Yankees and miserably incompetent political leaders. In 1809, when Irving created his work, the Dutch were an easy mark for satire. Losing their economic and political power to energetic Yankees moving into New York, the Dutch did not stay in the cultural competition long enough for later citizens to inform the type with new life. Apparently because citizens in the South and the West had little direct experience of Irving's target, they did not make it their own. Nonetheless, Irving's comedy of a scheming, incompetent government was easily transferable to any established group claiming economic and political power, and his works enjoyed frequent reprintings and long lives.[20]

In ordering their social universe, Northeastern and Western citizens gave limited attention to Southerners in the Old South. The very category Southerner seems to have meant to many Northeasterners an elite and entrenched way of life. It is true that Northern speakers heaped a large measure of satirical characterization on Southern elites, alluding to Virginians as "eye-gougers" and "eleveners" (that is, they had to have a drink before eleven in the morning) and describing Southern gentlemen as self-indulgent, hot-tempered, and vain. But middle-class speakers apparently did not associate these

qualities with their counterparts in the Southern middle classes (who were in fact some-what difficult to identify from a distance) or even the lower-class Southerner, where the real competitive tension lay. Thus they rarely developed the characterizations of "South-erner" per se onstage or spun popular stories about them to be reprinted across the country.[21]

What they focused on instead as characteristic of the southern regions was the group of emigrants from the southern coast and Piedmont who had moved into the "South-west" when it first opened to settlement in the 1810s. This area included western Geor-gia, Alabama, Mississippi, and Louisiana, as well as Arkansas. The citizens who first fanned out over it were perceived in the regions they had left as definitively of the "lower orders," and as though to confirm judgments that they were unambitious and lived hand-to-mouth, few of them traveled on in search of better prospects in the great west-ern movements of the 1830s and 1840s. Hence, the better sort elsewhere—and those who would claim to be such—not only disdained Southwesterners' origins, but their ap-parent contentment at staying in the backwoods. They were contrasted, much to their disadvantage, to rural New Englanders. "With the awkwardness of the Yankee coun-tryman," fumed J. H. Ingraham in 1835, "[Mississippians] are destitute of his morals, education, and reverence for religion. With the rude and bold qualities of the chivalrous Kentuckian, they are destitute of his intelligence, and the humour which tempers and renders amusing his very vices." Visitors and newcomers to the Southwest, including newspapermen and lawyers who moved there to make their fortunes, characterized these squatters as barely short of degenerate, redeemed—if at all—only by their inde-fatigable scheming. Assuming the guise of reporters, they sent to New York and Saint Louis newspapers stories about Southwestern characters that were filled with swindles, false identities, ear-pulling fights, and preposterous hunting adventures. Tales such as "The Pre-emption Right; or Dick Kelsy's Signature to His Land Claim," "Swallowing an Oyster Alive," and "Chunkey's Fight with the Panthers: A Thrilling Hunting Story of Mississippi," were reprinted across the nation and published in such collections as "Streaks of Squatter Life." The Southwest, in this configuration, was the location of go-ahead democracy at its most pernicious.[22]

The frontiersman could hardly have differed more. Like the Yankee, he was an early invention. Variously perceived as backwoodsman or frontiersman depending on one's assessment of the westward-moving enterprise, and invented as early as the 1790s by anxious New Yorkers and New Englanders, the frontiersman embodied what North-easterners perceived as the social threat of the increasingly substantial portion of the constituency who moved westward to live in the wilderness. Few city citizens—indeed,

few agricultural citizens—doubted that life beyond civilized boundaries resulted in so-
cial, intellectual, and moral breakdown. Although the West was in theory a classless
arena where citizens could begin life anew, urban citizens were sure that in actuality
classlessness resulted in leveling down—in vulgarity, ignorance, and lack of moral stan-
dards. Reflecting the historical phenomenon of early migration from western Virginia
over the Alleghenies, the earliest frontiersman was a Kentuckian. On the positive side, as
Northeasterners imagined him, he was devoted to the wilderness and capable in the
manly, yet uncivilized survival skills that the wilderness demanded. But they also saw the
frontiersman as much more—or less—than a competent woodsman. Self-centeredly
garrulous and possessed of a florid vocabulary and a propensity to outrageous exaggera-
tion, he was a "rip-roarer," a self-proclaimed "half-horse half-alligator." As a woodsman
the frontiersman was the ideal classless male; as an exuberant trickster, he fulfilled every
cynic's conception of the lower-class man in the wilderness. In this less flattering incarna-
tion, he represented the dangers of the southwestern environment as well as that of the
remote western backwoods.[23]

The Western frontiersman shared with the Yankee the skill and propensity to make
sharp deals. As the nation developed, the economic threat of the westward- and south-
westward-moving entrepreneur—and the political power that accompanied his move—
became an increasingly important part of Eastern, specifically New York, characteriza-
tions of the frontiersman. Economic power in agriculture shifted to what is now the Mid-
west, and then in cotton to the Southwest, and New York merchants had to deal more
frequently with Western farmers and merchants. Political power migrated dramati-
cally—by 1830 more than one-third of the population was west of the Alleghenies. The
type of the Westerner underwent permutations in Eastern storytelling and dramatic pro-
duction that represented the relative positions of regional power. Versions of the life of
Daniel Boone presented him variously as a genteel standard-bearer of civilization and a
frontiersman who was at home amid the roughest challenges of the wilderness, and by
the 1820s the tensions in encounters between the rough but honest frontiersman and
the socially self-conscious settler moving West led James Fenimore Cooper, son of landed
gentry in upstate New York, to create the character of natural man Leatherstocking.
Cooper's Leatherstocking novels made unequivocal the conviction of many urban East-
erners that the Westerner might have an admirable honesty and strength but that his
social and moral standing was definitely inferior to that of society. As the Western states
gained political power, consolidated in the election of Westerner Andrew Jackson to the
presidency, stories that both heightened and made ridiculous Tennessee woodsman and
politician Davy Crockett's exploits in the wilderness swelled into mythic proportions

while he was still alive. Versions of the adventures of trapper-pioneer-boatman Mike Fink, also a historical character, exaggerated his violence to larger-than-life dimensions.[24]

Like the Yankee, the Westerner served needs of Easterners across class lines. Eastern speakers could berate him for violence and bad manners; they could envy him because he was free to rove. In a kind of inverse commentary on what was bothering Northeasterners the most about their own social world, the Westerner could be praised as blissfully inattentive to social conventions, commercial demands, and urban competitiveness. The frontiersman was at once a symbol of what was properly American—independence and competence—and what was secretly longed for and forbidden—freedom from strictures.

As types with which citizens sorted out issues of power, virtue, and authority, the Yankee and the Westerner had few competitors. Others appeared briefly and faded. Pious Quakers and French dandies, Scotch tradesmen and Irish peasants, notable figures in certain metropolitan areas or simply types inherited from English humor, were not strong contenders for sublimated envy, anxiety, or disdain. In the larger issues of political and economic power—adjudicated primarily along regional lines—they were too local or too marginal.

Two other types, however, appeared prominently in jokes, stage productions, caricatures, and stories. But storytellers calculated their presence not to explore the competitive potential of the constituency represented by these types but to verify that they were inferior presences amid the citizenry. These types were blacks and women. In contrast to the energy and intractable autonomy that citizens at the center attributed to Yankees and Westerners, they presented blacks and women as both predictable and dependent.

Blacks in the earliest stories and caricatures were amusing, servile, and lazy. Usually they were given "typical" names. One early materialization in both caricature and onstage was Sambo the fiddler, another, slightly later, Agamemnon the coach driver. These caricatures sprang up across regional and class lines. Beginning early in the period, whatever characteristics were attributed to blacks served to their disadvantage. Caricatures and stories, for example, presented them as speaking a virtually unintelligible dialect, whereas tales featured the vernacular of the Yankee and the frontiersman as colorful. As tensions over slavery gathered strength in the 1830s, blacks were condemned as having a strong propensity to violence; again, in this they were set apart as different. Citizens conceived of blacks' toughness as completely unwarranted, and thus distinct altogether from the adolescent—and excusable—savagery of the frontiersman. Even in the rising antislavery sentiment of the 1840s, characterizations emphasized more than

ever blacks' inadequacy in the social and mental skills that gave their white counterparts mobility in the entrepreneurial society. Minstrelsy, which gained immediate popularity after its introduction in 1843, embodied the wishes of many citizens of both North and South that the conflict over slavery would disappear; minstrels enacted blacks as silly, childlike, and emotional, deserving their place and happy and grateful for it.[25]

Women, too, were characterized in ways that justified and sustained their subordinate political, social, and economic position. This typing permeated the constituency. Early almanacs and caricatures contained such typical lighthearted misogynist slants as take-offs on women's supposed credulousness and desire to dominate men. But as women organized in the 1830s and 1840s to claim more social and political power, two things happened to their characterization. First, they became figures of abuse ranging from po-litical caricature to virtually institutionalized comic situations in jokes, in stories, and onstage. Second, whereas women were sport for condemnation in jokes and fugitive literature, in more respectable forms of expression they were presented as ideal figures. Images and stories in abundance—many of them presented in the domestic market-place—represented wives and mothers as demure, sweet, lovely, passive, beautifully dressed, and in the home. These characterizations always represented women who were obviously helpmates in a domestic world rather than independent beings in the larger social universe of the male.[26]

And finally, on the urban scene, in the late 1840s dramatists and printmakers drew on stories and slurs about the urban working class to create a lower-class urban type. Such a character seems first to have materialized on the New York stage, in Benjamin A. Baker's *Glance at New York*. Mose, as he was called, was a fire fighter. Presented to New York audiences as arrogant, pugnacious, and finely dressed, he strutted the streets of the Bowery in glorious self-esteem. The characterization cultivated the prejudices of both ends of the social spectrum: the "better sort," who found such confidence and behavior completely unwarranted (although urbanites were grateful for the services of fire *com-panies*), and the "lower orders," who looked up to Mose and emulated him. Just as the materialization of the Yankee pointed the finger at popular anxieties about commerce, and the frontiersman the great tensions of a body politic spreading through the wilder-ness, Mose the fireman embodied the worst fears of the educated about the urban masses. With no traditional rural pursuits, the old values were lost; the city was the scene of trickery, bad influences, and social confusion. Mose—vain, vulgar, and masculine—embodied every characteristic at odds with what citizens in the middle and upper classes called republican values.[27]

With a vast and growing network of printed material exchanged and reprinted across

a dispersed society, as well as of troupes of actors bringing characterizations onstage to far-flung towns, this typing formed a crucial part of the discourse, both formal and throwaway, of the nation. In moments snatched from their own drive for success, citizens competed in wit and accuracy to define themselves by looking at those unlike them. Much of the scrutiny and self-definition materialized in vernacular expressions and (mis)pronunciations peculiar to types from different regions and social groups. Cultivated by city audiences and editors as a kind of social code that expressed at once their democratic sympathies and, because they employed an ironic tone, their social superiority, this vernacular, like the range of types, was at once a common bond and a tool of discrimination. Men in the wharf district of Manhattan, in the pulpit in Cincinnati, and in the editorial room in Portland, Maine, whether high born or ordinary, adopted such coinages as "go-ahead," "reckon," and "calculate" as a kind of floating social currency. It could be sincere, or ironic, or amused; in all cases, it represented being in the fray. As the population grew and spread, and newspapers and journals proliferated, editors and almanac publishers operated with an insatiable appetite for copy and for fillers that were entertaining; in turn, the material they reprinted abetted readers' need to (ostensibly lightheartedly) abuse their fellow citizens elsewhere in the nation.

Some pretended not to understand the tensions that were being reified and discharged by typing. New Yorker James Kirke Paulding thought in 1817, when he was an idealistic young man, that typing was an unfortunate habit that would surely diminish: "I am satisfied, that nothing but ignorance of each other, causes those stupid misconceptions, unfounded aspersions, and ridiculous antipathies, that still subsist between the different extremes in our country. A little social intercourse would do away all these, by showing distinctly to all, that there may be a difference in people, without any inferiority on either part; and that in every class and every climate, there is enough of a family likeness to demonstrate us to be one people."[28]

That Americans explicitly did not *want* to be "one people" is clear in a Bostonian's self-flattery in his assessment of the population in 1822. Nowhere, he wrote, was there "greater variety of specific character, than is at this moment developed in these United States of America . . . the highminded, vainglorious Virginian, living on his plantation in baronial state . . . the active, enterprizing moneygetting merchant of the East . . . the Connecticut pedlar . . . vending his '*notions*' at the very ends of the earth . . . and the long shaggy boatmen '*clear from Kentuck*.'" As the testimony of the Bostonian would suggest, informing the fiction of type were the tensions between the dominant or would-be dominant groups and everyone else: regional, racial, and gender typing substituted for class differentiation. With typing, citizens ordered the disorder about them, assigned the

proper blame for the incongruities in the democracy, and above all announced them-
selves as the moral center of the body politic.[29]

By 1825, the energetic would-be center of this great national dialogue
was New York City. Its economic and political authority was virtually
unchallengeable, and its most ambitious citizens strained to surpass the social authority
of Bostonians and Philadelphians. Already a major Atlantic port when it was catapulted
into economic leadership of the nation's interior by the opening of the Erie Canal in
1825, New York played the central role in the expanding commerce of the nation. In
politics, with its capital at Albany a short distance up the Hudson from New York City,
the state was the earliest to develop a two-party system, which was in place by 1830, and
the earliest to develop a party machine, which remained in place for generations. The
social changes in the new nation were at their most intense in dynamic New York City,
where ambitious ordinary citizens rather than those of good family assumed commercial
and political leadership and where immigration from the countryside and from abroad
was at its highest. There, as was repeatedly pointed out by writers of all persuasions,
whatever the social community of the nation might be, society received its most dramatic
challenges to coherence.[30]

As New Yorkers rose to positions of national influence in such institutions as banking,
politics, publishing, and commerce, they assumed varyingly dominant roles in the na-
tion's literary, artistic, and popular matters. In the up-and-coming New York of the
1820s, editors formed cultural journals and publishers aimed at the broadest possible
audience. Writers Edgar Allan Poe from the South, William Cullen Bryant from New
England, and James Fenimore Cooper from upstate New York all migrated to the city to
make their mark. Comic theater and political and social caricature began their rise there.
The National Academy of Design, established in the city in 1826, assumed leadership in
painting and sculpture, encouraging patronage organizations, dealers, and art journals.
Artists either went to New York themselves or sent their works to the city to be exhibited,
purchased, and assessed. Concentrated in New York were patrons of new wealth, men
who had taught themselves about art and were interested to show their public spirit.
Critical reviews in the city's cultural journals and newspapers were reprinted across the
nation, dominating national commentary on art.[31]

Considering themselves the nation's cultural brokers, New Yorkers, both of the rising
merchant classes and of the older privileged class, operated with a peculiar persona.
Many of them from rural New York and New England, they had the self-congratulatory

pride of the new urban sophisticate. They held themselves distinct not only from immigrants but also from New Englanders, Southerners, and Westerners. They were superior to New Englanders in worldly matters, they thought, and to Southerners on moral terms; they condescended to Westerners as naive and rough but because of economic ties felt the closest allegiances to them. At the same time they cultivated a rich irony about themselves. It was a New Yorker who pronounced in 1837, "We have become the most careless, reckless, headlong people on the face of the earth. 'Go ahead' is our maxim and password; and we do go ahead with a vengeance." Presiding over the nation's major symbolic production with a presumptuousness that infected all who tried to make their mark there, and yet constantly challenged by the dissident voices of colleagues and adversaries within the city, New York was where the tensions in the meaning of American culture were most self-confidently perceived and most tendentiously adjudicated.[32]

The story of antebellum genre painting is one with New York at its center.

Two An Image of Pure Yankeeism

By 1830, when the population in the twenty-four states of the United States was twelve million people, of whom more than half were women and blacks, a number of white male voices from different social levels declared optimistically that democracy would at last be realized. Many had benefited from the vast expansion of suffrage in the years following the ratification of the Constitution; and more than a few previously humble citizens had risen to positions of economic power. With the triumph of the Democrats in national politics in 1828 and the intoxicating expansion of the economy in the early 1830s, enthusiasts envisioned a great harmony of individual enterprise and respect—an official recognition at last of the importance of the common man. Although much of this talk about the ideal sovereign seems to have been honestly put forth by such earnest and privileged men of the people as Ralph Waldo Emerson, a great deal of it, even that expounded in the official organ of the Democratic party, the *United States Magazine and Democratic Review,* was whistling in the dark.[1]

William Sidney Mount, the first genre painter critics would call "absolutely American," came to maturity during this deceptively confident period, took stock of its implications, and built his career on representations of the Yankee farmer.[2]

Genre scenes were not his first choice. Born into an established land-owning family on rural Long Island in 1807, Mount was only seven when, on the death of his father, he was sent to lower Manhattan to live with his uncle Micah Hawkins, a successful wholesale grocer. At age seventeen, he was apprenticed to his brother Henry Mount, a sign painter in the city, and before long he had also enrolled in drawing classes at the National Academy of Design (NAD). Introduced there to the high ambitions of history painting, in 1828 he exhibited *Christ Raising the Daughter of Jairus* (Museums at Stony Brook), but the painting received only the barest notice. While prints of rural scenes by the Scots genre painter David Wilkie were circulating to approving American viewers, Mount struggled to improve as a history painter. By 1830, however, perhaps sensitive to the popularity not only of Wilkie and other English "peasant" artists but of Dutch and Flemish prints, Mount decided to try genre scenes.[3]

As though born to the proposition, Mount created paintings that played country simplicity to the hilt. In his first such picture, *Rustic Dance after a Sleigh Ride,* 1830 (pl. 2), he

took clues for his topic from one of John Lewis Krimmel's images, *Dance in a Country Tavern* (watercolor, Library of Congress). Mount pictured a mix of countryfolk, some ungainly, others self-conscious, and still others somewhat sophisticated, dancing in a plain front room while other countryfolk look on. Although the subject of rustics dancing had a long heritage in genre painting, Mount placed his characters in a specifically American social arrangement. In Mount's image three types appear from the roster of the American constituency: the African-American (in three incarnations—the fiddler, the bellows pumper for the fireplace, and the coachman), the yeoman, and the white woman. In the social relations implied by his group, Mount suggested several motifs in public discussion of rural life and of the citizenry. Blacks are on the sidelines, in service positions, and are male; men, even in the celebrating white group, receive the emphasis; and although the dancing women appear more self-confident than the men, they are depicted as silly and clumsy. Critics endorsed the painting as giving "earnest of future excellence," and, presumably because it fed a hunger of its audience, it won first prize on exhibition.[4]

Over the next five years Mount followed the success of *Rustic Dance* with other works about the yeoman and rural life. Drawing on the repertory of rural activities featured in recent paintings (and prints after the paintings) by George Morland and David Wilkie (although in those works rural typically meant peasant), Mount painted rustics dancing in barns, rural schoolboys fighting (with an admonishing woman hovering in the background), and small tavern life. He represented the country population variously as homely, earnest, and silly: yeomen and boys were his main actors, rural women hovered to instruct boys or serve as romantic foils for young men, and blacks were amusing servants. Each exhibition season critics wrote of looking forward to Mount's works, and they began to propose that an American school of painting might at last be in the making.

The growing number of favorable reviews suggest that Mount's pictures made much of their mark by flattering the self-styled sophistication of his city audience. Critics delighted in noting authoritatively, for instance, that Mount's subjects were not "*gentlemen* and *ladies*." Urban fans alluded to Mount as the "American Wilkie" who, by implication, painted an American peasantry. They took pleasure in identifying his rustics as Long Islanders, the nearest rural other that most Manhattanites knew. One writer was pleased that Mount's compositions "are all American. We could almost say that they are all of Long Island." Another assured fellow viewers of their exalted status with the transparent regret that "we might be disposed to wish such superior talents and skill as are here displayed had been exercised on a subject of a higher grade in the social scale."[5]

Grounding his work in the explosion of discussion about the citizenry that erupted

in the 1830s, Mount soon pursued more complex themes. While he developed his reputation, political and economic events were building to a level of tension that seemed unprecedented. Although political manipulation had always been part of republican life, commentators in the 1830s tended to overlook that history. During Andrew Jackson's first term as president (1829–1833) the Democratic party extended its power by organizing local precincts, and alarmed members of the opposition, behaving as though such practices had never occurred before, accused Democratic party officials of promising judgeships, postmasterships, and other spoils to Jackson supporters. Claiming that party loyalty had come to replace rational discourse and that political decisions were now transparent exchanges to gratify self-interest, doomsaying editors and opposition leaders urged citizens to choose principles over party. Although Northeasterners generally applauded Jackson's firm stand in 1832 against the South Carolinians who would nullify their obligation to the Union over Congress's tariff legislation, many rose in arms when the president withdrew federal funds from the United States Bank and released vast amounts of paper currency into the economy in 1834. Speculation grew rampant. Not within memory, older citizens complained, had incentives to go-aheadism been so blatant.

These events, following in rapid succession, produced an outpouring of story and stage characterization, of visual caricature and verbal pun, all of them constructions through which citizens attempted to come to terms with the economic and political instability that seemed to threaten the democracy's—the Experiment's—very survival. Political caricaturist Edward C. Clay in New York created broadsides that cast national politicians as card players, boxing opponents, and even animals. Stories about the general constituency represented citizens as calculating farmers, Jonathans, or Yankees cheerfully going after the "main chance." Wits across the country exchanged, printed, and reprinted tales of farmers involved in horsetrades that were thinly disguised scenarios about both political exchange and economic speculation: the buyers in the stories were typically so anxious to make a deal that they neglected to notice that the horse was riddled with sores or blind or deaf. In Maine in 1830 enterprising publisher Seba Smith began a commentary on Democratic politics and economic policy—his series of Jack Downing letters, in which the naive, impetuous Yankee Jack tried to set the president straight. On the New York stage, characterizations of the Yankee satirized an increasing range of rural and semi-urban variations on the entrepreneur. The Yankee farmer as a type bore the brunt of urban satire against old-fashioned New England traits and at the same time was used to wage sallies against the general American citizenry.[6]

From early on, Mount had witnessed the creation of at least some of this comic repertory. In fact, it is impossible to imagine Mount's subsequent achievement without this

Figure 4.
DAVID CLAYPOOLE JOHNSTON
PLATE 1 FROM *Scraps,* 1829. Engraving, 10 × 17 in.
Courtesy Library of Congress.

experience. His uncle had been an important figure in New York's growing theater district, collaborating with actors in developing stage characters of the Yankee. Hawkins introduced Mount to the work of comic artist and actor David Claypoole Johnston, who barbed his fellow citizens for three decades with single-sheet caricatures, illustrated books and comic almanacs, and collections of comic imagery (fig. 4). Inspired by the techniques of English graphic humorists William Hogarth, Thomas Rowlandson, James Gillray, and George Cruikshank, Johnston hit his comic stride with *Scraps,* collections of visual gags published from 1828 to 1846. With sharp vignettes supported by texts that satirized frontiersmen, schoolmasters, Quakers, blacks, temperance reformers, politicians, Yankees, women agitating for women's rights, and many more, Johnston created an ongoing comedy in which types in the citizenry behaved outrageously. His most popular weapons were his satires on American vernacular speech. Indirectly undercut- 27

ting the dignity of the national experiment by subverting the dignity of the national language and the people who used it, Johnston pictorialized such phrases and words as "A Grave Mistake," in which a hearse passes a drunk who mistakes it for a bus; "Corned Beef," in which a farmer surveys two drunken cows; and "Curtailing," in which a youngster cuts the tail of a dog. Johnston exposed the incongruities of the language and, through the language, of society at large.[7]

It was not only Mount's exposure to Johnston that was important but New Yorkers' affection for that kind of humor. As *Scraps* came out year after year, New Yorkers were Johnston's first and best supporters. Bostonians, still attentive to the social stratification and proprieties of discourse that characterized ideal life in England, tended to find his work offensive; New Yorkers, by contrast, many of whom were self-made men only twenty years from humble country antecedents, had no such impediment to a delight in reductive humor or vulgarity. Even the most aggressively middle-class citizen could justify an appreciation of Johnston's humor by invoking the artist's didacticism. As one New York reviewer concluded, "We advise those who are fond of laughing and being instructed at the same time, to launch out the trifling sum of one dollar, to pay for a copy of Johnston's *Scraps*, in the full assurance that he will find five dollars worth of amusement and ten dollars worth of instruction."[8]

With so successful a model before him, in a climate of issue-charged jokes, dramatic productions, and stories, Mount abandoned the general rustic to create a type specifically identifiable as the American sovereign. He switched from gatherings of both sexes to scenes of the male constituency, representing them as Yankee farmers who were a far cry indeed from the ideal yeoman. In the next five years he produced his—in fact, the— finest images of the Yankee farmer.

Mount's first work in this new enterprise was *Bargaining for a Horse*, or, as he called it, *Farmers Bargaining*, 1835 (pl. 3). The good cheer in the color, space, and activity of the painting give it an innocent veneer. In the foreground, two farmers negotiate in front of an open shed in a large farmyard. One is white-headed, wearing a country straw hat, the other young, sporting a black top hat that suggests the city. The men smile good-naturedly but not at each other, concentrating instead on their whittling, which they take very seriously: the old farmer has gotten his stick down to little more than a sharp point, while the younger one has virtually ignored his own, apparently in order to follow the progress of his companion. A sleek

saddled horse stands prominently nearby. The shed is nearly empty—visible only are a hayfork, a yoke for plowing, a pan on a ledge, and a few corn husks—implements, but no products. In the background, a woman strains to discern the men's activity.[9]

What the men are doing, apparently, is trading for the horse. They seem serious and sly. Carrying out something of a shuffle a few steps apart, whittling so as not to look each other in the eye, smiling as though not much was really at stake, they convey the quintessentially shrewd naïveté with which "wide-awake" sovereigns were busy carrying off the best deals. There is no inherited social hierarchy here, only the power to be achieved by pulling the best trade.

Although such calculatedly offhand deal making is funny enough, Mount put the farmers' trading into moral perspective. In the ideal republic, trading or buying of any kind was simply one aspect of economic life, subordinate to production. The farmers in this picture, however—as over against the ideal yeoman—have not paid much attention to production. As far as the viewer can see into the shed, there are no stacks of hay, no corncrib, not even chickens scratching around. The shed itself is in disrepair: the beam over the front is broken and the portions of the roof just behind it hang precariously over the open space below. In their devotion to getting a good deal, the yeomen have abandoned the productive work of plowing, sowing seed, harvesting, stacking hay, and even maintaining their property. Indeed, as Mount defines the transaction fever, young and old, city and country are implicated, with the young cityish fellow carefully calculating just how much farther he can push his older counterpart on the deal.

Having learned his lesson well from Johnston, Mount embedded in his image an unmistakable reference to horsetrading that was political as well as economic. A usage that had just entered the linguistic marketplace to describe Democratic politicking, the cynical vernacularism placed politics in the economic sphere. Politicians who horsetraded promised material benefits in exchange for political support. Such quid pro quo not only violated rational decision making but was as risky as buying a good-looking but unknown horse. Thus the logism blended judgment and amusement, conveying the tension between an ostensibly benign appearance and the actual process underway. By the 1830s, *horsetrading*, alluding not only to politics but to the uncertainty of all social exchange, was part of the vocabulary of the moralist, the cynic, and the worldly-wise alike.[10]

Mount's studies for the image show that he struggled to devise his painting so that the words crucial to the humor would be suggested by the image rather than being written in it, as Johnston had done. He sketched various possibilities (fig. 5). At one point he planned for his bargainers to be the same age but placed them on opposite sides of a rail

Figure 5.

WILLIAM SIDNEY MOUNT

Studies for *Coming to the Point*, ca. 1835. Oil on canvas.
The Museums at Stony Brook, Stony Brook, New
York. Bequest of Mr. Ward Melville, 1977.

fence, showing their competitiveness; in another sketch he placed them on the same side of the fence but distinguished their ages. In his most detailed working through of the possibilities Mount dressed the younger bargainer in a jockey cap and holding a riding crop; the headgear invoked the vernacular *jockey* by which speakers meant a trader, sometimes specifically a horse trader. In this sketch he also put the horse inside the shed to invoke yet another popular metaphor, *horseshedding,* which alluded to electioneering, or, literally, going out to the horseshed to talk confidential politics. Ultimately Mount settled on horsetrading rather than horseshedding as his metaphor, which meant that he could convey the widest indictment of mid-1830s public behavior—economic *and* political bargaining.[11]

Colloquialisms were fundamental to other aspects of Mount's picture as well. One witticism is the "coming to the point" of the older farmer with his whittling; another, given away by the fine cuttings on the ground, is that the older farmer is doing some "shaving," or carrying out some deceit, himself. Yet another is that the birds sitting on the roof—readable as either gulls or pigeons—tip off the alert viewer that someone is about to be gulled, or that a "pigeon"—a term ubiquitous in the anxious vernacular of the period—is about to be plucked. Mount's strategy was transparent: his image was as loaded, and at the same time as innocent, as ordinary language. Just as a punning speaker places the recognition of the joke and the burden of interpretation on the hearer, so Mount gave his painting a title—"Farmers Bargaining" rather than "Horsetrading"—that would shift the responsibility to his viewers for getting the joke. The critique of the sovereigns would thereby be theirs.[12]

Mount's viewers were apparently a varied group. They included members of the educated and financially secure old guard who were influential in the support of the National Academy of Design, newly successful merchants who were receiving their artistic education from exhibition walls, critics who wrote early, halting reviews of paintings for journals and newspapers, and audiences who came to exhibitions out of curiosity, social conviction, or the desire to be seen. Those who recorded their reactions, and who so in doing apparently spoke for others, seem for one reason or another to have been absolutely taken with this painting.

The surviving reception of *Farmers Bargaining* is a combination of delight and amazement. A writer in the *New York Herald* proclaimed, "This is an image of pure Yankeeism and full of wholesome humor." Then, considering that readers and potential viewers might want to linger over the colloquial implications of the activity, he wrote, "Both of the yeomen seem to be 'reckoning,' both whittling, both delaying." Another critic found the work so amusing that he applauded Mount's humor as "better even" than that of

Wilkie. Yet another viewer, obviously pleased with the painting but puzzled as to how to define its relation to art, admitted, "The genius of this artist is of a most eccentric kind." Yet, eager to show that he, too, appreciated genius, he continued, "We shall not pretend to criticize [the painting] but content ourselves with a simple acknowledgement of [its] superior merits."[13]

In moving from scenes of rustics to the startling vernacular of *Farmers Bargaining*, in which he projected the unyeomanlike sins of the body politic—including the urban viewer—onto the Yankee farmer, Mount had the support of a patron newly successful in the world of trade. Luman Reed, who commissioned the painting, was an enormously prosperous New York merchant from a humble farm background in upper New York state. Indeed, Reed's success in the activity alluded to in the painting—in its economic dimension, at least—suggests that the work served him variously as exoneration of, celebration for, and amusement at his cleverness. Reed was apparently ambitious about his status and cultivated important friends at the same time as he used his entrepreneurial success as a yardstick by which to encourage home-grown artistic efforts. When Reed met Mount in 1834, the merchant had already pursued an interest in things Yankee. He had supported the Yankee actor James Hackett, was a friend of Washington Irving, followed the Jack Downing stories, and had begun a collection of American art that included the American landscapes of Thomas Cole; when he saw Mount's scenes of rural life, he commissioned *Farmers Bargaining*. The details of this commissioning, however, are unknown. It is a matter of speculation whether Reed, fresh from the vigor of a Yankee performance by Hackett, or filled with admiration for Irving's incessant punning, or mirthful over Seba Smith's hilarious Jack Downing, or struck by the latest edition of Johnston's *Scraps*, suggested to Mount the vernacular fulcrum of the painting, or whether the irrepressible Mount tried it out on Reed, or even whether the two found the idea evolving in their conversation. Whatever the case, Reed was so pleased with the result that he pronounced *Farmers Bargaining* worthy of the attention of Irving and evidence of "a new era in the fine arts in the country."[14]

Almost in verification of that projection, and certainly in assertion that a wide audience would enjoy the image, in 1839 Edward L. Carey of Philadelphia published an engraving of *Farmers Bargaining* in *The Gift for 1840*, a sentimental annual that contained poetry, short stories, and engraved illustrations of ideal women and cherubic children. It was one of many such books destined for parlor tables and domestic readers across the growing nation. Apparently to make sure that this larger (perhaps less alert) audience got the pun, Carey changed the painting's title to *Bargaining for a Horse*, putting in the

climactic position the crucial term of the colloquialism that inspired the painting. This has remained the title ever since.[15]

Within a few months of his spectacular success with *Farmers Bargaining*, confident that he had found a mother lode in the Yankee type, Mount created the bold picture *Farmers Nooning*, 1836 (pl. 4). In *Farmers Bargaining* he had taken as his target citizens' drive for economic and political self-interest; in *Farmers Nooning*, painted when antislavery campaigns had reached what many analyzed as crisis proportions, he criticized abolitionists. The paintings are completely different in their targets: in the first work, Mount assumed the role of the amused onlooker and criticized a large fast-dealing Yankee citizenry; in the second, he assumed the role of insider and ridiculed the minority of outside reformers. In both works, however, the painter assumed the superior vantage point of a New York sophisticate eager to cast judgment on a rambunctious citizenry.

The picture shows four farmers and a boy in a hay field taking a noon break from harvesting. The cast of characters is again rural, but all the figures are young. The three white farmers (the yeomen of the picture), white boy, and black man comprise a larger social world than Mount portrayed in *Farmers Bargaining*. These characters use their time in distinctly different ways. The worker on the left, a model of neatness and prosperity, sands a riffle, or scythe sharpener, in preparation for the afternoon's work; the one in the middle sits with his back to us, his attention directed in front of him; the third, farthest to the right, with ragged clothing and holes in his shoes, stretches out languidly on his stomach, his feet in the air. This foreground group rests under the shade of an apple tree, while in the bright sunlight of the middle ground of the picture, the black man and white boy form a second group. The African-American, comfortably dressed and healthy looking, lazily relaxes into sleep atop the haycock, while the grinning boy, about ten or eleven years old and wearing a bright tam-o'-shanter, tickles his ear with a straw. Scattered through the scene are accoutrements for refreshment and tools for work, the most important of which is the scythe that hangs from the tree. But for this detail, the picture is a veritable idyll.[16]

Yet, the African-American worker, with all that his sensual pose implies, and the tam-o'-shanter the boy wears announced unequivocally to Mount's alert viewers that the main allusion in the painting was to slavery. In 1835 tension over slavery was at fever pitch. In undisguised evaluation of the slave revolts in the West Indies that followed Britain's pro-

clamation of gradual emancipation in 1833, Americans warned that similar outcomes were likely in the United States should abolitionists have their way. Antislavery reformers in the early 1830s battled this national intransigence with journals, mailing campaigns, and public speeches. They outraged many of their fellow citizens, who accused them of fomenting revolts and conspiring against the nation. The *Long Island Democrat*, Mount's paper, was one of many that regularly alarmed its readers about the dangers of abolitionism and the meanness of African-Americans with such reports as "We find the most vicious, and wicked [blacks] on large farms . . . [whom abolitionists] tempt with news of European abandonment of slavery and freedom in the West Indies." Across New England and New York, angry mobs of the educated as well as uneducated swamped meetings at which antislavery speakers appeared; in 1834 one such group held New York City at bay for three days. President Jackson deemed the issue so explosive that in his annual message of December 1835, he called the activities of organized antislavery "unconstitutional and wicked."[17]

The tam-o'-shanter became a transparent reference to abolitionism. Because English and Scottish emancipation societies aided American reformers, such editors as New Yorker James Watson Webb in the *Courier and Enquirer* routinely referred to even local abolitionists as "foreign agitators" who were financed by a "bevy of old maids at Glasgow." Graphic artists adopted the tam-o'-shanter, shorthand for Presbyterian, Scottish, and thus foreign-influenced opinions about emancipation, as a derisive visual symbol of the movement, and virulent political caricatures showed blacks wearing Scotch caps talking about "bobolition" (fig. 6).[18]

Mount, apparently aiming *Farmers Nooning* for strongly antiabolitionist New Yorkers (he was one as well), moved from a critical assessment of the Yankeeism of dealing sovereigns to a rebuke of the moral reformers who would wreak havoc on economic and political order. He cast the relationship of slaves to the larger society in the terms both of their "nature" and of the nation's economic production. Among the white labor force—the yeomen—in *Farmers Nooning*, from the middle-class energetic citizen to the ne'er-do-well lying in the shade, Mount depicted a spectrum of attitudes toward work. But he presented the African-American as unambiguously lazy, undercutting the beauty of the figure by the social associations of the man's clear enjoyment of his leisure. Moreover, by contrasting the details of the black man's comfortable dress and the ragged clothing of the white man in the foreground, Mount materialized the claims of some antiabolitionists that slaves were so much better cared for than many whites that they did not need emancipation. There is yet another complexity in this ostensibly benign image: with the ambiguous relationship of the black man and the white child Mount alluded to claims

Figure 6.
EDWARD C. CLAY
"The People Putting Responsibility to the Test, or the
Downfall of the Kitchen Cabinet and Collar Presses,"
1834. Lithograph published by T. W. Whitley, New
York. Courtesy Library of Congress.

that slaves were so lazy that if freed, they might refuse all work, as had blacks in Jamaica, and that slaves were so naturally prone to violence that they might riot if their "ears were tickled" with impossible dreams of freedom.

Here again, Mount chose a vernacular expression as fundamental to his image. *Ear tickling,* the activity of the young boy in Mount's picture, meant filling a naive listener's mind with promises. Indicting antislavery speakers as childlike and irresponsible, Mount couched his critical construction in a deceptively low key. One might well decide, in fact, that the image praised the benignity of the status quo. Just as resolutely cheerful viewers—and those who did not get the colloquial allusions—could read the yeomen in *Farmers Bargaining* as innocently passing time, so they could read the young boy in *Farmers Nooning* as a happy child and the black man as good-natured and "safe." Neither ugly nor explicitly foolish, the sleeping man is a far cry from the near-caricature of the blacks on the sidelines in Mount's *Rustic Dance.*

35

Yet, it is hard to resist the hypothesis that Mount included a warning in *Farmers Nooning* to which more thoughtful viewers could pay solemn attention. Like the detail of the untended barn in *Farmers Bargaining*, the scythe hanging on the left points to a "harvest." This harvest will be reaped by these yeomen, counterparts of the viewers in the exhibition room and of citizens in the larger body politic. Will the harvest be one of bounty or, if the abolitionists are allowed to pursue their mischief, one that the nation will regret? Mount's ingenious combination of light-heartedness and awareness in *Farmers Nooning* could not have embodied more precisely the deliberate naïveté about slavery that European travelers, and an occasional clergyman or American leader in the privacy of a diary, remarked on time and again: American citizens lived matter-of-factly with a potential powder keg.

Like *Farmers Bargaining*, the painting was commissioned by a merchant, Jonathan Sturges, a successful New York wholesale grocer who had been the partner of Luman Reed. Like other New York merchants, Sturges had much to lose by the projected economic upheaval that doomsayers insisted would follow emancipation. Again, one wonders about the process by which Mount conceived his work. Unfortunately, there is no record of what kind of painting Sturges requested. In the only known sketch (fig. 7), Mount oriented the image exclusively toward the motif of industry and idleness—with five white (and no black) workers in the field, one of whom readies his scythe while the rest sleep or relax. Mount may have developed the antiabolitionist "twist" for *Farmers Nooning* in conversation with Sturges as they studied this first sketch, or perhaps Mount thought of it in his studio after the agreement with Sturges. What seems to have impressed Sturges most about the finished work was the blitheness of Mount's treatment of the issue. He wrote the artist: "I was sitting opposite the 'Farmers Nooning' *last evening* and enjoyed myself so much I suddenly felt quite anxious to get a peep at some other scene in the same line." Whether "in the same line" referred to Mount's specific embodiment of an antiabolitionist stance in the work, or whether it alluded to his construction of the painting on the vernacular, makes for tantalizing speculation.[19]

Like Sturges, Mount's reviewers avoided explicit discussion in print of the issues he raised in the painting. Was this because the issue was so inflammatory that no one would risk alienating a readership? One critic wrote happily about *Farmers Nooning*, "This very fine picture from the pencil of the American Wilkie represents Long Island hay-makers resting at noon from their labours. It is truly American. The figure who lies face downward in the shade, and is 'kicking up his heels' is only surpassed by the negro who sleeps on a hay-cock in the sun." Another wrote, "What can be more true, more replete with dry humour, varied expression and character, in costume, physiognomy, repose, &c.

[than] the sprawling, sleeping negro imbedded in the straw under the apple tree's shade, grinning his noonday dreams as the young urchin insinuates the straw in his ear[?]" Is it that the very duplicity of Mount's images, like the multiple implications of the spoken language, both compressed and discharged his viewers' tensions, making it unnecessary that they speak directly of them?[20]

Like *Farmers Bargaining, Farmers Nooning* was soon transformed into a print, meaning that the taste of Mount's patron and critics was identified as appropriate for a much broader audience. The directors of the new patronage association known as the Apollo Association (soon to become the American Art-Union), all New Yorkers, had the image engraved in 1842 for distribution to a national membership, contrasting in both subject and tone to the association's usual landscapes, literary scenes, and flower pieces. Two years later, the Philadelphians who edited the home magazine *Godey's Lady's Book* chose *Farmers Nooning* to be engraved as an illustration for a monthly issue, and again, the work was unusual in its new context. Did these various arbiters judge as good for Mount, 37

for viewers, or, most likely, for national politics the dissemination of the image into as many households as possible?[21]

Although Mount seems to have been the only painter in the mid-1830s to take as his subject discrepancies in the democracy, writers did not hold back. In Georgia, August Baldwin Longstreet had just published his *Georgia Scenes,* the first in a long string of unflattering accounts of the raucous Southwesterner. Nathaniel Hawthorne, in his *Twice-Told Tales,* situated his absorption in the moral dimensions of the citizenry in colonial New England, and Edgar Allan Poe, first in New York and then in Philadelphia, transposed into gothic tales his own ominous sense of commercialism and social decay. Taking the opposite approach with heightened hyperbole, the official journal of the Democratic party—the *United States Magazine and Democratic Review*—began publication by declaring, "We have an abiding confidence in the virtue, intelligence, and full capacity for self-government, of the great mass of our people—our industrious, honest, manly, intelligent millions of freemen." Mount took the middle road: a Democrat but neither a Cassandra nor a crusader, he put the issues about the body politic into the public arena with symbols that audiences had already devised. In his paintings the issues were both there and not there.[22]

The year 1837 was a big one for Mount—and for the Yankee yeoman—at the National Academy of Design. It was Mount's best, in fact, in a career that lasted three more decades. In addition to *Farmers Nooning,* he exhibited *The Raffle* (now *Raffling for the Goose;* fig. 8). With this painting Mount took aim at another manifestation of the yeoman: not the mature yeoman farmer implicated in *Farmers Bargaining* or the yeoman with abolitionist leanings in *Farmers Nooning* but the young sovereigns of town and country whose zeal for speculation rather than hard work endangered the Republic. It was the closest Mount ever came to indicting an explicitly urban citizenry.[23]

The Raffle is a small painting set neither in the fields nor in the barnyard. Rather, the yeomen are inside a tavern, or what seems to be a back room to a tavern, and once more, the world is that of the male. Here six assorted do-wells and not-so-wells, elegant and ordinary, younger and middle-aged, gather around an improvised table. The dapper young group of four in the foreground is balanced by the two middle-aged men at the end of the table, one with a threadbare hat and a girth that strains the vest of his wrinkled clothes. Filling in the low end of this economic and social spectrum is a humbly dressed seventh man, who, pipe in mouth, leaves the scene through the door at the back

Figure 8.

WILLIAM SIDNEY MOUNT

Raffling for the Goose, 1837. Oil on wood,
17 × 23 1/8 in. The Metropolitan Museum of Art. Gift
of John D. Crimmins, 1897.

left. Mount has depicted a tense moment. Four pairs of eyes are on the hat and its contents—presumably raffle tickets. One participant grasps by a leg the ostensible object of the raffle, a decapitated and plucked goose.

This poultry raffle, like the horse trade in *Farmers Bargaining* and the lunch break in *Farmers Nooning,* purported to portray a real event. Such raffles were common in the Bowery, a nexus of evil in lower Manhattan where gambling dens attracted men of all social classes, especially young men just come to the city. Prizes of poultry both excused and disguised the gambling for money that was the real objective of the activity.[24]

And yet *raffling* was a general term that meant speculation. Mount painted the work in the early months of 1837 at the height of an economic frenzy. On his own Long Island, land speculation on the railroad route was feverish. Property values, the Baltimore weekly summary *Niles Register* had reported in 1835, had multiplied unbelievably: "Three years since, building lots on Brooklyn heights would be readily obtained for $700—now they are worth $8,000!" In March 1836 New York merchant Philip Hone, in his diary a rather 39

circumspect conservative, could not resist the opportunity to cash in on the speculation and sold his house on Broadway; he noted with satisfaction that he had made a large profit: "I have turned myself out of doors; but $60,000 is a great deal of money." With inflated currency fueling intense speculation, in fact, many citizens had crossed the line from turning a profit to outright gambling. The *Niles Register* had reported as early as 1835 that across the country "small tradesmen, shopkeepers, clerks of all degrees, operatives of town and country, members of the learned professions, students in the offices, beginners in the world without capital, or with a little, all frequent the exchanges and the auction-grounds to try their fortunes as with the lotteries." In journals and caricatures moralists intensified their warnings of the dangers of this frenzy—threats to the economy but even more important, to the individual character. The present "gambling spirit is apt to prove epidemic, and becomes violent in proportion to its spread," preached *Niles*, and the next year the popular newspaper moralized that speculation would "blunt the moral feeling of young men, who are looked to as the future hope of commercial and manufacturing enterprise."[25]

The goose in Mount's picture, like the horse trade in *Bargaining for a Horse* and the ear tickling of *Farmers Nooning*, was central to his wit. Virtually no rural term of ridicule than "goose" was more popular in the repertory of metaphors in the 1830s with which citizens denigrated each other, whether they were describing politicians, social crusaders, or rustics. Especially popular was the phrase "gone goose," which meant a foolish person who had just depleted his or her supply of luck. Like a group of boys at play, Mount's raffling citizens are variously cheerful, hopeful, certain, and slightly anxious, but they—at least all but the one who will win—are as out of luck as the goose on the table. Country men, city men, middle-aged, young, gullible, and sophisticated—all have surrendered themselves to the fatuous illusion that they will win the draw. Only one bows out of the activity in *The Raffle;* he, the wise viewer might suspect, has already "lost his shirt," his discreet exit sounding the warning provided by the scythe in *Farmers Nooning* and the broken beam in *Farmers Bargaining*. As John Frost concluded the story he wrote to accompany the engraving of Mount's image in a gift book, "[He who speculates on real estate] is 'raffling for a goose.'" Indeed, "Every one who goes [to the raffles] is very likely to turn out a 'gone goose.'"[26]

Art lover and diarist George Templeton Strong referred to Mount's *Raffle* and *Farmers Nooning* as "perfect . . . Yankee pictures," absolutely "true to life." So important were the specific associations of "goose" to the moralizing of Mount's gambling picture that later viewers began referring to it as *Raffling for a Goose*, just as Carey had transformed "Farmers Bargaining" into *Bargaining for a Horse*.[27]

The patron for whom Mount created this small image was quite unlike the self-made men who had commissioned the other two works. Henry Brevoort was a conservative, wealthy Federalist from an old New York family who collected Old Masters. His own political bent in the democracy was to remain aloof; but his economic stake, and that of his children, was clearly at risk in the speculative climate of the 1830s. An older member of the same group of New York families as Washington Irving, Brevoort shared the comfortable classes' discomfort at the average yeoman's social crudeness. In 1832 he wrote Irving on Irving's return after a long stay in Europe, "I am glad to hear that you mean to travel. Jonathan has grown up a stout gentleman since you knew him in the days of yore, and I think you will see many whimsical features in his crude character, unknown to you before." Although we know nothing of the arrangements between Mount and Brevoort for the picture, certainly Mount's constructions were a long way from the solemnity of Brevoort's Old Masters. For Brevoort, irresponsible economic activity was a proper object of upper-class concern. Beyond the shock of recognition of the plucked goose, there is little to laugh at in *The Raffle*.[28]

Although he created several other genre scenes during these years, it was in these three paintings of 1835, 1836, and 1837 that Mount constructed in deceptively innocent pictorial language the participation of the citizenry in the most intensely contested activities of the era. These pictures not only earned Mount his reputation but became the benchmark against which his future work, and the genre paintings of other artists, would be measured. The relation between Mount's paintings and political caricature, which achieved a new intensity in this period, shows clearly the cultural functions of his paintings. Whereas caricaturists' targets were specific public figures and particular political issues, Mount critiqued the body politic at large and general economic and political behavior. His figures were subtle variations on the yeoman—the calculating Yankee farmer, the working yeoman, the interfering reformer-yeoman, and the gambling sovereigns. In all three paintings Mount showed his citizens as blithely ignoring the moral implications of their activity.[29]

In his success with patrons and critics, Mount developed a very calculated persona. He presented himself to his public with much of the ambiguity of the yeoman-Yankee farmer-Long Islander who is both part of and separate from the constituency. Calling himself a "hard working farmer's boy" (when he had actually spent much of his youth in the city) and studding his speech with puns, he capitalized on his country antecedents for both his topics and his "homely" wit. At the same time, he frequently said that the

only place an artist could work was in the stimulating city and, trying to prove it, periodically relocated from Stony Brook to the city, though he never stayed for long. He refused offers to study in Europe. Surely it was to curry the fancied superiority of his city audiences that he referred to as "mugs" the faces of his (presumably middle-class, but all rural) Long Island portrait sitters, on whom he depended for his living.[30]

Mount's *Painter's Triumph*, 1838 (fig. 9), which can be read as a kind of self-portrait, suggests that strategy. Mount pictured the painter as virtually in complicity with his audience of one, who chuckles in delight as the painter points to a detail on the canvas. In turn, confirmed in the judgment that the viewer would catch the joke, the painter raises his palette in a boyish gesture of exaltation. His studio is devoid of casts and stylish props; he paints from what's going on *outside* the studio, "for the many, not for the few," as Mount exhorted in his journal. All the works in the studio except the one on the easel are turned toward the wall. Only a drawing of the head of the Apollo Belvedere, in the extreme right background, is visible, with the maulstick drawing the viewer's attention to it, and Mount's placement of this image seems to have been as calculated as the jokes on his other canvases. The head of this revered monument is turned away from a scene so obviously devoted to popular rather than fine art.[31]

It was not long before critics were assessing Mount as *the* painter of American character. They praised him as cutting from the whole cloth. Reviewing *The Tough Story—Scene in a Country Tavern* (now called *The Long Story*, Corcoran Gallery of Art), exhibited in 1838, for instance, one writer called Mount "the most original of our artists, . . . and the only one who paints truly our country, life and manners." Others wrote that in his work there was "nothing to remind you of the print shops," and "Mount is *his own author* . . . the American Painter of American Character." A critic for the *New-York Mirror* climaxed his approval of Mount's work in 1838 with the statement that Mount was "a vigorous, untaught and untutored plant, who borrows from no one, imitates no one, and should be compared to no one." More than one enthusiastic viewer urged Mount not to go to Europe, for fear that his simplicity and wit would be tainted. Typical was an exhortation in 1837: "We fear that if Mr. Mount should visit Europe and fill his mind with foreign images, unless he keeps them, as no doubt he will, so distinct and apart from the faces, figures, and attitudes of his country-folk, that no mixture can take place when he mingles his colours on canvas. . . . We hope orders for pictures will detain our friend Mount at home, until there can be no fear of foreign scenes supplanting such as the gallery this year exhibits."[32]

Yet, many still questioned, was Mount's work the kind of *art* that an ambitious nation deserved? Attractive as it was to merchants, new critics, and other enterprising citizens,

Figure 9.
WILLIAM SIDNEY MOUNT
The Painter's Triumph, 1838. Oil on wood,
19 1/2 × 23 9/16 in. The Pennsylvania Academy of the
Fine Arts, Philadelphia. Bequest of Henry C. Carey
(The Carey Collection).

Mount's paintings were only one point on the spectrum. Other claims to artistic authority, some vague and some strident, were made by collectors, reviewers, artists, and patrons. Although many citizens might have agreed with Mount on the character of the American yeoman—the character of *other* Americans, at least—they wrestled with the conviction that art must be something quite different from what appeared in his paintings.

Fundamentally, this problem stemmed from the belief (for many a hope) expressed by Mount's first dubious reviewers that art should be ideal—that it should point to beauty, intelligence, and goodness. Although many of these same critics felt that they should encourage native art, at the same time they expressed confusion as to what such art should be. If, as William Dunlap urged, artists who worked in a democracy needed to 43

prove the superiority of democratic government, then artists were truly in a defensive position. Was art at all compatible with political, economic, and social equality? In addition to the matter of equality, the relation of art to material ambition was particularly thorny. Many who openly disdained commerce, trade, or capitalism—as long as someone else's profit was at stake—urged widespread, even government, support of artists so that the "Beauty, and Moral Elevation" of their art would correct "the spirit of the age." Mount's pictures did not forward such a mission—indeed, they comically celebrated the incongruities in the "mechanical and utilitarian" spirit with which Americans implemented political and economic equality.[33]

In the interest of transcending, even denying, their material concerns, American art collectors—many the same ones who encouraged Mount—hovered around dealers who peddled Old Masters; they traveled to Europe to see the monuments in the grand tradition. As patrons of the academies in New York, Philadelphia, and Boston, they helped finance collections of copies of paintings in the grand tradition and of sculptural casts for students and audiences. They encouraged the exhibition of what the critic above called "foreign scenes." Several encouraged promising native artists like Gilbert Stuart Newton and Thomas Cole to study abroad and gave them substantial support, so that they could generate on American soil a respectable, reassuring—a demure—art.

In the years before and during Mount's success with genre paintings in the 1830s, other artists avoided genre painting altogether. They were praised for imitating urban English taste in ideal figures, scenes from literature, and landscapes. Articles and illustrations from English periodicals filled American journals, and artists like Henry Inman and Thomas Sully, responsive to this taste, exhibited pictures of pious mothers, children, and families. Literary themes sent to New York by such expatriate artists in London as Charles Robert Leslie and Gilbert Stuart Newton inspired artists to paint subjects from Shakespeare, the comic novelists Lawrence Sterne and Tobias Smollett, and Sir Walter Scott. Painters combined the known appeal of literary topics with the new fervor for a literature about American types. On the heels of the success of Washington Irving with his stories about the Dutch and New Englanders, and of the excited reception that James Fenimore Cooper received with his novels about frontiersmen, such painters as Asher B. Durand and Augustus Browere pleased audiences with constructions of Irving's and Cooper's most popular scenes. Literary subjects linked painters and audiences to social certainties, but even more important, to a literary culture that was eminently respectable.[34]

History painting, although its pursuit was always difficult in the United States, was the strongest manifestation of the respectability of the ideal. At the same time that Mount was critically examining the political constituency of the present, ambitious would-be

history painters in the late 1830s were shaping interpretations of the past. History paintings constructed a moral, principled past that made it unnecessary for viewers to ask uncomfortable questions about the present. Discovery scenes planned for the Capitol, for instance, presented explorers as motivated by religion rather than hope for commercial gain. In another contrast to Mount, an exhibition in 1839 of the Old Master–like paintings of Washington Allston, frustrated Bostonian history painter of an earlier generation, caused an outpouring of affection in New York viewers for the "old" techniques, moods, and exalted subjects. A *New-York Mirror* critic of the National Academy exhibition in 1841 pontificated that "it is through [historical painting] mainly that we judge of the state and prospect of painting; and it is gratifying to find in the present exhibition some sterling productions." Praising the discreet coloring, completeness of accessories, and good character and expression of John F. Weir's *Columbus before the Council of Salamanca*—qualities absolutely unlike those in Mount's paintings—he encouraged collectors to establish their social class through their patronage of such elevated works: "If we had a study wainscotted with polished oak, garnished with antique tomes, choice bits of statuary and fragments of Roman armour, we would hang this picture (if it were ours) over our reading-desk."[35]

Attractive as were literary and fancy subjects and history painters, the rising landscape movement offered elite viewers the most alluring alternative to Mount's genre paintings. During the years that Mount was probing the potential of the Yankee type, American landscapists, with Thomas Cole in the forefront, were winning strong critical favor for their "uplifting" scenes. With landscapes outnumbering genre paintings by about seven to one, and the portrait an exasperatingly perennial exhibition staple, reviews concentrated almost exclusively on landscapes. Such vocal critics as Houston Mifflin saw the mission of art as best achieved in depictions of nature. The landscapist Thomas Doughty, Mifflin wrote in 1833, "infuses into his picture all that is quiet and lovely, romantic and beautiful in nature." The same year that Mount exhibited *Farmers Bargaining*, Thomas Cole published his "Essay on American Scenery," in which he described landscape as "an unfailing fountain of intellectual enjoyment, where all may drink, and be awakened to a deeper feeling of the works of genius, and a keener perception of the beauty of our existence." Such terms were applied neither to the political and economic decisions of American sovereigns nor to Mount's paintings.[36]

As a consequence, Mount began to encounter increasingly discouraging criticism. The intense regional and class conflicts in the mid-1830s that had inspired his first flash of imagery became enduring strains in the culture. The frantic economic dance in which the citizens of farm and city alike had stepped higher and faster slowed and then stopped.

The economy had begun to collapse in the spring, and by 1838 and 1839 it was at its nadir. In June 1837 English visitor Captain Frederick Marryat found that "suspicion, fear, and misfortune have taken possession of [New York City]. . . . Not a smile on one countenance among the crowd who pass or repass." Into the early 1840s, Mount, like other artists in New York and elsewhere, had to make his living primarily with portraits. In two paintings with which he attempted to rekindle the inventiveness that had won him popularity, he turned to the theme of politics, commissioned to do so by an astute observer of the techniques of political persuasion.[37]

Although New Yorkers boasted even in 1839 that their city was "the great Emporium of the commerce, the enterprise, and the wealth of this great country," politics alone, New York cartman Isaac Lyon reminisced thirty years later, "ruled the day."[38]

The horsetrading that Mount had alluded to in *Farmers Bargaining* had been dramatically overshadowed, many believed, by the rise of machine politics and strategies to manipulate uninformed voters. By 1837 the Whigs, earlier referred to simply as the Opposition, were making major gains against the Democrats at the local and national level across the nation. Many of them new to politics, Whigs capitalized on the Panic of 1837 to assail Democratic economic policy as dangerous. Large numbers of Democratic merchants and bankers became Whigs almost overnight, and local fall elections in 1837, especially in New York and Philadelphia, reflected this shift. To win even more voters nationally, Whig strategists developed highly polished campaign rhetoric that put into practice what the Democrats had already found would work with a large electorate: they claimed to be the party of the people and, moreover, the party that most faithfully fulfilled the principles of George Washington.

Caricaturists lampooned Democratic candidate Martin Van Buren as desperately attempting to align himself with the revered political heritage that the Whigs claimed. Prime material in this battle of rhetoric was vernacular wordplay. Playing on the aural similarities of *wig* and *Whig*, cartoonist Edward C. Clay, the most vigorous of the caricaturists, depicted Van Buren at a "Whig Bazaar," or store, trying to get fitted up for the campaign (fig. 10). In other wordplay, the trap became a major theme. A Democratic broadside (fig. 11) warned Louisiana voters to "beware the Federal-Whig-Abolition trap" with the two symbols of the Whig campaign, the log cabin and the cider barrel, the log cabin functioning like the box in a deadfall trap. Once the naive voter in this caricature bends down to take a drink of irresistible cider (in so doing he will have crawled under the delicately poised cabin), he will set off the trap. That is, if he falls for the rhetoric of the party, or if, in another colloquialism of the period, he is a sucker, he will be trapped.

Vernacularisms had provoked Mount's wit before and they were to do so again. The

Figure 10.
EDWARD C. CLAY
"W(h)ig Bazaar," 1837. Lithograph published by H. R.
Robinson, New York. Courtesy Library of Congress.

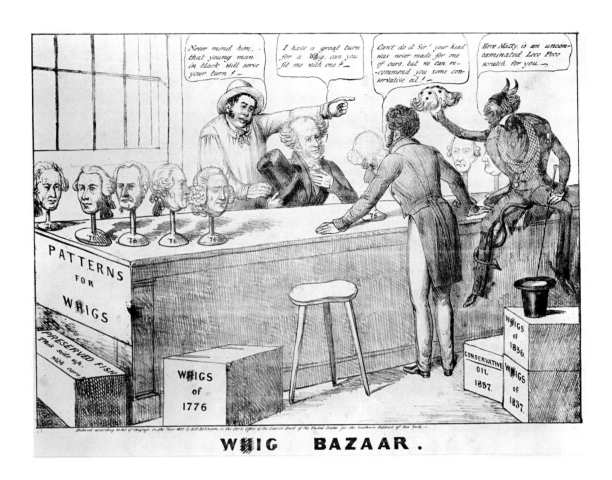

Figure 10.
EDWARD C. CLAY
"W(h)ig Bazaar," 1837. Lithograph published by H. R.
Robinson, New York. Courtesy Library of Congress.

new politics provided him new metaphors for imagery. In the naively fashioned winter scene that he called *Boys Trapping*, 1839 (fig. 12), a fairly small, harshly colored painting, two raggedly dressed boys about eleven and thirteen tend to their deadfall rabbit trap, which has been set in a snowy woods. In their clothing and shoes, the boys are virtual ragamuffins—arm seams ripping out, holes at the elbows, tattered hats. But in stance and facial expression they are gleeful. One boy triumphantly displays a trapped rabbit, holding it high and looking directly at the viewer; the other kneels in the snow to reset the trap. The box is a homemade wooden contrivance, with a piece of bait inside to lure the rabbit. When the rabbit nibbles the bait, it triggers the device that causes the top and end piece to fall, trapping the animal inside. As in *Bargaining for a Horse,* the cast is limited, the details are minimal, and the energy of the image is derived from vernacular speech.

Trapping rabbits meant to convert voters (by trapping them) to the Whig cause. Whigs 47

Figure 11.
"Federal-Abolition-Whig Trap to Catch Voters In," ca. 1840. Woodcut,
Broadside Collection. Courtesy Library of Congress.

FEDERAL BANK WHIG MOTTO.

"WE STOOP TO CONQUER."

FEDERAL-ABOLITION-WHIG TRAP,

TO CATCH VOTERS IN.

PEOPLE OF LOUISIANA, above you have an accurate representation of the federal *"Log-Cabin"* Trap, invented by the *bank-parlor, ruffle-shirt, silk-stocking* GENTRY, for catching the *votes* of the industrious and laboring classes, of our citizens, of both town and country. The federal party has always looked upon the poor, laboring people as an ignorant class, destitute of reason and common sense. Hence they always, as in the present contest for the presidency, appeal to their passions, with mockeries, humbugs, shows, and parades, with the view of blinding and leading them away from the true principles of the constitution of their country.

In the above cut, you have a typical illustration of the means they resort to, to get your votes. The "log cabin" is raised to blind you with the belief, that they are your friends; and they have invented what they say is a poor man's drink, called 'Hard Cider,' generally made of 'bald-face' whiskey and water, with a little *sour vinegar* added. They place this drink in a barrel, inside of the 'cabin,' for the purpose of enticing you in, thinking that if they can once get you to take a *suck,* you are safe. Do you not see the man above, creeping in? Just let him get a taste, and they come down at once upon him, hard and heavy, *swig after swig,* until they get him in a *ranting way,* shouting and bawling for *Tip. and Ty.* as though they had caught the devil himself.

These *vote traps* are generally *set* and *baited* in cities and towns, and are usually infested by a considerable swarm of *loafers.* Do you see that fellow up there now? How slily he creeps under, on *all-fours,* with his lips poked out, to steal a suck. He is a loafer—not much to be made by him, if they catch him. And they think that the industrious, hard-working people of the country, have no better sense than to be caught just that way.

They have one of these traps setting here in New Orleans; just like the above, for all the world—only the *logs* are not so close. They have, however, made a bad business of it. No one has been caught but loafers, and they creep out between the logs, as fast as they catch them—unless it is occasionally a fellow who gets his belly popped out so full with 'hard cider,' that he has to remain awhile and go through the *roll and tumble* system, before he can squeeze through. We believe it is now nearly deserted. No one goes to *bait* it, and of course no one goes to *nibble* and *suck.* People of Louisiana, what think you of the invention? Are you willing to swallow the *bait?*

We have just understood that one at each of the towns of Monroe and Franklin, in this state, has been *set, triggered,* and *baited;* but we have not learned whether they have yet been able to catch many *suckers.*

48

Figure 12.

WILLIAM SIDNEY MOUNT

Catching Rabbits, 1839. Oil on panel,
18 1/4 × 21 3/8 in. The Museums at Stony Brook,
Stony Brook, New York. Gift of Mr. and Mrs. Ward
Melville, 1958.

were *rabbits* because of the long-popular pun, tediously overworked in English and
American joke books, that transformed *rabbit* to *hare, hare* to *hair,* and *hair* to *wig.* Mount
built on this pun (as he had built on *horsetrading* in *Bargaining for a Horse*), to propose a
simple story: the time is winter, a barren season in the Republic. The rabbit catchers, or
Whig partymen, are down-at-the heels youngsters, the new leaders of fiercely partisan
Whig politics, who have suffered (like everyone else) the consequences of the economic
bust. With little use for a politics of rational discourse, they carry out political persuasion
by entrapment. The world in which farmers cheerfully try to get the best of each other
by bargaining and trading—a world Mount had presented only four years earlier—had
become, in the new era of mass parties, the world of trappers and the trapped. The new
players in the political life of the nation were like irresponsible youths.[39] 49

Although Mount created the work for a prominent Whig, it cut through partisan politics with its dominant metaphor of entrapment. New York banker and merchant Charles August Davis, Mount's patron, was a particularly dour conservative. Of fertile imagination and fierce political antagonisms, he had written a series of Jack Downing letters to the Whig paper the *New York Daily Advertiser* parodying those of Seba Smith and completely transforming Smith's tone of gentle amusement. Not only violently anti-Jackson, Davis was contemptuous of the general citizen, and his Yankee character is edged with meanness and sarcasm. Unfortunately, as in the case with Mount's relationship with Reed and Sturges, no records of the exchange between Davis and Mount survive to indicate how they arrived at the topic of the picture. But Mount's painting has the decidedly cutting tone of Davis's Jack Downing letters: the ironic assessment of politics is aimed at the whole system. Critics, perhaps perceiving Mount as having come very near to the line between comic and dark criticism, generally restricted their remarks to his technique. One wrote cautiously, however, that "although the subject is not very attractive, Mr. Mount has succeeded in producing a very interesting picture."[40]

The image piqued the appetite of printmakers, as had Mount's earlier paintings. And it, too, underwent a title change that suggests that an owner did not want its clever roots in the vernacular to be lost. The picture became *Catching Rabbits*, the key term in the metaphor once more made explicit and unforgettable.[41]

In what was to be Mount's last win—although a shaky one—in the roll that he had begun in 1835, Mount painted for Davis another political picture, this one the most elaborate of all his works. *Cider Making*, of 1841 (pl. 5), is a large-scale allegory of specific political behavior of the yeoman—the presidential election campaign of 1840. Two cider barrels, ubiquitous Whig symbols, dominate the foreground of the painting, one prominently identified with the date 1840. In the middle ground, a cider press sits under a large roof, and to the left is the mill, a white wheelhorse turning the grinding stone. Several men, prominently placed across the scene, are doing their part in the operation. Atop the cider press roof, a fish weather-vane moves in the wind. Off to the right in the sun lie two large hogs, near which a hen and some chicks peck at the grass; in the distance geese swim on a pond, and beyond them a man sits on a fence talking with two others, one on each side of the fence. The picture is bright but almost hard in its coloring, graphic in its careful delineation of parts.[42]

The Whigs' log cabin and cider campaign for William Henry Harrison in autumn 1840 had been directed by party leaders Thurlow Weed and William Seward of New

York and Thaddeus Stevens of Pennsylvania, and financed behind the scenes by the wealthy and powerful Whig sympathizer Nicholas Biddle. As president of the U.S. Bank from 1823 to March 1839, Biddle had made important political and financial allies whose money proved fundamental to the success of the Whig campaign. Weed and Stevens used this money to hold parades, barbecues, and rallies, dispensing cider as well as promises of offices and other political plums to those who voted properly. The literal process of cider making, traditionally carried out in October, presented Mount the tools to make a detailed metaphorical reading of the campaign and, by implication, of the political techniques that now characterized election strategies.[43]

The specific allusions of the painting were so fundamental to a full appreciation of it that a few days before it was to be seen in exhibition Mount or a friend (perhaps Davis), inserted into the leading Whig newspaper, the *New York American,* a long story about a cider-making scene that, with the help of italics and punning names, clued the viewer to every political reference.[44] The explanation, in effect a guide to the picture that the reader could take along to the exhibition when it opened, was entitled "Letter from a 'Jaunting Gentleman' enjoying rural life, to his Friend on the Pavement." "If our readers should recognize in the collection of pictures to be exhibited shortly in the Academy of Arts, any thing like the scene described in the following letter, they will, perhaps, like both the better." In this story, the writer describes himself as a gentleman who visited the country and is now writing to his city friend about what he saw there. The alert reader of this story might well have drawn the following inferences about Mount's painting.

On visiting the farm in the fall, this gentleman found himself amid the "joyous and hilarious occupation of *"high vintage"* (cider making, or political campaigning, that had assumed the finesse of winemaking). When he stopped at the farmhouse, he saw old *"Mrs. Josslin"* (matriarch of the farm that had until this election been Democratic, a play on the name of Lewis Josselyn, publisher of the influential Jacksonian Massachusetts newspaper the *Bay State Democrat*). She sent the visitor "down to the cider Mill," where "all the folks" were. The season, she had reported, was full of prospects for a *"good cider"* year (a good Whig campaign). Once down at the mill, the visitor found a lively scene. The "process of 'cider making' [the machinery of party politics] was in full progress." The "old Squire" (Nicholas Biddle), was pouring cider from the settling tub through a strainer into the barrel. His elder son, "'the young and gallant captain of the *Light Horse*', (whose promotion had been celebrated but a few weeks previous)" (the son is John Tyler, a Virginia Southerner and very recent ex-Democrat who was now candidate on the Whig ticket for Harrison's vice president) was pushing the screw bar of the apple press and "causing the juice to flow freely from the 'cheese'" (getting an enthusiastic response from

the voters, especially Southerners). "*Colonel Billings* [a conflation of Whigs "Little Bill" Seward and Colonel Weed), bearer of *the whip*" (party whip) with which he usually kept the wheelhorse moving along, was taking a break and "lending his aid in *dipping*, but not *barreling*" the "pure juice" from the settling tub (he was enjoying party perks, but not outrageously). The visitor also found young "*Amos Josslin*," with his arm in a sling, who had "met with a serious accident, by having, in the occupation of shaking the trees, shaken himself off a limb with the apples, and sprained his wrist, and otherwise injured himself." Amos rested against an empty barrel, present only as a "looker-on" (Postmaster General Amos Kendall, campaign manager for the Democratic party, who had not been able to shake enough Democratic voters [apples] out of the trees to make a good election showing and therefore damaged his reputation considerably). At Amos's side was his terrier Trim, "the terror of stray hogs" and "best *rabbit chaser*" in the country (Trim is the wiry Francis Preston Blair, editor of the Democratic Washington *Globe*, who in his columns chastised turncoat Democrats, or hogs, and blasted the Whigs, or rabbits). The full barrel was marked 1840, "a year ever famous . . . for 'hard cider,'" and was "intended as a present to 'Old Tip'" (Old Tip is William Henry Harrison, president-elect [and not in the scene himself], to whom Biddle, as financier of the Whig campaign, was now handing the prize, the election). The squire's second son, "*Caleb Josslin*," who "gained the prize by his activity and industry" (Josslin is Caleb Cushing, powerful Whig representative from Massachusetts, who wrote Harrison's campaign biography, *Outline of General Harrison's Career*, and secured his own position as a powerful Whig) had "his straw in the bung hole." Caleb was telling his sister Fanny that she was "too ugly to suck cider" and that, moreover, she should learn to "exercise the virtue of patience in *waiting*—as all *ugly faced girls*" would be called upon to do (Fanny is Fanny Wright, campaigner for women's rights, whom party leaders vilified as aggressive and unattractive, as they did all advocates of woman's rights; Whigs had reluctantly agreed to a woman's rights platform, and thus Fanny and others like her had a marginal place in the campaign). "As a reward for past services," "the younger ones" were permitted to ride on the cross beam of the wheel (younger party workers received modest rewards). In the distance, the visitor saw three figures: "my friend Mount seated like a good *Conservative* on the fence" (the artist judiciously did not take sides) and, on opposite sides of the fence, the schoolmaster and the deacon, disagreeing amiably (Mount's patrons, of both parties).

Once in front of Mount's painting, the viewer saw additional details, so much a part of the common vernacular and current political caricature that the "jaunting gentleman" had not mentioned them: snoozing hogs (the Democrats, sleeping right through the

Whigs' successes); a hen and chicks (the federal bank system, of which Jackson's destruction had caused Whigs to leave the Democratic party); geese (woman's rights groups who were hanging on to the party); and on the cider mill roof a weather vane in the shape of a barnbunker—an odorous local fish used for fertilizer.[45]

Although most of Mount's earlier works had not been partisan, *Cider Making* was clearly so, and viewers' reactions reveal it. Writers with specifically Democratic connections saw the painting as a triumph of American humor. The critic for *Knickerbocker* wrote: "We see here much of Mr. Mount's peculiar graphic talent. This picture is better than any which the artist has produced for several years. It *tells* upon the beholder at once." *Arcturus*, another Democratic journal, was also pleased: "Cider-making is a picture that no one but Mount could have painted." Mount's brother thought he ought to exhibit the work in Washington, perhaps to show the newly elected Whigs that he saw right through their tactics. Other reviewers, however, were ambiguous, electing to see the work as a happy scene. One noted simply that it was "a characteristic composition, so closely painted to nature that its location is readily discovered to be Suffolk County." And the critic of the generally restrained *New-York Mirror* was not at all taken with the painting. He grouped it with James Clonney's caricatural *Fourth of July* in order to protest, "We put these together because they partake of the same character, and because we wish to say, that, altogether, we prefer Clonney's picture." He went on to complain that although Mount's "Dance on the barn-floor" and "Bargain" were wonderful, his later pictures were "fallings off." He scorned *Cider-Making* because "the *tout ensemble* is wooden."[46]

That the patron for the work was a Whig (the same Whig who commissioned *Catching Rabbits*), and that a Whig newspaper published the "Michelin" guide to the work reveals yet again the sense of irony with which many citizens, even those representing powerful positions of interest, adjusted themselves to everyday realities of political behavior. Mount's fine-tuning of the metaphor in these two paintings—comparing a political campaign in *Catching Rabbits* to the mechanical baiting of a rabbit and in *Cider Making* to the elaborate but mechanical, and thus predictable, process of grinding down apples to make cider—was perhaps as far as he could take the implications of a colloquialism. It was a dead end.

In employing vernacular metaphors for his pictures, Mount constructed them from yeomen's behavior already so notable that it had spawned specific vocabulary. Yet his depiction of himself as on the fence in *Cider Making* was both accurate and disingenuous, for the very act of constituting pictures from activities and colloquialisms that are funda-

mental to the economic and political realms was to put himself, and art, in the thick of the debate.

Mount was far and above the best-loved painter of the Yankee yeoman, and although his best creations about the yeoman were already behind him, with varying degrees of inventiveness and success he persisted in his objective to spoof the shortcomings of the citizenry. Over the years, other artists occasionally attempted Mount's appropriation of the vernacular for works that similarly alluded to problems in the democracy, but Mount's success was elusive. Two images are notable in revealing the fine line that Mount had trod with *Bargaining for a Horse*.[47]

Francis W. Edmonds's studious attention to Mount is most apparent in his *Image Peddler*, a large painting of an American family in a rural cabin that he exhibited at the National Academy of Design in 1844 (fig. 13). The family, composed of parents, grandparents, and children of various ages, is visited by an itinerant peddler of small sculptures. The peddler displays these plaster images on a tray on his head and a basket over his arm. Most of the works are of political figures: several bust portraits in the Roman style so popular with sculptors of the period (as, for instance, Horatio Greenough's portrait of Andrew Jackson), a small standing figure of Napoleon, and, most prominently, a large head of George Washington; others include figures of animals and bowls of fruit. On the left side of the picture, the grandfather has placed the bust of Washington on the family table and seems to be talking about it to his young grandson, who, dressed in a Continental army costume, stands ready for a lesson in patriotism; the father, wearing work clothes, looks on approvingly. On the right side of the picture, the women prepare food and care for the other children; they look longingly at the peddler's decorative wares. Not only are the members of this republican family separated into their proper spheres, but the activity and the title of the painting were a clear reference to contemporary politics. Whereas Mount had constructed the campaign of 1840 as grinding out a predictable result, Edmonds used the colloquialism *image peddling* to invoke the widely decried practice of promoting political candidates with persuasive images that bore little relation to reality. In the elections of 1840 and 1844, both parties claimed to represent the principles of the Founding Fathers—the Whigs, as already seen, exalting their political lineage as directly traceable to George Washington, the Democrats championing the principles of recently retired president Andrew Jackson, whom they called the "noble Roman." The painting seems to propose that the yeomen can be counted on to admire the principles of Washington rather than the latter-day despotism of Napoleon. In spite

Figure 13.

FRANCIS W. EDMONDS

The Image Peddler, ca. 1844. Oil on canvas, 33 × 42 in.

Courtesy New-York Historical Society, New York City.

of its vernacular roots, however, Edmonds's image did not sell (he eventually gave it to the New-York Gallery of the Fine Arts, Reed's collection), and one suspects that it was because viewers found no ready humor in the painting—the moral was so obvious that they had no "second take" as they looked at it. Moreover, the painting was quite large, and the family members were earnest and humorless.[48]

Yet just how adaptable was Mount's use of the vernacular to pointed allegory is clear in its employment by the New England landscape painter George Henry Durrie to protest the Compromise of 1850, in which Congress admitted California as a free state in exchange for agreeing to voter sovereignty over slavery for the territories that comprised the future states of New Mexico, Nevada, Utah, and Arizona, and in which they enacted a harsh fugitive slave law. A lithograph of Mount's *Bargaining for a Horse* had been published by the Art-Union the very year of the politically intricate compromise (one as-

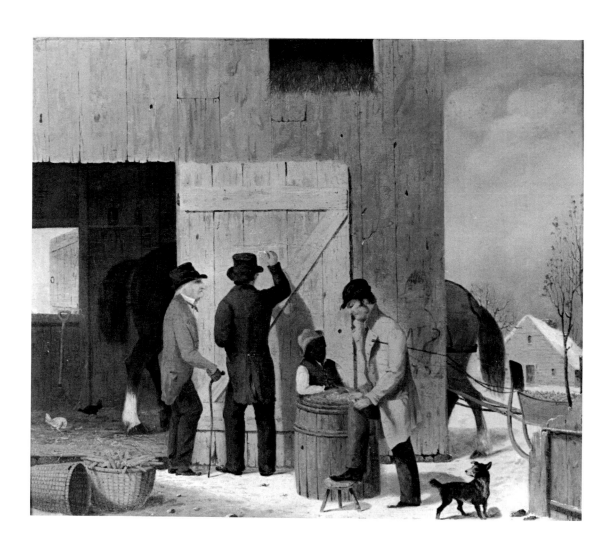

sumes that the directors had a fine sense of irony); the print may have provided Durrie his clues.

The scene in *Settling the Bill,* 1851 (fig. 14), is the New England, or at least northern, outdoors (the saltbox profile of the farmhouse makes this explicit), the activity an economic transaction. The bargaining has already taken place, and we see the figuring up of the bill by a black-suited man who writes the calculations on the barn door. The characters represent at least two generations and both country and city interests; at the center of the picture is a young black boy, who, along with the well-dressed city figure, is looking at some coins on top of the barrel. Two large draft animals (too large, in fact, for the scale of the picture), one hitched to a corn-filled sleigh, wait in the barn, their conspicuously protruding posteriors heightening the viewers' sense that all is not well. On

the barn wall are a profile caricature of Andrew Jackson, the letters N and S (the S inverted), and the date 1832; inside the barn a pitchfork leans against an open window, and two chickens, one black and one white, scratch at the floor.

The allegory is an indictment of Northern complicity with the powerful Southern interests of the Democratic party, which had been consolidated by Jackson's election in 1832. In Durrie's extended metaphor, the Southerners and city interests pay "cash on the barrelhead" (the bung hole prominent on the side of the barrel identifies Northern complicity as a betrayal by the cider-associated Whigs); they will take away exactly what they want—and what they have been able to get since 1832—support to sustain slavery in exchange for the profitability to the North of their crop, cotton. As in Mount's *Bargaining for a Horse*, the barn of these farmers—their store of integrity (and by implication the character of the national yeoman)—is nearly empty. Durrie painted this work for a patron, apparently, for he made another version as well, the slight difference in details suggesting a different buyer's specific requests. Unlike Mount's paintings, Durrie's work was comic only in so much as it called for the viewer to get the point; ambiguous it was not.[49]

After his qualified success with *Cider Making* in 1841, Mount's troubles materialized. His reception at the academy in 1840, when he exhibited three uncommissioned pictures, only one of them verbally comic, was hostile. More than one critic accused him of a lamentable falling off. "Mr. Mount has not put forth his strength this year," the *Knickerbocker* critic intoned. "Neither of the pictures under consideration . . . possesses in itself sufficient scope for the exercise of his peculiar talent." Pronouncing his peculiar talent virtually inimitable, patron Jonathan Sturges had been eager for some time for Mount to "stir people up a little" with another painting along the line of *Boys Trapping*. But in 1842, when Mount finally produced and exhibited *Scene in a Long Island Farm-Yard* (now called *Ringing the Pig*, Museums at Stony Brook), depicting a farmer "ringing hogs" while two boys look on with great amusement, the painting was not applauded. The scene was a transparent reference to the Whig victories over the Democrats in New York beginning with the elections of 1837; Mount showed hogs having rings put in their noses (a practice by which farmers prevented the animals from pulling up ground cover, roots and all, and therefore a metaphor for the Whigs' arrest of the Democrats' power). In *Scene in a Long Island Farm-Yard* there is none of Mount's earlier rich ambiguity, in either characterization or story line.[50]

Thereafter, Mount scrambled for topics. From about 1843, he recorded possibilities in

his diary that reveal an ongoing puzzlement about what might suit a general audience or attract patrons. He rummaged through earlier successes for repeats, starting with the idea for *The Truant Gamblers (Undutiful Boys)* that he had painted for Reed in 1835. But when he exhibited the new version, in 1844 (*Boys Hustling Coppers*, Brooklyn Museum), he was reproved for repeating himself. The usually friendly critic for *Knickerbocker* wrote that the painting "is a repetition of the same subject in the REED gallery, which we regret to see, because we know that Mr. Mount does not lack original subjects on which to exercise his ability; and borrowing from one's earlier works without improving upon them, looks as if an artist had exhausted his ideas." He tried to come up with new visual puns that inspire pictures: in December 1844 he made a list that included "A Clergyman looking for a sermon at the bottom of his barrel," an "Officeholder," and "A Negro fiddling on the crossroads on Sunday." He thought about and sketched such broader themes as the "Camp Meeting" (the subject of prints by Clay and others), the militia, and marriage and courtship. He thought he might paint "Woodman Spare that Tree" and even made a sketch for it; he made sketches of characters from the comic theater and from the growing repertory of Jonathan stories and jokes. He even entertained topics about urban poverty and filled his sketchbooks with plans for images: "A poor widow about to part with relics of better days in order to supply bread for her starving children," "Please to give me a penny," and "Cold victuals." But he was never to transform a city scene into a painting. Although after 1842 he would always have trouble finding a topic, and other artists began exhibiting occasional city scenes, Mount stayed with the rural type.[51]

Neither would Mount paint from literature. As he was struggling to keep his career going on the path he had struck, his friend Charles Lanman, a landscape painter, was preparing a text that praised Mount specifically for inventing his own subjects. Comparing Mount to his contemporaries, Lanman wrote: "[Mount] is peculiar in the habit of tasking his own mind for his subjects, so that you never see him illustrating the pages of any writer, historian, poet or wit. And this is a feature I greatly admire. The man who cannot conceive and execute a picture on his own hook entirely, is nothing but a copyist, whatever may be his knowledge of the art. Thinking and strictly original painters are the only ones that exert a lasting and salutary influence on the pictorial genius of their country, and Mr. Mount, I am glad to know, is emphatically one of these."[52]

Other critics, imagining themselves helpful, tried to direct Mount in what he ought to paint. An early admirer (one who obviously disagreed with Lanman) wished that he would paint a scene from Irving. Another wrote in 1846 that he *ought* to paint the "remnants of the Indians that remain on [Long Island]" and then turned his ire on Mount's fellow Long Islanders, only two of whom, he complained, had given Mount any patron-

age.[53] Few complaints could have made clearer the centrality of New Yorkers to Mount's jokes: Long Islanders were his "other," and few of them found his paintings attractive.

Perhaps the most detrimental influence on Mount's career was a shift in his audience's perceptions about the democracy. The high tension of the mid-1830s, which had inspired both Mount's ironic works about the sovereigns and their grateful reception by patrons attempting to make the democracy work for them, never returned to public life. The experience of living through the first decade of intense party-dealing would not be re-peated—party machinations continued, but no longer were citizens so shocked. The eco-nomic uncertainties of the 1830s were more intense in 1853 and 1857, but the potential for devastation of the new economic life would never again take most citizens—wherever they were—by surprise. The incompatibility of political and economic actuality with re-publican ideals became absorbed into national consciousness. Few people stated their disillusionment more clearly than Mount's patron Henry Brevoort in 1843. Brevoort, who had chuckled to Irving in 1832 that Jonathan had grown up and developed "many whimsical features," was thoroughly disgusted a decade later. He wrote Irving that "this our native land is degenerate and corrupt to the very core. You would not believe the symptoms of rottenness which I could point out and establish, but which are now appar-ent—political, moral and social—nor am I able to discover any hope of amendment; any counteracting principles to arrest the downward tendency of all our institutions."[54]

The prospects for the American body politic in all its fragmented and blurred interest lines in the early 1840s were about to receive another jolt. In 1844, when Mount was so uncertain about his own direction, the dispirited tone with which editors and private citi-zens discussed national life took an abrupt turn. The annexation of Texas was again on the political agenda (it had been so briefly in 1836, with the achievement of Texas inde-pendence), and the issues of the expansion of slavery, settlement in the West, and the relation of the West's future to the entrenched problems of the East virtually took over the newspapers. What to do about the West—and who would go there—became an ur-gent question almost overnight. A new group of genre artists, those who took as their subjects the characters and scenes of the West, began to command attention at exhibitions.

Mount, who had refused to go to Europe, went no farther west than Wyoming Valley, Pennsylvania. He had found his subject in agrarian life and was determined to stick with it. Indeed, none of the artists of Mount's generation—Inman, Edmonds, and others—undertook Western topics. Those who had started out painting Eastern themes, whether the yeoman or English and American literary topics, stayed their course.

Three *From the Outer Verge of Our Civilization*

The Yankee yeoman, because so familiar, was comical, but the frontiersman who explored the West, or anyone who moved westward, was an unknown quantity. Just what *did* characterize the typical Westerner? At stake, as an educated and urban (and Eastern) American elite seemed to see it, was the relationship of politically empowered but uneducated human beings to the wilderness. What, these Easterners pondered, were the social implications of the new setting for at least part of the sovereign community? And, more ominously, what were the economic and political implications for all the proper members of the community, those who had stayed in civilization? Any Westerner, many back East came close to saying, was a threat—politically, economically, and, perhaps most of all, socially.[1]

This point of view did not go uncontested. Although many Europeans tended to see America as the western wilderness—largely unsettled and either barbaric or at least socially undefined (which in turn purportedly characterized the American people)—Americans were discriminating. Their assessments of the West grew from their personal investments in geography and class. The election of quintessential Westerner Andrew Jackson to the presidency in 1828 both crystallized and drove the debate: Was he vital and independent and therefore wonderful, or a scheming, violent, uncultivated lout? In their appraisals of the influence of the West in general, privileged and educated citizens on the East Coast (and most of those who spoke or wrote were men, speaking about men) were torn between wonder and suspicion. Although New Yorker William Cullen Bryant optimistically referred to the prairies, that vast expanse of land beyond the Mississippi, as the "gardens of the desert," the environmental difference of the prairies was also perceived as ominous for human character. Washington Irving, who had gone West to see for himself, wrote in 1835: "There is something inexpressibly lonely in the solitude of a prairie. The loneliness of a forest seems nothing to it. There the view is shut in by trees, and the imagination is left free to picture some livelier scene beyond. But here we have an immense extent of landscape without a sign of human existence. We have the consciousness of being far, far beyond the bounds of human habitation; we feel as if moving in the midst of a desert world." In New England, Thoreau mused that he had an inner needle that was constantly pulled westward, a destiny that simultaneously at-

60

tracted and repelled him because it represented "a wildness whose glance no civilization can endure." How could he be sure, he asked, that such uncharted territory would kindle authenticity instead of savagery? While some cited the manly competence in wilderness skills that Westerners necessarily possessed, many, especially New Englanders entrenched in Puritan-rooted stories about the otherness of the Indian, were certain that people who moved westward would become violent and inscrutable—in effect, white Indians. The effects of the trackless prairies on an ambitious citizenry were worrisome indeed for those who watched from afar.[2]

Westerners, of course, held very different opinions. Many of them contributors to thriving communities west of the Alleghenies as early as 1795, they saw themselves (again, these were middle-class men writing and speaking about men) as manly, capable, and independent. They boasted that they were free from the social degradation and pretensions of urbanized Northeasterners. Many asserted that class distinctions disappeared in the spirit of Western egalitarianism and that, in fact, Western communities could serve as models for the nation. In 1835, for instance, James Hall, in Illinois, was sure that only a citizenry in the open environments of the West could fulfill the promises of Eastern character, wealth, and institutions. Few commentators who dwelled on either the strangeness or the promise of the West acknowledged what seems clear today: that the structures of Western experience would be determined overwhelmingly by the social structures of the East.[3]

This struggle to define the West was constantly being renegotiated. Western territory was appropriated at a rapid pace, both geographically and imaginatively. As citizens settled in Ohio, and then in Indiana and Illinois, and then in Missouri, making the West their own and forming states that became part of the Union, they spoke of the real West—the West that was potentially barbaric—as constantly moving beyond them. George Catlin told of being referred further and further westward in 1831 in his search for "out West": he first went to Erie, where he was pointed to Saint Louis, where he was referred to Fort Yellowstone, where he was assured that he would not reach "out West" until he arrived at the Pacific coast.[4]

During the 1830s and 1840s, writers on the Atlantic coast, if they could not indicate precisely where the West *was*, were eager to define the precise border *between* East and West. The very language they used revealed their assumptions: some wrote of this territory as the frontier, others who tended toward pessimism about the doleful influence of wilderness on the ignorant lower class called it the backwoods, and still others, enchanted by the confrontation of civilization with an otherness that obscured class differences, alluded to it as the borderlands. Visitors from Europe made obligatory trips to

such western territories as Wisconsin and Oklahoma to see for themselves Western trap-
pers and scouts and guides at work—men whose bold exploits transcended their (cer-
tainly) lower-class origins. Travelers reported on Western characters, lore in both the
East and the West began to accumulate around the wilderness skills and social repu-
tability (or disreputability) of Daniel Boone and Davy Crockett, and storytellers found
themes that spread across the country through newsprint and began to settle into the
national consciousness. In newly urban Western centers in Illinois and Ohio, publishers
established Western journals that they devoted to the publication of Western material.
Even these centers of publication mixed friendly interest with urban disdain for the
more common backwoodsman. Thus the *Illinois Monthly Magazine* promised its Western
readers "original tales, characteristic of the western people," as though "the western
people" were a group apart from the readers, while the *Western Monthly Review* in Cincin-
nati praised an annual for publishing "characteristic, happy and genuinely Western" fic-
tion, embodying faithfully "the unique and amusing backwoods dialect." And in 1835,
wanting to distinguish themselves from common—presumably nonurban—standards of
amusement, the editors of the *Western Monthly Magazine* noted in no uncertain terms that
they did not approve the "Jack Downing and Davy Crockett taste" that had sprung up
everywhere.[5]

Whatever their prejudice about the real nature of Westerners, citizens in settled re-
gions fought fiercely to establish a West that would maintain their interests. Western citi-
zens grew increasingly stronger economically as they began to exploit the vast territory's
untold wealth in raw materials and potential for agricultural products, and bankers and
factors in the East competed for their business. The balance of power in both houses of
Congress shifted inexorably westward. Attempting to maintain control, Northeasterners
seized the phrase Manifest Destiny to hammer the strength of their convictions that
they—that is, groups who shared their political commitments—should move west. And
finally, many elite and middle-class males in the Atlantic coastal area—novelists, editors,
merchants, tourists, and other dreamers, like Thoreau—appropriated the West, wher-
ever and whatever it was, as an integral imaginative dimension of their own perceived
manhood. This meant that the male types they constructed as Western were never ur-
ban, and never agrarian, but other than that were richly ambiguous. All evidence sug-
gests that many Eastern men constituted Western male types to function in an open
territory in ways they could not, to live out options they could not openly entertain, and
to symbolize the myth they were building about themselves as classless, individualist, and
powerful.[6]

Depictions of early Westerners conveyed sectional and racial tensions that were soon subsumed in quasi-romanticism about *the* Western male. Essentially, there were three categories of such preliminary images. The first was the caricatural rendering of the Anglo-Saxon Westerner, the Kentuckian, in political cartoons and illustrations of Western tales from about 1828. Like Mount's treatment of the Yankee farmer, these representations treated perceived regional threats comically. Caricaturists such as Edward C. Clay and David Claypoole Johnston, working in Philadelphia and New York, incorporated into their images of the 1830s the satisfying fiction in Eastern stories and jokes that all Westerners (by which they inevitably meant Anglo-Saxon Westerners) were tall, dressed like Indians, spoke hilarious vernacular, and were capable of prodigious feats (fig. 15). By 1835, when the fame of Davy Crockett had spread up and down the Atlantic seaboard, the comic woodcuts that illustrated the Crockett almanacs showed Davy carrying out such preposterous feats as walking with a friendly bear, killing a twenty-foot rattlesnake, and rescuing a woman from a catamount (fig. 16). In these depictions, Crockett was implacable and direct, superhumanly capable in wilderness skills, and clearly and absolutely unsuitable for the society of an urban drawing room.[7]

The second kind of image of the Westerner was that based on literary sources: painters such as Henry Inman and John Quidor probed the enthusiasm of their self-described elite audiences for images of James Fenimore Cooper's fictive frontiersman Leatherstocking, explicitly a lower-class figure. These images, too, combined condescension and humor.[8]

Representations of Indians formed the third type of image. During the 1830s, the young Philadelphia painter George Catlin journeyed past the Mississippi to preserve the "memory of a vanishing race." A few years later, Baltimore painter Alfred Jacob Miller accompanied the aristocratic Scottish traveler William Drummond Stewart on a trip to Wyoming territory to see the fur traders and the Indians amid whom they worked. Both painters inherited eighteenth-century sympathetic European formulations of the Indians as noble primitives, as well as two centuries of American stories of savage Indians that justified white citizens' fears of them. Catlin's and Miller's representations of the "vanishing" race set Native Americans off as fundamentally different from the conquering race in everything from clothing and body decoration to economic practices and ritual. These constructions of difference drew large audiences in East Coast cities. Catlin's images schematic and Miller's idyllic, they heightened, naturalized, and romanticized for Eastern viewers the decline of the "savages" of the West. This accumulation of hopes

Figure 15.

EDWARD C. CLAY

"Set-to between the Champion Old Tip and the Swell
Dutchman of Kinderhook," 1836. Lithograph
published by H. R. Robinson, New York. Courtesy
Library of Congress.

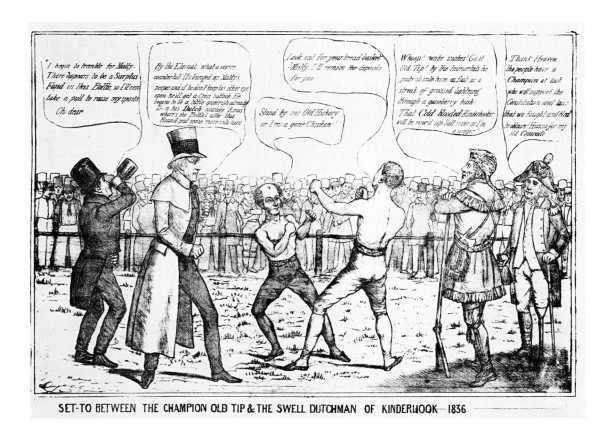

SET-TO BETWEEN THE CHAMPION OLD TIP & THE SWELL DUTCHMAN OF KINDERHOOK—1836

and fears about the West, and about early Westerners, was the ground from which
sprang genre painting about the liminal citizens who headed West to prepare the way for
the proper domination of the land—the trappers and hunters who were the first Anglo-
Saxon entrepreneurs.[9]

A rapid series of events in the 1840s provided the immediate impetus for artists to
incorporate Western types. As Mount was despairing of finding any more good Yankee
subjects, Eastern perceptions of the Western constituency shifted dramatically. With citi-
zens from the farms and immigrants from Europe crowding into Eastern cities, in 1841
Congress passed the Distribution-Preemption Act to encourage hard-pressed urban citi-
zens to settle public Western lands for minimum rates of purchase. In 1842 Colonel
John Charles Frémont began a much-publicized four-year sequence of exploration of
the Rocky Mountains and the Far West, publishing reports about his adventures and
discoveries. The next year emigrants began the first overland treks to Oregon and Cali-
fornia, and Congress schemed and negotiated to acquire these territories. In 1844,
James K. Polk, the Democratic candidate for the presidency, took as his platform one of

Figure 16.
Cover from *Davy Crockett's Almanack of Wild Sports in the West,* 1837. Wood engraving. Courtesy American Antiquarian Society, Worcester, Massachusetts.

the most controversial issues of the era: the annexation of Texas and the occupation of Oregon. Then in 1845, as one of the last acts of his presidency, John Tyler set into motion the official annexation of Texas. Westward expansion—and all it entailed about social, economic, and political power—became the issue of the rest of the decade. The implications of national expansion for the body politic as a whole—which would erupt in the expansionist Mexican War the next year—were immediate.

How, then, were these forces—contradictory, overlapping, and insistent—embodied in genre painting? Whereas the Yankee farmer had been the triumphant visual province of one artist—Mount, with Edmonds joining him to some extent in the 1840s—several artists put forward representations of the Westerner. The painters who took up the task made very different claims, informed by their own and their perceived audience's position in the citizenry. Their images proposed the Western sovereign's differentiation from, cohesion with, and at times even vicarious relationship to the Easterner in three factors: class, gender role, and political dependability.[10]

Charles Deas was the first artist to appreciate the changed Northeastern appetite. When he exhibited *Long Jakes* in 1844 (pl. 6), he was an unknown self-taught painter from the East who had seen Catlin's images of Indians, gone out West to visit and sketch, and stayed there. In a sudden assumption of artistic power with the turn of events, he sent *Long Jakes* to a New York audience.[11]

The painting is riddled with ambiguity. A large, attention-demanding work, it shows the trapper alone in what seems to be a vast space. Wearing a bright red hunting shirt and seated in a Mexican working saddle on an obeisant horse, Long Jakes travels light, his long gun and tight bedroll the tools of his skill and self-sufficiency. He is bearded, lean, and wizened, the veined skin touched with red on his nose and cheeks but vulnerably white just above his collar, where the sun has apparently not beat directly on it for years. Man and horse halt in heightened alertness, as though startled by a sound. The vast wilderness would seem to be their province, but they are not relaxed. Painted with great attentiveness to detail, Deas's image claims that danger and potential conflict are the very material of the trapper's daily life.[12]

In the same painting with these flattering aspects, however, are more homely details. The fastidious viewer could observe that the trapper's profile is considerably less than handsome; his rough facial skin is tinged with a red that implies an overfamiliarity with alcohol. His scraggly hair is gray around the temples; the front brim of his fraying hat seems to have had a bite taken out of it. The horse, too, with a dark mottled and scarred

hide, has seen many years. While the compositional scheme suggests the distant, heroic aura of an independent frontiersman, Deas's details allude to the questionable social status such a person would have in a socially ambitious household.[13]

What are the implications here? As we have seen, Mount's images subverted a surface cheer. This Western type, however, encouraged contradictory readings.

Let us look first at the formation in popular culture of the type that Deas depicted. Of all the fictionalizations representing real frontiersmen who had probed the West before the first settlers—scout, hunter, trapper—the Southwestern trapper was the most complex in association. He was one of a distinctive group of Western adventurers: not the legendarily sociable trappers of the upper western rivers (many of whom were French), but the wave of solitary, mostly Anglo-Saxon trappers headquartered in Santa Fe who roamed the vast mountain wilderness of the southern Far West. These trappers had done much to construct their own legend. As they and their (often carefully cultivated) Eastern admirers recounted it, these trappers worked the high prairies and the southern Rocky Mountains mounted on strong and swift Spanish horses. Some worked for companies, but many of them worked resolutely "on their own hook"—that is, as risk-taking entrepreneurs. They boasted of working conditions that included parching heat, devastating cold, encounters with hostile Indians and antagonistic competing traders, drought, and starvation—all endured in solitude. They called themselves "mountain men" to distinguish their own ardor from that of their predecessors.[14]

This constructed image of the trapper had the advantage of being more reminiscent than contemporary. In fact, the image *could* be so carefully constructed because the men themselves were almost inaccessible. By the early 1840s, when Deas painted his image, trappers were a vanishing breed. The hey-day of trapping had been in the early 1830s, when trappers roamed the western part of the continent from its northern to its southern border, and trappers and trapping companies were engaged in cut-throat competition. After 1837, when the panic and depression severely interrupted demand, the trade never recovered. By 1841, the annual rendezvous—when trappers met their buyers—was an event of memory. Thus the character that Deas placed before his audience in 1844 was a figure whose major activity had been in the past and whose situation, and the putative virtues and vices of his typical character, could thus be tempered, or exaggerated, by the lens of Eastern needs.

By 1844 not only had trappers themselves virtually disappeared, but the character of the "typical" trapper had undergone a considerable transformation over a twenty-year period. Early on, the trapper had been cast as lower-class by elite Eastern and European travelers. In 1830, for instance, Connecticut merchant Timothy Flint, son of the clergy-

man who was president of Yale College, included trappers in his novel *The Shoshonee Valley: A Romance*. Almost unremittingly disapproving, and explicitly worried about the sexuality of these renegades, Flint characterized mountain men as "renouncing society, casting off fear, and all the common impulses and affections of our nature." They have, he wrote, "an instinctive fondness for the reckless savage life, alternately indolent and laborious, full and fasting, occupied in hunting, fighting, feasting, intriguing, and amors, interdicted by no laws, or difficult morals, or any restraints, but the invisible ones of Indian habit and opinion." The trapper was even more disreputable when he was considered a model for social communities springing up in the West. Eastern authorities on emigration gave earnest advice about such men's lack of social standards. Guide writer J. M. Peck, who in 1836 advised westward-bound emigrants from his exalted location in Boston, was pessimistic about the implications of the untrammeled life for any kind of orderly community. Predicting that the demoralized world view of the mountain man would also infect pioneers if they were not careful, Peck warned future settlers that Western hunters and trappers were "an interesting but melancholy example of the tendencies of human nature towards the degraded state of savages." Again, the issue was also one of environment. "The improvement of the species is a slow and laborious process—the deterioration is rapid, and requires only to be divested of restraint, and left to its own unaided tendencies."[15]

In the mid-1830s, however, representations of this distant Westerner had begun to shift. The type of the trapper metamorphosed in travelers' accounts from lower-class toward a classless ideal. What had been vulgarity became masculinity competent in outdoor skills and conscious of freedom. The construction of people who *were* Westerners or who were sympathetic to westward expansion, this new "mountain man" as an independent, capable, and successful entrepreneur (a characterization that ignored his dependence on a vast economic power structure in which he was actually near the bottom) seemed to offer rich possibilities for vicarious experience to city-weary and competition-anxious Eastern males. Informing Easterners' hunger was the propensity to idealize the beneficence of an unstructured West in contrast to a decadent, regimenting East. Washington Irving's reaction is instructive. In 1837, fresh from a tour of the West that revivified him after nearly two decades in Europe (actually, he went as far west as what is now Oklahoma), Irving had singled out the mountain man from another otherwise vulgar Western lot that he described as "hangers-on, half-breeds, and other disreputable types." Claiming that the mountain man stood up as no other human being under physical extremes and mortal danger, he rhapsodized in *The Adventures of Captain Bonneville:* "There is perhaps no class of men on the face of the earth who lead a life of more con-

tinued exertion, peril, and excitement, and who are more enamoured of their occupations than the free trappers of the west. No toil, no danger, no privation can turn the trapper from his pursuit." Irving exalted the trapper as a Robin Hood—not an outsider, but a half-known half-unknown romantic side of the self who had rewritten the terms of his existence *within* the larger society. Thus while such earlier commentators as Flint and Peck, with their eye on future settlement of the West, saw the trapper as an example of Western degeneration, Irving claimed that he exemplified an ideal regeneration in personal characteristics. In the next step, the trapper became a figure *for* Eastern males, one who acted vicariously for them.[16]

By 1844, the year of Deas's painting, the transformation had received its most powerful incarnation. Stories presented the mountain man as a thoroughly admirable transplanted Eastern yeoman (the yeoman, of course, was an asexual construction) who returned to fundamental values. Kit Carson was the most stunning example. In the first published accounts of his expedition in 1843–1844, John C. Frémont celebrated trapper Kit Carson as a man who had deliberately cast aside the effete book-learning, manners, and polish associated with the East to take on the admirable wilderness skills, forthrightness, and courage required in the West. Almost overnight, Carson became a major figure in stories and novels. One anonymous writer described him in 1848 as "one of the best of those noble and original characters that have from time to time sprung up on and beyond our frontier, retreating with it to the west, and drawing from association with uncultivated nature, not the rudeness and sensualism of the savage, but genuine simplicity and truthfulness of disposition, and generosity, bravery, and single heartedness to a degree rarely found in society."[17]

Deas, at the very moment of the apotheosis—at a time when westward expansion needed social sanction—painted a figure who was by no means a savage, but not quite a Kit Carson either. By qualifying the arrestingly dramatic form of his alert horseman with homely details, he enabled his Eastern viewers to read the type in what ever way they found congenial: to assess western expansion as a general proposition, to define others (specifically, Westerners), or to define self.

The mingling of these appeals is clear in the painting's reception. A reviewer for the *Broadway Journal*, for instance, identified the painting as one of the two "great favorites" of the Art-Union exhibition, raving that "'Long Jake' comes to us from the outer verge of our civilization; he is a Santa Fe trader, and with his rifle in hand, his blazing red shirt, his slouched hat, long beard and coal black steed, looks as wild and romantic as any of the characters in Froissart's pages, or Salvator Rosa's pictures." Wanting to make the claim for an authentic Western American social gentility, the reviewer continued, "[Be

assured that] 'Long Jake' was not always a Santa Fe trader—there are traits of former gentleness and refinement in his countenance, and he sits upon his horse as though he were fully conscious of his picturesque appearance." It was now possible, in other words, to be both refined *and* from the outer verge of civilization.[18]

Popular story writer William Henry Herbert, based in New York, renamed Deas's painting "Long Jakes, Man of the Prairies," invoking the open environment of the prairies as a symbol of opportunity and autonomy. The United States, not insignificantly, had just declared war on Mexico, a conflict that led to the U.S. annexation of territory from Texas to the Pacific, land with much of which the trapper had been associated. In praising the painting, Herbert aired the gripes of a man frustrated with "common" uneducated men after the main chance and indicted Northeastern society as devoted wholly to trade, overrun with masses of undistinguished people, and enslaved to public opinion. In contrast, he identified Deas's trapper as enjoying "hair breadth escapes" and "the glorious, the free, the untrammeled sense of individual will and independent power" that made him a "knight" who lived with the "old chivalric virtues of truth, honor, and the search for adventure." Transforming into a member of the medieval elite a type that had been identified only two decades earlier as the very scum of the ignorant, self-aggrandizing American sovereigns, Herbert insisted that true freedom lay only in the West. America was redeemed by the "men of the prairies," Herbert pronounced, " . . . her own appropriate and independent sons, known to no other land."[19]

The image of Long Jakes was engraved in New York almost immediately. As time passed, Eastern printmakers judged that their customers—concentrated in the Eastern urban centers, and especially in New York—preferred to see Long Jakes not with the ambiguity that Deas had presented him, that is, with the unresolved tensions between his class, regular pursuits, and Eastern standards of gentility, but as Herbert's independent knight. The first engraver of Deas's picture, working in 1846, retained almost all of the details of Long Jakes's wizened physicality (fig. 17), but when Leopold Grozelier made a lithograph of the painting for national and international distribution in 1855 (by which time the fur trade and the wild men of the prairie had receded even more into the past), he celebrated Long Jakes as fully handsome, noble, and in control, indeed, as a knight of the prairies (fig. 18). It was *this* Long Jakes who inspired subsequent descriptions of Kit Carson, yet another step in the appropriation of rough Western experience to elite, or would-be elite, Eastern men.[20]

Still another factor was important in Eastern appetites for this new male Westerner. Although the romantic outlaws of Sir Walter Scott's novels had long fed the popular imagination, in the 1840s middle- and lower-class American (male) readers became en-

Figure 17.

HENRY JACKMAN

"Long Jakes," 1846, after Charles Deas. Engraved
illustration in *New York Illustrated Magazine of Literature
and Art*, vol. 2. Courtesy New-York Historical Society,
New York City.

Figure 18.
LEOPOLD GROZELIER
after Charles Deas
Western Life—The Trapper, 1855. Lithograph,
26 1/4 × 19 1/2 in. Courtesy Amon Carter Museum,
Fort Worth.

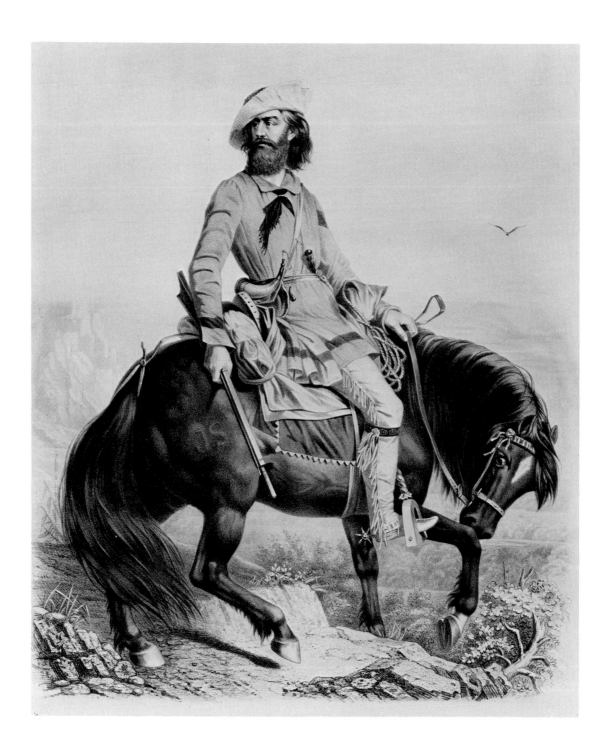

thusiastic audiences for a rash of Western adventure literature in periodicals and weekly papers that packaged conflict at a high pitch. In these stories, the thrill of adventure, with sudden resolution in clichéd endings, advanced the personal heroism of Western males as an answer to—or escape from, or substitute for—the lack of autonomy and adventure that many readers perceived in their lives. Sidestepping the uncertainties of middle- and even lower-class Westerners' roles in the social structure that prevailed in more sophisticated discourse, these stories provided an ideal of manly behavior that largely subsumed class differences. Such works as Charles W. Webber's enormously successful story "Jack Long; or, The Shot in the Eye," of 1844, his full-length novel *Old Hicks, the Guide,* of 1848, and a rapid succession of tales with threads of violence and heroic manhood were picked up and quickly elaborated by other writers, some in weekly story papers devoted to the purpose. Members of the old elite were apparently as receptive to this new ideal of manliness as were their so-called inferiors. The most stunning testimony to this is Francis Parkman's narrative *The Oregon Trail,* which began serial publication in 1847 in the widely read journal *Knickerbocker.* Parkman, a New England patrician who excoriated himself throughout his account for his physical sickliness on the trail, told his readers that he had gone West to become "an Indian." Through great exertion he became a master of violence: he redeemed his persistent weaknesses with brutal killings of buffalo, thereby, he boasted, proving his manhood at last.[21]

Catering to these tastes in *The Death Struggle,* 1845 (fig. 19), the next image he sent to New York, Deas placed the trapper definitively in the world of the Indian. The painting shows a white man and an Indian man locked in mortal combat. Both are trappers, both are consummate horsemen, both are fierce, and both are willing to fight to the death. As they cling to their horses, the white trapper grips a beaver that is still in a trap; he in turn is gripped around the waist by the Indian. The knives of both men drip with blood and their horses are wounded. The riders and their mounts are about to fall over a precipice, toward the viewer. The white trapper, whose desperate grasp of a slender branch emphasizes the inevitability of the disaster, stares out with horror. His brilliant red long shirt, together with the blood from the wounds, brings the emotional pitch of this painting to a high intensity. *The Death Struggle* presents the knowing viewer with an enactment of the wrenching final moments of Indian *and* trapper *and* fur trade.[22]

Although the painting seems to the modern viewer to be almost an allegory of the end of these stages of the West, Deas's audience proposed other readings. New York journalists, in responses quite different from those they had offered to *Long Jakes* a year earlier, vied to provide readers with the most dramatic narrative of the painting. The

Figure 19.
CHARLES DEAS
The Death Struggle, 1845. Oil on canvas, 30 × 25 in.
The Shelburne Museum, Shelburne, Vermont.

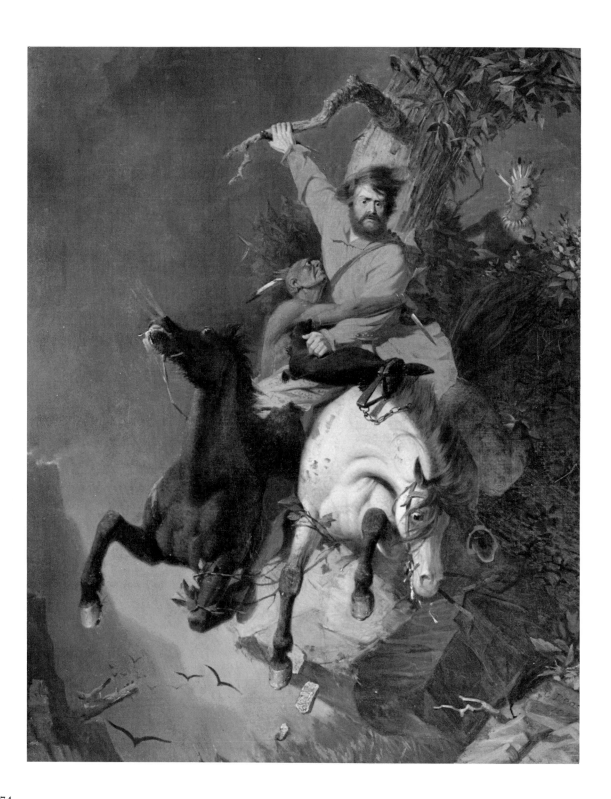

Broadway Journal found the putative gentility of the trapper of no interest whatsoever. Instead, to interpret the painting, it printed a high-pitched narrative of the conflict that concluded with the combatants' dramatic plunge over the cliff. In 1846, after the United States had declared war on Mexico, William Henry Herbert wove for the readers of the *New York Illustrated Magazine* a scenario of the painting that evoked blood and gore. Referring to the white trapper as "Carson," Herbert told of a trapper's pursuit of his enemy in a case of disputed bounty that concluded disastrously for both. Justifying the white trapper's mistaken chase of an innocent Indian, Herbert concluded the story with an emotion-rousing image of "the white hunter's senseless head . . . scalped and gory, and his clenched hands dismembered by the savage knife." It was a story guaranteed to shape the passions of an audience divided over the morality of the war with the "disreputable" and "savage" Mexicans. What interested the more discreet *Democratic Review*, a periodical generally mute on art, was the extent to which Deas had captured the excitement of unrestrained adventure; the *Review* hailed *The Death Struggle* as "one of the most spirited and effective works ever hung upon [the Art-Union's] walls."[23]

Deas had made his mark at last. Raised in Philadelphia and New York, he had been deeply disappointed early in his manhood in not being admitted to West Point. He turned to painting to earn his living. Deas had spent several years in New York in the 1830s painting literary scenes from Butler, Shakespeare, Irving, and Cooper, as well as imitations of Mount and Edmonds. Soon after seeing Catlin's Indian Gallery, he traveled westward to visit a brother in the Wisconsin territory and embarked on trips to sketch Plains Indians; from 1840 to 1844, working in and out of Saint Louis, he worked up his sketches of Indians into paintings. Eager to assume the meanings of the West as his own, he took to dressing like a trapper and adopted the nickname "Rocky Mountain." With *Long Jakes* and *The Death Struggle*, he fused his new identity and definitions of the West with the fantasies of more remote male viewers in the East, constructing a type that would be repeated with little variation across the century.[24]

Deas experienced his success within a new structure of patronage, second in importance only to his timing in the popularity of the Western type. Mount's patrons had been individuals—socially secure or ambitious, materially successful, and often well-educated men in New York City, with whom he had consulted about what he would paint. But by the early 1840s, a number of New York entrepreneurs, bankers, patrons, and a few artists had stepped into the breach of the collapsing Apollo Association to create the machinery of institutional patronage, the American Art-Union. Taking their objectives from and modeling their structure on such organizations in Europe, the directors of the

new organization aimed to patronize and distribute across the country a broad a range of paintings. Planning thus to help artists as well as to educate a public to art, they juried and purchased American paintings that they then distributed to members through an annual lottery, along with at least one engraving that everyone received. With membership-selling secretaries across the country, as far south as Savannah, west as New Orleans and Detroit, and north as Portland, Maine, the directors of the Art-Union determined within the bounds of what artists submitted to them the pictures that would satisfy, indeed create, a national popular taste. This meant that works the directors bought for distribution ideally had three dimensions: they were arguably national in implication, they were easily readable by a minimally experienced audience, and they *appeared* at least to be high-toned in content. Mediating national culture for members from all regions, this board of directors became warm sponsors of Western images. Buyers who might have been reluctant to admit their attraction to images associated with violence could claim a democratic nationalism as their motivation. The broad policies of the Art-Union contrasted sharply to the self-consciously artistic ambitions of the directors of the National Academy of Design, where juried figural scenes tended to be either literary or historical and virtually no Western paintings (except landscapes) were hung.[25]

Another factor, too, was crucial. The larger number of cultural journals in the 1840s, with more broadly conceived audiences than those that had circulated in the 1830s when Mount began his career, contributed handsomely to the success not only of Deas but of the Art-Union. During the first heady days of national expansion in the 1840s, the images of Western types, emblems of masculinity and vigor, had almost a guaranteed appeal to critics who wrote for these journals, just as did the project of creating a national art. The Democratic *Knickerbocker,* its carefully public-spirited editors ever eager to promote the cause of ordinary citizens and their appreciation of art, reported that "motley crowds" of young and old, merchants, working men, and families "go forth from [the Art-Union] with minds elevated by what they have seen, with manners and feeling refined, with new checks fastened upon coarse and unruly passions." The critic for the *Literary World* emphasized the high-toned character of visitors to the exhibitions: "Everybody is the friend of the Art Union. . . . In the shifting panorama of dress, action, expression, and character, he would find a complete epitome of the city life. . . . [G]entlemen . . . who drop in between nine and ten in the morning . . . are merchants in South and Front Street. . . . Lawyers, brokers, stockjobbers, and financiers there are too, who, on their 'down town' way, give five minutes to the arts. . . . [T]he middle of the day scene grows brighter with bevies of ladies."

Then the writer, obviously less democratic in his sympathies than the *Knickerbocker* critic, carefully distinguished the many degrees of entrepreneurial and social power, and the obvious lack of it, in the viewing audience. "It is in the evening . . . that the Art Union is in all its glory. . . . Here they all are, from the millionaire of the 5th Avenue, to the B'hoy of the 3rd, from the disdainful beauty of Fourteenth Street . . . to the belle of the Bowery." For this viewer, the social unity in the gallery was made possible by the art.[26]

In these complex ways, Western images became the possessions of a much larger range of viewers than had those of Mount.[27] And it was within this considerably large audience that New York writers began to rank Deas with Mount as a definitively *American* artist. In 1846 a writer pronounced unequivocally in the *Broadway Journal* that "excepting Mount [Deas is] the most purely American in his feelings of any painter that we have produced." Critics could hardly say enough about how distinctive Deas's works were from the literary interpretations of the West by Cooper. Whereas Cooper had always come down on the side of restraint and social order, the implications of Deas's images were exhilarating and free. The *Literary World,* quoting an article in the London Art-Union, wrote that Deas "delights in the subjects which Cooper has made familiar to Europeans by his novels: Indians, half-breeds, squatters, and the wild rovers of the prairies . . . [However, Deas's works convey] an air of wildness and daring in the whole composition, of half-savage life and freedom from the restraints of civilization, of which the readers of Cooper's novels can form but an inadequate conception."[28]

Deas's socially free and masculine Westerners—authentic mountain men—could hardly have contrasted more with Mount's farmers. The type of the trapper indicated major differences between the male citizens in the new West and the old Northeast: Long Jakes is alone, basking in the individualism that the open West (and an open economy) makes possible, and the trapper in *The Death Struggle* endures to the death in a contest that requires the utmost courage. Both are the masters of weapons and of horses, masculinity- and power-enhancing accessories. Northeasterners, in contrast—the "farmers" in *Farmers Bargaining, Farmers Nooning, Raffling for the Goose,* and *Cider Making*—gather in groups, dressed in ordinary clothing with only their wits as accessories. Their primary interest, indeed their primary opportunity, is the manipulation of political, economic, and social arrangements within a limited arena. Genre paintings of Northeasterners are set in enclosures: cabins, farmyards, front porches. In works by Deas, however, as with his followers, the setting is the open prairie. The mountain men, larger than life, are the embodiment of Eastern fantasies of manhood, adventure, and power. The representations preserve the illusion of masculine independence, and they

construct male power as attained through violence. They proclaim that the West is the territory for personal redemption.

Two artists followed Deas in depicting the Western trapper. Picking up the energy of the demand he had created and satisfied, they modified with narrative, and then with romance, the ambiguity that had been integral to Deas's images. Their careers reveal two phenomena: the crucial importance of timing in the unfolding of genre painting, and the quick reification of a type once social change had crested.

William Ranney was the first of these artists. Before Deas had "invented" the trapper for Eastern consumption, Ranney, too, tried various directions as an artist. Like Deas, he did not spring into successful artistic production until the 1840s produced the climate of yearning and rationalization he needed. But he had had the material to do so considerably earlier. Studying art in Brooklyn in 1836 when the Mexicans captured the Alamo— the year Mount seized attention with *Bargaining for a Horse*—Ranney volunteered for duty in a Texas regiment. By spring 1837, his adventure having lasted under a year, he had returned to New York City, where he put aside his sketches of the Texas prairies, horses, and trappers and hunters. He left this material untapped for almost a decade while he scrambled for whatever subjects seemed to be popular, painting portraits and scenes of sentimental and urban genre. Only when Texas and points farther West once more entered national consciousness, which in the art world included Deas's attention-getting exhibition of *Long Jakes* and *The Death Struggle,* did Ranney turn back to his Western material. He set up a studio in West Hoboken, New Jersey, handy to potential patrons in New York, filled it with saddles, guns, and his Western sketches, and began to focus almost exclusively on the Western type. He never returned to the West. He did not need to.[29]

Ranney's chief success, *The Trapper's Last Shot,* 1850 (pl. 7), placed the Western trapper in a heightened world of adventure. This image, actually a carefully refined second version, exploited those elements that had been the keys of Deas's work: male heroism earned through thrilling conflict with the savage. But there is a significant difference from Deas: this painting has a clear story. A trapper whose horse stands in deep water on the prairies twists in his saddle to face a challenge from the left. The trapper is tense, his stare anxious; his horse, mired in the water, stands stock-still in terror. Locked into the foreground, the two are closed in from the left background by Indians on horseback. The landscape behind the trapper and his horse, a vast, flat expanse, heightens their

helplessness, and a sky filled with dark clouds provides another ominous motif. The work is fluid in its handling, the vigorous brushstrokes contributing expansiveness and drama to the image. With the title, *The Trapper's Last Shot,* Ranney squeezed from his image every possible bit of narrative implication. Has our hero fired his last shot? Or does he have another? If he does, and if he shoots, will he survive? The painter's intentions, and thus the viewers' responses, have shifted. No longer is the crucial question the gentility of the trapper (this trapper, in fact, is coarse in appearance); rather it is the danger within which the trapper proves his envied mettle. One might even say that action has replaced class as the central interest. The solitary "posing"—and socially ambiguous—trapper in *Long Jakes* has become the horseman proving his courage in action. He has become the figure for independent activity of all kinds—Tocqueville's autonomous male relocated in the West. Yet the bravery is a melodramatic courage, not the resolution faced by the trapper in Deas's *Death Struggle*. Indeed, the Indian in Deas's painting was a worthy antagonist of the trapper, but the Indian or Indians in *The Trapper's Last Shot* are barely discernible. The foe in Ranney has become a stage-prop who provides drama to enhance the trapper. How important this was to at least some of Ranney's viewers is clear in a criticism that one reviewer made of Ranney's painting *The Retreat*, of 1851, which depicts three trappers rushing to escape a hostile attack. A writer for the New York *Daily Tribune* complained that the painter had not given his audiences more fuel for their own narratives of male heroism. "We could have wished a more spacious view of the Prairie," the writer chided Ranney, "which by its vastness and magnificent monotony of line would have intensified the interest by revealing no rocks, or trees, or devices of escape."[30]

Certainly thrilling heroism—and by implication independence to be tested—was one concern of Eastern viewers. We can sense the importance of another in Ranney's second type of presentation of the trapper: that which shows men outdoors together. Having rendered almost moot the issue of social class (and thus moving from an assessment of the *social* meaning of the West to the West as space where private meanings and hopes could be posited), Ranney presented Western males enjoying the masculine camaraderie that Eastern males were beginning to cultivate. First participating with Deas and storytellers in representing the West as an arena for independent behavior, he then held it up as a theater for the activities of male groups. In picture after picture in the 1850s, Ranney portrayed a West in which some social community of men matter-of-factly presides over the landscape. In Ranney as in Deas there are no hangers on, no scalawags such as those lamented by Irving, Ruxton, and other writers. Ranney typically placed two or three dignified trappers on horseback, accompanied by pack animals, conferring in a spacious prairie-scape. Sometimes the trappers seem at ease, as in *Halt on the Prairie,*

1850 (Archer M. Huntington Art Gallery, University of Texas at Austin); at other times they face danger together, as in *The Retreat*. Even when Ranney undertook the theme of Daniel Boone, he depicted the archetypal hunter and explorer not as a lone figure but as one of a group of scouts who stand together in harmonious tranquility to look out over Kentucky (*Boone's First View of Kentucky*, 1849, National Cowboy Hall of Fame, Oklahoma City). In these very years urban Eastern elite males were retreating to Eastern wilderness areas in small groups to mountain climb, camp, hunt, and ride. The congenial Western trapper on horseback who with a companion tested his skills in the wilderness would seem to have been very much a model for Eastern buyers, who aspired to the same competence in their leisure activities.[31]

The second painter of the Western type, Arthur F. Tait, an English-born lithographer who landed in New York in 1850, virtually reified the possibilities that Deas and Ranney had explored. Deas had an emotional breakdown in Saint Louis and stopped painting in late 1847, just three years after his resounding success with *Long Jakes*. Ranney, maintaining his distance from the "real" West in his studio in West Hoboken, contracted consumption in 1853 and died in 1857, but in the last years of his life he passed on his skills and props to Tait. Tait perspicaciously took his authority directly from the experience of Ranney, as well as from the works of Catlin and Miller, providing New York lithographers with twenty-two Western images from 1851 to 1862.[32]

He began his work in 1852 by appropriating Ranney's *Trapper's Last Shot* for a large work he called *The Prairie Hunter—One Rubbed Out!* (fig. 20). Whereas Ranney had preserved a certain amount of ambiguity, Tait banked on his viewers not wanting any. The narrative key to *The Trapper's Last Shot* had been the viewer's curiosity about whether the trapper would make it. Tait kept several of Ranney's pictorial devices—the pursuit, the trapper looking back, and the wide expanse of prairie. But the newcomer made the trapper gleeful, the horse spirited, the muddy prairie solid earth, and the sky clear. The outcome of Tait's scenario is not in doubt. His title not only tells all—that one of the Indians in the background group is going down, and the trapper is not—but also employs the newly popular colloquialism *rubbed out* to give the image vernacular authority.[33]

With Tait, the Western type effectively *left* the specific arena of genre painting in which Deas's—and Mount's—images had functioned. Tait's Western male addressed gender tensions rather than regional antagonisms. He transferred the specific identity of the male as a trapper, already dated in Western history, to the more general category of hunter. With no experience of the West farther than Chicago—and all his outdoor experience restricted to the Adirondacks and the marshes of Hoboken—Tait brought

Figure 20.
ARTHUR F. TAIT
The Prairie Hunter—One Rubbed Out! 1852. Oil on canvas, 14 × 20 in. Courtesy Gene Autry Western Heritage Museum, Los Angeles.

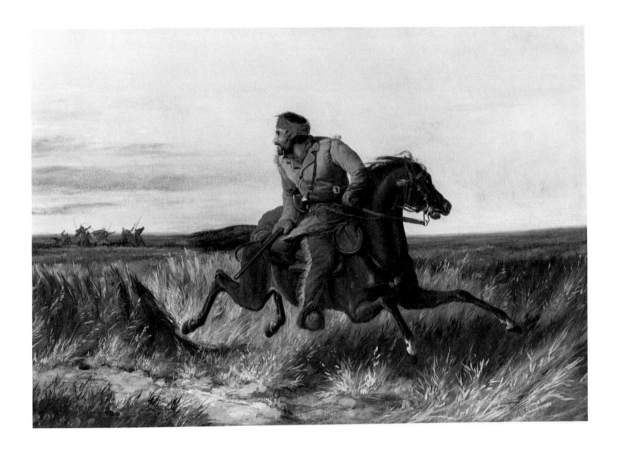

the terms of Western experience to Easterners who confidently enacted in their own wilderness—or what was left of it—earlier Western hunters' skills, courage, and hardiness. Critics like a writer for the New York *Herald* pretended to scorn Tait's derivativeness. "[Mr. Tait's] manner is a melange made up from the manners of many. . . . He seems to have been bitten by Mr. Ranney, and to have imbibed all his extravagance." And the *Literary World* complained that such images were "becoming painfully conspicuous in our exhibitions and shop-windows, of which glaring red shirts, buckskin breeches, and very coarse prairie grass are the essential ingredients." Yet the derivativeness and the formulas seem to have been crucial to the power of the images. In the painting *The Life of a Hunter: A Tight Fix*, 1856 (fig. 21), for instance, the scenario is so assured as to cloy: the hunter has lost his weapons and his footing and faces a snorting bear. But he isn't really on his own; a friend on the sidelines has a perfect shot at the bear.[34] Almost overnight, the figure of the Western trapper—now hunter—locked into place a reassuring ideal of individualism, hardiness, and masculine bravado that seemed to justify the

Figure 21.

ARTHUR F. TAIT

The Life of a Hunter: A Tight Fix, 1856. Oil on canvas,
40 × 60 in. The Manoogian Collection.

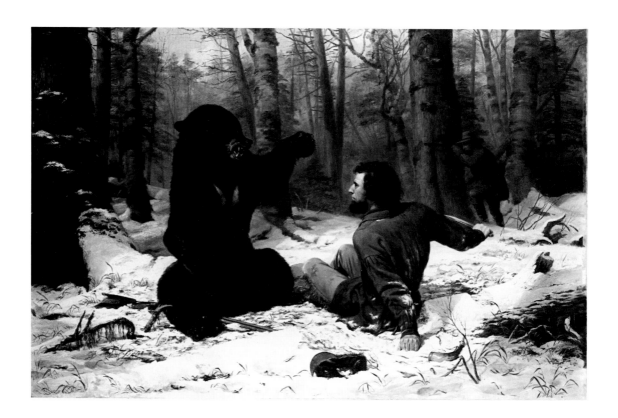

individualistic economic and political behavior that citizens across the constituency were
undertaking on a larger scale than ever.[35]

Western citizenship did not necessarily mean bravado, or suspect character, to Westerners. Missouri artist George Caleb Bingham proposed in the 1840s a very different interpretation of the Western constituency. Equally comfortable in Saint Louis and Columbia, in a state that by 1845 was not only emphatically settled but overwhelmingly agricultural (and yet still very much associated with the West), Bingham had the perspective of an urban, traveled Westerner. He knew the East Coast through direct experience. In 1845 he had just returned to Missouri from several years in Philadelphia, Washington, and New York, where he had gone to study and to validate his talent. During that time he had painted portraits amid the varied pulses of Northeastern politics and artistic endeavors, and he had seen the Art-Union exhibitions firsthand.[36]

82 Bingham presented the West—the site of Western types—not as the great expanse of

remote, inaccessible prairies envisioned by Northeastern commentators and pictured by Deas, Ranney, and Tait but as a potential agrarian territory connected to the East by rivers. That is, Bingham looked eastward and saw the West as an extension of it. From its statehood in 1820, Missouri had been prominent in national politics and economic life. Missouri farmers sent wheat and corn south on the Mississippi to New Orleans, where it was shipped to Northeastern and mid-Atlantic seaports, and merchants in Saint Louis served as transfer agents for goods that had come by river from the East and the South. For nearly a century Saint Louis had been the entrepôt of exploration and trade further west on the Mississippi and Missouri rivers. Under the encouragement in the early 1840s of Missouri senator Thomas Hart Benton, who had sponsored Frémont's expeditions to map the Oregon Trail, Independence and Saint Joseph had became the starting points for the pioneers' journey. To most Missourians, the West was in effect part of an economic and political network, the link of which was the river. To them, the characteristic Western citizen was caught up in the social functioning of this network.[37]

Perhaps less class-bound than Northeasterners, comfortable and powerful urban Missourians certainly saw a wide range of ambitious, vulgar, accomplished, and misguided settlers in a body politic on the move. Immersed in a world of liminality—between the Far West and the distant East, and near a very different South—Bingham constructed images not of mountain men, or men of the prairies, or, with two exceptions, Indians, but of rivermen. His choice of subject in 1846 bore in some ways a tactical resemblance to that of Deas and Ranney. The flatboatman—the Anglo-Saxon on the river—as seen by other Westerners, as well as by Easterners, was at once the most discussed and the most ambiguous type associated with the western river in the antebellum period. The boats on which rivermen worked took raw materials and produce downstream to markets along the vast interior river network, the Allegheny, the Ohio, the Missouri, and the Mississippi. Although the steamboat quickly became a much faster form of transportation after about 1825 (and provided round-trip service), flatboats continued to be used until the later 1840s. The rivermen who worked the boats, keeping the craft in the middle of the river, steering to avoid snags and dangerous currents, and protecting the cargo, were generally young and unattached. They were perceived by fellow citizens, particularly Easterners, in terms considerably different from the trapper. Boatmen had a reputation neither for hardiness, nor for fearlessness against Indians and privation, nor even for near savagery, but for disrespect for social order that they expressed in roughhousing, carefree idleness on the job, and drunken revelry on shore. To travelers and Eastern commentators, especially to the respectable family, they were figures of disdain. They constituted the drifting nature of the ordinary sovereign who moved west.[38]

The social construction of this type, like that of the trapper, served the needs of citizens to differentiate the citizenry on the basis of class and social responsibility. In many ways, flatboatmen were like trappers—they had removed themselves from ordinary social structures and were now associated with functions fast disappearing. Yet the type of the boatman was not predicated so explicitly on the issues of masculinity that had come to be important in images of the trapper and hunter. Disapproving commentators often described flatboatmen as young men who had left their family homes in order to pursue a less demanding life than farming. Others had stronger objections. New Englander Edmund Flagg called boatmen a "singular race" who threatened social anarchy. James Hall, who as a judge in Illinois had seen more than his share of violence, told his Eastern readers that "boatmen, proverbially lawless and dissolute, were often more numerous than the citizens, and indulged, without restraint, in every species of debauchery, outrage, and mischief."[39]

Yet many urged that there was no cause for alarm. This opinion was promulgated by groups on the Atlantic seaboard who saw it to be in their interest to persuade settlers and others of the civilized nature of the West. Peck, who had worried about the degrading effect of the wilderness on trappers, reassured Eastern readers that they need fear no recklessness from boatmen. In his *New Guide for Emigrants,* Peck wrote that boatmen are "the fresh water sailors of the West, with much of the light hearted, reckless character of the sons of the Ocean, including peculiar shades of their own . . . but this race has become reformed, or nearly extinct."[40]

Bingham offered a Western point of view. In *The Jolly Flatboatmen,* 1846 (pl. 9), which he sent to the Art-Union in New York for an Eastern audience of middle- and upper-class families acutely uncomfortable about their own young sovereigns, Bingham constructed his type with the interest and perspective of an insider. Mount, of course, had played both sides of the rural-urban coin in depicting his Yankee farmer. But Bingham was an advocate for the Westerners' view of the liminal figure. In *The Jolly Flatboatmen* a crew of eight young men, fresh faced, cheerful, colorful, and clean, enjoy music and dancing on the cabin roof of their flatboat. One plays the fiddle, another provides percussion with a skillet, and the rest watch in comfortable abandonment to the moment. Bingham arranged these figures in a pyramid that conveys relaxed order, with the dancer at both the apex of the pyramid and the precise center of the picture. One figure even calmly stares out at the viewer, as though inviting examination. In other calculations of order, Bingham placed the flatboat in the middle of the river, its poles and the cabin structure paralleling the picture edge. The riverbanks stretch out protectively in

the background. Virtually without texture or sharply contrasting colors, the painting is flooded with a clear, warm, softening light.[41]

One could hardly imagine a greater contrast to the types in the works of Deas and Ranney. The very wellspring of *Long Jakes, The Death Struggle,* and *The Trapper's Last Shot* is a type engaged in conflict that implicates and thus uplifts the viewer; the theme of Bingham's is high spirits that vaguely discomfit the viewer. Deas and Ranney's worlds threaten human safety and therefore enhance male fortitude; Bingham's environment is peaceful, with human beings naturally relaxed in it. These young men, Bingham assured his audience, may be interested in fun, but they are not disreputable. They sport no beards, are not engaged in lascivious behavior, and don't seem to be drunk. Since at least one character in the painting almost brazenly invites viewers to observe, they would seem to have imposed a social order on themselves. Yet the work on the river to which the image alludes is common and insinuatingly vulgar rather than dashingly romantic, and the figures are not individualistic. They would never be mistaken for knights of the prairie. Like Peck and other boosters of emigration, who emphasized that the boatmen were a disappearing group, Bingham presents the boatmen as safe. He seems, in fact, to dare his audience to disapprove, both of their class associations and of their liminality.[42]

Bingham's Eastern viewers were variously charmed and annoyed. The New York critic for the *Literary World,* for instance, apparently put off in the first place by the inclusiveness of the Art-Union, began his assessment of the Art-Union paintings that had thus far been gathered for distribution with the flippantly superior statement that "there are many . . . which we wish we could refrain from mentioning, since we cannot justly speak well of them; but . . . whatever has been deemed worthy of purchase by the Art-Union, ought to be worthy at least of a word either good or bad, flung at them." Then he launched his critique of *The Jolly Flatboatmen* and *Raftsmen Playing Cards,* 1847 (fig. 22). "The first of these subjects has by some fatuity been selected by the committee, to be engraved for distribution to the members of the present year. The painting is not now on the walls [it was at the engraver's], and as few probably of the subscribers have seen it, we are sorry to inform them that the opinion we formed of it last year, when it was exhibited at the rooms for a few days, was that it was a vulgar subject, vulgarly treated, that the drawing was faulty and the composition artificial,—altogether a most unworthy and unfortunate selection. . . . Of Mr. Bingham's qualities as a painter, however, [*Raftsmen Playing Cards*] and another subject yet unpurchased, are a sufficient example. In color they are disagreeable, a monotonous, dull, dirty pink pervades every part; and in texture there is the same monotony. . . . In composition, Mr. B. should be aware that the regu-

Figure 22.

GEORGE CALEB BINGHAM

Raftsmen Playing Cards, 1847. Oil on canvas,
28 × 36 in. The Saint Louis Art Museum.
Purchase: Ezra H. Linley Fund.

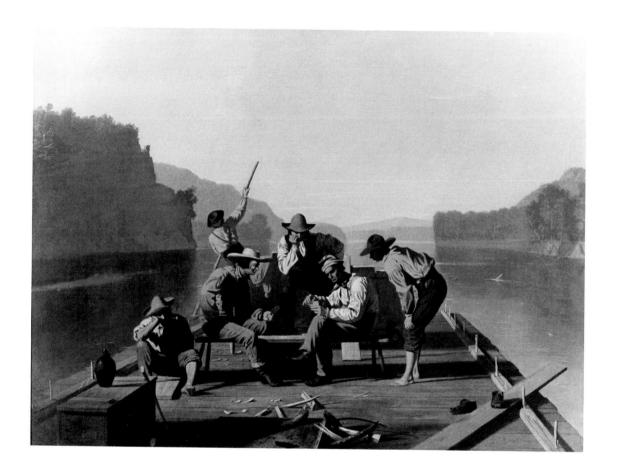

larity of the pyramid is only suitable to scenes of the utmost beauty and repose." This
was the same journal, aimed at an elite readership, that had found complete pleasure in
the "wildness and daring," the "half-savage life and freedom from the restraints of civi-
lization" of Deas's trappers. Masculine acceptability, it would seem, was constituted by
autonomy, not social community, and by power in the midst of danger (as signified by
horse and gun), not leisure.[43]

In the Western metropolis of Saint Louis, however, where citizens carried out their
daily lives in the presence of flatboatmen, watching them on the wharves, passing them
in the streets, and overhearing them in the taverns (and no doubt forming any number
of opinions about them), the newspaper critic for the *Missouri Republican* saw the paint-
ing quite differently. Presumably a man of comfortable social status informed by a cer-
tain amount of Western boosterism, in assessing Bingham's river scenes this critic wrote:
"The western boatmen [are] a peculiar class in most of their habits, dress and manners.
Among them, often in the same crew, may be found all the varieties of human character,

86

from the amiable and intelligent to the stern and reckless man." Seeing them as repre-
sentative of human rather than regional traits, the equanimous reviewer did not assume
that Bingham had implicated all American citizens, or even all Western citizens, with
these types. He went on to note that "in dress, habit, costume, association, mind, and
every other particular, [the boatmen] are an anomaly." With the urbane tone of a sophis-
ticated, broadly tolerant—indeed, worldly-wise—citizen of the urban West, the writer
expressed pleasure that Bingham had taken up this subject: "Mr. Bingham has struck
out for himself an entire new field of historic painting, if we may so term it. He has taken
our western rivers, our boats and boatmen, and the banks of the streams, for his sub-
jects. The field is as interesting as it is novel." The directors of the American Art-Union
apparently agreed. Perhaps sensitive to its many allusions, they ordered the image en-
graved in 1847 for distribution to the national membership.[44]

Over the next several years Bingham painted at least twelve variations on the flat-
boatmen, depicting them playing cards, watching cargo, waiting to transfer wood from a
boat, and relaxing in port.[45] He compiled a portfolio of sketches of men and boys, fat,
slender, straight, and slouched; of townspeople and countryfolk lounging, looking, and
waiting. He seems to have arrived at the final versions of these sketches—the only ver-
sion now extant—with his paintings in mind, for he incorporated them into his paintings
with little alteration. They are not individual characterizations but distinctive attitudes.
These attitudes include indolence, audacity, pride, and skepticism. Bingham's characters
present themselves to be examined. In such pictures as *The Wood Boat* and *The Squatters*,
both 1850 (figs. 23, 24), Bingham's Western types may look clever or uncomprehending,
sly or gullible, but above all they stand ready to meet the world. Bingham interchanged
these types in his paintings: what was more important to his works than narrative—in-
deed, in contrast to paintings by Deas and Ranney, most of Bingham's paintings lack a
narrative—is the attitude that Bingham encouraged his Eastern audience to have to-
ward the Western type. Lacking moral definition, Bingham's characters are not malign
but not precisely benign either. Bingham shifted the last word on them to his viewers.
And the word that many of them pronounced, as was apparent in the reactions of the
New York literary critic, the New York booster of national art, and the Saint Louis so-
phisticate, was determined by their prejudices and interests. Mount encouraged his
viewers to laugh at his characters, Deas and Ranney to marvel at exploits they would
never themselves be called upon to make, and Bingham to suspend judgment on charac-
ters just making their way in the newly settled West, and, by extension, in newly forming
communities.

Bingham's definition of a national class, or at least a national subject, was persuasive.

Figure 23.

GEORGE CALEB BINGHAM

The Wood Boat, 1850. Oil on canvas, 24 3/4 × 29 5/8 in.
The Saint Louis Art Museum. Museum purchase.

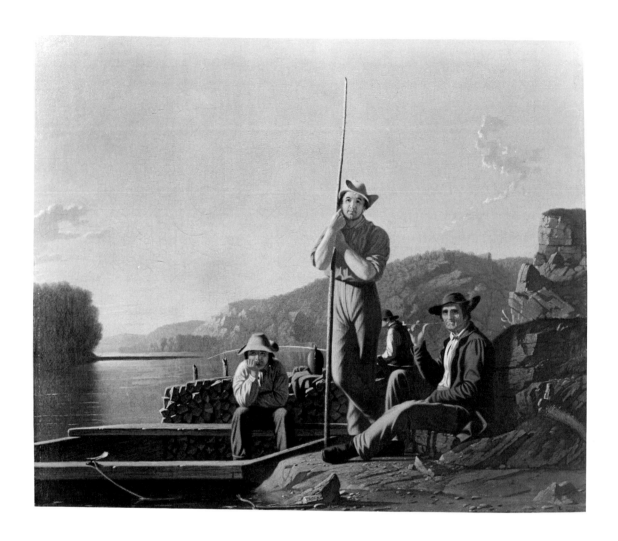

In 1849, the new *Bulletin* of the American Art-Union reported to its burgeoning membership that Bingham's paintings were "thoroughly American in their subjects" and explained—indeed justified—their patronage of Bingham primarily on this basis: "It was this striking nationality of character, combined with considerable power in form and expression, which first interested the Art-Union in these productions." So essential to Bingham's success was this nationality of character that after the demise of the Art-Union, and with it the subsidence of all the structures that had participated in that institution's vision of a national art, Bingham did not exhibit in New York City. Only Ranney, whose Westerners embodied Eastern ideals of male individualism and power, ideals that were shared across social strata, sustained his popularity. Bingham's next

88

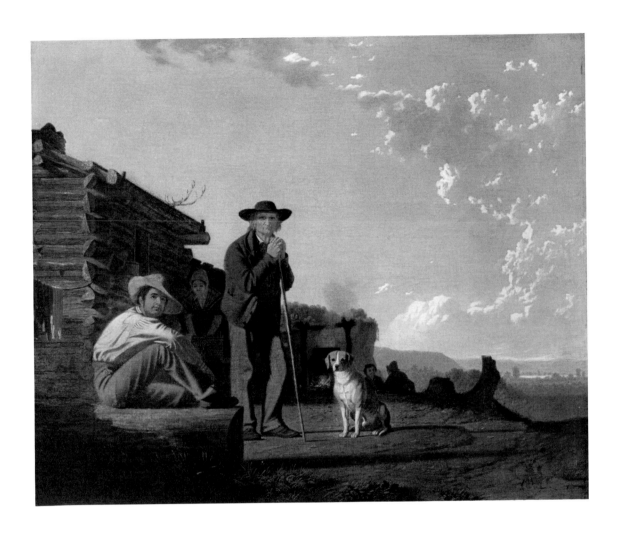

project, scenes of the social world of American electoral politics, received virtually no Eastern exposure.[46]

 The Art-Union's celebration of images by Bingham in the late 1840s seems to have gone against an increasingly strong current of opinion about imagery. Other New York critics were finding the depiction of American and even Western types to be remote from images they construed as art. Mount had faced viewers as early as the mid-1830s who were exhilarated by the Americanness of his paintings and yet wondered if they were really art. In the case of images of the Western male just ten

years later, the competition was the aesthetic sophistication associated with specifically European art. In 1848 the critic Nathaniel P. Willis reported in the New York *Home Journal* to an imaginary "Western Belle, returned home" that "French Art has come over and fairly pitched its tent on this side [of] the water." He reported with a mixture of irony and excitement that the French firm of Goupil and Vibert had just opened a dealership in New York, featuring Ary Scheffer's *Mary Prone on the Dead Body of Christ*, "the world's highest instance of the pathos expressible by the pencil." At the same time, French history painter Paul Delaroche was exhibiting his dramatic *Napoléon* at the National Academy of Design. The next year the entrepreneur H. Boker bought the entire gallery of paintings owned by an art union in Düsseldorf and installed them on Broadway, thereafter presenting large, ongoing, and accumulating exhibitions of paintings from across the Atlantic. Flocking to see and write about such star exhibits as the enormous *Martyrdom of Huss* by the German artist Carl Friedrich Lessing, New Yorkers seem to have been intrigued and intimidated. The large presence in New York of European images of all kinds asserted to status-conscious viewers the authority of "vastly superior" European painters.[47]

Other developments modified the attractiveness of imagery of national types as well. In 1850, in the very same distribution at the Western Art-Union in Cincinnati in which the print of Ranney's *Trapper's Last Shot* was a prize, the Art-Union raffled Hiram Powers's *Greek Slave,* the neoclassical nude sculpture that had attracted more attention and commentary across the nation than almost any American work in recent years. In this case as in others, elitist associations with high art displaced the socially contested, and definitely nonideal, associations of genre. American history painters, legitimated by examples of French and German art, achieved new prominence through the very institutions that had earlier been charted to encourage "native" productions. The Art-Union, for example, gave history and allegory painter Daniel Huntington his own gallery in 1850, in which he showed more than a hundred works, each quite far from a genre painting of American types. Then in 1851, the Art-Union paid Henry Peters Gray two thousand dollars for his mythological *Wages of War* and *Apple of Discord*. Critic Willis quipped that artists who painted America's "favorite nationalities" focused on "our Washington [referring to the rash of historical paintings honoring Washington], our women, and our Niagara." It was not an auspicious time for images that raised the contested issues of the citizenry, even images that substituted fantasies of manhood for representations of ordinary trappers.[48]

The implications of imagery about Western types were thrown into further complexity with the discovery of gold in California in 1848. Only two years after the Art-Union

had engraved Bingham's image of the flatboatmen for national distribution and four years after Deas had excited his New York viewers with *Long Jakes,* Eastern newspaper headlines shifted from stories of respectable family emigrations to the West to accounts of riches available practically for the asking.

The gold miner as a type, however, did not appear in paintings on exhibition walls in New York, Boston, or Philadelphia. For one thing, the artists who joined the frenzied rush to California were too busy. Some from Europe, others from the East, and still others from the Midwest, they often began as prospectors and only slowly worked their way into work as professional artists. Once in San Francisco, they found the market to be predominantly for portraiture and landscapes—local viewers, like those in New York, were socially ambitious. Actual genre artists were few. Typical is the career of Charles Christian Nahl, who came from Germany and arrived in the gold fields in the spring of 1851; unsuccessful at prospecting, he worked in Sacramento as an illustrator and then, in 1852, settled in San Francisco as an engraver and portraitist. Although Eastern periodicals published many of his caricatures of mining life in the 1850s, not until a climate of support for local art and artists developed in San Francisco in the 1860s did Nahl win commissions for paintings of miners and mining scenes. Upstate New Yorker August Browere, another artist-prospector, failed dramatically and brought his paintings and sketchings back East with him, but these, too, he exhibited only after the Civil War. Thus although there were jokes aplenty in New York about down-at-the-heels Easterners hoping to strike it rich in California (and on their quick return denying that they had gone broke), and caricatures of prospectors abounded, before the war the forty-niner was simply a dark variation on the speculating American sovereigns of all classes who were ever after the main chance. The Reverend T. Dwight Hunt made this clear in an article entitled "California, Oregon and Washington," in which he pronounced that settlers who went to those areas were simply *"Americans let loose. How better could I describe a fast people? . . . The haste to be rich has been desperate, the wreck of character has been fearful, but the amount of work accomplished within the time has been altogether without precedent. . . . Some of the world's best people have mingled with many of the world's worst."*[49]

In no circumstance was the resistance of viewers and critics to the implications of genre painting clearer than in Bingham's experience with his election scenes. Beginning in 1847, though he continued to exploit the popular image of the boatman, Bingham also examined the American electorate—the Western electo-

rate—in action. He depicted these citizens as largely ordinary, even broadly lower-class, as orators and listeners, as political bosses and voters—in short, as perhaps dangerously empowered members of the body politic.[50]

Bingham's sovereigns at the polls bear no resemblance to Deas's and Ranney's trappers working out their own dramatic destiny in the wilderness. They are not even of the same family as his boatmen. They are yeomen moved west, plebeian farmers and townsmen. They are the democratic mass slowly fanning out across the continent, distinguished not by dramatic feats but by degrees of intelligence and moral fiber, qualities to be read by facial and body type, clothing, and gesture. Unlike Mount's Yankee farmers, these figures at the polls listening to political speeches, casting their votes, and hearing the results present an openness that challenges the viewer's prejudices.[51]

Of the three large paintings on the political process that Bingham completed in this series, *County Election*, 1852 (pl. 10), is the richest.[52] *County Election* sets forth in startling clarity under the clear blue sky of a Western town a group of citizens casting their votes. The sovereigns line up across the foreground. The ordered town, with classical porticoes and outlines that include a church steeple, stretches diagonally to the left background. The light is early morning, the colors pure and bright. Sixty or so male figures wait in line, talk, listen, calculate, toss a coin, drink (or show the effects of having done so earlier), and, finally reaching the judge at the polling place, vote by oral declaration. The painting presents to the viewer men old, middle-aged, and young, with boys playing in the foreground, men well dressed and poorly dressed, some hatted and some bareheaded, some fat and prosperous looking, others lean and haggard, some smiling, others musing, still others looking befuddled. Two signs indicate the symbolic quality of the painting: the hotel in the background is the Union Hotel. And a banner resting against the polling porch reads, "The Will of the People the Supreme Law." In the distance are silhouetted a rider on a horse and a covered wagon, allusions, perhaps, to the "Long Jakes" type and to the migration that made the West an agrarian community.

For this, his most complex painting to date (only *Stump Orator* approached it in ambition), Bingham based his composition and certain supporting motifs (particularly the line-up of voters and the prominence of "refreshment") on Hogarth's *Election Series* (fig. 25). Such modeling demonstrated the terms of his topic: European painting, like European experience, offered no precedents for trappers or flatboatmen, but when politics entered the picture, American citizens joined European history. Yet where Hogarth was severe, Bingham was amused. He implicated his own party in the humor, placing a cider barrel prominently in the left foreground to convey the active role that the Whigs played

Figure 25.
WILLIAM HOGARTH
The Polling, 1758, plate 3 of *Election Series.* Engraving
by François M. la Cave, 15 7/8 × 21 3/8 in. Yale Center
for British Art, Paul Mellon Collection.

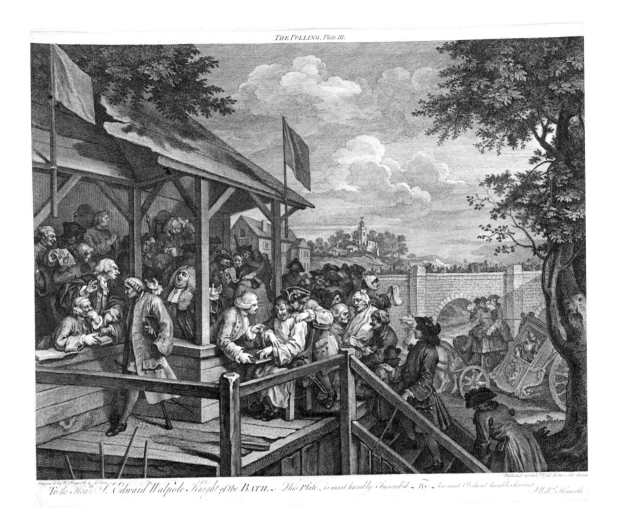

THE POLLING. Plate III.

in the election. He idealized the village architecture and plan, painted the sky as one of
Edenic beauty, delineated characters with individuality of manner from solemn to silly,
of status from well-dressed to ragged, and of age from boyhood to old veteran. He dis-
played a group of men variously caught up in the excitement, scheming, solemnity, and
hope of the day. His examination is gentle, critical, and tolerant all at once. There is a
character type for everyone—the inebriate, the innocent boy, the thoughtful plowman,
the self-confident merchant, the thick-bodied common man. Bingham showed his audi-
ence, in effect, that Mount's yeomen farmers of the 1830s were living in Western towns,
having brought with them all their skills in calculation, their devotion to self-interest,
their credulity and weaknesses. Bingham's only unequivocal dark note is the tendentious 93

action of the coin tosser, who stands just below the voter and the judge. When he painted a replica of the scene the next year, he did not include this figure, deciding, perhaps, that the action too strictly swung to one side the ambiguity of the painting.[53]

Although Missouri politics in 1850 and into the early years of the decade were virulent, with conflicts over slavery, transportation, and land running so high that Senator Benton was defeated for reelection after thirty years' tenure in Congress, Bingham's image is *not a Cider Making*. Indeed, Bingham constructed an astonishingly generous reading of antebellum political tensions. Like the theme of political oratory, the election was a subject that lent itself to idealism as well as to satire. The outcomes of the several revolutions of 1848 in Europe drove home to even the most despondent that the American political process had a unique resilience. Newspaper editors who printed demeaning anecdotes about Irish voters and other ignorant "sovereigns" lavished idealistic tributes to the orderliness of American political transitions. A joke lampooning the naïveté of the average voter appeared in the Saint Joseph *Gazette* on the same page as the announcement that Bingham was bringing his painting *The County Election* to the city for exhibition.[54]

Bingham, however—as he had done with boatmen and squatters—virtually asked his audience to judge for themselves. Just as he had achieved in his images of rivermen, he presented a group of Westerners who were not quite definable. They are by no means dramatically heroic, like the trappers of Deas and Ranney, but neither are they duplicitous, like Mount's farmers.

And the judgments of Bingham's viewers were revealing. Those that exist are almost all by Western viewers. Bingham did not exhibit the painting in New York. By 1852 the American Art-Union, his usually dependable patron, was on its last legs. Bingham took *The County Election* with him to Baltimore in 1852 when he attended the national Whig convention and exhibited it while he interviewed potential engravers. The Baltimore *American* commented on the work as though Bingham's topic were completely alien to sophisticated urban—Eastern—experience: "The picture . . . contains a great many figures, among them some of the strange and eccentric characters known as village politicians."[55] This reviewer, at least, could not acknowledge the stunning appropriateness of Bingham's image to politics as practiced in the East (to say nothing of in Maryland).

Other venues that Bingham chose for the painting were all Western and Southwestern. He exhibited the work across Missouri and Kentucky (Louisville, Lexington, Danville, Frankfort, and Harrodsburg, and perhaps other places) and in New Orleans. Audiences commented profusely. They did not need to denigrate Bingham's types as "strange and eccentric." Indeed, they praised them as completely recognizable, and then

went on to specify what they found recognizable. This was their own political philosophy. They knew well that towns rose overnight, that social classes there constantly overlapped, mingled, and reorganized. They also had known well, and chaffed at, the easy social generalizations and disapproval of Eastern cousins. Whereas in New York in the 1830s and 1840s, Mount's critics in cultural journals and newspapers voiced the satisfaction of the self-made wealthy with entrenched interests, in Saint Louis, Louisville, and Columbia, Bingham's reviewers and supporters were newspaper writers with a broad sense of themselves, of social change, and of what an American genre painter might well undertake.[56]

An early enthusiast in Columbia who saw Bingham working on *The County Election* in his studio described it to his readers in affectionate detail, highlighting the "well-set Irishman in a red flannel shirt," a "political striker, distributor of tickets, *very* politely tendering his services in that regard to an approaching voter," and figures "engaged in earnest conversation." Concluding that the picture was so "full of reality [that it was] a seeming incarnation," he stated confidently that "persons of highly cultivated taste in the fine arts, and critics in general, will accord to it a remarkable degree of genius and merit."[57]

Bingham's picture brought out the equanimity of other Westerner writers as well. This was the spirit not of idealization but of acceptance of human frailty. The Saint Louis *Evening Intelligencer* praised the work, at the same time affectionately mocking some of the "originals" who inspired it: "Whoever looks at it seems to recognize at once some old acquaintance in the various groupings. . . . We saw most unmistakeably an old County Court Judge, of the interior, who may invariably be seen on 'election day' perched upon the court house fence, discoursing with the learning and authority which are inseparable from high official position, upon the infallibility, and super-excellence of the 'dimmi-cratic' party."[58]

The *Daily Times* of Louisville, even more embracing, wrote that Bingham had depicted "groups of sturdy old farmers who have come to town with a grave sense of their responsibility as citizens . . . how serious and honest and sensible they look, as they gravely discuss the affairs of the country, and the questions of the day! . . . See the scene at the polls—an old man's vote is challenged and the Sheriff is swearing him on the book, while the Judge of the election searchingly scans his countenance. . . . That very complaisant, officious and lawyer-looking personage, who stands near the place of voting, and is incessantly smiling, bowing, and shaking hands with the voters as they come up the steps to the place of voting—you will know him at once as a candidate by his excessive politeness and his universal intimacy." This viewer enjoyed Bingham's mixing of classes: "There is a

group of quiet and intelligent gentlemen sitting under the eaves of the house, reading the newspaper, and enjoying an agreeable chat and some amusing anecdotes, while hard by on a log, an ominous rag, spotted with red-colored stains, encircling a drooping and 'damaged phyzimahogany,' and a rent or two in his shirt and trowsers, tell the sad story of a rash freeman, who, having taken several 'horns,' fancied he could 'whip his weight in wild-cats,' until a sound drubbing dispelled the flattering illusion." Even stuffing the ballot box did not disturb this critic: "Yonder the friends of one of the candidates are bringing up on their shoulders a chap whom they have been treating at the grocery [grog shop] over the way, until his legs would debar him the exercise of the great franchise, and his memory has to be frequently reinforced with the name he must vote for when he reaches the polls."[59]

There was only one recorded disgruntled voice. It was the very openness, the frank assessment of human nature in the painting that disturbed a man who identified himself as "Public Weal" and scolded readers of the Lexington *Kentucky Statesman*. Viewers expected paintings to provide information, this writer argued, and *County Election* would provide a dreadful legacy for future generations. Objecting to the "miserable loafers," a man "too drunk to rise," and a "judge, candidates and voters [who] are a reproach to any precinct or county," the correspondent refused to recognize Bingham's work as a proper representation of county elections. An artist, he insisted, should be idealistic. "It is a mortifying reflection that neither our religious or political institutions remain as pure as when they came from the hands of the founders of them, but do let the world struggle on in defense of them, with the cheering hope which the bright side affords, and never surrender, as we must do if we believe in such dark views as are given by this picture."[60]

Particularly telling in Bingham's openness about the citizenry is the political experience that he brought to the series. From the late 1830s he had been an enthusiastic Whig, and during the same years that Mount was satirizing Whig tactics in New York, Bingham in Missouri formed friendships with politicians, painted banners for conventions, became a candidate himself, and acquired a reputation as a stump speaker. In 1846, he ran for the state legislature from his county, fighting a tough campaign against firmly entrenched Democratic interests. He won the election, but by so narrow a popular vote that his opponent contested the outcome, and the Democrat-controlled legislature subsequently declared that Bingham had lost. In his outrage, Bingham wrote his friend James Rollins that political campaigning was like wallowing in mud. "An angel could scarcely pass through what I have experienced without being contaminated. *God help poor human nature.* As soon as I get through with this affair, and its consequences, I intend to strip off my clothes and bury them, scour my body all over with sand and water,

put on a clean suit, and keep out of the mire of politics *forever*." But in almost no time Bingham had swallowed his fury and returned to politics, and over the next twenty years he enjoyed numerous political successes. Throughout his adult life Bingham remained embroiled in politics, as devoted, skeptical, and amused at its chicanery and its hoopla as his fellows.[61]

He felt no need to pretend cynicism about the process. When he was at work on the second of his election series paintings, he wrote Rollins that "*the gathering of the sovereigns is much larger than I had counted upon. A new head is continually popping up* [in the painting] *and demanding a place in the crowd, and as I am a thorough democrat, it gives me pleasure to accommodate them all.*" He good-naturedly confessed that "the consequence, of this impertinence on one side and indulgence on the other, is, that instead of the select company which my plan at first embraced, I have an audience that would be no discredit to the most populous precinct of Buncomb."[62]

Projecting that the picture had a potentially immense audience, Bingham garnered the financial backing of friends for an engraving to be marketed primarily in the West. He painted a replica to have a version that he could exhibit in order to raise subscriptions. Bingham's influential political friend James Rollins, also a Missourian, believed the national implications of the picture were its most significant aspect. But to persuade Easterners of this point of view was another matter. Urging the Art-Union directors to purchase and engrave the picture, Rollins wrote of its proper interpretation: "It is a *National* painting, for it presents just such a scene, as you would meet with on the Aroostock in Maine, or in the City of New York, or on the Rio Grande in Texas, on an election day." Rollins enumerated the social types that were by 1852 national rather than regional. "[Bingham] has left nothing *out*, the courtier, the politician, the labourer, the sturdy farmer, the '*bully*' at the poles [polls], the beerseller, the *bruised* pugilist, and even the boys playing 'mumble the peg' are all distinctly recognized in the group. . . . As a mere work of art a delineation of character it is superb." Rollins went on to identify the foundation of Bingham's conception. "But this is not the point of view in which its excellence is to be regarded. The elective franchise is the very corner stone, upon which rests our governmental superstructure and as illustrative of our fine institutions, the power and influence which the ballot box exerts over our happiness as a people, the subject of this painting was most happily chosen, and executed with wonderful skill by its gifted author." Rollins's endorsement fell on unresponsive ears, for the Art-Union declined to buy the picture as well as to engrave it, citing the complexity of the undertaking. Although they may have been unable to offer as a reason their own perilous standing, their response was like that of the Maryland group—the subject was peculiar.[63]

Bingham, however, persisted in his conviction that the image had a potential national—and thus popular—audience. He directed the Philadelphia engraver John Sartain, whom he chose to engrave the work, to change the name of the newspaper in the lower right-hand part of the painting from "Missouri Republican" to "The National Intelligencer," a Washington newspaper. "There will [thus] be nothing to mar the *general character* of the work," Bingham explained to Sartain, "which I design to be as *national* as possible—applicable alike to every Section of the Union, and as illustrative of the manners of a free people and free institutions." He followed *County Election* with two more works and attempted to sell the group of three as a series.[64] His Western and Southwestern reviewers agreed that the paintings were national in scope. The New Orleans *Daily Picayune* proclaimed that Bingham was "to the Western what Mount is to the Eastern States, as a delineator of national customs and manners." The *Western Journal*, in Saint Louis, informed readers that Bingham was "'par excellence' the American Artist" and "one of the New Masters." Bingham had even self-confidently proclaimed his national appeal in a letter to Rollins in 1853: "The fact is I am getting to be quite conceited, whispering sometimes to myself, that in the familiar line which I have chosen, I am the greatest among all the disciples of the brush, which my native land has yet produced."[65]

But Bingham was not to have his Western supporters' and his own confidence confirmed. The middle and late 1850s were not propitious times for investment in images that examined Americans as political actors. The national Whig party had collapsed after the election of 1852, in which it was routed by immigrant-reinforced Democrats, and the nascent Republican party had begun to challenge the power of Southerners. Party politics became so deplorable in 1853 that Bingham wrote Rollins that only the profitableness of plunder under a united front had kept the Democrats together. "It will be a glorious time for the country when the present party organizations shall be broken up entirely. We need not expect until then to have a revival of the good old times, when honesty and capacity, rather than party servility, will be the qualifications for office." A financial panic in 1857 and subsequent depression further demoralized the nation. Without success Bingham tried to sell the election paintings to the Library of Congress in 1860, and then, in the anxious months before the outbreak of the Civil War, he exhibited the works in Washington, Philadelphia, and Cincinnati. Failing to find a purchaser, he placed them on indefinite loan at the Saint Louis Mercantile Library Association in 1862.[66]

Bingham's journey from making one "type" the centerpiece of his work to setting forth the great variety of types that comprised the franchise, most of them from the lower and middling orders, drove to the heart of the social and political anxiety of much of his audience. This anxiety was not that rivermen were a distinct social class and level

of evolution from farmers, and that both rivermen and farmers were distinct from merchants, but that *all of them* had the vote.

And, too, there was progress. Very quickly into the years of westward expansion, Easterners began to construct "authentic" Western experience as having been in the past. In 1855 New Yorker Edward P. Mitchell regretted that "in 1820, Missouri was the 'far West,' and Independence the boundary of civilization. Now, in 1854, there is no 'far West.' It has been crowded overboard into the Pacific ocean. . . . Pioneer life and pioneer progress must soon pass away for ever, to be remembered only in story." Mitchell and others might have recognized their desire to assume rhetorical control over distance, or their happy conviction that all change was progress, or even the pleasure they found in recollecting what is safely beyond recovering. But what artists recollected for them in imagery during these years of retrospection bore much less relation to what was safely beyond recovery than to identities that were being forged and reforged at that moment.[67]

In the 1850s and 1860s the lithographs of Arthur F. Tait were the most widely known images of the West among the American public. Having carefully eliminated from his pictures ambiguity of character and of narrative, Tait's prominent theme of the confrontation between white man and Indian man, or white man and beast, completed a cycle of Western subjects that had begun with images of Indians, turned to images of autonomous Anglo-Saxon frontiersmen and trappers, and paused in a solemn assessment of the electorate as modified by Western characteristics. As the West was settled and its political future determined, Tait's images of the white man in the West constructed the saga of the "winning" of the West as a triumph not of white man over the wilderness but of white man over the Indian—of noble masculinity over savage animality—*and* of autonomy over community. Among the most popular lithographs embodying these myths were *The Pursuit* (pl. 8) and *The Last War-Whoop*, both 1856. Thematic prototypes for the images of the cowboy by Frederic Remington and Charles Russell at the end of the century, they assured their viewers, as do their successors today, that certain ideals of manhood could be translated into their own lives.[68]

Four Standing Outside the Door

The fictions that whites built about the black people in their midst were very different from those they constructed about one another. In the eyes of almost all the dominant citizens who put themselves at the center of the body politic, scheming Yankee farmers and vaguely disreputable Westerners might be of dubious commercial malleability or low social standing, but they were indisputably in the competitive race that linked citizens across the electorate. African-Americans, however, were not.

These relationships had persisted since colonial times and before that, in European countries and colonies that engaged in the slave trade, as early as the sixteenth century. Slaves in the United States had no political and economic rights, and by the early nineteenth century those few who were legally free had been limited in their freedoms. In 1830 this oppression was an integral part of the economic network that enormously benefited citizens across the country and was held in place by them. Whites justified setting African-Americans apart with extensive psychological buttresses. Most argued that the fundamental factor determining African-Americans' place in the social order was that blacks were racially—that is, *essentially*—different from whites as human beings. Iterating these convictions as firmly in Massachusetts as in Georgia, as doggedly in Ohio as in Missouri, citizens of different classes and both genders assigned character traits to African-Americans to demonstrate that they were physiologically and intellectually inferior. With such stock assessments of blacks as childlike, lazy, and natural (sensual), they thereby distinguished them from the vast hordes of otherwise undistinguished white citizens who—putatively at least—had the innate capacities for equality: mental acumen, economic drive, and self-control.[1]

And thus qualities that the ambitious and dominant had tolerated and often admired in lower-class whites and in one another became badges of inferiority for blacks. Citizens who excused the ferocity of the frontiersman as commendable toughness accused blacks of being uncontrollably violent; those who dubbed the crabbed speech of the Yankee and the effusive vocabulary of the frontiersman as colorful diagnosed the African-American as unable to speak except in deformed dialect. Englishwoman Harriet Martineau, who toured the country in 1836, saw the major function of the differentiation as maintaining the fiction (important to both the dominant and the under groups) that all

whites were of the same class. She declared that American society was divided into two classes, "the servile and the imperious."[2]

Abolitionists who crusaded for an end to slavery, first in the late eighteenth century against the slave trade and then in the 1830s against the practice of slavery, faced a generally intransigent white population. The certainty of clergyman Michael Hammett of Cincinnati was typical. He told the American Colonization Society in 1833, "Find [blacks] where you may, whether in Philadelphia, Cincinnati, Richmond, or Charleston—in a free or slaveholding state, you find them, with very few exceptions, the same degraded race. No individual effort, no system of legislation, can in this country redeem them from this condition, nor raise them to the level of the white man, nor secure to them the privileges of freemen." New York writer James Kirke Paulding was sure that anyone who objected to slavery did not realize the actual childlike character of blacks, and thus the appropriateness of the slave system for maintaining their innocent cheerfulness. Echoing many of his counterparts in the South, he intoned in his prescription for social order in 1836 that "of all the varieties of the human race and of human condition that have ever fallen under observation, the African slave best realizes the idea of happiness, . . . for he is . . . the most light-hearted, sportive, dancing, laughing being in the world." And yet a powerful undercurrent in the systematic oppression of blacks was the declaration that African-Americans had a unique psychological sensitivity, a characterization that was at once a concession by whites to blacks' humanity and a weapon against their potential freedom. Citizens who urged a reformulation of the proper place of blacks in the larger society based their appeal on the emotional depth of the black nature. This emphasis provided a powerful wedge to challenge the status quo.[3]

In 1830, as William Sidney Mount was beginning his career, the body politic was poised on the brink of three decades of tumultuous conflict in which the relationship of blacks to the larger society was fundamental. The African-American population rose steadily: the census of 1830 counted population of nearly thirteen million, of which more than two million were slaves. By 1860, there were nearly four million slaves. As the slave population expanded dramatically, so did the geographical expanse in which slavery was legal. In 1830, twelve of twenty-four states were slaveholding; by 1860, fifteen. Throughout this extension and simultaneous entrenchment of the slave interests, the dominant and the "sovereigns" pontificated on the political implications of (Southern) expansion, preached sermons on "God's will" for the races, and launched political campaigns that avoided—and eventually delicately incorporated—the issue of slavery.

That New York was the center of the art world was as crucial in the construction of images about blacks as it was in images of farmers and Westerners. Mount created his

paintings of the yeoman as Yankee farmer for viewers who saw their social world in antipathy to that of rural life and, even more, to that of New England. Deas, Ranney, and Bingham created Western types that played on the complex economic relationships and social assessments with which New Yorkers urged, supported, and regretted Western expansion (Bostonians, unconnected with the West by river, were too far from the fray; Philadelphians by the 1840s too insular). The position of African-Americans in New York, where blacks both slave and free (although small in numerical proportion) had long been significant presences in both the city and the state, was the most complex and contested of any major Northeastern center. New York had relied more heavily on slave labor in the eighteenth century than any other Northern colony. After the outlawing of slavery there, many African-Americans in New York City had become domestic servants, in which conspicuous function they served ambitious white citizens as coveted status symbols. Blacks who strove for the prestige of independent labor as artisans soon found themselves on an economic and social downward path. Throughout the early years of the nineteenth century, members of the white labor movement restricted access to black craft workers in one urban occupation after another. This closing of doors operated in a vicious circle to confirm the white-constructed adage that blacks were unable to perform more than menial labor. In the 1850s, the immigration of large numbers of completely unskilled white immigrants into New York made the position of African-Americans even more marginal: these immigrants, who had a distaste for agricultural labor, generally went into domestic service and thus gave blacks yet one more competing element for their slender economic foothold. As Frederick Douglass lamented sadly in the 1850s: "Every hour sees the black man elbowed out of employment by some newly arrived immigrant, whose hunger and whose color are thought to give him better title." The most devastating opposition was political: the Democratic party, which had secured New York as a major stronghold and palliated Southern Democrats at every crisis, refused to address the issue of slavery right up to the outbreak of the Civil War.[4]

Not only was New York the negative proving ground of the place of African-Americans in the evolving economic and political world and in the social relations that those worlds brought into being, but it was the source of the dissemination of this typing. It was thus the prime location (rather than the South) of the cultural construction and perpetuation of African-American character across the United States. A thriving center of journal and book publication (not to be edged out by Boston until the mid-1850s), and the major site of the production of caricature, it was the theatrical nexus as well. Stage caricatures of African-Americans became prominent in New York theaters in the 1820s and from there

traveled across the country. Then, in the 1840s, minstrelsy took lower- and middle-class audiences by storm. The characterization of the minstrel reinforced the type of the happy slave that writers of the Southern plantation novel had created in the 1820s. Over the next decades, status-hungry New Yorkers coined jokes, wrote stories, and appreciated drama in which blacks hovered to serve, provide amusement, and give them a group of nonsovereigns who were unarguably beneath them.[5]

Artists constructed images of blacks for viewers who needed to believe firmly that these human beings were explicitly—and unalterably—different. Such convictions called for images distinct from those of theoretical equals—even though in such other orderings, sovereigns outside New York were assigned roles and behaviors complimentary to those at the "center" of the society. In contrast to representations of even the most dubious members of the citizenry, white painters typically gave blacks no separate world. Mount had shown Yankee farmers interacting, Deas and Ranney had depicted the Westerner in all his solitary (and Ranney often his communal) glory, and Bingham had created an energetic and varied community of Western citizens. But most painters depicted blacks only in relation to whites (and, characteristically, only one to a picture). As in representations of members of the body politic, the black figure was typically male. And although painters created differences between Yankee farmers and Westerners in everything from body language to costume to activity, they made no distinctions among blacks. Artisan or agricultural worker, literate free business-owner or illiterate slave, light skinned or dark, African-Americans existed in images as a single type: generally dark, well dressed as a farm worker, and cheerful. Moreover, in *these* pictures, whites' own differentiation in the constituency—farmer, trapper, or boatman—tended to be downplayed. In the presence of blacks, no matter how problematic the circumstances, whites were simply generic yeomen—sovereign, free, and superior.[6]

Within these generalizations, there were subtle changes in artists' representation of blacks during the period before the Civil War. It is difficult, however, always to chart these changes in conjunction with specific political events. In the case of Mount, who focused on the Yankee farmer, it is clear that he created his most compelling and tension-filled images in the mid- to late 1830s when economic, political, and social tensions were at a high pitch and New York patrons and viewers, flushed with urban success tempered by anxiety about the *means* of that success, were eager for a national art. As their attention turned elsewhere, and they began to assess art in terms unflattering to genre painting, Mount and followers like Edmonds faltered. And artists constructed images of Westerners on cue as well: they began as soon as the issue of westward expansion be-

came important in New York, and they were able to maintain their drive so long as Eastern constructions of Western experience maintained openness and complexity. Images of blacks, however, were produced throughout the period. But no antebellum artist specialized in genre scenes of African-Americans. Rather, some artists painted scenes that included blacks. Critics gave no single kind of reception, either. Reviews, when these paintings received any notice at all, were typically oblique. Such silences are additional evidence of the uneasiness with which viewers examined and attempted to order a social world that included African-Americans.[7]

Until the mid-1830s, the role of blacks in American paintings was simple: they were foils for cruel humor. Working from an eighteenth-century tradition in painting in which blacks were often depicted as monkeylike presences in a crowd or, at best, as servants on the margins, artists in the United States made them clowns in the middle of a group, at other times laborers at the edge of social gatherings. American prints mimicked this tradition. Flattering the least checked of audiences' antipathies or sentiments, prints had a considerably broader circulation than paintings. Surely predominant among buyers were citizens intent on the social reassurance of such explicitly denigrating imagery as black men dancing "Jim Crow" and African-American couples prancing through Northern city streets in outrageous finery. When printmakers in Philadelphia and New York began large-scale lithographic production in the 1820s and 1830s, they met the lowest common denominator in whites' assessments of African-Americans.[8]

Larger social worlds were constructed by two early painters who situated blacks within white groups—the German immigrant John Lewis Krimmel, who arrived in Philadelphia about 1808, and Francis Guy, who came from England in 1799 and eventually settled in Brooklyn—but in their works, too, the black figures provide comedy. In Krimmel's *Quilting Frolic*, 1813 (fig. 26), both a young black serving girl and a tattered older male fiddler grin broadly as they provide the means for much of the pleasure of this gathering of a white family, and in election scenes he painted in the teens, African-Americans are prominent exemplars of drunkenness and other disorderly behavior. Francis Guy used blacks to add to the sprightliness of his *Winter Scene in Brooklyn*, about 1816 (fig. 2). Whites were pictured in serious conversation or walking in a purposeful way. In contrast, Guy depicted two blacks as common laborers—one sawing and the other carrying a hod (in fact, they are the only people working in the picture)—and one

Figure 26.

JOHN L. KRIMMEL

Quilting Frolic, 1813. Oil on canvas, 16 7/8 × 22 3/8 in.

Courtesy Henry Francis duPont Winterthur Museum.

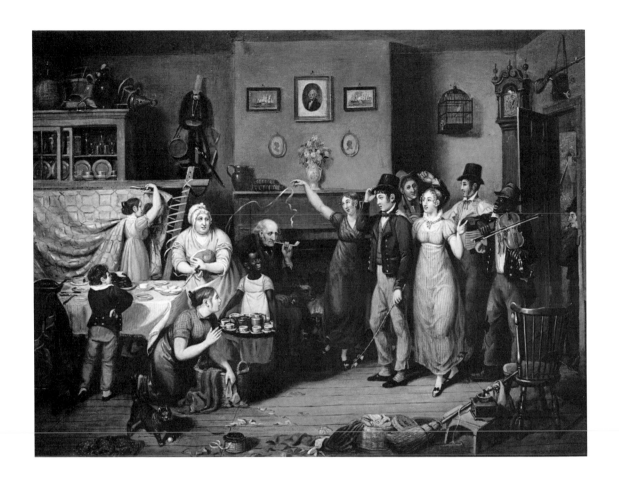

black man who has fallen, apparently on a patch of ice, and is being ridiculed by passing boys. Then Guy made a key for the viewers that identified all the white citizens but left the African-American figures nameless.[9]

Mount, painting to please a skittish and yet highly charged New York audience, became the bellwether in the changing configurations of blacks in American genre paintings. He began his work by treating blacks as peripheral and fundamentally comic.[10] Probing the possibilities of genre with *Rustic Dance after a Sleigh Ride*, 1830 (pl. 2), he took cues for the picture from a lithograph of Krimmel's early watercolor *Dance in a Country Tavern*. His primary interest the festivities of the rural whites, he devised a social space in which blacks are both functionary and almost invisible. The three black males placed in distinctively servile positions at the literal edges of the room do not assume equality in the merriment; instead, they make it possible. They create the music for the

dancing, pump the bellows to keep the air warm, and drive the carriage that has brought the guests. Their role, as Mount represents them, is to serve, and their caricatured grinning faces—like the prints of Jim Crow—suggest the happy, childlike black.[11]

Although painters continued to place African-Americans on the margins of pictures throughout the antebellum period—sometimes as groups of servants (including females) to a white family, at others as individual males within a large gathering of white males—it is generally accurate to say that from the mid-1830s painters represented blacks with considerably more psychological potential than had Krimmel and other artists, and Mount in his early years. Though less negative than their predecessors, most painted images after 1830 were not exactly positive. Rather, their chief mark was ambiguity about the nature of African-Americans and their place in the social world. This uncertainty is revealed in artists' placement of the figures in space, in their delineation of the black figures' emotional reaction to actions undertaken by others, and in the interplay between the dress and gestures of the blacks and the general mood of the scene.

This change in representation began to occur at precisely the moment citizens perceived the place of the black in American society to have reached a profoundly problematic status. After 1833, Southerners committed themselves inextricably to the political and economic consequences of a rigid stance on slavery, and in opposition, a few Northern crusaders moved abolitionism into higher gear. Northern newspapers responded by bombarding citizens with high-pitched publicity about the fizzling of American plans to export and colonize slaves in Africa, about campaigns by abolitionists to emancipate the slaves, and about the riots of Britain's recently freed slaves in the West Indies. Publishers fed the hysteria of white audiences across the country with a spate of images of "amalgamation" that countered images of slave beatings commissioned by abolitionists for propaganda (fig. 27). Depicting interracial couples and their offspring in grotesquely burlesqued situations, these prints equated emancipation with intermarriage and the consequent degradation of Anglo-Saxon characteristics. Tensions in Congress were so high on slavery during the late 1830s and 1840s that Democrats forced a gag rule to prevent all discussion of it. Like Congress, many journals refused to mention African-Americans or slavery, because editors alienated so many readers with whatever stance they took.[12]

Whereas printmakers merely pandered to a white public's worst fears (or, those few who worked for abolitionists, prepared woodcuts of scenes of excruciating torture), most

Figure 27.
EDWARD C. CLAY
"The Fruits of Amalgamation," 1839. Lithograph
published by John Childs, New York. Courtesy
American Antiquarian Society, Worcester,
Massachusetts.

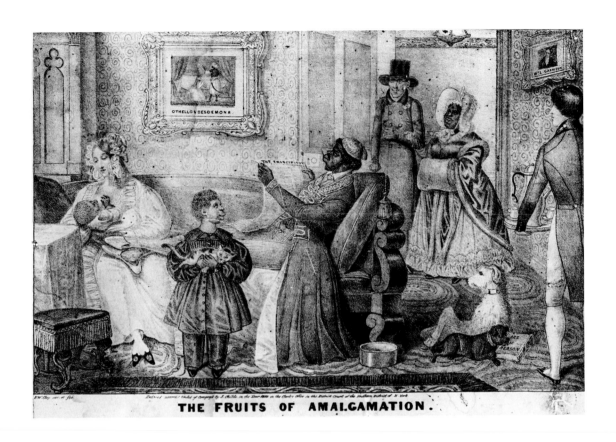

THE FRUITS OF AMALGAMATION.

genre painters who depicted blacks took more complex paths. Veering between hesita-
tion and affirmation, artists seriously examined the African-American as a candidate, if
not for suffrage, then at least for a place in the social constituency that was something
other than explicitly marginal.

Mount's *Farmers Nooning*, 1836 (pl. 4), was the first image to embody this shift. As de-
tailed in chapter 2, Mount's very placement of the black in the painting was for his white
viewers at once ingratiating and tendentious. The black man is behind the foreground
group of white figures—at first glance, reassuringly so—but he is also the focus of the
painting. He is so well dressed, so comfortable, and so winsomely presented as a living
being that both his interiority and his potential behavior are conundrums. The range of
attitudes toward work in the white constituency is a given; that in blacks is an ominous
uncertainty. Just what kind of being is this black man? Reviewers of *Farmers Nooning*
were surprised and delighted. The image made palpable the fictions and joined some of
the symbols with which whites across the body politic pontificated on blacks, slavery, and
the economic and political future of the Union. But Mount went on immediately to 107

other topics—indeed, for a while he turned away from images of the black altogether as though he had already played his best card.

James Clonney, however, an artist who had been trying his hand at first one subject and then another, was galvanized by *Farmers Nooning*. A year after the work was exhibited, he painted his first images that included blacks. Although Mount had moved away from caricature in *Farmers Nooning* and placed the black *in* the group (although not yet "of" it), Clonney moved as close to it as possible in a series of paintings in which blacks occupy not the margins but part of the main stage. Clonney, too, found an audience (whether patrons actually commissioned them, the images found buyers). Viewers seemed to be as willing to entertain Clonney's explicitly negative reading of the impact of the African-American in the constituency as they did Mount's more ambiguous consideration. Or perhaps there were different sets of viewers. Clonney's images incorporated at least two things learned from *Farmers Nooning*—that genre painting could evoke specific polemical issues and that it could originate in colloquialisms. Throughout his career, Clonney created scenes of blacks and whites engaged in a figurative tug of war; almost always, he produced these works after a significant political decision or event. Unlike Mount's richness, however, Clonney painted images that barely rose above political cartoons without words. They were cynical rather than amused.[13]

Clonney's first such picture was *In the Woodshed*, 1838 (fig. 28). As he was to do in images with blacks the rest of his career, Clonney set forth a small cast of characters and a simple action. A standing, gesturing white man and a seated, pipe-smoking black man talk in a woodshed during a break from sawing. They have been throwing the wood on a huge, disorderly pile. Behind the black man is a cider barrel across which Clonney conspicuously signed the work; the barrel would seem to be a general symbol of election entertaining (it being somewhat early for a specifically Whig connection). Without the reference to the vernacular that the viewer draws from the title, however, the painting is puzzling if not meaningless. The title snaps the image into focus: its allusion is to "nigger in the woodshed," or "nigger in the woodpile," colloquialisms that alluded to abolitionism camouflaged in campaign rhetoric. Speakers sympathetic to abolition were accused by their opponents of disguising their designs for emancipation with advocacy of deceptive positions on representation or taxation. Clonney's reaction to this new political phenomenon was to picture both black and white as one-dimensional—the black man is not only prosperous but comic to boot, and the white man (perhaps a parody of the Whigs, associated with abolitionism) is a foolish, gesturing idealist who stands while the black man sits. To a viewer strongly antipathetic to blacks, this picture urged that it was white political machinations that had coddled the black and put the issue of abolition in

Figure 28.

JAMES CLONNEY

In the Woodshed, 1838. Oil on canvas, 17 1/4 × 14 in.
Gift of Mrs. Maxim Karolik for the Karolik Collection
of American Paintings, 1815–1865. Courtesy Museum
of Fine Arts, Boston.

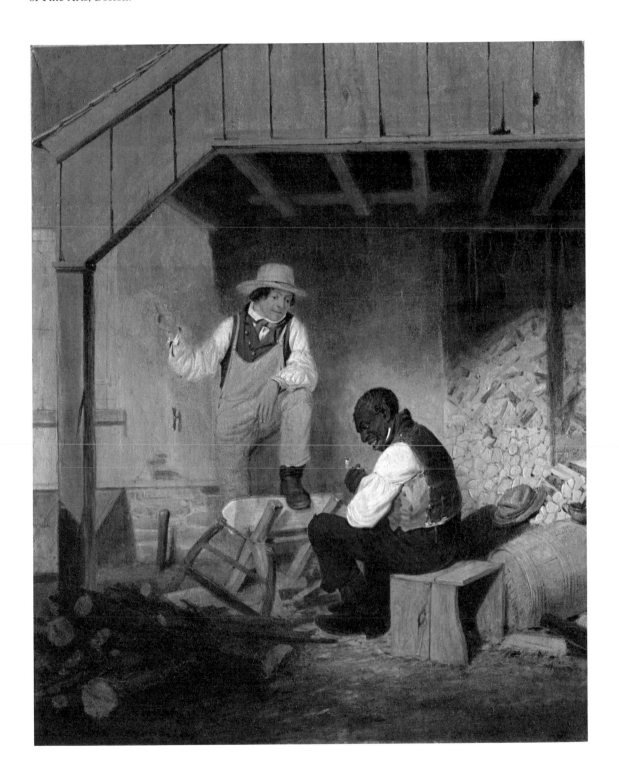

the center of politics. Although the penciled identification of one of the drawings for the painting is "Nigger in the Woodshed," Clonney exhibited the work as simply *In the Woodshed*. The viewers who caught the joke were thus in the same position as Mount's earlier viewers who realized that the farmers in *Farmers Bargaining* were horsetrading.[14]

Events in the next twenty years were to give Clonney grist for many such pictures. Each time a fevered political or economic issue hinged on the character of blacks and the issue of slavery, Clonney was able to use it as the starting point for polemical images. In 1844, for instance, when the annexation of Texas entered public debate, which raised the implications of the potential extension of slavery in the Union, Clonney's *In the Cornfield* (fig. 29) satirized political machinations by depicting a black boy riding a horse hitched to a plow in a field of sprouting corn while in the foreground a kneeling white boy adjusts the plow. Both boys are dressed in blue, one predictably ragged and the other neat; otherwise, the painting is spare in its details. Clonney exhibited it that year at the Art-Union with the giveaway title "Preparing to Plough Corn," a phrase with which speakers characterized election campaigns as "ploughing the corn," with all the rich ambiguities of both *plowing* and *corn*. *Plowing the cornfield* was a metaphor for political hackwork, and *corn*, of course, meant (as it still does) variously foolish or highly suspicious rhetoric. The painting slyly interprets the major political issue of the campaign: the white boy has put the black fellow in the saddle—and on a dark horse—and is now having to supervise the plowing. He is open-mouthed, as though surprised at the drastic consequences of a slavery-dominated politics.[15]

Six years later Clonney took up his political cudgel again. Within about eighteen months of the Compromise of 1850, in fact, Clonney did at least three paintings on the domination of American politics by slavery. While argument raged in Congress, he exhibited *Trappers* (Manoogian Collection) at the American Art-Union. A deceptively benign work, it shows a white boy and a black boy trapping rabbits, with the grinning black boy triumphantly holding up a caught hare and the kneeling white boy resetting the trap. Moving beyond Mount's treatments of the colloquialism—which suggested in *Catching Rabbits* that political rhetoric literally traps runaway voters—Clonney proposed with imagery that the problematic black is the controlling motif of politics. He also exhibited *Which Way Shall We Go?* (now lost) in 1850, which features a black boy sitting on a fence and whittling a stick while a white man behind him holds a gun. Here the terms of power are reversed. Under the guise of an innocent hunting scene, the scenario evokes the contrasting directions in which the legislation—and thus the fate of blacks, especially in their subjection to a fugitive slave law—could go. In his third scenario, *Waking Up*, 1851 (fig. 30), Clonney seems to have implicated the outcome of the compromise. An

Figure 29.
JAMES CLONNEY
In the Cornfield, 1844. Oil on canvas, 14 × 17 in.
Gift of Martha C. Karolik for the Karolik Collection of
American Paintings, 1815–1865. Courtesy Museum of
Fine Arts, Boston.

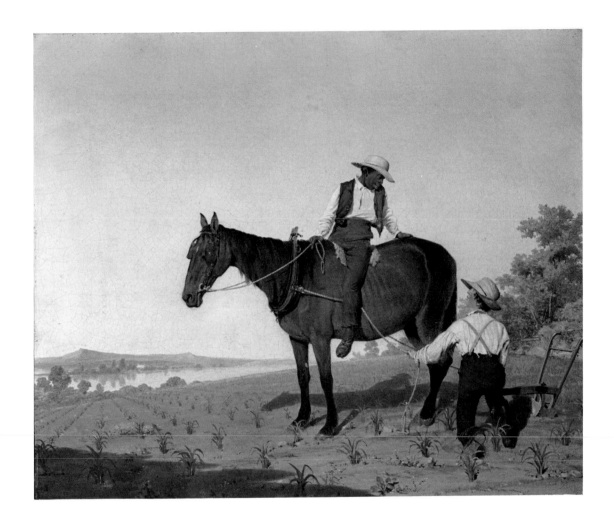

ostensibly cheerful painting dotted by bright touches of red, it subverts several of Mount's motifs in *Farmers Nooning.* Two white boys tickle the nose of a sleeping, middle-aged silly-looking black man, who is resting not from work but from fishing. Prominently by his side are clam shells—metaphors, perhaps, of the gamble of politics. The man is about to "wake up" to the new fugitive slave law and other harsh provisions of the compromise. As one critic noted with his own version of double entendre, the picture was "*hardly* painted, but a very clever picture." After these images, throughout the 1850s Clonney exploited the implications of "fishing," long a metaphor for all kinds of social transactions, with scene after scene pairing black and white males. These paintings, too, seem to be programmatic and may have been constructions of the significance of the Kansas-Nebraska Act in 1854, which after bitter debate opened the Kansas and Ne-

Figure 30.

JAMES CLONNEY

Waking Up, 1851. Oil on canvas, 27 × 22 in. Gift of
Martha C. Karolik for the Karolik Collection of
American Paintings, 1815–1865. Courtesy Museum of
Fine Arts, Boston.

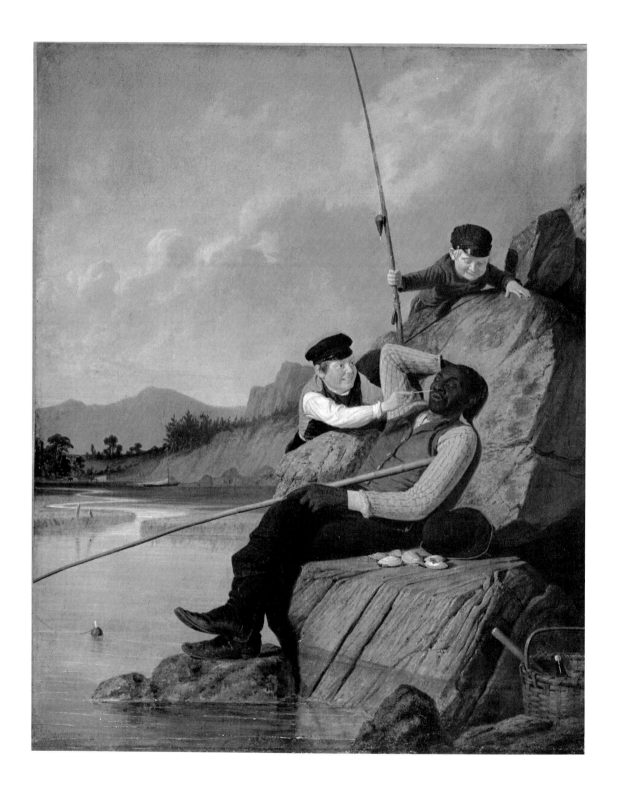

braska territories to slavery. Whatever their allusions in the 1850s, the paintings convey a world in which white males are veritably dogged by black males, who variously assist in, and even dominate, their activity.[16]

Among all the works in which Clonney constructed a body politic unable to escape from or deal with the presence of the black, *The Political Argument*, 1844 (now called *Politicians in a Country Bar;* pl. 11), makes the most readable statement in sheerly formal terms. The two yeomen who are the ostensible protagonists of the picture are found in the interior of a country tavern, one man young and aggressive and the other old but a willing partner. They seem to have begun a heated discussion, and the older man pulls up a chair to sit down and "dig in." In 1844, these characters are most certainly arguing about westward expansion and its relation to slavery. Yet the politicians are not Clonney's only subjects. A black man with a large grin on his face leans against the door facing on the left. Looming much larger to the viewer than the yeomen, he introjects his presence into even the audience's perception of their fellow "sovereigns." Cheerfully listening as though dumb to the implications of the argument, nonsovereign but unfailingly present, he is intractable, fundamental to the very terms of American political discourse. For the cynical white viewer, the black is having the last laugh.[17]

Although Clonney's readings on the issues of race in American society were inevitably reductive and harsh, whereas Mount's were on occasion ostensibly compassionate but always complex, critics frequently identified Clonney as "following in the footsteps of Mr. Mount." What else the two had in common, we do not know. Whether Clonney invented his own images or whether one or several patrons helped him cannot be determined. Although Mount's paintings often dignify a black whom he caricatured in his sketches, the disjunction between some of Clonney's pencil studies of blacks and the black figures in his paintings works precisely the other way, and it is startling. His drawings of his models often convey a full-dimensioned, sympathetic rendering of blacks' individuality. But when he incorporated black figures into his paintings, he deflated them into caricatures. Although critics often made such comments as "[Clonney's] figures are painted so sharp and hard that they look as if cut out from pasteboard and pasted on the canvas; there is no roundness, no 'other side' to them," this harshness was evidently much to viewers' liking. Clonney exhibited many works at the American Art-Union, which into the decade of the 1840s broadly encouraged native artists; even more surprising, he exhibited some of them at the National Academy of Design, which had not been particularly friendly to genre painting. Critics who were uncertain about the relation of Mount's paintings of the 1830s to traditional categories of art did not, apparently, have difficulties accepting Clonney's work. Notable patrons Jonathan Sturges, Robert Gilmor,

and Charles Leupp (who had supported Mount) were not among Clonney's buyers, but his work sold and he was appreciatively reviewed. Perhaps his buyers were the large numbers of ordinary white New Yorkers who provided the strongest resistance to abolition.[18]

Mount's cleverly (but devastatingly) ambiguous *Farmers Nooning* and Clonney's reductive *In the Woodshed* and his many such later images are worlds apart from a painting of American black people by German immigrant Christian Mayr in 1838. This painting is so typically a genre painting in the seventeenth-century tradition of the village dance that one realizes with a shock the particular social configuration within which American painters—insiders rather than outsiders like Mayr—constructed imagery of blacks. For in *Kitchen Ball at White Sulphur Springs*, 1838 (pl. 12), Mayr not only gave African-Americans center stage but presented them in their own social world. Although this world is within the limitations of their servitude, it is exclusively black. Mayr chose as his subject a kitchen ball of the servants (probably slaves, since the location is a Virginia resort) who had accompanied their owners to the resort. He depicted old as well as young, beautiful as well as plain, and light-skinned and dark-skinned in a celebration that may have marked a wedding. Dignified, graceful, and well-mannered, the blacks in the painting contradict every conclusion an audience might have drawn from Mount's *Farmers Nooning;* they are as far as possible from Krimmel's caricature and Clonney's brutal formulations. As an immigrant, having no inbred political investment in racial circumstances of the United States, Mayr perhaps created the subject *because* he was a cultural outsider and thus able to feel sympathy for the oppressed. Whether Mayr was aware of its implications, he recorded an ordering that clearly shows that these blacks make merry in a world they did not create on their own terms. Those who are the most lightly pigmented enjoy the fanciest dress and prominence in the foreground. The dance steps, even the costumes, are modeled after the conventions of the families they serve. And in these respects the painting subtly formulates the very premises of the black social world in American society while it explicitly assures (white) viewers of the probity and middle-class dignity of black people. Mayr, who had worked and exhibited in New York for more than a decade as a portraitist and genre painter, did not exhibit the picture immediately. In fact, he saved it for a New York venue until 1845, by which time a new, ostensibly sympathetic racialism had entered public discourse.[19]

By 1845, Clonney had long since rigidified his position, perhaps because of personal

disposition but certainly also with the approval of his viewers and patrons. Mount, how-ever, had moved on to another informing point of view. After having omitted the Af-rican-American from his repertory of types for about eight years, Mount again took up the figure. The three scenes involving blacks that he painted in the next two years are the richest in psychological implication of all his images. What seems to have affected Mount's new constructions was a humanitarianism that originated across the Atlantic and that in turn informed public discourse about the African-American in the United States.

On the broadest level, Mount's change of direction was part of an international phe-nomenon that gathered steam in England, France, and Germany in the early 1840s. This was a series of interrelated reform movements that had been spurred primarily by the influx of the rural poor into cities, although the new campaigns for morality also involved the renewal of earlier antislavery sentiments. Taken up by middle-class leaders many of whom were women, the messages of reform were characterized by an emphasis on religion, temperance, health, and good work habits as remediations for poverty. The suffering members of the lower classes who had fled the sterile farms of the countrysides for an even bleaker existence in crowded cities began to appear in European imagery in both paintings and prints. Before long, pictures of street urchins, girls selling matches, and beggars in the throes of old age were also exhibited in New York, most of them produced by French, German, and English artists. This picture-making emphasized the humanity that sufferers shared with comfortable middle-class audiences. As abolition agitation in the United States was taken up by secular rather than religious leaders, the tone of much public discussion about blacks sifted perceptibly. Even citizens who were convinced that blacks were inferior (and most white Americans believed this) and those who doubted that slavery would be abolished in their own lifetimes urged in periodicals and newspapers that blacks and whites shared a "universal humanity." Many, as though in an excess of guilt, claimed the black to be in some ways superior to the Anglo-Saxon. New York Unitarian minister Orville Dewey, for example, rejoiced that the African-American nature was a healthy corrective to the "rough, fierce Northern energies to rend and tear to pieces." Others argued that the black was more spiritually developed than the Anglo-Saxon. Alexander Kinmont of Cincinnati, for instance, claimed that blacks had a receptivity to religion that whites regrettably lacked: "All the sweeter graces of the Christian religion appear almost too tropical and tender plants to grow in the Caucasian mind; they require a character of human nature which you can see in the rude lineaments of the Ethiopian." In Boston, James Russell Lowell even more strongly elevated the character of blacks, seeing them as exemplary to whites in their selfless hu-mility: "We have never had any doubt that the African race was intended to introduce a

new element of civilization, and that the Caucasian would be benefited greatly by an infusion of its gentler and less selfish qualities."[20]

Concrete events enhanced the attractiveness of this "romantic racialism" and encouraged otherwise dubious listeners to adopt it, or at least to entertain it though they believed completely different assessments. One of the most spectacular was the takeover of the slave ship *Amistad* in 1839 by African slaves who became minor heroes in Northern newspapers. In the early 1840s, Southern slaves who had escaped to the North gave public testimony of their cruel treatment at the hands of Southern masters. As the issue of the expansion of slavery again made headlines with the possibility of the annexation of Texas and then with the prosecution of the Mexican War, even citizens who favored national expansion expressed distaste at its implications for the fate of individual blacks.[21]

Sympathetic reactions began to appear in sentimental poetry and music. John Greenleaf Whittier campaigned indefatigably for abolition, and among the many sympathetic cultural reactions to fugitive slaves was the pathos-steeped poem by Henry Wadsworth Longfellow, "The Slave in the Dismal Swamp," written in 1842. Songs about blacks, and after 1843 minstrel tunes, presented such poignant themes as "The Grave of the Slave," written by a "Lady of Philadelphia" in 1838, and "The Bereaved Slave Mother," published in Boston in 1844. Although many of these songs had a clearly abolitionist platform, others simply expressed a general sympathy for the sorrows of people of color. Audiences who saw Hiram Powers's sculpture *The Greek Slave* (fig. 31) when it was exhibited in the United States in the 1840s frequently identified it as a critique of American slavery.[22]

These opinions formed part of the complicated patchwork with which white Americans dealt with guilt over slavery while deeming the inferior status of blacks to be perfectly natural. The contradictions, subterfuges, and sense of impending disaster in these convictions slowly moved many Americans toward an insistence that regardless of the nature of the black, slavery was untenable.

This climate freed Mount to do his most profound work. From his rural childhood, Mount had experienced his family's strong affection for the blacks who worked on their farm (all, apparently, former slaves). This was especially true for Anthony Hannibal Clapp, who played the violin right up until his death in 1816, during Mount's childhood, and for whom the entire family felt near-reverence. Yet Mount was a rabid anti-abolitionist. Only when a cultural shift made it possible was he able to admit into his imagery the gentler dimension of his relationship with black people.[23]

In one of the most remarkable paintings of the period—paintings of *any* subject—

Figure 31.

The Greek Slave, 1843. Marble, 65 1/2 in. high.
Collection of the Corcoran Gallery of Art.
Gift of William Wilson Corcoran.

Mount made his only representation of a black woman. It is one of the few genre paintings of a black woman in the entire era. In *Recollections of Early Days—"Fishing along Shore,"* 1845 (now called *Eel Spearing at Setauket;* pl. 13), Mount combined personal experience and the specific requests of a patron into a delicate construction of black-white relationships. The painting was commissioned by George W. Strong, whose Long Island boyhood had been somewhat like Mount's in that slaves or family servants had taught both to fish. The image is large, and golden in tonality; in it a fishing boat occupied by a white boy and a black woman stands out against a landscape of a shallow river and the buildings of the estate on which the patron had spent many happy hours. In the boat, a sturdy mature woman wields a spear off the bow, while the boy steers from the stern; between them sit a terrier and a picnic basket. Mount painted this touching foreground group in great detail, using warm browns, greens, and dashes of red and blue. Reflections in the water lock these details into stillness, the entire vignette being made all the more vivid by the hazy, almost blurred setting. The combination conveys both the heat of a summer day and the clarity with which specific incidents jump out from memory. The boy child is radiant in his concentration on his task, and the black woman, dressed somewhat dowdily, is maternal, reassuring, and capable. Mount exaggerated her profile slightly, as though he found irresistible a touch close to caricature.[24]

The image radiates the comfort of childhood, in which the black woman, an expert in "nature" and thus the "lower spheres" (which had both positive and negative associations), is both guide and nurturer. It suggests the ideal relationship not only of black to white but of female to male. Women of any color, with no political or sexual power whatsoever, no feared capacity for violence, bring the male into being, initiate him in lower-order, natural skills, and provide comfort around the edges of his life. The picture sets forth a childhood memory but also a social dream: black and white coexist comfortably, but only if the white is eternally the young boy, the black the maternal, nurturing, occasionally laughable female. With this configuration of types, the world is peaceful, property is secure, and relationships follow predictable paths.

As potentially satisfying a metaphor as the painting would seem to have been to Mount's audience, however, reviewers had little specific to say about *Eel Spearing* other than that they did not quite like it. Perhaps they expected the kind of joke that Mount had embedded in earlier paintings. Mount himself gave, as usual, no explicit clues to the work's social implications. The usually friendly critic for *Knickerbocker* fell back on criticism of Mount's technical achievement, a tactic with which critics often disguised either puzzlement or disdain: "Full as [*Eel-Spearing*] is of expression and character, it is very indifferently colored, especially the shadowless landscape." The critic *did* appreciate,

however, Mount's subtle demeaning of the black woman: "The amphibious negro-woman in the boat, however, is '*one* of 'em, and *no* mistake.'" The reviewer for *Morris's National Press* was also cautious. Insisting that the painting was a landscape rather than genre scene (perhaps so as not to have to acknowledge the black female figure as other than an accessory), he began: "This picture, the catalogue informs us, is a view of the residence of the Hon. Selah B. Strong, at Setauket, Long Island. The artist has confined himself to a literal embodiment of the scene, so far as the landscape is concerned. The figures give us something of Mount—just enough to tantalize us." He admired Mount's casting of the black woman: "The energy and character of the negress, in the act of hurling the weapon at some unconscious victim under the water, are admirable, as is also the eagerness and suspense in the face of the boy, seated in the stern of the boat." Yet perhaps because Mount's choice of black female reified the black as comfortably domestic rather than, as the representation of a black male would have accomplished, as the unpredictable, threatening other, the critic panned the work as yet one more demonstration that the artist had fallen away from his earlier brilliance. "And now, Mr. Mount, a word in your ear. It is getting whispered about that you are falling off both in your conception and execution . . . we cannot gainsay it for want of proof." [25]

This dubious response to *Eel Spearing* was conspicuously different from reviewers' voluble pleasure on seeing Mount's representations of African-Americans in 1846 and 1847. These two images, *Dance of the Haymakers* (Museums at Stony Brook) and *The Power of Music* (Century Association) focused on the black male, on his association with music, and on his reassuring occupation of a separate social sphere. Whereas earlier interpretations of music emphasized its dionysiac qualities, nineteenth-century theorists tended to celebrate music as a gentle, feminine force that called forth the softer emotions and calmed any "beast." Moreover, because both kinds of emotional experience were considerably beneath rationality, the putative susceptibility of blacks to music—and their talent at making it—was believed virtually to define their emotional, nonrational nature. [26]

The Power of Music (originally called *The Force of Music;* pl. 14), by far the more powerful and challenging of the two pictures, sets forth a small cast of characters on a small canvas. The colors are richly gold and brown, with small areas of green, blue, and red. In the interior of a barn, a fiddler at the left provides the mood; there is no movement in this painting, only quiet listening. He plays to an audience of three: two white males in the barn, a seated older man and a younger listener propped against the barn door just inside it, and on the outside of the barn, a middle-aged black man who leans thoughtfully against the outside of the door, his hat removed. There is gray in his hair; his

physique shows the thickening of middle age. Near him rest a jug and an ax, as though he had just put them down. The mood is altogether reflective and somber.

The social relations here are thought-provoking. The white group is within, the single black outside. The interior group is literally higher than the man on the outside in the foreground, and the younger white man and older black man stand on opposite sides of the door. These four men, in spite of their separate worlds, share their absorption in the music. Yet Mount complicates these simple social relations. The black man may be outside, but he is not otherwise demeaned. He is the most sympathetically treated figure in the painting. His dreaming face turned toward the viewer, he has more interiority than any other figure in all of Mount's paintings. The work is not only Mount's most sympathetic image of the African American, it is the most empathic of all the antebellum images of the black male.

With *The Power of Music*, then, Mount changed the very terms in which the social meanings of black males might be imaged: in *Rustic Dance* blacks were servants (although one was making music, it was of a light-hearted nature), in *Farmers Nooning*, economic and political threats of the gravest portent, and in *The Power of Music* pure emotional beings whose spiritual receptivity was enviable.

In contrast to the near-silence that greeted *Eel Spearing, The Power of Music* generated an outpouring of response. What apparently made the difference was Mount's use in this picture of such reassuring elements as the male, the music, and the separate space. While Clonney was appealing to his viewers in the mid-1840s with formulas about black intractability, Mount gave his the opportunity to demonstrate a proper sympathy for the African-American as individual. The tribute from the *Literary World* conveys the complexity of the painting's appeal; even the length of the commentary is rare in antebellum criticism. First, the reviewer raved at the work's charm, while managing slightly to condescend to it, and identified the painting as related to earlier Mount undertakings: "Out of the most simple and humble materials Mr. Mount has contrived to make one of the most thoroughly original and successful little pictures it has ever been our lot to behold. The subject is one which he has in other ways treated before, but never so successfully as now." Then the reviewer discriminated among the white figures' (the Yankee yeomen's) capacity to appreciate the music, a capacity that was limited because they were rural.[27]

"'The old man,' as the head of a family is styled in the country, is seated with his hands clasped upon one knee . . . greedily swallowing with open lips, but closed teeth, as if he were *straining* the music through them, the melody as it rolls from the fiddle. He is no connoisseur, not he! but he loves music, and swallows it without stopping to analyse its quality. Another figure leans in a listless attitude against the door-post, apparently won-

dering by what process the lad contrives to turn the tune, and manufacture so many modifications of sound with such slender means. He don't enjoy the melody, but wonders at the skill."

Climactically, the reviewer turned to assess the black listener. Having set up the white listeners as lesser others, above these limited sovereigns (but presumably, above only these) he could make the black man soar. "But the triumph of the picture is the negro standing outside the door, out of sight of the main group but certainly not out of hearing. He is an amateur, plays himself, and listens critically, at the same time delightedly. We never saw the faculty of listening so exquisitely portrayed as it is here. Every limb, joint, body, bones, hat, boots, and all, are intent upon the tune. He leans his right shoulder against the barn door, holds his hat respectfully in his hand, and inclines his ear towards the musician; while his eye, looking at nothing, but seeing through the whole affair, melts with delight at the effect of the ravishing sounds."

"This picture," the reviewer concluded—with what was surely welcome praise to Mount after several dry years—"will insure Mount a permanent reputation." The next year, another critic approved the social implications of Mount's picture with self-congratulatory piety: "His humor is of that rich and legitimate quality which cultivates the love of our kind, and awakens an interest in all that has come from our Maker's hand. It inclines us to cast away any contempt which may lurk in our minds for those in manner or in circumstances not exactly to our taste."[28]

So sympathetic a chord did Mount's *Power of Music* seem to promise for an international audience that the French firm of Goupil and Vibert, recently arrived in New York, lithographed the image for their European buyers in 1848. Goupil changed the Mount's title from *The Force of Music* to *The Power of Music*, connecting it with the poem of that name by Wordsworth, an often-cited romantic evocation of the effect of the music played by a blind fiddler on passersby in Oxford Street. The advertisement for the lithograph proclaimed the black's kinship, although on a "rude" level, with the viewer: "Never was the power of music more beautifully portrayed than in this rude audience, no longer vulgar, but transfigured. The music has struck the electric cord, and kindled the latent soul that now shines through every feature."[29]

Whereas Mount's representations of African-American figures—in *Rustic Dance, Farmers Nooning,* and *The Power of Music*—charted delicately changing projections within his own complex cultural group, Richard Caton Woodville, painting from abroad, enjoyed a certain distance from these intricacies. This remoteness he seems to have exploited most dramatically in *War News from Mexico*, 1848 (pl. 1). As discussed briefly in chapter 1, the painting presents a group of white citizens of various ages, types of dress,

and apparent interests on the porch of the symbolic "American Hotel" reacting excitedly to news about the expansionist war against Mexico. Separated from the primary space, and painted with greater detail and emphasis than the other figures, a black man and black girl occupy the foreground. Given a psychological interiority denied the other figures, this humble and ragged pair share a destiny. As father and daughter they suggest a family orientation that other artists had not touched. Moreover, they are not contiguous to the white group's space in the comic or annoying way that Clonney had depicted in *The Political Argument*. Rather, heart-breakingly attentive to the topic under discussion, the figures call the viewer's attention to the poignant vulnerability of blacks to the outcome of the war—the expansion of slavery westward. With his very placement and depth of detail—procedures Mount had relied on in *The Power of Music*—Woodville insisted that the viewer take notice of slavery's personal costs. Like Mount, Woodville may have been influenced by the strong cross-Atlantic reform movements. And, although he had grown up in Baltimore, in the slave-holding state of Maryland, his point of view was perhaps so modified by his residence in Europe that he, like Mayr, brought to the image the perspective of an outsider. So moving was the emotional richness of the male figure in *War News from Mexico* that at least one critic compared the black man to Mount's black listener in *The Power of Music*, suggesting not only the kinship of the images but their distinctiveness from all others.[30]

Softened as were these images, either commissioned by prominent New Yorkers or successful on the market, a reaction against blacks asserted itself strongly after about 1850, and affected even Mount and Woodville. The measures of the long-debated Compromise of 1850 effectively signaled a political impasse. In the aftermath, earlier sympathies were modified and new ones created. Harriet Beecher Stowe's *Uncle Tom's Cabin*, of 1851–1852, inspired by the author's indignation at the consequences of the Fugitive Slave Law in the compromise legislation, in turn had a stunning emotional impact on hundreds of thousands of readers. With deeply human black characters who suffered heart-rending indignities and losses, Stowe's novel sold 300,000 copies in its first year and persuaded thousands of readers not only that slavery was intolerable but that all American citizens, not just Southern slaveholders, were tarred by it.[31]

Yet slaveholders and others, rigidified by the compromise, argued that blacks were definitely not ready for emancipation and continually raised the specter of slave revolt.

They, too, had their ready listeners. Those who wanted to prove the inadequacy of blacks for freedom pointed to the ongoing political chaos in Haiti. George Fitzhugh, for instance, wrote in 1852 that "the fruits of freedom in that island, since its independence, in 1804, are *revolutions, massacres, misrule, insecurity, irreligion, ignorance, immorality, indolence, and neglect of agriculture.*" In the middle of the decade Herman Melville probed the horrors of slave revolt, as well as the twisted machinations of slave-master relationships, in his story "Benito Cerino." Sensitivity to the slightest mention of slavery as part of the American political fabric was so intense that sculptor Hiram Powers found it politically impossible to include a liberty cap in his projected sculpture "Liberty," which he proposed for the United States Capitol; the association of the cap with abolitionism made it too provocative. Instead, Powers's competitor Thomas Crawford, also angling for government patronage, won the commission because he proposed conspicuously to exclude both the liberty cap and a broken chain on his *Armed Freedom.*[32]

From about 1850 on, genre painters who painted American blacks—Woodville, Clonney, Edmonds, *and* Mount, as well as others—registered only the negative formulation of the issue: complicity with the compromise. They may have reacted this way out of real political conviction or a desire to avoid controversy; perhaps both. Mount, engaged in commissions from William Schaus, print agent for the European print firm Goupil and Vibert, for half-lengths of "Ethiopian" black musicians, or minstrels, reported being warned by friends to stay away from blacks as subjects. Woodville, who had earlier presented the compassionate *War News from Mexico*, depicted blacks as foolish-looking family servants in his *Sailor's Wedding*, 1852 (fig. 32), and Edmonds painted the condemnatory *All Talk and No Work*, 1855–56 (Brooklyn Museum), in which a white farmer skeptically assesses a black man who holds forth nothing but an empty basket and seems to plead to excuse his lack of productivity with an outstretched finger. In 1861, Edwin White exhibited *Thoughts of Liberia: Emancipation* (fig. 33) at the National Academy of Design, a painting that would seem to honor the humility of the old black man sitting in a ramshackle empty room. Yet, benign as the title might be (implying a sympathy for the oppressed black hoping to emigrate to an all-black nation), the painting features a conspicuous poster labeled "Hayti" across the back wall of the room, connecting his urge for freedom with the political chaos of Haiti, where blacks had not been able to "manage" their freedom.[33]

And in Mount's career, few images convey such a capacity for an artist's equivocation in the presentation of blacks as his *Lucky Throw* of 1850 (fig. 34). In comparison with his *Power of Music* of only three years earlier, the painting is a stunning deflation. The image, which survives only as a lithograph (called in that incarnation *Raffling for a Goose*), is

a portrait of a smiling black boy who wears a bright red tam-o'-shanter and holds in his hands a plucked goose. Although Mount wrote Schaus that the goose was one of several "silly" objects he could depict the negro holding, he did not make an innocent choice. The tam-o'-shanter, of course, had long been associated with abolitionism. By the 1850s "goose" was part of the vernacular expression "sound on the goose," which had come out of the debate on whether slavery in new states and territories should be determined by Congress or by popular sovereignty in the affected areas. To be "sound on the goose" was to be on the correct side of the issue—that is, to be against (the silly notion of) abolition and to favor popular sovereignty. The implications of Mount's image are thus chilling. The black has won "the lucky throw," ironically, the "throw" of the Compromise of 1850.[34]

124 Although viewers could have chosen to remain oblivious to Mount's allusions, critics

seem to have been delighted at the rawness of the image. One inscrutably compared the
work to Lessing's *Martyrdom of Huss,* then enjoying a wild popularity on Broadway, and
found Mount's painting infinitely superior. The critic for the Northern-oriented *Harper's
Monthly Magazine* was pleased to be able to sound sympathetic as well as knowing about
the black figure: "W. S. Mount, the only artist among us who can delineate God's image
carved in ebony; or mahogany, has just finished a picture in his happiest style. It repre-
sents a genuine sable Long Islander, whom a 'lucky throw' of the coppers has made the
owner of a fat goose." Another critic wanted to clarify the difference between the beauty
of Mount's exotic musicians and the homeliness of this American black. "The subject
is the Lucky Throw of the raffler, a genuine Long Island negro, painted *from* and *to* the
life . . . Unlike the African Adonis in [Mount's] 'Right and Left,' the subject of the

Figure 34.
JEAN-BAPTISTE ADOLPHE LAFOSSE
after William Sidney Mount
The Lucky Throw, or Raffling for a Goose, 1851. Colored
lithograph. The Museums at Stony Brook, Stony
Brook, New York. Gift of Mr. Richard M. Gipson,
1951.

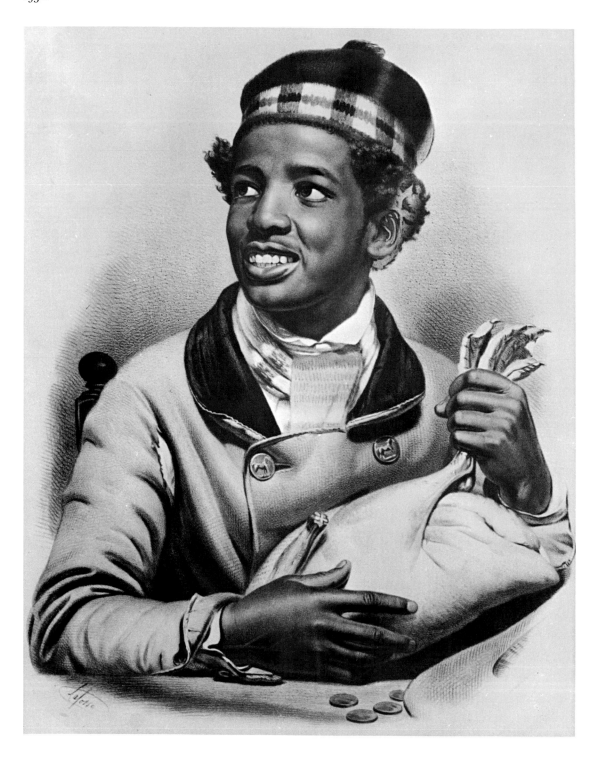

126

present design has a handsome, but still a decidedly characteristic face." A reviewer for the *Sunday Courier* seems to have been pleased to bring Mount's idealization down to earth: *Raffling for a Goose* "represents the head and shoulders of a young negro man, supposed to be a 'Long Island nigger.' . . . [A] grinning darky . . . dressed in coarse clothes . . . is not one of those objects that a person of nice taste would care to have hung up before him."[35]

So unalloyedly reductive was Mount's image that an entrepreneur bought the work for a Southern raffle distribution, and a critic from Mobile, Alabama, prodded his viewers' conviction of their superior caste system with: "[Our friend Strickland] has doubtless paid for the boy," he wrote merrily, "for, be it known, a nigger of his value can only be bought, even in New York." In 1851, Mount's admirer W. Alfred Jones, reading *The Lucky Throw* as a presentation of the Southern viewpoint, urged Mount to find patronage among planters of the South for depiction of blacks on plantations: "One field still remains open to [Mount] which he could worthily occupy—the Southern negro, plantation life, corn shuckings, &c. He would find openhanded patrons among the cultivated and opulent planters."[36]

Eastman Johnson found such a strategy unnecessary and indeed unflattering to the viewpoint of either the Southerner or the antiabolitionist Northerner. The one artist during the 1850s who combined ostensible humanitarianism with telling stereotyping in his images of blacks, Eastman Johnson was some two decades younger than Mount. His large picture *Negro Life at the South* (pl. 15) is a provocative work that both concludes the antebellum tradition and serves as a fulcrum for work after the Civil War. Raised in Maine, Johnson had studied in the major European centers of Düsseldorf, The Hague, and Paris from 1849 to 1855. Absorbing there the interests in imagery that suggested sympathy with the underclasses, he produced as his first paintings scenes of beggar children. Soon after he returned to the United States he followed through with two works that focused on characters in *Uncle Tom's Cabin*.[37]

Negro Life at the South, which he painted in 1859, was the first genre picture of blacks (other than Mayr's) to represent a specifically Southern setting. It was also one of the few pictures that focused on a black domestic group. Johnson's painting amasses virtually all the arguments about blacks in American society that were in place in 1830 but that in 1859—with the Dred Scot decision and John Brown's insurrection at Harper's Ferry the latest consequences of the breaking of the Missouri Compromise by the Kansas-Nebraska Act in 1854—were portentous indeed.

In *Negro Life at the South,* Johnson's characters seem to be in their own social world, the backyard of their home. A large extended family group of two young adults, two older women, a fatherly figure, and several children, they are relaxing. Johnson's depiction of blacks as domestic, as parents and as lovers, is unusual. As a quick assessment of blacks' life in the South, it would seem to derive directly from plantation novel motifs popular since the 1820s: blacks are at home, not in the fields; they live as families; they court, make music, play with their children. The black men do not work. All are happy.

While seeming to exculpate Southerners from horrid treatment of their slaves, however, the image also indicts blacks for all the faults that whites had been ascribing to them for decades. Johnson scattered his blacks across a space that impresses the viewer with its barrenness, clutter, and lack of function. This backyard is a mess. Across the middle of the picture, a back roof is collapsing, the back wall and window structures are deteriorating, and under the roof, near the precise center of the picture, an empty hearth conveys the emptiness of the moment. Several groups of blacks pass the time idly: a young mulatto couple on the left casually courts, near the fireplace a musing man plays the banjo for a young boy nearby, and in the right foreground—the most energetic exchange in the picture—a brightly clothed woman sits on a quilt or carpet on the ground playing with a child in her lap. Other figures are placed across the picture, including a woman and baby leaning out of the broken second-story window. On the ground lie an ax, cornhusks, a child's toy, and a pot. These are the obvious elements of the picture. The world of the black is one of decay, disorder, and moment-by-moment activity. Left to themselves, blacks pass the time rather than use the time. In its coloring and handling, the picture persuasively communicates the South. The tone is soft, the coloring a vaguely greenish gray, suggesting a moist, warm climate; the picture has highlights of red and blue clothing, hinting at the exoticism of the blacks.

All superficial hints to the contrary, just how close this image is to stereotypes by which white citizens justified slavery is clear in comparing Johnson's black figures to the images in caricatures. The broadside "Slavery as It Exists in America; Slavery as It Exists in England" (fig. 35), published by J. Haven in Boston in 1850, contrasts happy blacks and miserable English factory operatives. An American black man is playing a banjo, children are enjoying themselves (one is playing with a dog), and two black couples are dancing. Advocating the paternalism of American slavery over the cruelty of English wage slavery, the caricature sets forth some of the stock characterizations on which Johnson drew for his painting: the black man as banjoist, the black couple as courting, the children as happy. In the background are four white slave owners.[38]

In Johnson's scenario, however, there is only one—and that by implication. At the ex-

Figure 35.
"Slavery as It Exists in America; Slavery as It Exists in England," 1850.
Lithograph published by J. Haven, Boston. Courtesy Library of Congress.

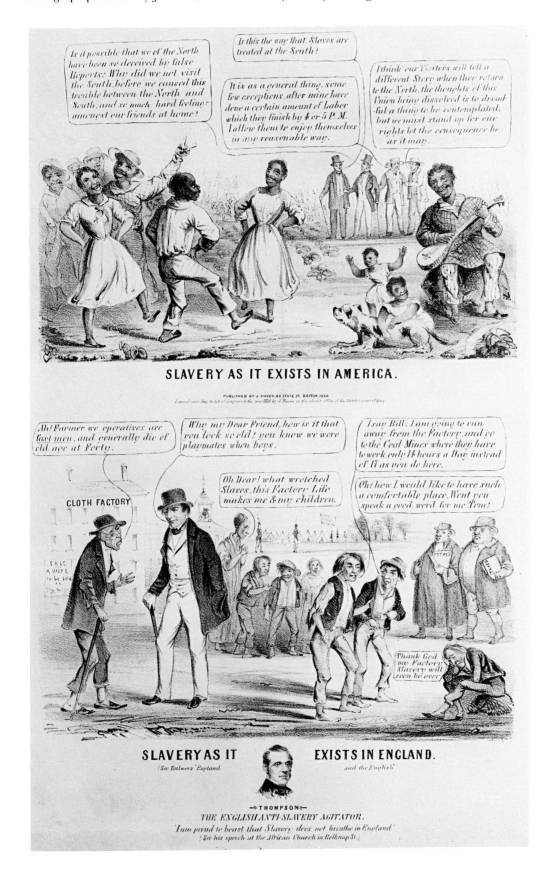

treme right of the composition is a large white stone structure, in perfect condition; in the lower righthand corner, a beautifully clad white woman, perhaps the wife of the slave owner, enters the backyard. These black people are under the aegis of the white group next door: their social world devolves on, and needs the care and supervision of, the white group. Johnson's picture presents a metaphor of the relation of the two communities: the black community can function only through the arrangements of the white. Although viewers could have seen Johnson's picture as critical of this oppression—as representing "Negro life at the South" as dispirited because of the demoralizing effect of slavery—they apparently did not pick up on—or express—this possibility until after the Civil War.[39]

Negro Life at the South validated New York viewers' negative assessment of the black while flattering their goodwill toward fellow human beings. One critic identified the function of the work with typing in calling it a "first-class character piece." The response of another critic, in the *Crayon*, reveals the complex array of human condemnation and sympathy that the painting made possible, as well as the stereotypes of which it had been composed:

> [*Negro Life at the South*] is one of the best pictures in respect to Art and the most popular, because presenting familiar aspects of life. . . . Here are several groups of negroes. . . . The melancholy banjo player arrests our attention first. . . . Immediately in front we see a knotty-limbed wench and one or two dancing "pickaninnies," . . . near the player, a boy [is] completely lost in wonder as he gazes at the musician . . . off to the right are noisy children . . . perhaps they hear the approach of "white folks" as two ladies step out from a garden door on the extreme right to enjoy "Poor Lucy Neal" [a song, presumably being sung by the man with banjo] . . . a mulatto-woman [is] in the adjoining window [of the second story] and her child . . . [is] perfectly alive with infantile glee. . . . The only group that appears not to be directly under the influence of the external music, but no doubt alive to a better music within, is that of a graceful mulatto-girl on the left, who is listening to the blandishments of a colored gallant. . . . The accessories are in harmony with the subject. A peculiar curly-haired dog in the foreground shows his ownership unmistakably.[40]

The reviewer then expressed the complex sense of assurance the image gave him. "Notwithstanding the general ugliness of the forms and objects, we recognize that its sentiment is one of beauty, for imitation and expression are vitalized by conveying to our mind the enjoyment of human beings in new and vivid aspects. . . . [It] is of a kind of Art

that will be always popular, so long as lowly life exists to excite and to reveal the play of human sympathy." The critic stated unequivocally, however, that Johnson had created not art but something picturesque: "But 'Negro Life at the South' is not 'high Art,' for the reason that the most beautiful thoughts and emotions capable of Art representation, are not embodied in the most beautiful forms, and in the noblest combinations."[41]

As revealed by these images of blacks across the antebellum period, white artists who assigned a place to African-Americans in the American social world conspicuously made that place one of relationship. Autonomy, and thus authority and power, was reserved for white figures. Moreover, white painters avoided any reference to activities that actually defined the place of blacks. There were no scenes of labor, a scant few (after the early images of Krimmel) of blacks in white homes as servants, and virtually none of black females (which may account for the startling depths in Mount's eel-spearing matriarch, the women in Mayr's ballroom scene, and Johnson's *Negro Life at the South,* all exceptions). With the exception of Woodville, white artists did not depict black males as heads of, or even as members of, families; they did not show blacks in what Emerson called an "original relation to the universe"—that is, in a world, even circumscribed, the terms of which they defined themselves (as, for instance, did Deas's *Long Jakes* and Bingham's boatmen), and, most pointedly, they did not show blacks as chattel.

In other words, painters denied blacks all the attributes that they gave to sovereigns and most of the attributes that artists in other times and places gave to the lower orders. To show a member of the lower orders working, as had Brueghel in the sixteenth century and the French peasant painters in the late eighteenth and early nineteenth centuries, was to claim for them a near-heroic status; whereas that African-Americans were constitutionally lazy and dependent was an article of faith with which owners and others clarified its social necessity. Second, painters of peasant life in Europe often depicted peasant families to arouse sympathy for the laborer, whose softer emotions were called into play by family responsibilities. Although American genre painters typically focused on males rather than families, their objectives in depicting the black male were distinct. Whereas white males carried a variety of weaknesses that threatened the stability of the body politic—and painters variously exploited and perceptibly ameliorated these weaknesses—African-American males had to be perceived as powerless and foolish for current social and political arrangements to prevail.

The practice that most fundamentally defined the relations between blacks and whites was not social marginalization (which implies a continuous hierarchy) but the slave auction. As far as can be determined, however, no American artist painted a slave auction until after the Civil War. Although Northerners commissioned images of Southern mistreatment of blacks, the auction, in which they participated vicariously as members of the economic network that sustained slavery, seems to have been absolutely off limits. Actually, this constraint was by no means a departure from practices established earlier across the Atlantic. European painters and printmakers created images of blacks in blatantly painful situations only when the circumstances of this brutalization were clearly elsewhere—that is, in colonies remote from Europe. Encouraged by abolitionist sentiments, European painters and printmakers created images of whippings and horrible torture in such colonies as the West Indies and Brazil. When European visitors painted scenes of American slave auctions, they did them for exhibit back in their home countries, sometimes as part of their ongoing examination of the inconsistencies of American democracy, at others to demonstrate support for the abolition of slavery in the French colonies, and at yet others as a part of general reforming trends that demonstrated sympathy with the oppressed.[42] The two most prominent of European-painted images of American slave auctions reveal by sharp contrast the limits in depicting blacks that American painters placed on themselves.

Slave Auction in Richmond, Virginia (pl. 16) was painted by Englishman Eyre Crowe from sketches he made in 1850 while accompanying William Thackeray on his tour of America. The painting presents six adult slaves, five of them women, in an auction room. Two of the women are mothers, one holding an infant and another a child of three or four, and each is individualized in her dress, jewelry, psychology, and even age; their emotions range from complete devotion to a child to pensiveness to apprehension. On the right, Crowe placed a male figure who is also unusual in the context of American treatments of blacks: he is virile, sturdy, and discontent. Seated slightly apart from the women but facing them, the man is helpless to control their destiny as well as his. In a turning of the tables that does not occur in paintings by Americans (except Johnson), the whites in this picture are in the background and margin. They are the imperious auctioneer and the three buyers who enter the door on the left, painted with quick, thin strokes and not psychologically individualized. (Their clothing, however, suggests three distinct social groups in the South that have an interest in the proceedings—the aristocratic planter, the smooth urban businessman, and the rough plantation overseer.) In this picture, unlike all other pictures of the American social universe, the others are the

Figure 36.
Unidentified artist
Slave Market, ca. 1850–1860. Oil on canvas,
29 3/4 × 39 1/2 in. The Carnegie Museum of Art,
Pittsburgh. Gift of Mrs. W. Fitch Ingersoll, 1958.

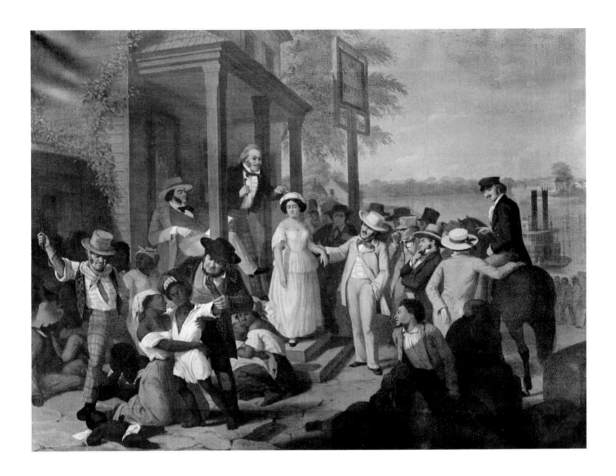

manipulating whites. They have one characteristic—an apparent coldness to the humans they are about to make the object of commerce.[43]

The other image of a slave auction, *Slave Market* (fig. 36), painted in the 1850s by an unidentified artist believed to be European, takes a higher-pitched approach. Representing an auction that takes place on the steps of the "Planter's Hotel" near a broad river with natural and architectural elements carefully chosen to represent the Deep South, the picture includes black figures of different racial composition and white males of distinct dress, bearing, and social class. At the center, a man in a conspicuously white suit examines a light-skinned young African-American woman dressed in pink. Alone and vulnerable, she turns aside in distaste, and perhaps modesty (like the *Greek Slave* of Powers). Other males nearby peer at her through eyepieces. On the porch of the hotel, the nattily attired auctioneer chants his patter and the merchant supervising the proceedings leans back in a large chair. A dandily attired young man on horseback stops to

chat with some of the buyers as though this is the most common of everyday occurrences. Across the foreground of the painting, blacks sit or lie in dispirited groups. A mulatto male has thrown himself down in the right foreground and looks longingly—the viewer might infer hopelessly—at the woman being auctioned. Along the near edge of the porch and the back wall on the left are other blacks, all dark and all women and children. The darkest skinned, however, are the woman and child being separated in the left foreground. A white overseer, marked by his gaudy dress as lower-class and by his deportment as relentless, cracks a whip over the woman to force her to give up her child. The painting indicts the iniquities of slavery as though an abolitionist were reeling them off: The white male population, all classes and all ages, perpetuates slavery. They use female slaves to satisfy their lust (and in so doing beget children who are born into the system). They separate families. In fact, the entire South—its plantation system, its affluence, its economy—rests on this unthinkable exploitation. The colors of this painting are vivid and cold, the facial and body expressions absolutely readable.[44]

Although Crowe's image is quieter in its effect, both paintings act on the viewer in ways distinct from American images of blacks. They do not assert blacks' lack of intelligence, beauty, or capabilities; neither do they depict blacks as bothersome political intransigences or childlike beings. The artists claim not that the black might be violent or the economy collapse or political balance break down. Rather, they criticize the white dominant group and implicate this group—notably, the group is composed only of white males—in a system in which human beings, regardless of their beauty, intelligence, or capabilities, are made chattel.[45]

The tide turned after the war. Johnson's *Negro Life at the South*, so unlike the slave auction scenes by the Europeans in its confirmation of the qualities that whites assigned to African-Americans to justify slavery, was sold at auction in 1867. The presale exhibition gave critics the opportunity to comment on the work in a newly charged milieu. The auction catalog described it as "a faithful and charming picture of domestic life in the 'South,' one which will be feelingly recognized by many, and yearly increase in historic value as time speeds us onward from the 'days gone by.'" Henry Tuckerman, the writer, poet, and historian, who was then completing his updated edition of *American Artist Life*, was even more explicit. He began his detailed description of Johnson's mature career with, "No one of our painters has more truly caught

and perfectly delineated the American rustic and negro, or with such pathetic and natural emphasis put upon canvas bits of household or childish life, or given such bright and real glimpses of primitive human nature."[46]

Tuckerman gave special emphasis to *Negro Life at the South*. By this time the painting had acquired a new title, *The Old Kentucky Home*, given to it perhaps by an owner who was both fond of the newly popular song by Stephen Foster and pleased with the romantic bygone days motif the title gave the image. This second title pushed the institution of slavery away from the Eastern seaboard, indeed, the nation's capitol, where legislators from New England as well as the South had so long countenanced it, and into the backwoods, where other citizens could be represented as having been its perpetrators. Moreover, if the viewer reads the title as meaning that the banjoist is singing the song, it even further relieves former slave holders from their burdens, for the song reminisces about the wonderful days of the past. Significantly, Tuckerman did not show his own hand in discussing the painting's implications for the recent American past but quoted an unknown critic:

> Here we see the "good old times" before the "peculiar institution" was overturned—times that will never again return. The very details of the subject are prophetical. How fitly do the dilapidated and decaying negro quarters typify the approaching destruction of the "system" that they serve to illustrate! And, in the picture before us, we have an illustration also of the "rose-water" side of the institution. Here all is fun and freedom. We behold the very reality that the enthusiastic devotees of slavery have so often painted with high-sounding words. And yet this dilapidation, unheeded and unchecked, tells us that the end is near.
>
> The prophecy has been fulfilled. No more does the tuneful banjo resound in that deserted yard; no more do babies dance or lovers woo; no more does the mistress enjoy the sport of the slave, but scowls through the darkened blind at the tramping "boys in blue." The banjo is silent; its master sleeps in the trench at Petersburg. The lover has borne the "banner of the free" through hard-fought battles, and now is master of the soil.[47]

After the war, when the black was at last master of the soil—the phrase always reserved for the yeoman—the painting stood, or could be made to stand, as a powerful voice for abolition.[48]

Mount, having commented defensively in his journal in the mid-1850s when he was criticized for painting black musicians that "a Negro is as good as a white man as long as he behaves himself," did not return to the black until his last years, right after the war.

His Democratic sympathies as stolid as ever, he painted an image of a black man asleep, a rooster trying fruitlessly to awaken him. As Mount explained the image to uncomprehending viewers, he meant it to signify that the black as a political issue was dead. "The fact is, the painting represents the Negro Politically Dead. Radical Crowing will not awake him. It is the Radical Republican—Rooster—trying to make more capital out of the Negro, but is about used up for their purpose; *which is glorious news for the whole country. The African needs rest.*"[49]

Like Tuckerman and Johnson's post–Civil War viewers, the art world was happy to claim that the social crisis had been laid to rest.

Five Full of Home Love and Simplicity

In turning an examination of American genre painting to representations of women, we find patterns that are both predictable and surprising. The genre painters discussed thus far were male, participating as citizens with the relative freedom of discussion and self-definition that white males enjoyed. These painters devoted their imagery to issues and nuances that embodied the sphere of public life as they and New York patrons, viewers, and critics perceived it. Although discussion about women's proper contributions to this public life was an important motif in certain forums—in publications aimed at women, for instance, in platforms for women's rights, and no doubt in conversations of many kinds—the major issue in the public life of those who comprised the "responsible" classes was the potential power and malleability of the men in the nation's constituency. And for this reason, genre painting in antebellum America—as far as women were concerned—differed strikingly from its predecessors and contemporary counterparts.[1]

Several generalizations about these paintings come immediately to mind. First, women are usually absent, whether the images represent the Yankee citizenry or the Western constituency. In *Bargaining for a Horse, Farmers Nooning, Raffling for the Goose, The Painter's Triumph*, and *Catching Rabbits* (pls. 3, 4; figs. 8, 9, 12), Mount critiqued the opportunities and shortcomings of the sovereign yeoman. Bingham devoted his energy from 1845 into the early 1850s largely to constructing reassuring or at least healthily ambiguous images of males of the West, whether they were rivermen, as in *The Jolly Flatboatmen* (pl. 9), or the citizenry gathered to take part in the political process, as in *County Election* (pl. 10).[2]

A second retrospective generalization is that in the few genre paintings of the citizenship after 1830 in which female figures do appear—that is, in paintings created by male artists to ring the changes on the conundrum of male sovereignty—the women take a place that is not only subsidiary to but different in its very grounding from that of men. As though to trigger in the viewer immediate assent to this differentiation—both to acknowledge and to define the boundaries of the female presence—artists typically depicted women one to an image, as they did African-Americans. Mount, for instance, included a single vague female figure in the very back of *Bargaining for a Horse* (pl. 3). There, she is conspicuously restricted to her own sphere: behind the fence that separates farmyard from homestead, she is neither a part of economic or political activity nor a

consultant to it. In Bingham's *Squatters* (fig. 24) the single woman in the group performs distinctly menial work. Indeed, bent over the tub, washing clothes in the dark middle-ground of the image, she carries out the only labor in the scene; in contrast, the men look into the physical and psychological distance, contemplating their freedom and future. In yet another formulation of the differences between male and female Edmonds divided the homely cabin interior in his painting *The Image Peddler* (fig. 13) into two spheres: the women of the family are associated with housekeeping, food preparation, and child care, while the men are linked with hunting, reading, and assuring the political continuity of the Republic.[3]

Several images present explicitly critical assessments of women. These readings were aimed not at women who were properly domestic but at females who had stepped out of their place. In *Cider Making* (pl. 5), Mount's ostensibly innocent depiction of the young woman in the foreground—waiting her turn to sip cider from the barrel—is a sign for the abolitionist and woman's rights advocate Fanny Wright, who had inserted herself into a political context where she had no rights and would have to "wait her turn." Richard Caton Woodville's wry reading of the female in *War News from Mexico* (pl. 1) not only excluded her from the gathering of sovereigns but relegated her to an explicitly inside space, from which, like Mount's woman in *Farmers Bargaining*, she is able only to look on. Even Bingham, who was forgiving in his assessments of the male body politic, was unequivocal in his situating of women. Creating *The Verdict of the People* (fig. 37) at the very time that the extension of slavery in the Kansas-Nebraska Territory was being debated and when women had made prominent public stands against slaveholding there, Bingham encouraged viewers to see women as amusing by identifying their drives for political reform as impractical idealism. His few colorfully dressed women stand on a hotel balcony—at the edge of the painting—beside a banner that announces not "Freedom for Kansas," the usual rallying cry of abolitionists, but "Freedom for Virtue."[4]

So limited a repertoire of images about women would seem to have been at odds not only with the genre tradition but with the ideals for American painting expressed by critics. Reviewers who praised Mount, Edmonds, and Bingham cited as models for American genre painting the works of David Teniers the Younger and Gerard Terborch, Hogarth and Wilkie. In many of these revered images, women of varied social classes, physical types, and ages appeared prominently. One thinks of the tranquil and pious mothers, servants, and grandmothers, the very embodiment of domestic order and happiness, or the delicately sexual images of beautifully dressed young women opening love letters, making music, or entertaining male guests, in seventeenth-century Dutch and Flemish painting. Other potential models for American artists were paintings produced

Figure 37.
GEORGE CALEB BINGHAM
The Verdict of the People, 1853–1854. Oil on canvas,
46 × 65 in. From the art collection of the Boatmen's
National Bank of St. Louis.

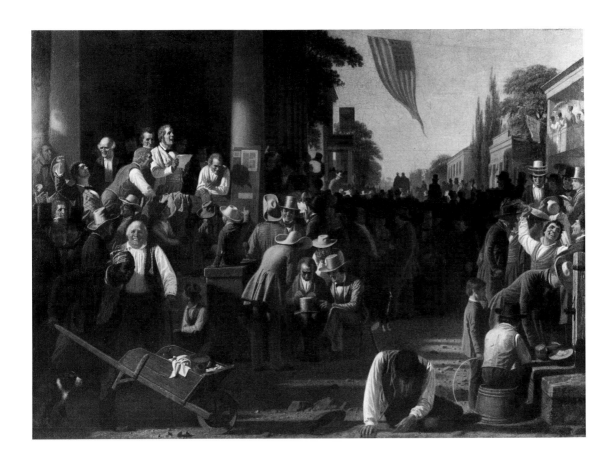

in mid-eighteenth-century France, when such artists as Greuze and Fragonard, working in a society in which gender roles were subtly changing, promoted new ideals of family life with pointed depictions of mothers and grandmothers being adored by their husbands and children. Even closer in time were the warm scenes of English country people produced by such artists as George Morland, Francis Wheatley, William Mulready, and David Wilkie, which, like the French images, were widely reproduced in prints. And as contemporary models, when urbanization and its ominous implications for social order were being keenly felt in Europe, the Biedermeier painters in Germany specialized in images of home comforts presided over by gentle women, and artists in London swamped exhibitions with images of women instructing their children, welcoming their husbands home from work, reading, and guiding the family in such wholesome activities as prayers, meals, and picnics.[5]

Such was not the case in the United States from 1830 until the outbreak of the Civil War. In fact, only *before* 1830 did women play roles in the few genre images produced

that were somewhat consistent with both the tradition and its contemporary exploration across the Atlantic. Such painters as John Lewis Krimmel, Francis Guy, and Alvan Fisher constructed community scenes in which women of various ages, disposition, and degrees of stylishness appeared fairly liberally, taking their closely defined place along with men in the human comedy of custom and vanity. By 1830, however, after the elite's hopes for a deferential, responsible social order had been dashed by the rise of new men in determined pursuit of their own interests, artists whom critics and audiences considered to be the most important genre painters and who began their career in the new climate of anxiety rarely included women in their repertoire. The one significant exception to this generalization was the work of Lilly Martin Spencer late in the period. Spencer, however, as we shall see, devised her images within specific restraints.[6]

Genre painters' devotion to defining the new sovereigns was not constructed in a vacuum of discourse about women. From early in the 1830s, a few bold American women of the white majority contested their place in the democracy. As they challenged women's lack of legal, economic, and political rights, their protests provoked many men into justifying the status quo. Some men drew heavily on the stock of female archetypes and misogynist expressions that had accumulated throughout Western history; others invented new jokes, stories, and visual caricatures that ranged from simple condescension to fierce satire. As this antifeminism became a major issue in public discourse, an ideology of female virtue simultaneously rose to virtually unchallenged prominence. Urged by such public figures as (male) newspaper editors, journal publishers, clerics, and educators, and acceded to by prominent women as well (even some who crusaded for women's rights), the domestic virtue of women was championed as the very bedrock on which the Republic would survive. This call for domestic virtue, like the motif of the happy slave, was enormously complex in its implications.[7]

The ideology of female virtue had two essential parts: first, that women were the moral center of the nation, with special spiritual gifts and responsibilities, and second, that women were properly domestic—that they should exercise their gifts and responsibilities exclusively in a home-centered life. Although many men and women seemed genuinely to believe that female purity was somehow inborn or essential, and thus the opposite of masculine selfishness and physicality, such a formulation also held a special place in the public discourse of a country attempting to make democracy work.

With so uncertain a political and economic experiment underway, in which the sover-

eigns fiercely sought and contested status and power, the principle of separate spheres for men and women marked off boundaries that, ideally, kept order. This order was, of course, in the interest of the male citizenry. The public sphere belonged to them, the economic and political actors who carried out the business of the society—investing, building, voting, and claiming the West—and the private sphere "belonged" to women, the domestic actors who carried on the moral work of society at home—raising children, providing a harmonious retreat for husbands, exercising religious influence, and even exhibiting good taste in purchases. Harriet Martineau, during her visit to the United States in 1835, identified separate spheres as a invention designed to keep women under control:

> The Americans have, in the treatment of woman, fallen below not only their own democratic principles, but the practice of some parts of the Old World. . . . [T]here is no country in the world where there is so much boasting of the "chivalrous" treatment she enjoys. That is to say,—she has the best place in stage-coaches; when there are not chairs enough for everybody, the gentlemen stand; she hears oratorical flourishes on public occasions about wives and house, and apostrophes to woman; her husband's hair stands on end at the idea of her working, and he toils to indulge her with money; she has liberty to get her brain turned by religious excitements, that her attention may be diverted from morals, politics, and philosophy; and, especially, her morals are guarded by the strictest observance of propriety in her presence. In short, indulgence is given her as a substitute for justice.[8]

In this light, the ideology of female virtue seems to have been one more ordering of the body politic that put those who were already subordinate through cultural practices in an approvable supporting relationship to those with power. In a similar way, as discussed in chapter 4, blacks were pronounced childlike and born to serve. Significantly, while discourses about domesticity and female rights were vying for expression, white men were simultaneously developing an ideology of male essence. As the popularity of images of Western trappers and hunters would suggest, white American males' assumption of their absolute autonomy as *males* bolstered the justification of separate spheres for the sexes. And as a counter to the worrisome implications of class stratification in the democracy, men's devotion to the exploration of economic and political autonomy was in many ways a commitment to a self-sufficient masculinity that underlay class. Fascinated by this phenomenon, Tocqueville wrote that American men rarely enjoyed the communal sympathy with their wives typical of gender relations in Europe, in which men and women shared the circumstances of class. If American men felt any common identity, he

observed, it was with other (white) men, with whom they shared the opportunity—more accurately, the fierce drive—to go for the main chance. Antebellum sovereigns' commitment to male autonomy produced a gender-based hierarchy of class that coexisted with, and in many cases ultimately dominated, orderings based on regional and ethnic identity.[9]

This ideology of masculinity—and with it the ideology of the domestic sphere—was particularly useful to men of the new urban middle classes, who wished to be at once essentially male (independent and strong) and successful in the social world of the city. To assume this identity, they needed the "natural" arrangements of urban middle-class gender definitions. Sweet domestic influence in the parlor and female subservience to male authority and expertise obviously could not be exercised by women who did half the outdoor work on a farm, or the washing, sewing, gardening, and cooking in a settlement in the wilderness. Nor could these responsibilities (or "privileges") be implemented by the new groups of women in towns and cities entering industry or working in other people's homes as domestics or doing piecework in garrets as seamstresses. Thus, even though both male and female advocates of female virtue proposed their definition as universally valid, they preached it primarily for the woman who comprised the domestic support for the problematic new urban merchants, professionals, bankers, clerks, and publishers who were devoted to the accumulation of wealth and political power. These new men, the justification went, typically acted solely out of self-interest. Many of them new to the social requirements of middle-class status, they needed wives, mothers, sisters, and daughters who could temper the manifestations of their calculating spirit and, through natural expertise in the finer points of the arts and social relations, give them respectability by Old World genteel standards.[10]

Thus, just as representations of yeomen critiqued urban males' participation in political and economic action, and images of Westerners embodied Eastern anxieties about personal and social freedom, the primary function of American artists' representations of women in domestic circumstances—few as these images were—seems to have been to set out guidelines of conspicuously proper middle-class social behavior for the new urban man. With gender relations endlessly prescribed, yet deemed subordinate to pressing public issues, representations involving women were typically constructed by artists who concentrated on other subjects. These artists never depicted women as autonomous in their sphere—as, for instance, alone in a well-appointed home that would have been comparable to the prairie in which Deas's *Long Jakes* radiated such mastery. Nor did they present women in relation to each other, as Mount had shown men in *Bargaining for a*

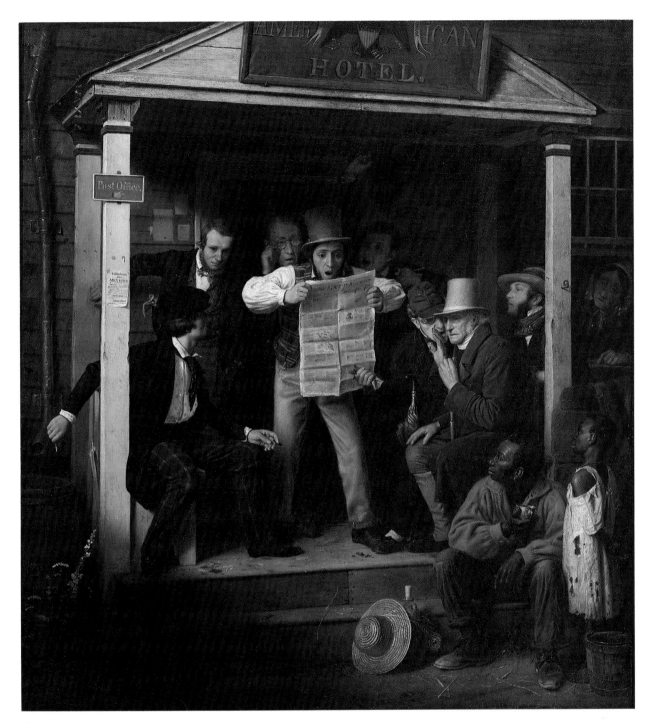

Plate 1.

RICHARD CATON WOODVILLE

War News from Mexico, 1848. Oil on canvas, 27 × 24 3/4 in. The National Academy of Design, New York.

Plate 2.

WILLIAM SIDNEY MOUNT

Rustic Dance after a Sleigh Ride, 1830. Oil on canvas, 22 × 27 1/4 in. Bequest of
Martha C. Karolik for the Karolik Collection of American Paintings, 1815–1865.
Courtesy Museum of Fine Arts, Boston.

Plate 3.

WILLIAM SIDNEY MOUNT

Bargaining for a Horse, 1835. Oil on canvas, 24 × 30 in. Courtesy New-York Historical Society,
New York City.

Plate 4.
WILLIAM SIDNEY MOUNT
Farmers Nooning, 1836. 20 1/4 × 24 1/4 in. The Museums at
Stony Brook, Stony Brook, New York. Gift of Mr. Frederick
Sturges, Jr., 1954.

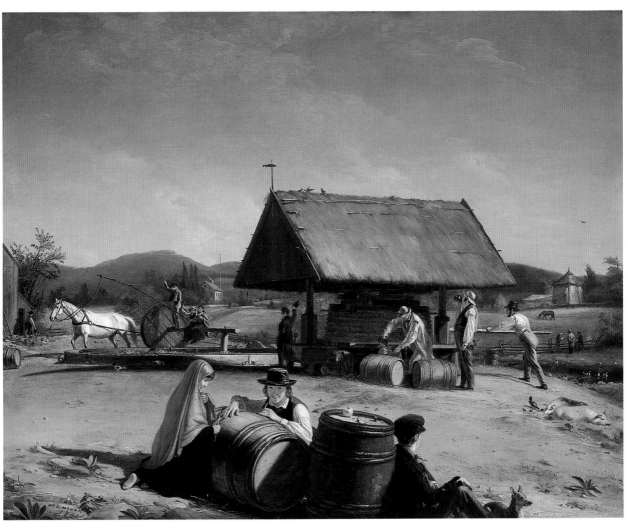

Plate 5.
WILLIAM SIDNEY MOUNT
Cider Making, 1841. Oil on canvas, 32 1/2 × 39 1/4 in. The Metropolitan Museum of Art, 1966, Charles Allen Munn Bequest.

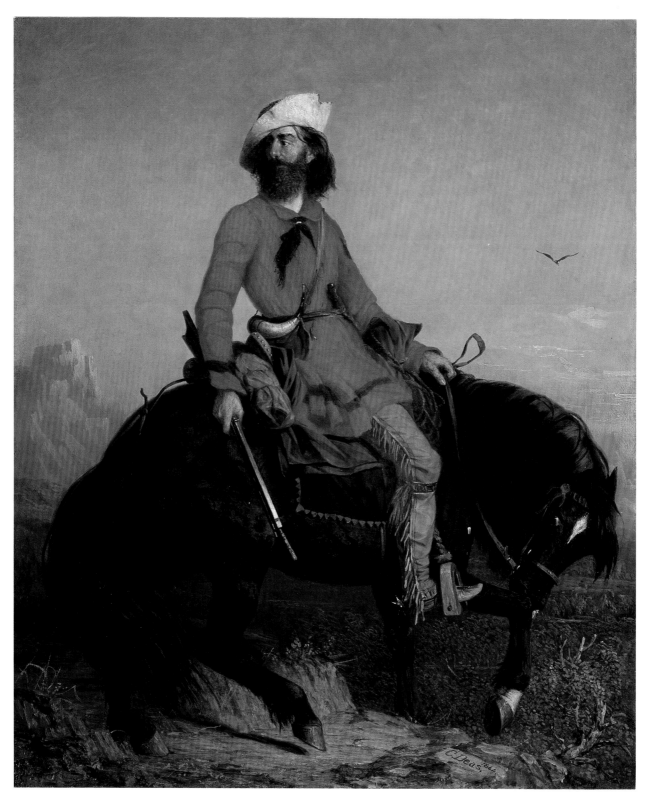

Plate 6.
CHARLES DEAS
Long Jakes, 1844. Oil on canvas, 30 × 24 7/8 in. The Manoogian Collection.

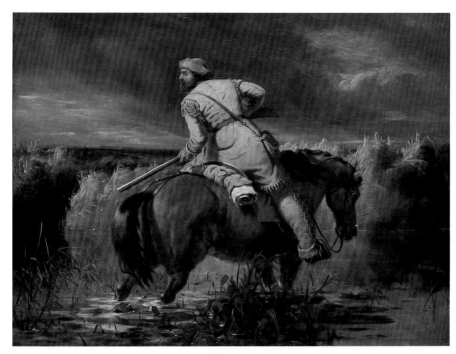

Plate 7.
WILLIAM RANNEY
The Trapper's Last Shot, 1850. Oil
on canvas, 18 × 24 in. W.
Graham Arader III Gallery.
Photograph courtesy Vose
Galleries, Boston.

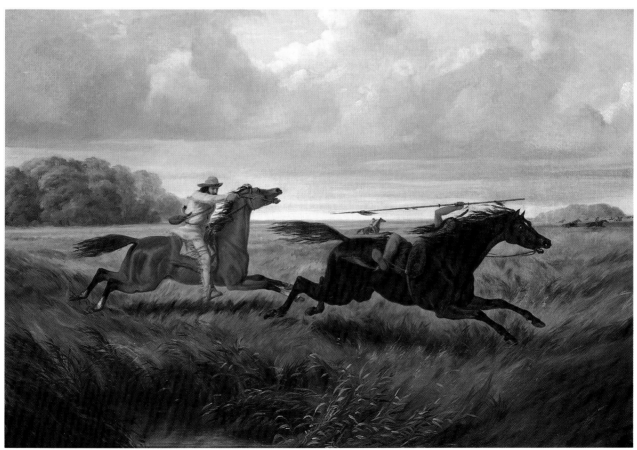

Plate 8.
ARTHUR F. TAIT
The Pursuit, 1856. Oil on canvas, 30 × 44 3/8 in. Milwaukee Art Museum Collection. Gift of Edward S. Tallmadge.

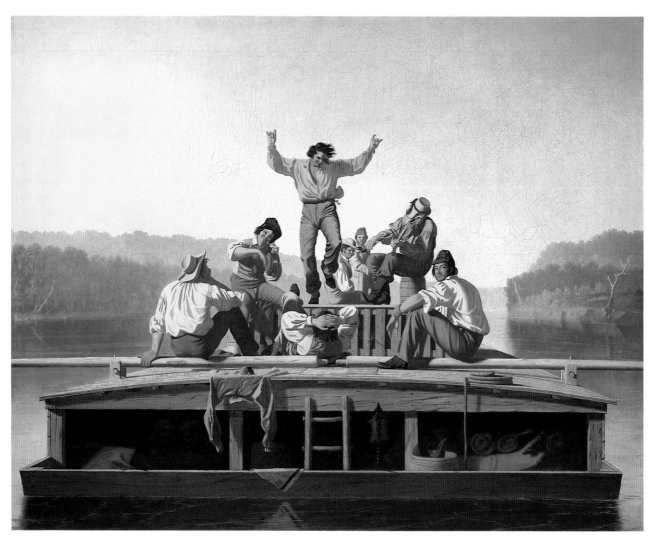

Plate 9.

GEORGE CALEB BINGHAM

The Jolly Flatboatmen, 1846. Oil on canvas, 38 × 48 1/2 in. The Manoogian Collection. Photograph: Dirk Bakker.

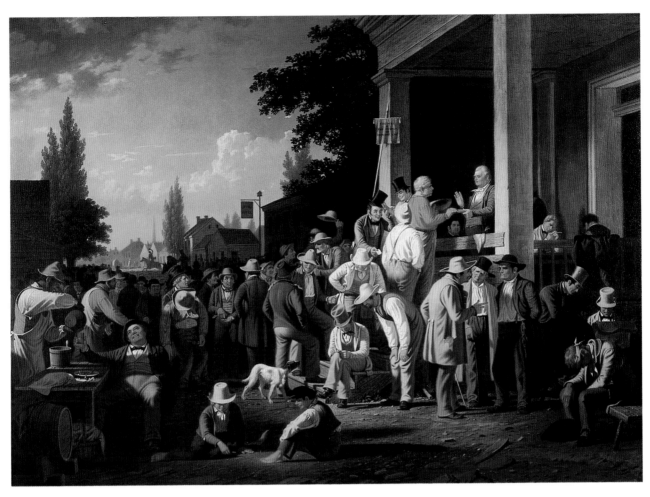

Plate 10.

GEORGE CALEB BINGHAM

County Election (2), 1852. Oil on canvas, 38 × 52 in. From the art collection of the Boatmen's National Bank of St. Louis.

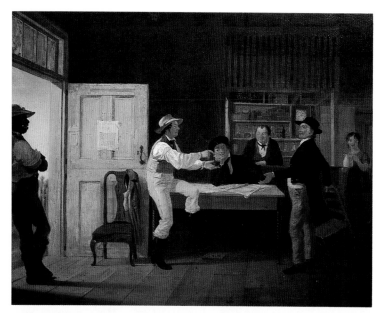

Plate 11.
JAMES CLONNEY
Politicians in a Country Bar, 1844. Oil on canvas,
17 1/8 × 21 1/8 in. New York State Historical
Association, Cooperstown.

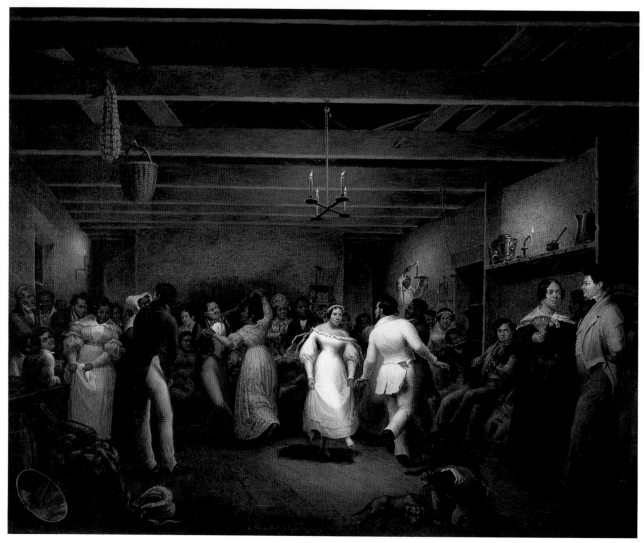

Plate 12.
CHRISTIAN MAYR
Kitchen Ball at White Sulphur Springs, 1838. Oil on canvas, 24 × 29 1/2 in. Courtesy North Carolina Museum of Art, Raleigh.

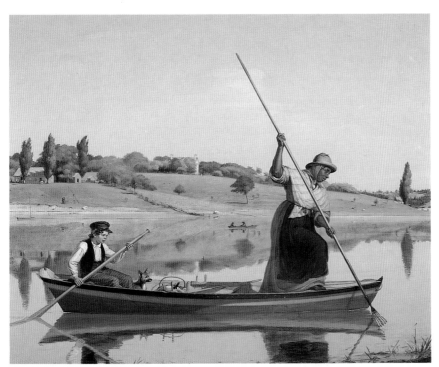

Plate 13.
WILLIAM SIDNEY MOUNT
Eel Spearing at Setauket, 1845. Oil on
canvas, 29 × 36 in. New York State
Historical Association, Cooperstown.

Plate 14.
WILLIAM SIDNEY MOUNT
The Power of Music, 1847. Oil on canvas,
71 × 21 in. Formerly at the Century
Association, New York.

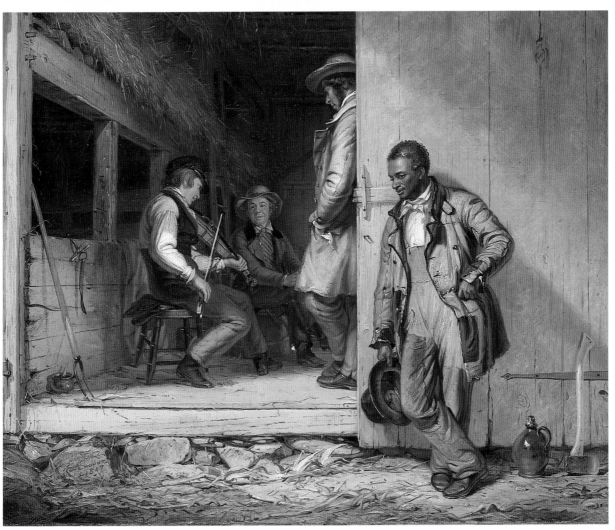

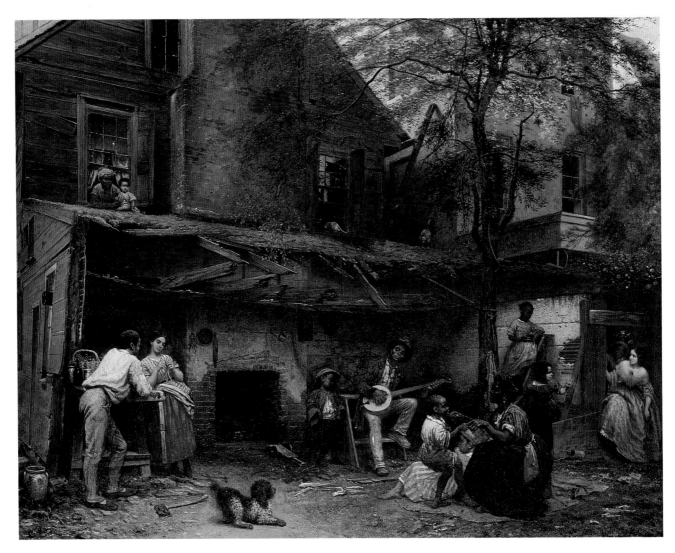

Plate 15.

EASTMAN JOHNSON

Old Kentucky Home (Negro Life at the South), 1859. Oil on canvas, 36 × 45 1/4 in. Courtesy New-York Historical Society, New York City.

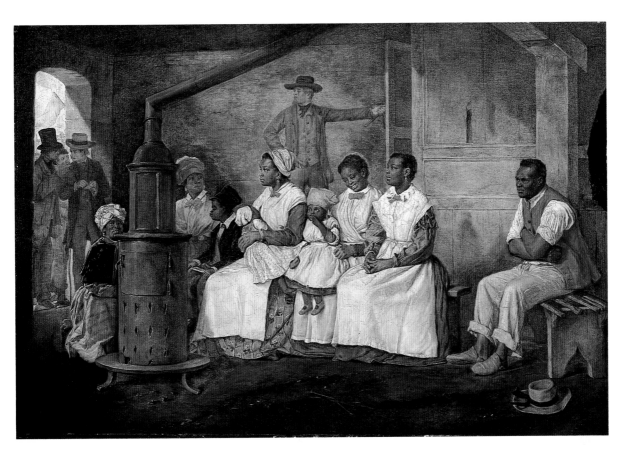

Plate 16.
EYRE CROWE
Slave Auction in Richmond, Virginia, 1852. Oil on canvas, 21 3/4 × 32 in. Private collection.

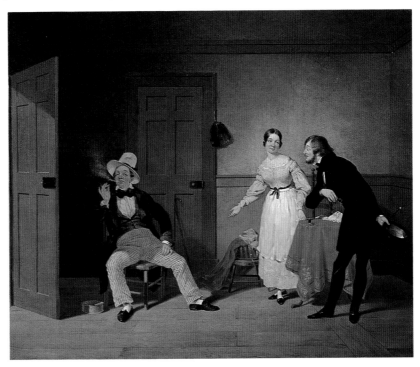

Plate 17.
FRANCIS W. EDMONDS
The City and the Country Beaux, 1840. Oil on canvas, 20 1/8 × 24 1/4 in.
Sterling and Francine Clark Art Institute, Williamstown, Massachusetts.

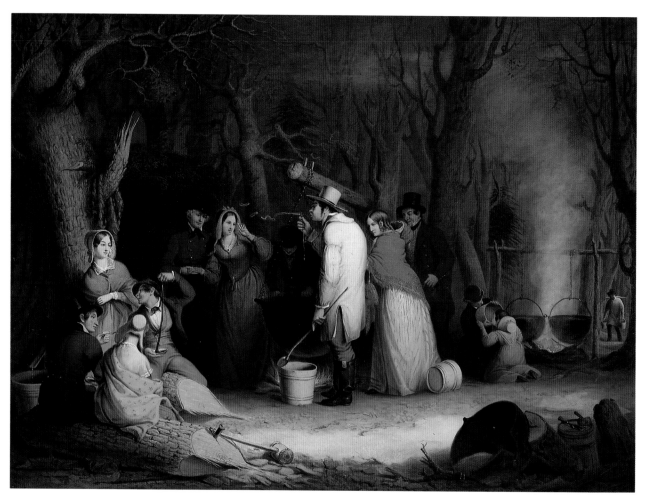

Plate 18.

TOMPKINS MATTESON

Sugaring Off, 1845. Oil on canvas, 31 × 42 in. The Carnegie Museum of Art, Pittsburgh. Bequest of Miss Rosalie Spang.

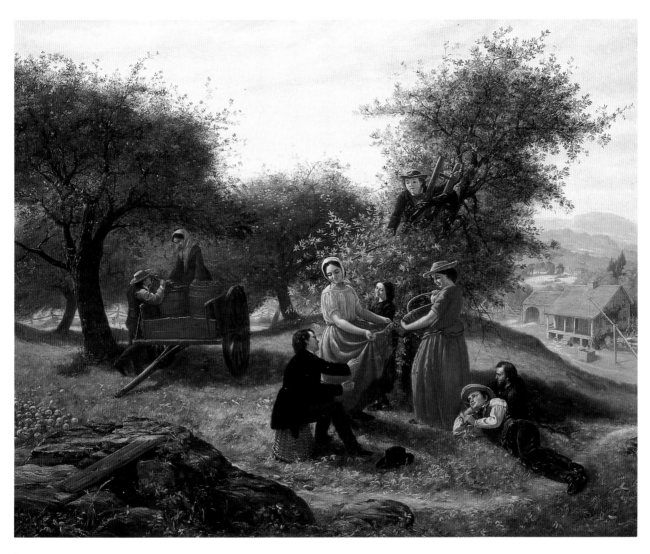

Plate 19.

JEROME THOMPSON

Apple Gathering, 1856. Oil on canvas, 39 13/16 × 49 3/4 in. The Brooklyn Museum. Dick S. Ramsay Fund and funds from Laura L. Barnes Bequest.

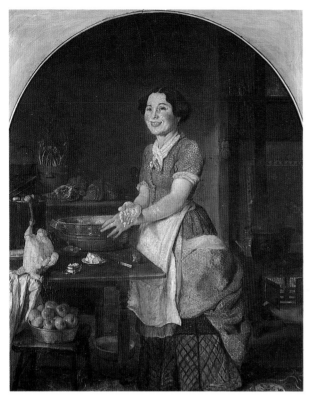

Plate 20.

LILLY MARTIN SPENCER
Shake Hands? 1854. Oil on canvas,
30 1/8 × 25 1/8 in. Ohio Historical Society,
Columbus.

Plate 21.

LILLY MARTIN SPENCER
This Little Pig Went to Market, 1857. Oil on canvas, Ohio Historical
Society, Columbus, Campus Martium Museum.

Plate 22.
RICHARD CATON WOODVILLE
The Card Players, 1846. Oil on canvas, 18 1/2 × 25 in.
The Detroit Institute of Arts. Gift of Dexter M.
Ferry, Jr.

Plate 23.
RICHARD CATON WOODVILLE
Politics in an Oyster House, 1848. Oil on canvas,
16 × 13 in. Walters Art Gallery, Baltimore.

Plate 25.
DAVID GILMOUR BLYTHE
Street Urchins, 1856–1860. Oil on canvas, 27 ×
22 in. The Butler Institute of American Art,
Youngstown, Ohio.

Horse. Instead, artists portrayed women in relation to men. Their pictures assessed the implications of the bourgeois social sphere in which men dealt with, and defined their masculinity against, women. One might say, thus, that these genre paintings, too, were essentially about men.[11]

This is dramatically the case in Mount's *Rustic Dance after a Sleigh Ride* (pl. 2), which depicts a crowd of men and women enjoying a celebration with varying degrees of boldness. The seven women in this picture are undifferentiated. All have the same facial and body types—long oval face, Roman nose, curled hair piled on head—and each wears the same dress varied only by color and type of lace ornamentation. The men, however, are a different matter. The two prominent male dancers are quite dissimilar in style and bearing. The one in the middle wears a soft collar and neckerchief (both suggesting informality) and his frock coat is pushed back in abandon; his dancing is overdone and clumsy. In significant contrast, the dancer to the right wears a high collar and neckpiece that set off his elegant dark frockcoat to perfection; smooth and experienced in his gestures as he prepares to lead a young woman to the dance floor, he is the picture of suavity. Elsewhere in the room, men portray various levels of sophistication. Without exception, those in less formal shirts and neckwear (including the black fiddler) project awkwardness and even foolishness in demeanor; those in more formal neckwear radiate sophistication. These clues are enhanced by the onlookers' headwear, which ranges from a dilapidated soft hat to a high top hat. Rustic these men may be, but some are learning new ways.[12]

Rustic Dance was only the first of many paintings that transparently pointed to problems of male definition. Although surviving paintings are not a completely reliable gauge of artistic production, one can dependably say that over the next three decades, in spite of European models that offered explorations of many dimensions of female experience, American male artists made domestic images that examined just two situations in men's relationships with women: courtship and childhood. These were the two most culturally complex experiences in men's associations with women.[13]

Courtship in America's socially fluid society was a conundrum, potentially both traumatic and comic. The varieties of subtle shared experience in courtship that had found expression in English and German paintings—shyness, frustrated longing, sexual energy, even sentimentality—were not explored by American genre painters. Rather, American artists interpreted the activity as a proving ground of the middle-class male. Stories and homilies from the period highlight courtship as the fulcrum of the unequal relations between the sexes. Tocqueville and others marveled that young American women had an astonishing freedom before they got married. Upon marriage, however,

women exchanged this freedom for a domestic role in which they became virtual servants to their husbands and as mothers shaped the future citizens of the Republic. Because a woman's responsibility at marriageable age was to serve in this "bondage," a marriage proposal was the point at which the critical stage of her life—her service to her family—began. For the man it was a milestone of mastery and liberation. Courtship proceeded according to codes of genteel behavior; thus cultural perceptions of male anxiety in this ritual were embodied in stories of courtship that projected the social awkwardness of the urban suitor onto the laconic, graceless Yankee rustic. In the early years of the antebellum era, in fact, courtship as a cultural theme seems to have served much the same function as stories of horsetrading—courting stories poked fun at the "new man," the bumpkinish, inexperienced, but ambitious sovereign, making his way in a strange world of social (and thus economic and political) exchange.[14]

Mount—alert to every topic for genre painting except the West—was the first artist to undertake the theme, some five years after *Rustic Dance*. In *The Sportsman's Last Visit*, 1835 (fig. 38), a demure young woman, fashionably coiffed and outfitted in a virginal white dress over which is tied a decorative (but useless) dark green silk apron, is the object of the attentions of two men, one citified and one rustic. The setting is a rural house, simply furnished and sparely decorated, and her parents are nowhere in evidence. As she concentrates on her fancy ribbon work, a formally dressed blond young man, elegant in high collar, stock, and black trousers and frockcoat, leans forward on his chair devoting himself to serious exhortation of her favor. His counterpart, the sportsman, is no peasant. He wears an impressive brown outer coat, his chest crossed with the straps of a powder horn and other hunting equipment. But to no avail. There is no chair for him (perhaps he has just arrived); he scratches his head, having knocked his stovepipe hat to a foolish angle, while he assesses the discouraging situation. As his clothing and body language would suggest, he is comfortable with outdoor pursuits and has not prepared himself for the domestic sphere.[15]

The young woman is virtually flat in presentation. In her white dress, she strikes a pose that suggests her readiness for motherhood; she proclaims her virtue by wearing a cross on a chain around her neck (the cross is upside down, perhaps so that she herself—if we are to see her as extraordinarily pious—can "read" it properly or perhaps, if Mount is making a comic point, as a sign of insincerity). Having so obviously prepared herself to attract a proposal, the independence that she is apparently ready to surrender seems hardly to have been cultivated.

The suitors, in contrast, represent two constructions of masculinity. The ascendant is

Figure 38.
WILLIAM SIDNEY MOUNT
The Sportsman's Last Visit, 1835. Oil on canvas,
21 1/2 × 17 1/2 in. The Museums at Stony Brook,
Stony Brook, New York. Gift of Mr. and Mrs. Ward
Melville, 1958.

the suave city dweller, skilled in social manipulation, which includes that with women. His sophistication is signaled by his knowledgeability about dress. He is alarmingly deceptive looking—a veritable confidence man. The second is the man who is at home outdoors, and it is his enactment of masculinity that is threatened here. He seems honest—we can scrutinize him face on, whereas we can respond only to the insinuating facial and body profile of the dandy. Yet the city dweller more clearly understands the implications of the new urban rules for deportment. Whereas the outdoor or public activities of economic and political manipulation like those in *Bargaining for a Horse* and *Cider Making* could lead to the somewhat awkward, even occasionally comic achievements of the Yankee yeoman, social skills were necessarily interior and urban. Yet the objectives were not that different: one involved a horse as the object of exchange, the other a young woman. To secure either involved role-playing and deception.[16]

But one could carry the calculation (and deception) too far. By the time that Edmonds painted *The City and the Country Beaux,* 1840 (pl. 17), styles of masculinity as reflected in dress and consumption had become a major focus of political rhetoric. During the presidential campaign of 1839 and 1840 incumbent Democrat Martin Van Buren was vilified as vain in his dress and self-indulgent in his consumption (the cry went that he "drank champagne in the White House"). Opposition strategists created a very different image for Van Buren's challenger, Whig candidate William Henry Harrison: they praised him as plain, rural, and sensible, an upstanding farmer. Class associations seem at least partially to have informed these generalizations about masculine styles, for Van Buren was the son of a self-made (and thus lower-class) taverner, Harrison the scion of a genteel landowning family.[17]

In *The City and the Country Beaux,* Edmonds was urging his viewers to distrust the process of urban socialization about the same time that Mount painted *Cider Making*, the image that cast politics into so skeptical a light. Although the parlor in Edmonds's painting is modest, his family is more urban than that implied in Mount's painting. There is a ceiling below the beams, and the walls are ornamented with wainscoting and moulding. Here, however, the young woman is not so much a virginal potential bride as a silly, vacuous young woman. Edmonds presents her as just having risen from her chair to introduce a dandyish male visitor in black to a suitor who is already present. This new arrival, hat in one hand and a pretentious monocle in the other, bows elegantly; the earlier visitor, dressed in loudly striped pants and generally rumpled attire, his hat still on his head, remains seated, puffing smoke from a dark cigar and sprawling his feet across the floor. Both male visitors are ludicrous in their attempts to assume sophisticated manners and dress. Each is overdressed: the one in black carries his city elegance too far; the

one in striped pants is clearly a newcomer to fashion *and* a new aspirant to middle-class status. Not only has he chosen the wrong style, he has not yet learned drawing-room manners. Edmonds also critiqued the woman: in her proper place at the back of the room, dressed and coiffed to attract suitors and engaged in the proper feminine pursuit of embroidery, she seems no more intelligent and capable than her suitors. These specimens of upwardly mobile masculinity so clearly play roles rather than act out of conviction that Edmonds's painting depicts not a triumph—of suitor or of young woman—but a standoff.[18]

Although the courtship ritual raised crucial questions in the 1830s and early 1840s about an urbanizing male constituency—a middle-class group defined in certain ways by its relationship to women—in the mid-1840s a few male artists who began their careers slightly later than Mount and Edmonds turned to other subjects that involved women. These artists constructed more flattering treatments of the theme of "female influence." Rather than being a cipher for courtship, women played roles of some agency. While Deas, Ranney, and Bingham were winning attention for their depictions of Western types, Tompkins Matteson and Jerome Thompson, the artists whose works seem to have been the best received as well as the most interesting in social implication, focused on the newly acclimated urban male. They depicted such group activities as picnics, maple sugar parties, and apple-pickings, occasions that made possible the comfortable radiation of collective female influence on the Eastern male in environments as far removed as imaginable from the Western prairies and rivers.[19]

The ostensible purpose of such excursions, which were the pleasures of urban citizens carried out in the country, was to remove men from the fast-paced, corroding influence of the city and place them in the context both of rural nature and of female influence. Typically the company was composed of informal pairs, and the nature in which they gathered was an outdoors long since tamed by human use—stream-side grass, old forests, and mature orchards. The high artificiality of such occasions was the inspiration for the oft-repeated comment by Davy Crockett that he thought picnics were a peculiar custom, but he once went to one anyway because of the food.

In Tompkins Matteson's large painting *Sugaring Off,* 1845 (pl. 18), a group of colorfully dressed visitors to a dark woods chat while the farmer and his assistants tap, boil, and pour up the syrup. In contrast to the workers—the men attending to the vat and the man in the right distance who approaches with pails on a yoke over his shoulder—the city visitors have all arranged themselves into couples. Even the children are paired. The

women are the central colorful figures in the painting, although the men, too, are dressed to the hilt in city fashions. Both the men and the women, in fact, could serve as fashion plates in *Godey's Lady's Book*. Moreover, the congruence in their fashions suggests a congruence in their social skills. The women's waists are small and accentuated, and so are the men's. The women wear bright colors and patterns, and so do the men. The men seem completely at ease: they know how to dress, how to talk pleasantly to their partners, how to relax and have a good time in female company.[20]

Only one person is out of place, and comically so: the farmer in the center of the picture. Wearing an old-fashioned, time-worn peasant smock that is a dull brown and about as far from fashion as imaginable, he also wears a huge hat. Conspicuously, he lacks a female consort. He seems to consider himself to be entertaining the group by blowing bubbles from the syrup, but Matteson implies that this is the impulse of a country bumpkin who has not had the advantages of education in the urban domestic sphere. The critic for the *Tribune,* promoting the justifications for such outings, saw the domestic female and the forest in the same benign category. Reminding his readers that both women and nature serve as retreats, providing recovery from the public sphere, he assured his readers: "The female faces in this picture are most admirable—full of home love and simplicity. They are faces worthy of the hallowed temples of the forests, where the human race recovers from the stunted and frightened expression imparted to it by the excitements of city life. Matteson has done every body a favor by painting these sweet faces."[21]

Matteson's image presented his urban women as models of stylish costumes and deportment in what was essentially a tableau, but a few years later Jerome Thompson's *Apple Gathering,* 1856 (pl. 19), suggested the emotional and even the sexual power of women in a painting that celebrated nature rather than fashion. *Apple Gathering* is a large painting, dominated in color by the glowing yellows and greens of the landscape and the bright red of the women's dresses, the apples, and the foreground sumac. Four women, four men, and a boy comprise the cast of characters. In the near foreground, in front of a tall apple tree, two smiling women in soft, full red dresses form a virtual allegory of the delights that womanhood and the country life offer properly sensitive men. With a third, slightly older woman in dark brown rounding out the group, the three radiate prescribed femininity in both the most literal and symbolic terms: one nestles a large basket against her stomach; another holds out her skirt to catch apples being thrown from the tree. A boy holds rather desperately onto a ladder propped against a tree as he gets ready to throw down an apple. While the boy is still preparing for adulthood, the three grown men around the central group of women are all literally at

the women's feet. Each woman is thus paired off with an admirer, and a separate courtship seems to be underway on the far left. The farmstead at the bottom of the hill in the right distance links domesticity and agrarian virtues. Thompson's association between natural fecundity and women's embodiment of it are unmistakable; even the tree from which the young boy is throwing apples into one woman's lap has a phallic shape. In withdrawing to the country, away from the distractions and perversions of the city, these men are in tune with nature's—and women's—sensual gifts. The painting is an idyll of young womanhood superior to, and yet at the service of, young manhood.[22]

What, we may ask, was responsible for the shift in emphasis from courtship in the 1830s and early 1840s, images that probed male initiative, to these representations by young artists in the later 1840s and 1850s of a subtle "atmosphere" under the agency of women? At least two factors are part of the explanation. Both involve cultural productions aimed at an increasingly large female market beginning in the 1840s. Such journals as *Godey's Lady's Book,* gift book annuals, and other publications appealed to female readership with narrative and poetic constructions of femininity that accepted the general outlines of the domestic role but strove to enhance them as desirable and even ennobling. The second factor, closely related, was the rise of illustrations and prints aimed at this market, many of them for journals, some (also) sold separately as enticements for many kinds of commercial ventures. The overwhelming number of these illustrations and prints were about the home, and those that focused on the interior glorified the woman's role in it. They did not necessarily focus on her directly but depicted the home as ruled by manners, beauty, and peace. Images like John Sartain's *Happy Family,* 1843 (fig. 39), constructed interior spaces as lovingly cared-for female domains, with children who behaved and husbands who exuded a middle-class handsomeness, self-control, and piety. In the Sartain engraving the elegant husband is at the center of the image, with his adoring wife seated at his left and his children, including a maid with a child in her arms, at his right; all gather around attuned to his wisdom. He dispenses this with the assistance of a small book he holds; even the family pet, sitting alertly on a cushion at his foot, pays him homage. In another print of the period, Napoleon Sarony's *Married,* 1846, the wife is at the center. The husband is attentive, she is lovely, and the children are ideal. All sit in harmony in a beautifully furnished parlor; the marriage portraits on the wall are identical to the faces of the couple some years later as they "pose" for this image. Their lives, in other words, imitate art.[23]

Thompson's *Apple Gathering* was engraved and distributed to members of the Cosmopolitan Art Association, an art union that was founded in 1854 after the demise of the American Art-Union. Aimed specifically at a patronage that included women, under the

Figure 39.
JOHN SARTAIN
The Happy Family, 1843. Engraving. The Historical
Society of Pennsylvania, Philadelphia.

philosophy that women were the guardians of art and culture, this art union marked the transfer of imagery from the public sphere to the domestic. In giving art new patrons, it depoliticized national imagery. The *Cosmopolitan Art Journal*, which began publication in 1856, disguised this shift consummately. In recommending *Apple Gathering* to the organization's huge constituency, it praised Thompson as having "pierced to the very spirit of country realities." No artist, the critic wrote, conflating women, beauty, and the pastoral retreat, "so genially and truthfully reproduce[s] country experiences, and pastoral beauty." With women joining the audience for images in significant numbers in the 1840s and 1850s, domestic subjects became a part, even if a minor one, of the repertory of painters beginning their careers.[24]

Thus, in images of courtship and female influence—few that there were—male artists depicted the relationships between the sexes in two ways: the first a representation of the inexperienced but ambitious sovereign struggling to assume middle-class ways by carrying out a proper courtship, and the second an assessment of the experienced urban male who, thanks to women's influence, had assumed a comfortable role in the domestic sphere. The first was aimed at the male viewer, the second at the female viewer.

Just as courtship and female influence were themes that revolved around the needs of the upwardly mobile male and then subtly included the desires of the female viewer for flattering assessments of their effectiveness as influences, so motherhood, when represented by male artists, was a discourse with the male child at its center. It was modified only in the later years of the period, again, by a female sensibility. Of the many images of mothers and children, and of children alone, that survive overall from during the antebellum period, the child is almost always a boy, typically a preadolescent boy. Few phenomena could suggest so clearly the centrality of the male to the many ideals with which citizens attempted to formulate the proper functioning of the Republic. As far as motherhood was concerned, domestic ideology in practice seems overwhelmingly to have meant that the mother existed to serve her son(s). Even as a youngster the (white) male was "sovereign."[25]

Motherhood in relation to boyhood could be assessed with various shades of meaning, depending on the interpreter's own investment in the social world. Across class and region boyhood was held up by many as the male's golden age. Somewhat analogous to the pretense that in an undifferentiated West men were without social class, adults looked at boyhood as a time when an essential boyness triumphed over distinctions of social level and regional identification. According to this mystique, the boy was carefully nurtured in

the home, assuming that the home was a middle-class one dominated by the ideals of domesticity, and had freedom to play and loaf and cavort. Popular moral literature hammered out the theme of the proper upbringing of the boy, the only period in which he was malleable. In jokes, caricatures, woodcuts exhorting good manners, and paintings, the mothering functions of domestic life revolved around sons, whose mischief (or, ideally, whose self-discipline) portended the behavior of the grown citizenry. When the boy—any boy—entered the liminal phase of adolescence, however, the social strains were intense. In the shifting social worlds of both rural and urban areas, with apprenticeship diminishing and rural families leaving the farm, there was no specific place for the adolescent male. No longer under the thumb of his mother, he could not yet take an explicit place in the adult world beside his father. These circumstances enhanced the celebration of boyhood: what could not be taken care of or ameliorated in an adult citizenry was blithely posited as proper to and confined to boyhood.

As texts from the period make clear, women experienced a double bind in the relationship of mother to son. That is, women received all the responsibility for nurture but little of the social power that would underscore that the responsibility mattered. During the 1830s and 1840s citizens and visitors complained vigorously about the terrible behavior of young American boys. The comments of some seem to have been motivated primarily by disdain for the "rabble." The elitist John Neal, for instance, who moved from Philadelphia to Portland, Maine, and spent time in England, declared that children "are murderers, mischief makers, devils at times." Neal had a very low opinion of American parents, citing as justification for his despair about the Republic's future that "as the twig is bent, so the tree is inclined." But many voiced complaints about the behavior of children hand in hand with judgments about those most responsible for such misbehavior: American women. In fact, by the 1850s the linking of boyhood and motherhood was almost automatic, typically to the denigration of women. As an editor of the general periodical *Putnam's* lamented in 1853: "The Ideal American Woman—would that her time were come!—will govern her children, which certainly the American woman of today does not. We will venture to say that so many utterly uncurbed children are not to be found any where as in the United States."[26]

But more favorable assessments of young American boys and their mothers were also put forth, and, as one might suspect, from strong positions of interest. Women wrote essays that rhapsodized about the special nature of childhood that somehow compensated for children's mischief (and thus exempted from dramatic criticism their work as mothers). *Godey's Lady's Book* praised children as having "a holy ignorance, a beautiful credulity, a sort of sanctity, that one cannot contemplate without something of the rever-

ential feelings with which one should approach beings of a celestial nature." The magazine *Arcturus*, founded in 1841 as one facet of the Democratic party's attempt to assert itself as the party "of the people," found it judicious to praise future citizens (prospective party-members) hand in hand with their mothers: "It is an article of our creed," editor J. M. Van Cott intoned, "that the American mother is the best mother in the world; and that the best elements of the American character, those which mark us as a peculiar people, and have most contributed to make us a great nation, were fashioned and moulded by the plastic hands of American mothers."[27]

Paintings of boyhood by male artists played to different pronouncements in this broad spectrum. Some altogether subverted rosy ideals of effective motherhood, pairing young boys' mischievousness with women's helplessness. Others, however—and these tended to be artists working in the later part of the period—sentimentalized the golden age, but in so doing reduced motherhood to servitude and decoration.

An example of subversion, painted at the same time that Mount found he had outplayed his emphasis on the yeoman farmer, is Augustus D. O. Browere's *Mrs. McCormick's General Store*, 1844 (fig. 40). First exhibited as *Boy in Trouble*, in this image Browere represents several boys aged about ten or twelve plaguing an urban shopkeeper by shoplifting from her outdoor display. One of the boys is a bootblack, another, ragged and barefooted, is a newsboy, and yet another is threadbare with no visible means of support. Although a first look would suggest that Browere's cast was drawn only from the urban rabble, this is not the case. A fourth boy, who thumbs his nose at the shopkeeper, is well dressed even to a beaver top hat. Whereas the three street children might be expected to behave with such disrespect, the well-cared-for young fellow has just stepped from the side of the other woman in the painting, a properly dressed middle-class woman, certainly his mother, who holds onto two children. In a humorous detail, his left foot is still at her side, anchoring him temporarily as he moves into the action. What Browere conveys with these misbehavers is that regardless of nurture (and class status) these boys are alike in their behavior. They are autonomous and uncontrollable. In the face of this challenge to order and discipline, the two women are helpless. The mother can just stand and watch, the shopkeeper scold; they have about as much power as the bird caged outside the shop door. Thus while Browere seems at first to direct the viewer's attention to the misbehavior that so many worried about publicly, he encourages laughter at the women's ineffectuality and reinforces the dictum that women's proper sphere is inside. The street—the public space, the arena for action—belongs to the boys.[28]

Although Browere made such a variety of images that one cannot generalize about the relation of *Mrs. McCormick's General Store* to his calculation of an audience or even his

Figure 40.
AUGUSTUS D. O. BROWERE
Mrs. McCormick's General Store, 1844. Oil on canvas,
20 1/2 × 24 1/2 in. New York State Historical
Association, Cooperstown.

personal bias (he was ultimately successful with a series of images based on Washington Irving's "Rip Van Winkle"), one *can* do that with Mount. Boys carry the meanings in his *Catching Rabbits,* conveying to viewers who chose to get the point that the new political leaders were about as mature as youngsters, and boys are part of the crowd in *Cider Making.* In the early period after Mount had first used the rural sovereign in *Rustic Dance,* one of his images had been of misbehaving young boys—*Schoolboys Quarreling* (Museums at Stony Brook). There, a woman hovers in the wings, so to speak, watching the boys fight; she wears a disapproving look, but she is only contingent to the real action—she is even positioned in an interior space, peering at the youngsters through the opening in a Dutch door. Her presence seems to be needed to define the action thoroughly, but at the same time she cannot interfere. Although the youngsters in Mount's

Truant Gamblers (Undutiful Boys), 1836 (New-York Historical Society), are conspiratorially playing cards and gambling with coins in environments in which women are not present, just how closely their misbehavior was associated with motherhood is suggested by the transformation of one of these paintings into an illustration for a periodical. In the painting several young boys gamble furtively in a barn, unaware that an older man, perhaps the hired man, or possibly the father of one of them, is approaching them with a long stick in his hand. The engraver who made the image for the annual periodical the *Gift*, 1844, transformed the admonishing man into a pinched-faced older woman holding a stick behind her back. The impending judgment to be administered by the strong masculine figure in the painting for a single patron thus became, for a mass audience, a scolding by a diminutive female figure with little real authority. With a new title for the image, *Disagreeable Surprise,* the engraver transferred the point of the narrative from the misbehaving young boys to the slightly disagreeable shock the unsympathetic older woman will give these (forgivable) miscreants. That the original motif was altered in this way to appear in a publication aimed primarily at women suggests the publisher's assessment that women, too, saw themselves as impotent scolds, unable to direct the energies of young boys.[29]

Other images tended toward the sentimental. Not surprisingly, they were created during the same period that artists like Matteson and Thompson were pursuing more flattering assessments of women's relationship to men. In contrast to the homage that the male figures seem to pay women in such pictures as Thompson's *Apple Gathering*, however, in even later paintings of motherhood it is the women who clearly pay the homage—to their boys.

In Edmonds's image *The New Scholar*, 1845 (fig. 41), for instance, the ostensible focus includes the mother, or a mother figure, but the emotional energy of the viewer is directed to the boy. A fashionably but modestly attired mother has brought a shy, very young, boy to school, apparently for his first day. He is so tender-aged, in fact, that he still wears the child's long smock, while through the schooldoor the viewer can see two boys who wear adult clothing. As the "new scholar" starts in dismay at the schoolmaster, even gripping his mother's dress in alarm, the schoolmaster, the picture of uprightness, punctiliousness, and even effeminate fashion, is formidable. Although he raises one hand as though in sympathy with the lad's shyness, with the other behind his back he grips a barely concealed whip. The rowdy behavior of the boys inside the schoolroom makes it clear that the new scholar's days of being indulged by his mother are over, that he now faces a traumatic rite of passage. Critics' responses to the painting reveal their emotional identification with the young male hero. One mused, "We don't wonder the

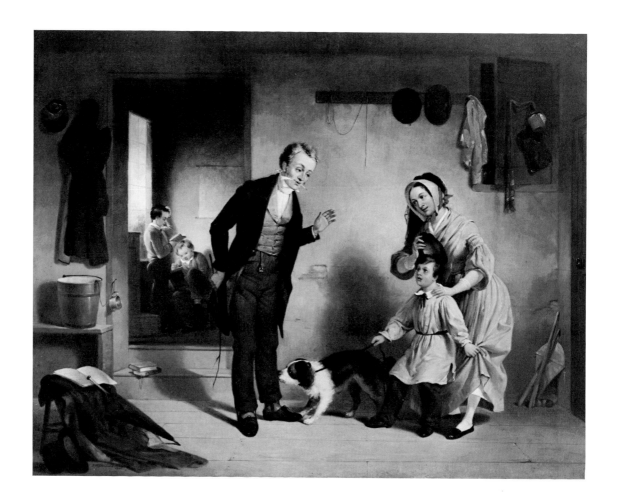

bright, cheerful-hearted little fellow hates to leave his sister and trust himself to that sin-
ister-looking old ogre of a Schoolmaster." Another, who assumed the female figure was
the lad's mother, went directly to the resonances of the subject for his own overworked,
unindulged adulthood: "We envy the little fellow the luxury of his nap, and could almost
kick the dog for spite, to see him enjoying himself so hugely, when we can hardly get our
natural sleep o'nights." Few critical responses reveal so clearly the implications of certain
images about the domestic sphere for male audiences. Just what a female response
would have been can only be speculated, but the American Art-Union selected the im-
age to be engraved for distribution to its members in 1850. That it was the only quasi-
domestic print distributed by the group over twelve years would suggest that, as far as
men were concerned (and men decided what images the Art-Union bought and en-
graved), the only point at which the domestic sphere would be of interest to the broad
156 American public was the point at which the boy left it.[30]

In the same tenor as this work by Edmonds, several images by James Clonney make the devotion of women to their sons explicit. But these paintings are not about the border between domestic and public environments that Edmonds addressed in *The New Scholar*. Rather, they depict full details of the domestic sphere and evoke the subtle spectrum of emotions between sentiment and gentle amusement. It seems startling that an artist who produced the pointed caricatures of blacks discussed in chapter 4 would also exploit, or find patrons who wanted him to exploit, the domestic sphere. In *The Good Breakfast*, 1852 (Ganz Collection), an adolescent sister or a small-figured mother serves breakfast to a boy of three or four; every element in the image, including the picture of the (presumably absent) father on the wall over the toddler's head, identifies the male child as the center of this simple home. Moreover, although a woman cares for him, the model for his development is the military man in the portrait. In *Mother's Watch*, 1852–1856 (fig. 42), Clonney depicted boys of about five or six who misbehave while their stylish young mother sits asleep, an open Bible on her lap. A pun provides a witty title: the boys play with their mother's watch (perhaps an antique, snatched off the knick-knack shelves) while she has lapsed into slumber from her metaphoral watch—which apparently has included readings from the Bible. Rather than providing incongruities with his other pictures, however, these works reveal Clonney's penchant for setting forth almost completely flattened types.[31]

Although American male artists represented courtship, domestic influence, and motherhood—subjects ostensibly about women—almost none created images to suggest that there were women who did not comfortably fit into the tightly prescribed middle class. Domestic ideology made middle-class urban domesticity the standard of measurement for feminine roles. Across the Atlantic, in England and France especially, artists pointed audiences' attention to social distress and class division in the cities with images of women as beggars, street vendors, and prostitutes. In England such artists as Richard Redgrave and G. F. Watts highlighted the plight of "redundant" women in the middle classes of England—women who were not chosen as wives—with poignant scenes of emotionally and literally poverty-stricken seamstresses and governesses.[32]

In the United States, however, the only artist to construct a female image that significantly departed from the narrow range of focus on "domesticity" was William Henry Burr, a portraitist who occasionally exhibited genre subjects. In *The Intelligence Office*, 1849 (fig. 43), Burr not only acknowledged that there were lower classes in the United

Figure 42.

JAMES CLONNEY

Mother's Watch, 1852–1856. Oil on canvas, 27 × 22 in.
Collection of Westmoreland Museum of Art,
Greensburg, Pennsylvania. Gift of Mr. and Mrs.
Norman Hirschl, New York City.

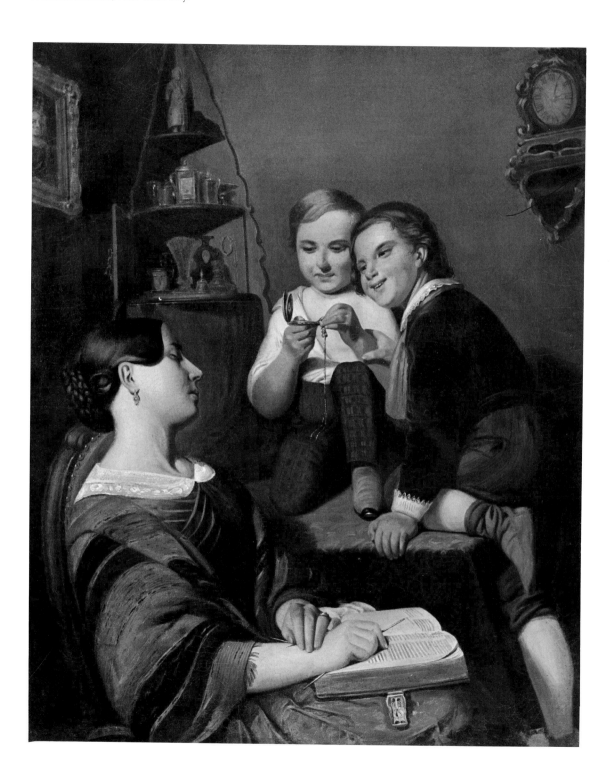

Figure 43.

WILLIAM HENRY BURR

The Intelligence Office, 1849. Oil on canvas, 22 × 27 in.

Courtesy New-York Historical Society, New York City.

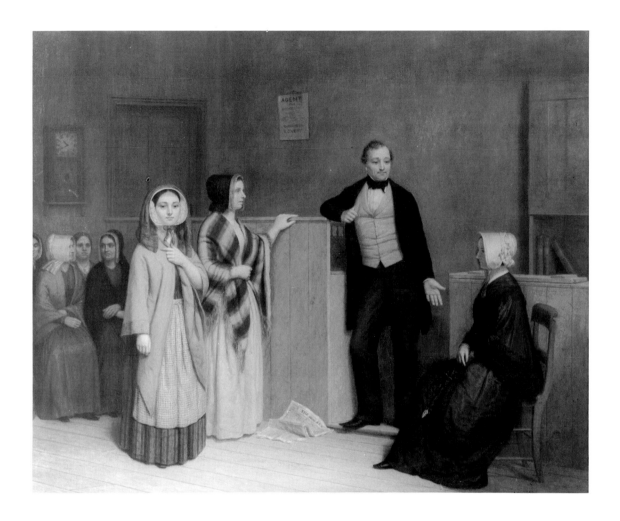

States but implied that the domestic ideal rested on their exploitation. The painting offers a severe contrast to the feminine softness that Thompson constructed in *Apple Gathering* and to the sweet subservience of mother to son in Edmonds's *New Scholar.* Burr's somber scene is not a home-centered woman's world but an employment office, the location of economic transactions that confirm the hierarchical class relationships in the society. A well-dressed man presides over the ritual of exchange, the sign on the wall behind his desk area revealing him to be an agent who provides domestic employees "warranted" to be "HONEST." Several women anxious to be placed wait on the left, having responded, apparently, to an advertisement in the *Sun,* the newspaper that lies prominently on the floor. The drama of the painting is focused on the moment in which two standing young women will receive the verdict of a potential employer who is seated on the right. Dressed neatly, but in well-worn clothes that do not form an ensemble, the

supplicants are tense in the agony of anticipation of the decision. One waits in open-mouthed hope, steadying herself by holding on to the nearby countertop; the other, facing toward the viewer but looking down, holds her stole beneath her chin as though to protect herself from disappointment. They turn away slightly from each other, put at odds by competing for the same job. The potential employer, also a woman, but self-assured in her chair, sumptuously dressed in rich green and brown, with gloves, an elegant umbrella, and a fancy pink bonnet, is even younger than these whom she would employ. She calmly assesses her choices. The agent, jauntily stepping out from behind his cubicle with one thumb in his vest in a self-confident pose, plays to the power of the upper-class woman as though to say, "Well, who will it be?"[33]

Burr's sympathy is clearly with the underclass. He highlights the heads of the two women who have applied for work but places the face of the wealthy employer in shadow. The space between the unemployed women on one side and the rich woman on the other is gaping, just as is, by implication, their difference in class. The supplicants— the "have nots"—stand, the one who "has" sits. The poor wear whatever clothes they can get, and they lack gloves; the rich one is generously furbished. The agent mediates between the groups, attentive to his financial rewards and unmoved by the emotional implications of the situation. When the painting was exhibited at the National Academy of Design in 1849, it was neither reviewed nor purchased. Although critics liked images of Italian beggars and scenes that focused on class differences in Europe, they were apparently not prepared to admit such topics into the repertoire of American painting. Indeed, that there were class differences at all in the constituency was disguised, even denied, in public rhetoric. After a few other such forays with urban subjects, all unrecognized, Burr soon gave up painting altogether and became a writer of moral tracts.[34]

The images of Lilly Martin Spencer in the late 1840s and 1850s presented a very different commentary on the role of women in society. The only female genre painter to pursue a career during the antebellum period, Spencer was also almost alone in constructing images of a type from within an implied group. No rural New Englander constructed the yeoman farmer; no black artist painted genre images of blacks. The only other inside voice in the construction of genre images was that of Bingham representing Westerners from the West; and as he was both urban and

urbane, even his representation of (rural) Westerners was from the outside. Within the general function of images of women, male artists were interested to show the intersection between women's and men's spheres as occurring on only the edges of the male world, but Spencer gave an insider's view of the domestic sphere that attempted to make this sphere central, dignified, and even glamorous. Her pictures, easily readable by the most inexperienced viewers, reassured women of their value and beauty. But Spencer did not seem to be particularly happy in her career. She had to work within a (New York) market in which the strictures of domestic ideology extended to her options as an artist.[35]

Essentially self-taught through several years of exhibition in Cincinnati, in 1848 Spencer sold several of her paintings to the American Art-Union in New York. Believing therefore that she would find welcome support in New York, within a few months she had moved there with her husband and children. Like other genre artists in the period, however—all of them male—she experienced great frustration. The drop in the New York audience's interest in American genre paintings about 1850 in favor of "uplifting" and less overtly topical landscape painting (indeed, to a large extent, the changing audience for painting) provided one great disappointment; another was the fascination of new art patrons with European paintings, being exhibited in New York in increasing abundance. These paintings variously hearkened back to the Old Master tradition, told complex historical narratives in intricate detail, or provided cultural novelties (scenes of minstrels in Italy, for instance) attractive to viewers eager for distractions. These were pleasures remote from the social anxieties invoked in American genre painting.[36]

But Spencer faced difficulties specific to her gender. She found that even though she had developed the capabilities to paint a wide range of subjects in Cincinnati, she had to work in New York within the prescriptions for interests and activities appropriate to her role as a woman. Although she brought with her a number of pictures and sketchbooks with Shakespearean and other literary or allegorical themes and two domestic scenes, she was able to sell only these domestic scenes last. Her literary scenes—created from a corpus of literary material that Sully, Edmonds, Leslie, and others had worked successfully for years—attracted no interest. A male friend back in Cincinnati diagnosed her situation precisely. Her problem, he wrote her, was that she was presenting herself as an expert in the wrong area: "The question then arises why you have not sold many more pictures—It is only because instead of two pictures of your peculiar 'genre,' you have not had twenty. The plain truth is that pictures remarkable for Maternal, infantine & feminine, expressions, in which little else is seen but flesh, white drapery, and fruits, constitute your triumphs, according to popular estimations." As New York critics in their very

language would reveal over the years of Spencer's career, her friend was correct: audiences' restrictions on what she might offer them had to do not so much with "popular estimates" of her "triumphs" as on estimates of her "natural" specialty.[37]

In contrast to her male counterparts' relative freedom to denigrate and satirize members of the body politic, then, Spencer's role as a female artist was to communicate virtue and to exercise moral influence. To do this, she had to depict the Americans who supposedly made virtue their province—the middle-class domestic woman. And these Americans, under her brush, were never the objects of satire. Her patronage is particularly significant for this reason. Just how free she was to negotiate relationships with individual patrons—even women—is not clear. But the record shows that her most dependable patronage was from art unions, first the American Art-Union and then, after it folded, the Cosmopolitan Art Association. This indicates at least two things: that she was most easily dealt with as a producer for a group taste rather than one who worked with the idiosyncrasies and taste of a private patron and that members of the boards of the art unions perceived her work as appealing to, and good for, a large, relatively inexperienced, and uneducated audience. That she sold many of her designs independently to lithographers also suggests the mass appeal to which she directed her constructions of the female sphere.

In spite (or perhaps because) of her popularity with a large audience, as a female artist Spencer was always treated with condescension, whether implicit or explicit. She was permitted to study drawing at the National Academy of Design, but only in the evenings; and in 1850 the board of the academy made her a member, but only an honorary one. In print she was almost always referred to as a "female artist," with the subtext that, as *Sartain's Union Magazine of Literature and Art* put it, "the occasions are rare, and therefore regarded as remarkable, that a woman appears as a competitor, coequally with the other sex, for distinction in the higher branches of art." Her staunchest supporters used special pleading to recommend her pictures. Frances Dana Gage, of Saint Louis, exhorted Spencer's audience as late as the mid-1850s, after she had enjoyed some success: "Let Men . . . know that with the skill of her hands and the power of her head, she sustains a family. . . . Aye, sustains them a thousandfold, better than she could have done with the needle or the washtub, and gives out to the world besides, the rich treasures which become the rays of sunshine in many a heart and home. Heaven bless thee, Lilly Martin Spencer." And unsympathetic viewers condemned Spencer for aiming no higher than the subjects to which the ideological convictions of patrons and critics had consigned her. Cincinnati artist John Frankenstein awarded her the ultimate putdown in his satirical verses "celebrating" art (*American Art: Its Awful Attitude; A Satire*). "Let not my justice,

gallantry and wit / A Lilly Martin Spencer here omit / The humor of the lower life she shows / Where in but few superiors she knows." New Yorkers could be just as savage. The *Literary World* complained in 1851, "We wish Mrs. Spencer could be persuaded to spend her time and talents on something more worthy than . . . druling, disgusting, naked babies; still we would rather see her painting such subjects than murdering Shakespeare. If she loves them she ought to paint them; but it does seem that there are fairer and more attractive subjects in her reach." Whereas Mount had been able to turn his country origins to his benefit, and Deas and Ranney their Western "experience" to their credit, Spencer had her experience—essentially, her gender—held against her at every turn.[38]

Spencer followed her friend's advice about proper subjects. Although her sketchbooks show that she never abandoned her fascination with themes from literature, at the easel over the next decade she specialized in the "maternal, infantine, and feminine" both in paintings and in drawings that she hoped would win commissions for paintings. Unlike her male counterparts, she did not undertake scenes of courtship or of female influence outdoors (this alone suggests that she saw courtship as essentially about men rather than women), she did not paint scenes of misbehaving young sovereigns, and she painted women only of the comfortable urban home. The satire, or even the comedy, of Mount, Edmonds, or Browere was not in her line. Rather, in the "maternal" line she depicted women taking care of infants, dressing toddlers, and reading to young children. These children are cute, manageable, and physically engaging. In the "infantine" area, she showed toddlers playing peek-a-boo and four- to five-year-olds teasing household pets, snatching forbidden treats from the dining table, and playing with such toys as dolls and boats. In the line of "feminine expressions," she produced paintings of marriageable young women and of women in the kitchen. Finally, she produced several works in which fathers or grandfathers take their place in the home, entertaining children with stories or games. While she heightened the beauty and importance of these roles, her pictures always make it clear (to modern viewers at least) that female domesticity is contingent on power that is elsewhere.

Although male genre painters had focused on courtship and the outdoor influence of women, themes of male self-definition, Spencer chose motifs of females in the home that undergirded female self-definition. The earliest image with which she gained a national reputation, in fact, was a celebration of female domesticity in its most practical form— that in the kitchen. It is an image that both accommodates the status quo and attempts to

invest it with new meaning. With *Shake Hands?* 1854 (pl. 20), Spencer refuted the common accusation that women were bent only on spending their husband's money to keep up with the latest fashions and made the case that domestic labor was joyous, healthy, and dignified. About as far as imaginable from Bingham's and Edmonds's presentations of women at the washtub, Spencer's representation shows a woman in command of her world. In *Shake Hands?* a spirited, self-confident woman presides over a scene of abundance. Standing at a kitchen table mixing a recipe in a large pan, she has at hand a tempting array of ingredients and equipment—chicken, celery, cabbage, apples, and onions, and shining pans, pots, and kettles. Behind her a fire glows in a stove, over which is a mantel decorated with more gleaming household equipment. Yet the furniture is simple and unpretentious; the abundance here is natural, remote from fashion. Spencer's heroine wears a workaday print dress protected by aprons (she has also pinned back the front part of her skirt); though she has her sleeves rolled up, she is neatly coiffed, and delicate earrings add a feminine touch. In her younger middle-years, she is a fecund mother-figure—buxom and radiating good nature and sexuality. Having turned from the production of children to the production of good things to eat in the kitchen, she extends her dough-covered hand to the viewer.

Her offer to "shake hands" is a bold one. Shaking hands was the ritual of male equality in the Republic, fundamental to male citizens' sense of status. Class-conscious European visitors were taken aback by what they claimed was Americans' ubiquitous rage to assert their equality—some remembered with distaste that even their hosts' coachmen had grabbed their hands to shake them. Spencer's woman is laying claim to her equality. It is a limited equality, of course, because she is rooted in the domestic sphere, and the patent messiness (and thus impossibility) of the transaction both diminishes and highlights the irony of Spencer's point, depending on the viewer's convictions. In spite of the resistance to domestic subordination embedded in the motif of the picture, the image was so flexible—so readable as diminishing *or* enhancing of women—that it was an immediate success: Spencer exhibited it in several cities, had it lithographed, and in 1857 sold it to the Cosmopolitan Art Association, which in turn engraved it again for distribution to its subscribers. The association, which perceived women as its primary readership, advertised the image in terms that avoided all reference to its social assertions. It subsumed these implications, in fact, by placing the work in the art-historical tradition. "Perhaps no picture painted in this country," the *Journal* claimed, "is better fitted for popular appreciation. It reminds us constantly of the incomparable pictures by the Flemish artists." The rest of the advertisement provides another insight into the contemporary rationalization of genre painting: as though Spencer, and American genre painters in general, had in

mind an invigoration of the tradition rather than an examination of the present, the critic concluded, "No person is doing more than Mrs. Spencer to 'popularize' art."[39]

Although critics found gratifying Spencer's situating of a mature woman in the kitchen, they did not like her attempt the next year in *The Young Husband: First Marketing* (fig. 44) to associate a man with domesticity, nor to imply in a companion painting called *The Young Wife: First Stew* (now lost; the study is fig. 45) that the role in the kitchen, even for women, was learned rather than natural. The "hero" of *The Young Husband: First Marketing* has shopped for groceries, and he is so inexperienced that he has not even been able competently to pack the basket in which he is carrying his purchases home. Although he wears a dignified black suit and hat, as well as fashionably heeled boots, the message of his sartorial elegance is completely contradicted by his dismay as he tries to keep a plucked chicken from following the path of another one that has fallen from his basket; both have been preceded by carrots, lettuce, eggs, and tomatoes. To make the situation worse, it is pouring rain, and the young husband clearly will not be able to raise the umbrella with which he struggles. His frown reveals his discomfort, and his humiliation is made clear by the smirking look cast at him by a passing male colleague who jauntily strides under his own umbrella in perfect freedom. Across the street posters proclaim the latest dramatic attractions and other citizens competently make their way. This picture clearly appeals to the amusement of a female rather than a male viewer. To offer pleasure to the other gender, Spencer ostensibly calculated the companion painting *The Young Wife: First Stew* to appeal to males: simpler than *The Young Husband*, this image presents a young woman who, apparently new to kitchen tasks, is chopping onions and shedding tears. Spencer's strategy did not work. When she exhibited the works at the National Academy of Design in 1856, critical response was negative, and she did not sell the paintings either. Correspondent "J. K. L." indignantly wrote the *Knickerbocker* that "*The Young Husband's First Marketing* is quite a comical thing; but it strikes me that his head is most enormously large, and quite out of proportion with his body; and as for *The Young Wife* . . . she looks like an old maid who might have been in a great many stews before." One notices immediately that this viewer's critique of the male figure was directed at Spencer's "inabilities" in drawing; his critique of the female figure disparaged femininity in general. The critic for the newly established periodical the *Crayon*, which self-consciously advocated "high art," was even more condemnatory. He saw the subject as frivolous, referring to the woman as a "grinning housemaid." He then blamed Spencer for making the very type of images to which her patrons and critics had limited her: "Is there in her woman's soul no serene grave thought, no quiet happiness, no tearful aspiration, to the expression of which she may give her pencil?"[40]

Figure 44.

LILLY MARTIN SPENCER

The Young Husband: First Marketing, 1856. Oil on canvas, 29 1/2 × 24 3/4 in. The Manoogian Collection.

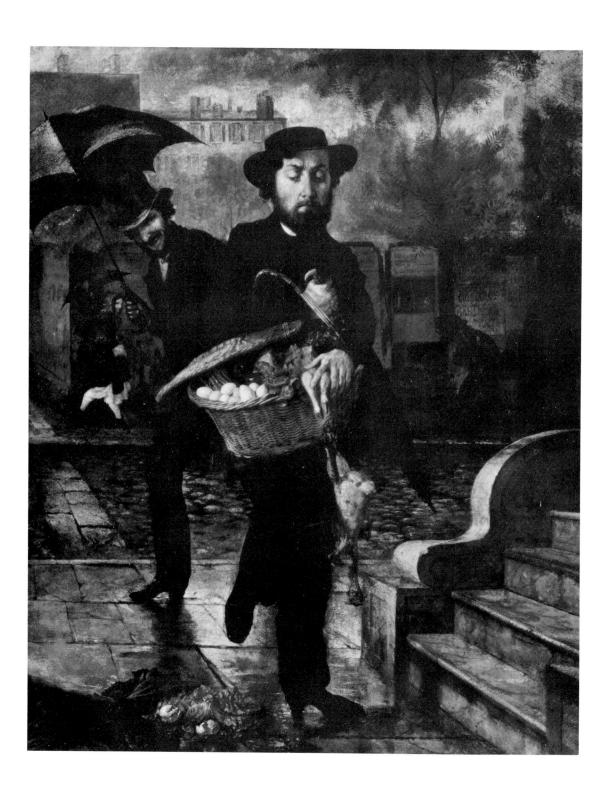

167

About this time, no doubt attempting to expand the narrow range of her options, Spencer took up a new direction in domestic imagery. Emboldened perhaps by the influx of European images in which women were sexual as well as domestic creatures, she began to shape within some of her images the theme of sexuality, virtually a forbidden topic in discourse—except, of course, in oblique references to males' sexual drives, always perceived as dangerous. The cultural denial of women's sexuality was not restricted to imagery but was a major constricting force in American literature as well. Of male painters, only Thompson in *Apple Gathering* had hinted that such a force operated between young American men and women. But Spencer, in *Kiss Me and You'll Kiss the 'Lasses,* 1856 (fig. 46), elevated it. The painting is, like *Shake Hands?* a scene of domestic abundance and kitchen expertise, but here the woman is younger, slimmer, and more decoratively dressed. Her hairstyle is more elaborate, her dress is more formal and constructed of elegant fabrics, and her earrings are quite fanciful. Moreover, she works in a space that leads not to a kitchen stove but to a well-appointed parlor. The kitchen table over which this young woman presides is the picture of nature's prodigality. The white tablecloth is pulled aside to provide room for her ingredients—pineapples and apples, raspberries, cherries, and figs—and for her equipment—a scale, vessels of several sizes, pitchers, a cruet, and various utensils. Not a mother-figure, however, this woman is a wife or a sweetheart figure. She looks around at the viewer suggestively. About to mix molasses into the apples in the pan before her, she has been tasting her mixture as she goes and threatens to give the intruder a jab with the dripping spoon in her left hand. The scenario is aimed explicitly at a male viewer, and it presents the woman not as a republican equal but as a sexual object. In fact, the actor here is the viewer—and the viewer is emphatically male. Spencer constructed the image from so low a point of view that the viewer sees first this woman's firm, youthful body; in *Shake Hands?* in contrast, the viewer looks directly into the subject's face. The title of the painting points in two directions and makes explicit the sexual dimensions of the invitation to the viewer: *lass,* of course, meant young woman, and "lips as sweet as molasses" was a common Yankee expression. Yet the setting within the painting contradicts an overt sexual invitation by providing the viewer with a glimpse through the kitchen door into the sedate, well-furnished parlor, the center of domestic quiet and cultivation. The parlor assimilates the flirtatious young woman into a proper sphere.[41]

The sensitivity of the Cosmopolitan Art Association to the marketability of such sexual titillation, as well as the necessity to construct advertisements that described this eroticism in disguised language, is clear in the managers' presentation to the membership of this and other of Spencer's images. The Association had commissioned *Kiss Me and You'll*

Figure 46.
LILLY MARTIN SPENCER
Kiss Me and You'll Kiss the 'Lasses, 1856. Oil on canvas,
30 1/16 × 25 1/16 in. The Brooklyn Museum.
A. Augustus Healy Fund.

Kiss the 'Lasses, just as it had commissioned *Shake Hands?* Carefully setting forth the work's appeal, editors described the heroine in the *Journal* as "a coquettish girl, apparently engaged peeling apples. She is teased by some person, whom the picture does not show, who is trying to kiss her. She quietly seizes a spoon from the bowl of molasses on the table beside her, and is poising it to give the 'provoking fellow' a daub." Emphasizing the flirtatiousness set forth in the image, the advocate for the association at once flattered the young woman's attractiveness *and* made it clear that, her resistance notwithstanding, she is an object of desire rather than one who desires. That this image was marketed through an organization so explicitly devoted to women's taste suggests how nuanced and various was women's capacity to work within domestic ideals. *Kiss Me* affirms at once women's desire to be attractive *and* proper.[42]

Just as Spencer exploited her responsibility to depict women as domestic, and in so doing was able to convey the sexuality that women longed to have acknowledged, so she created a distinctive repertory of images about children. Here, too, she exploited her limitations and subtle freedoms as a woman. Male artists, consistent with their preoccupation with sovereignty, masculine autonomy, and social control, attended to boys. Spencer, by contrast, was subtly empowered by her patrons and viewers to attend to children—not boys of five or six, but very young children, of about three or four, on the borderline between babyhood and childhood. These toddlers are so near to infancy that in representation they are primarily young bodies; at the same time they are so clearly young *people* rather than babies that the images of their bodies have strong sexual connotations. Spencer posed these children to be looked at, much as women throughout the history of image-making have been presented to be looked at.

That Spencer's images of children were her most popular works and were chosen for lithographs more than any other topic, would seem to reveal the hunger of her viewers for recognition of this suppressed area of emotional experience. Whereas the closest that she came to associating full-bodied sexuality with women was in her kitchen scenes, in her pictures of children she used many of the much more direct clues with which artists in earlier times and in other cultures had evoked sexual meanings. Spencer's very young children are epicene. Undifferentiated by dress as to gender (as was the cultural practice), they are represented in the world of the bedroom, of intimate dress, of toys, and of pets. She posed her slightly older children with a wide array of objects both natural to childhood and recognizable as motifs of the power relationships of gender—dolls for the young girls, wagons and boats (instruments of activity that are also vessels) for the young boys. Spencer depicted these "little darlings," as her critics were fond of calling them, with dress tops sliding off their shoulders (exposing incipient cleavage), socks

Figure 47.
LILLY MARTIN SPENCER
The Little Navigator, 1854. Unlocated lithograph.
Photograph courtesy Smithsonian Institution.

falling around their feet (implying the act of undressing), pets being fondling, toys defining the subordination and coyness that they are just learning to adopt, and postures conveying invitation with coquettish looks toward the viewer.

The Little Navigator (fig. 47) and *The Little Sunshade* (fig. 48), both from 1854, are the most blatant of these images. *The Little Navigator*, now known only through a lithograph, presents a blond ringletted child in underwear, the toy soldier and animal sculpture suggesting that the child is a boy. Chemise straps falling completely over his shoulders and accenting a slightly rounded bosom, he looks suggestively at the viewer. One foot is bare, and he floats his shoe in a commode bowl. The nearby pitcher verifies both the bedroom setting and the intimate nature of the service of this bowl. The coy title heightens and softens the innuendo of the activity: the designation "navigator" reminds the viewer-voyeur that the subject doing the navigating is after all a child playing at adult activities. His navigation is restricted now but portends his social power in the future. In recommending this titillating picture to their subscribers, the *Cosmopolitan Art Journal* would seem to have been writing of another image altogether. Reporting that this was one of Spencer's most popular pictures, the journal called it "fresh, finely-colored, delightful . . . showing something merry and genial in the soul of [the] . . . author."[43]

An image of a young girl is even more sexually allusive. In *The Little Sunshade*, now also known only through a lithograph, Spencer placed a small child in a dress with falling shoulders that accentuates the slight separation in her bosom. Her petticoats are evident beneath her skirt; her socks slide down her chubby legs to call the viewer's attention to the fact that clothing can be removed. From under the shade of a leaf that she holds like a parasol—a device that is as make-believe as the boat being navigated—the child looks insouciantly at the viewer. One wonders if contemporary viewers actually did not consciously *see* the sexual innuendoes. Women as well as men praised the picture in terms that sidestepped, but seemed delicately to acknowledge, the eroticism here. Spencer's supporter in Saint Louis, for instance, Frances Gage, praised the picture as depicting a "chubby rogue beneath the mimic sunshade."[44]

That audiences were able to read these pictures and enjoy the sexuality while never mentioning its existence—assuming that they did so—was apparently essential to the popularity of the representations. What Spencer could not convey directly about women, or about women's covert longings for recognition of their sexual natures, she was able to evoke in these many images of willful, independent, sensual, and above all theoretically perfectly innocent children. Just how skillfully critics normalized such sexual messages by identifying them as something else is especially evident in the reception of an image now lost, *Nothing Else to Do*, from about 1860. A writer described it as "a delightful little

picture, by the first among living female artists. A very pretty young girl, partially in undress, is playing before a mirror with a parrot, showing it its own image. The expression on the girl's face is one of archness and innocence." The cultural work that Spencer carried out in such images was, apparently, absolutely closed to male artists. It seems to have been the case that, as far as such public images were concerned, only the putatively passive members of society, who specialized in the indoors, the restricted, and the repressed, knew the codes and were permitted to use them.[45]

Later in the decade Spencer focused explicitly on motherhood. Although one cannot chart with absolute conviction the correlation of images about women with historical events, as one can with images of the Yankee and Westerner, that Spencer turned late in the decade of the 1850s to paintings that practically enshrined women as mothers is unmistakable. She may have been responding to the increasing attacks on feminist agitation as well as to critics who identified unruly children as the responsibility of inadequate mothers. Whatever the case, while she was winning audiences with her embodiments of bedroom sexuality in the "young folks," Spencer was representing motherhood as virtually sacred, in terms quite distinct from those of Browere, Clonney, and Edmonds. Her sketch books during her New York years are filled with dreamy depictions of such topics as "Mother and Child," "Mother and child with a Parrot," "Mother Holding a Sleeping child," "Mother Sketching a Sleeping Child," and "Mother Watching Over Two Sleeping Children." Carrying into contemporary life the long fascination in European art with depictions of the Madonna and Child that were so popular in New York for at least a short while and that had been popular since the eighteenth century in the work of such French artists as Greuze, Spencer made the urban middle-class mother into something of a secular saint. Her mothers are mothers of toddlers, children who are too young to be unruly but who bear some hint of the sexuality of the children pictured alone. The mother in these images is an ideal figure of beauty, taste, and emotional calm. This is especially apparent in *This Little Pig Went to Market*, 1857 (pl. 21), bought and engraved by the Cosmopolitan Art Association. The title of this jewel-like image is taken from the game that the mother plays with the child's body—specifically, the child's toes. The setting is the child's bedroom, with a festooned bed in the background on which pillows are heaped high. This is a room absolutely devoted to the child's comfort and, the modern viewer feels, the comfort that both child and mother feel with their bodies. The child is alive with pleasure, secure in being at the center of his mother's existence. In turn, the sumptuously dressed mother seems com-

pletely fulfilled; reds, greens, and blues in the image proclaim a psychological satisfaction on the part of the figures that is almost palpable. For Spencer, motherhood was never laughable and always perfect. Her women perform exquisitely the function society has placed on them.[46]

Able as she was to cope with market forces in the early and mid-1850s—forces driven primarily by an anonymous patronage of middle-class domestic viewers, Spencer saw her career taper off in frustration. Male genre artists still working in the late 1850s—Mount, Bingham, Clonney, and Edmonds—were also distressed, but Spencer was more severely limited than they. In 1858 she and her husband moved their large family to Newark because she was insolvent. Through the 1860s she colored photographs and drew illustrations for *Godey's Lady's Book*. By the time she was able to rent another studio in New York and reestablish her presence in 1868 and 1869, the market for what had been her specialties had vanished, and she turned to allegory and portraiture. The feminine role that was to be depicted after the Civil War, for the brief period before genre painting flickered almost altogether, was much more ambiguous, one for which she was not prepared.

Six *The Washed, the Unwashed, and the Unterrified*

By 1850, as Mount's investment in the Yankee farmer had almost stopped paying returns, Bingham was turning to the settled Western citizenry for his formulations (with what would be deceptive hopes), and Spencer was chafing at the constraints of her New York viewers, national genre painting seemed to have lost whatever edge it had enjoyed. The chief problem was that the polity implicated in genre scenes was no longer a tally of recognizable "others." For most speakers in the seats of cultural judgment, the body politic had become so diverse that the promise of the early days of the Republic, and even the fainter hopes of the more recent days of transition, seemed beyond recovery. To make matters worse, the citizenry was clearly becoming urbanized. Whereas citizens in agricultural areas could be identified with natural simplicity and those in the open West with individualism, the city was the locus of conflict, stratification, and frantic consumption. Urban citizens found it almost impossible to turn a critical eye on themselves and create a battery of urban types—merchants, clerks, artisans, vendors, laborers, and lawyers—people who were conspicuously not virtuous, or simple, or autonomous but who reveled explicitly in jostling each other to go after the main chance.[1]

The statistics about the growth of cities during the antebellum period suggest the intensity with which citizens' anxieties about urbanization must have been felt. While many Americans were striking out for the West—in any one decade from 1830 to 1860, between 44 percent and 70 percent of adult males moved away from the Northeast—others were heading to the cities. Between 1830 and 1860 New York grew from a city of 200,000 to one of 800,000; Philadelphia, at 161,000 people in 1830, was 500,000 by 1860; during the same period Boston's population grew from 61,000 to 133,000. Inland cities mushroomed, too. As river commerce grew increasingly vital in connecting the country, Pittsburgh, Cincinnati, Louisville, Memphis, and Saint Louis expanded enormously. Half a million immigrants arrived in the port cities in the 1830s, a fourfold increase over the previous decade, and then that figure also grew astonishingly, until during the worst years of the potato famine in Ireland, 1847–1854, more than 1.2 million immigrants arrived in America from Ireland alone.[2] Overwhelmingly, they stayed in the cities.

Early on, outspoken American critics did not consider the city as necessarily evil. Many

in the middle classes, especially those who had come in from the countryside, found themselves caught up in a whirlwind of excitement about personal potential in the city. Merchants saw it as a place of opportunities in commerce and association that could be found nowhere else. Visitors frequently commented on the breakneck pace of New Yorkers, who spawned one project after another, pushing out the city's boundaries and in the inner city replacing old buildings with new, establishing hotels and theaters, and scheming to connect the nation with canals and railroads.[3]

Yet certain citizens had been suspicious from the nation's founding about the compatibility of cities and republicanism. The mingling of large numbers of people in cities, especially young men eager to make their fortune but lacking stabilizing connections to families and other social structures, was seen as dangerous to character and judgment. By the 1840s, cultural critics had identified New York especially as the locus of severe threats to the Republic: there the rapid accumulation of wealth and its ostentatious display, overt class divisions, manipulative mass politics, and corrosion in the traditional relationships between employer and employee were ominous. The city as an abstraction could be blamed for providing the naive citizen the examples of social pretense that Anna Mowatt satirized in her play *Fashion*, 1845, and her book *The Fortune Hunter: A Novel of New York Society*, also 1845, in which a society of conscience-less businessmen, inordinately ambitious wives, and Americans of both genders were willing to be fooled by confidence men masquerading as aristocrats. With competition so strenuous and the push for mobility so frenzied, the constituency of New York seemed to many to be in constant flux. As John Todd warned in 1841, "Today you see a man who seems to be the centre of a vast circle, the main-spring of a great business. Tomorrow he drops into the grave,—the crowd pause a moment, and then the tide rolls on as if he had never lived."[4]

These circumstances posed a severe problem for visual representation. From the 1830s American printmakers had published European-derived city scenes that showed the hustle and bustle of commercial life, including merchants, factors on the wharf, shoppers, carters, and here and there a peddler or young street trader, and printmakers published editions of street cries showing characteristic vendors with their wares. But beyond such chauvinism about commerce in the cities, citizens seemed reluctant to develop recognizable urban types—from either the ambitious middle groups *or* the working classes. Although a small literature of city types was initiated by a few hopeful writers in the 1840s, and a battery of satirical images about con men and foolish city slickers dotted short-lived journals of humor, self-important merchants, bankers, industrialists, professionals—and the patrons of American art—did not see their own pursuit of money and status as topics for humor, as did European wits looking at such practices in

their own cities, and these efforts struck no spark of assent. Moreover, writers and car-icaturists created few literary and visual working class types beyond occasional lists of the types hustling and bustling on city streets, despite precedents in European genre paint-ing and popular imagery. This phenomenon suggests that a long-standing class system was fundamental to the creation of urban types. Whereas Europeans created artisan and laboring types (beginning with series of "Street Cries" in Paris and London in the eigh-teenth century) ostensibly to celebrate the economic productivity of cities, they seem more accurately to have inscribed social differences in the evolving economic order, differences that were matter of factly part of the social world. In the United States, how-ever, typing in the antebellum era specified an other who was in a competitive relation-ship with the group doing the typing. And thus the Yankee farmer—essentially as middle-class as the urban citizen—served American viewers well as a figure on which to project the irresponsible economic behavior of less responsible new men in their midst, and Western types provided another service in being repositories for fantasies of social freedom. The characterizations of blacks, and women, too, trained concern about threatening characteristics away from urban men and onto the groups they had subordi-nated in order to support the economic and social power at which they grasped. Al-though one working-class type did become prominent from the late 1840s—Mose, the strutting, self-satisfied fireman, the Bowery B'hoy—his creation formulated the de-mands of new theater audiences and buyers of prints who were members of the working class themselves, and who had begun to form a separate constituency for cultural pro-ductions. Mose, arrogant and sexually aggressive, was *not* a type that genre painters—who worked for a dominant group increasingly intent on "gentility" and those who would be like them—took up.[5]

Only one artist, in fact, took the urban middle class—more properly, the much maligned new men—as his (almost) explicit subject. Richard Caton Woodville perhaps had the courage to do this because he was painting from Eu-rope. Woodville's driving interest was the "middling level" of the citizenry—the mer-chants, young men, and people of no family who were on the make. An urban person himself, Woodville was unusual in studying, and then living, abroad. Not only Mount but Clonney, Deas, Ranney, and Spencer saw foreign study as beyond their means, and Mount even harbored the notion, encouraged by critics, that being abroad would inter-fere with his sensitivity to the forces of American culture. Woodville, by contrast, used his study at Düsseldorf and experience abroad to advance a vision in which careful draw-

ing, sophisticated handling of color and light, and extensive use of narrative detail enabled him to make a unique construction of America's urban, or at least skilled, body politic.[6]

Woodville's scheming, nattily dressed types—almost all men, following the focus with which his predecessors had built their audiences—were vastly different from Mount's and Edmonds's farmer-yeomen, and they showed none of the healthy openness and wilderness skills of Deas's, Ranney's, and Bingham's westward-roving trappers, rivermen, and sovereigns. Woodville chose city dandies, well-heeled merchants and leading citizens, newspapermen and women crusaders, and traveling card sharps. Instead of on the farm or on the expanse of an endless prairie, Woodville put his character types in interiors: a magistrate's office, a tiny oyster booth, a railroad or stage office, and the overarching porch of a hotel. Confining, dark, and cluttered, these spaces registered the transitions both literal and psychological of a changing populace. The issues in this citizenry are economic disorder and deceit.[7]

In his early *Card Players,* about 1846 (pl. 22), he placed three of these new types in a dark railroad waiting room. But they have none of the innocence that Bingham, then working from his position of interest in Missouri, was to assign young Western men; and they have none of the outdoor redemptive qualities of Deas's *Long Jakes.* Gambling, passing the time as they wait to move on, in a room in which tilted schedules and notices suggest a crooked moral atmosphere, they are indoor disreputables. The major interest of the painting is the psychological battle between the sharpster on the right and the potential victim on the left, with additional intimidation being provided by the kibitzer leaning over the table and ironic commentary by the guarded amusement of the slave sitting in the corner. Each citizen is out to dupe the others; they band together temporarily, remaining cohorts only so long as it helps their own interest.[8]

Another highly charged interior is seen in *Politics in an Oyster House,* 1848 (pl. 23). In this work, Woodville depicted politicking as occurring in the talk—apparently the endless talk—in the urban coastal oyster house. With just two figures in the picture, Woodville suggested a generational division that made his point even more widely allusive. Oyster houses were notorious gathering places for commercial and political exchange, and this one features the booth for privacy, cuspidor for spitting, and supply of newspapers for inevitably politicking patrons. The younger citizen seems enraptured with the point he is expounding, but the older man listening to him slumps in boredom; he turns away as if to say he has heard it all before. Unlike Mount in *Farmers Bargaining,* Woodville depicts no jostling for concrete, material advantage, merely talk and more talk.

Talk and even more evidence of self-interested calculation also form the central motifs

in the artist's *War News from Mexico,* 1848 (pl. 1). Gathered on the porch of the symbolic American Hotel to hear the news that will announce the wisdom of their schemes, from the open-mouthed newspaper reader to the fellow who hoists his hat in jubilation at what he hears, Woodville's gathered sovereigns are fully engaged in the business of the Republic. Each calculates his interests in response to the news. These interests, like the ages and social spheres, are diverse: the young man on the left raps his knuckles against the porch post as though for good luck; the two older men whisper excitedly, perhaps conferring or perhaps the spatted gentleman is being filled in on the implications of the news. Other characters in Woodville's cast, as already discussed, are literally, and by implication figuratively, at the edge of the crowd. Woodville's command of details is crucial to the point of his story: the feather in the black man's hat is at poignant variance with his independence and poverty; a pile of matches on the porch floor in front of the nattily dressed cigarette smoker indicate that he's been occupying that spot for quite a while; a placard calling for "volunteers for Mexico" suggests to the sharp viewer that the war has set in motion all kinds of volunteerism; and the sign on the right wall indicating a horse sale adds overtones of the horsetrading of economic and political palavering.

Although Woodville blurred regional differences into one scheming, self-conscious, worldly wise American figure that would seem to have been a direct indictment of many urban citizens, his New York audiences saw him as projecting the criticism on others in the population. Urbane New York reviewers in 1850 described his unflattering *Card Players* as a "capital western interior" and his cynical *War News from Mexico* as set in a "southern tavern." His *Young '48 and Old '76,* 1848 (fig. 49), in which he juxtaposed the implications of the Mexican War with those of the Revolution, even seemed to many the next year judiciously to indict several constituencies—none of them, of course, associated with New York. As the *Literary World* commented in 1851, when the painting was engraved for distribution through the Art Union, it was "a contrast of the past and present age, the days of Washington and Taylor." The contrast, in fact, potentially worked to support opposing points of view. Northerners and others against the war tended to see Zachary Taylor, a Southern slaveholder and general in the Mexican War who ran for president on his war record, as a demoralizing contrast to George Washington. For them, the analogy between past and present was a condemnation not only of Southerners but of the propriety of the Mexican War as opposed to that of the Revolution. For Southerners and others in favor of the war, however, the painting presented an endorsement of a justified war: the young man in the picture—"Young '48"—is noble looking, the proper home vouches for his virtue as well as the respectability of his point of view, and the hovering old revolutionary soldier—"Old '76"—is integral to a family

Figure 49.
RICHARD CATON WOODVILLE
Young '48 and Old '76, 1848. Oil on canvas,
21 × 26 7/8 in. Walters Art Gallery, Baltimore.

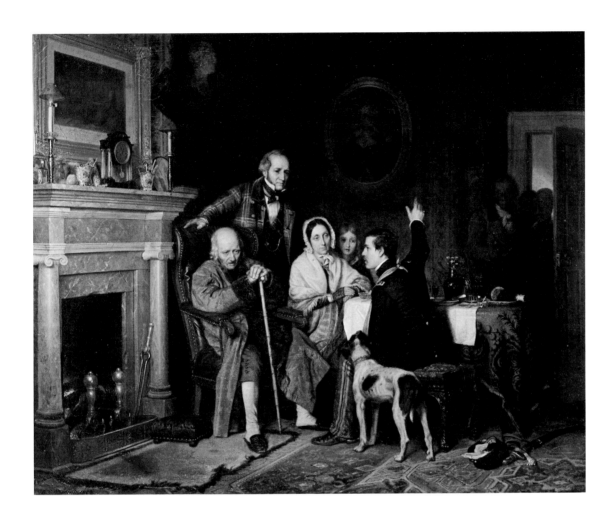

history of loyalty to tradition. Woodville, clever in the manner of Edmonds's image peddler, offers wares that can fulfill even opposing interests.[9]

Woodville's interpretations of a city-sharp constituency found a ready audience. The American Art-Union, acting on behalf of a membership increasingly interested in the narrative and detail associated with European paintings, was his major institutional patron, while the institution's directors were his primary individual patrons. He had embodied for them the characteristics they blamed for commercial decay. Woodville spoke to the concerns of Mount's earlier patron Henry Brevoort, for instance, who with the certainty of one who had seen better times assailed "the morals of businessmen and lawyers, and the manners and taste of commercial families [which are] degenerate and corrupt to the very core." But the pictures also colluded with the opinions of a much larger audience, registering a cynicism comparable to that in the growing literature of stories 181

about the calculating, amoral behavior of Southwestern yeomen, claim jumpers, lawyers, and civic authorities, written by Northern lawyers and editors in practice in the South and sent north for publication. He suggested the kind of population that Edgar Allan Poe presented in "The Business Man" in 1845, in which his main character perpetrates one sham after another, going sequentially into the "Assault and Battery business," "Eye-Sore line," "Mud Dabbling," "Cur-Spattering," "Organ Grinding," "Sham-Post," and "Cat-Growing," all dealings in speculation and self proclamation. At one with many writers, he was virtually alone among artists.[10]

Even rarer, in that no New York artist specialized in the motif, were painted images of the urban poor. Gambling, chicanery, and cutthroat competition notwithstanding, what aroused citizens' most profound fears in connection with cities—indeed, this topic headed any recitation of urban evils—was the influx of immigrants. By 1845 more than one-third of the population of New York City was foreign-born, by 1850 nearly 60 percent of New Yorkers had been born elsewhere, and by 1860 foreign-born accounted for more than half of Chicago, Milwaukee, Saint Louis, and San Francisco. Newspapers and journals, reprinting articles from across the nation, thundered daily about the ominous development of a permanent underclass. Trained neither in self-government nor in Anglo-Saxon middle-class manners, many immigrants presented what seemed to be unassimilable social differences; they brought few job skills and settled in crowded areas that rapidly became slums. So intense was the anxiety of the elite about immigrants' influence on crime in the city that Philip Hone began the New Year in 1840 with the following lament in his diary: "Riot, disorder, and violence increase in our city; every night is marked by some outrage committed by the gangs of young ruffians who prowl the streets insulting females, breaking into houses of unoffending publicans, making night hideous by yells of disgusting inebriety, and—unchecked by the city authorities—committing every sort of enormity with apparent impunity." So gaping had become distances within the nation's urban constituency by 1840 that William Ellery Channing lamented that in the cities "different ranks were so widely separate as, indeed, to form . . . two nations, understanding as little of one another, having as little intercourse, as if they lived in different lands."[11]

Any student of genre painting who looks at both sides of the Atlantic during the 1850s is struck by the contrast between the multiplicity of images of people in poverty in France, Germany, and England, and the veritable lack of them in the United States. Europeans pictured urban filth and degradation of the poor in horrible detail. As social

conditions in the crowded cities worsened, with huge influxes from the peasant popula-
tion, artists by the 1830s were depicting ragged street types in both painting and print.
French painters especially did not hesitate to paint a variety of social conditions in the
population, even to exhort that such conditions of misery be improved. America, in con-
trast, produced no comparable artists.[12]

One important reason for this difference seems to have been that established Ameri-
can citizens perceived the new immigrants and the urban poor as imposed on a body
politic the rules for which were already in place. The practices of this citizenry, especially
in regional competitiveness and economic individualism, seemed beyond the capacities
of indigent immigrants. And because a prominent function of the earlier typing had
been to adjudicate tensions between equals or near equals, language about the under-
class was flattening and reductive. In addition, painters may have calculated that viewers
would resist the dismal implications of acknowledging in formal picture-making that
such a threat to a stable society existed in its midst. In Europe, artists painted beggars
and street children to arouse the moral conscience of the elite and the comfortable to
perform acts of charity for those explicitly beneath them. In the United States, by con-
trast, sympathy was unlikely to be directed at figures who had both the vote and equal
economic opportunity.

Indeed, from the 1840s immigrants, laborers, and the urban underclass received the
disdain with which citizens dissociated themselves from practices of which they were
guilty or afraid. In story and moral example, the contempt for others that elite urban
speakers (sometimes subtly) had earlier projected onto Yankees and Westerners was now
blatantly attributed to the urban working class and poor. This was especially true in New
York. In 1846 critic and litterateur Nathaniel P. Willis confidently complained that only a
"superficial eye" would find the Five Points area (the most entrenched slum) colorful.
"At the Five Points," he wrote, "nobody goes in doors except to eat and sleep. The streets
swarm with men, women, and children. . . . They are all out in the sun, idling, jesting,
quarrelling, everything but weeping, or sighing, or complaining. . . . A viler place than
Five Points by any light you could not find." Poverty, many insisted, was deserved. The
writer of the observation that in the park behind City Hall were "little girls, with bare
feet, standing in the snow; infirm old women, half clad; and many, both young and
old, exhibiting traces of the severest privation and suffering," concluded his essay by
writing, "We have no 'lower orders,' except such as are made so by their own folly and
wickedness."[13]

Almost no figure was an easier target for the mixture of blame, projection, and at-
tempted amelioration than the child of the slums. Whereas European imagery often ex-

pressed sympathy with older women, impoverished mothers with children, and old men, American artists who took up the type of the urban poor focused on children. They singled out these children as examples of the entire class, in the same doubleness of the literature of reform: condemning those who were poor, yet urging sympathy and help. In 1840, the mayor of New York estimated that a thousand young vagrants in the city had been abandoned by their families or had left home in despair, and by 1850 the number had risen to three thousand. This street population slept in boxes in doorways; some became street traders by day, selling newspapers, matches, apples, flowers, gloves, or shoeshines, and by night resorting to pickpocketing, beggary, and thievery, often in groups with other youths or exploitative adults, to the extent that at least one-fourth of the 16,000 criminals sent to City Prison in 1851 were under age twenty-one, and 175 were under age ten. The American Sunday School Union railed in 1856: "The refusal population of Europe . . . congregated in our great cities and send forth . . . wretched progeny, degraded in the deep degradation of their parents—to be the scavengers, physical and more, of our streets. Mingled with these are also the offcast children of American debauchery, drunkenness, and vice. A class more dangerous to the community . . . can hardly be imagined."[14]

Artists, confronted with the inappropriateness of subjects of the urban poor for elite viewers who wanted both to differentiate the populace and to cherish a sense that the nation would survive on recognizable terms, typically chose to avoid the subject altogether.[15]

Those few who did, however, produced images of the newsboy and the bootblack the very characteristics of which underscore the dilemma of genre painters in representing urban types.

The first, Henry Inman's *News Boy*, 1841 (pl. 24), transformed a figure associated with grinding poverty into a prototype of American self-help. Although broadsheet sellers and news criers had filled the streets of American and European cities for some time, the newsboy's role had been created by the development of faster, cheaper printing technology in newspapers after 1833 and the subsequent burgeoning of a huge readership. Drawn from the street population, the newsboy was typically described as ragged and loud. Like the publishers who calculated the relations between what they printed and what audiences would pay to read, the young newsboys were also described as ruthless entrepreneurs: buying their supply from distributors and hawking them in heavy thoroughfares, they used such calculating tactics to attract customers that Joseph C. Neal wrote in 1843 that they considered the community their "collective trout." New York

merchant George D. Strong, disgruntled by what he characterized as dishonesty, haste, and rudeness in national life, in 1840 blamed the newsboy as the personification of all that had gone wrong in the nation. The newsboy, Strong asserted, was flagrantly rude, ill dressed, and a respecter of neither person nor custom nor truth. Projecting the sins of all the constituency on the urban newsboy, Strong wrote that, like America, the newsboy, "himself a creation of the hour . . . owns no ancestry."[16]

Inman painted *The News Boy* for Strong, who exhibited it in 1841, but the painter's representation suggests either his incapacity thoroughly to satirize a member of the underclass or his conviction that poverty was a temporary state if one worked diligently. Perhaps the painting meant both.[17]

Examining the newsboy alone rather than in social interaction, much as Deas did three years later with Long Jakes, Inman separated the newsboy from his "dangerous" peers and miserable family and placed him in the ordered, busy world of the comfortable classes, the world of the city street. Ten or eleven years old, fresh-faced and alert, the newsboy leans against the balustrade of a large building. Although his clothes and shoes are ragged and ill-fitting, he conveys a sense of style with a tie that matches the red collar of his overcoat and a threadbare hat set on his head at a jaunty angle. He holds a stack of newspapers, the top one prominently labeled SUN, and looks ready to call out the news for potential customers. His grin suggests a rash of startling headlines—and the eagerness with which the customer will buy a paper to read them. Behind him on the balustrade is a glowing bronze sphinx and just at his elbow is a partially eaten apple. On the wall below the sphinx is the faint scrawl "O.K." Large splotches of tobacco juice and other detritus of the city cover the steps and sidewalk; nearby are large, comfortable residences, one with smoke coming out of the chimney. The colors of the atmosphere suggest early morning, with dark shadows around the buildings and pink, glowing clouds in the sky. Far from the sharp-lined bright-colored images of Mount, and from the acid tongue of Strong, Inman's picture is a romantic idyll, painted with a loose, delicate brushwork in an oval shape usually reserved for "fancy pieces," sentimental pictures of young women or children.

Inman painted this image as the nation was barely emerging from a depression that had exacerbated urban poverty and unrest. Yet in iconography and style the painting was reassuring, both as to the newsboy as a social character and as to the vitality of the city. The building in front of which the newsboy hawks his papers is the Astor House Hotel, built in 1836 as New York's first modern hotel with every conceivable amenity, including steam heating and plumbing on each floor. The hotel sat on Broadway, the main thoroughfare for commerce and for the great procession of varied city types and

activities. The newsboy himself is an energetic fellow; though poor, and perhaps hungry (the half-eaten apple suggests a limited fare), in the hustling city these disparities seem to matter less than that the newsboy is up early and ready to capture customers from the hotel patrons and the hordes of passersby (each one, apparently, a tobacco chewer). The antiquity of the sphinx sets off the arrogance of the up-to-the-minute news of the city paper and, by implication, of its readers. The faded "O.K." chalked on the wall, an allusion to the presidential campaign of 1840 in which "aristocratic" New Yorker Martin Van Buren lost to "man of the people" William Henry Harrison, suggests that even in the rich city the common man will have a place. Yet the faded letters and the other items of ephemerality—the newspapers, the tobacco juice, the boy's youth—do evoke the fast pace of American life that Strong (and other commentators) bemoaned. Avoiding the comic digs with which Mount caused his viewers to laugh, Inman presented an interplay between new and old, poor and rich, and permanent and ephemeral that was pleasant and rosy. He represented urban poverty as American potential in this painting, blurring the obvious deprivation of his character with references to a larger, bustling world in which the newsboy (and by extension anyone so self-disciplined) makes his way on his own.[18]

Responding to this message that all was indeed well in the city, the *New-York Mirror* called the painting "a spirited thing; true to nature,"[19] and the Democratic organ *Arcturus* informed viewers that it charted the way for a fascinating popular portrait gallery of street types. Publisher E. L. Carey of Philadelphia engraved the painting for the 1843 edition of *The Gift*, for which Seba Smith wrote a story to accompany it that exalted the newsboy into an ideal realm. Smith's "Billy Snub the Newsboy" is an ambitious, honest, and self-disciplined youngster who overcomes a miserable family heritage and environment; having run away from home because his father is a drunkard and ne'er-do-well, Billy anonymously supports his mother and siblings by hurling packages of food through the window into their basement room. By dint of his hard work and honesty, Billy brings about the reform of his father. Billy was a character that every genteel reader and reformer wanted to believe was typical.[20]

Yet such imagery was rarely carried forward in the work of other artists. In the efforts of reformers to counter urban poverty, Charles Loring Brace had formed the New York Association for Children of the Poor, urging that street children were essentially good at heart and simply needed a chance. Philanthropists, in the conviction that morality in even small habits would lead to economic success, founded the Newsboys Lodging House, with rules that held the boys to strict standards of cleanliness, order, and responsibility. The implications of much of the literature of the movement were those of Inman's pic-

ture: that economic entrepreneurship and good middle-class habits would save the lower classes. Whether in 1841 Inman's viewers believed that the body politic was not severely threatened because the newsboys and street traders—and by implication all the other city types new to American society—were potentially middle-class citizens like the viewers, or whether they singled out examples that could be interpreted as such in order to distance themselves from the otherwise intractable problems of an underclass is not clear.[21]

But the incompatibility between the hopeful rhetoric and the dismal reality of the street child, to say nothing of the vast discrepancy between street children and republican ideology, meant that audiences preferred other topics for imagery. However promising the reception to Inman's early painting, he subsequently undertook no "popular gallery"—no gallery, that is, of street types. The year that Inman's painting won praise, the most popular picture at the exhibition was Daniel Huntington's *Mercy's Dream*, 1843 (Pennsylvania Academy of the Fine Arts), a scene of John Bunyan's ideal pilgrim described by *Arcturus* as being of the first importance. As the journal reported, the artist was no ordinary painter "working in the ordinary trading spirit" and the image was "no well-known scene or story floating on the popular breath, and already embodied in the ideas of beholders."[22]

The few artists who chose to be critical of urban poverty, sometimes of the street types themselves, but more prominently of the social phenomena in their environment, received almost no acknowledgment of their work and soon turned to other themes. William Henry Burr, discussed in chapter 5, was one, George Henry Yewell another.

Yewell exhibited *Doing Nothing* (fig. 50) at the National Academy of Design in 1852 (the work is now called *The Bootblack*). Having recently come to study in New York, with no coterie of patrons to satisfy, no exhibition precedents to follow—and perhaps from shock at seeing the social ills of New York City—Yewell painted *Doing Nothing* as his first picture. It was so out of step with the reigning excitement about the "national" landscape of New York and New England that although it is technically very capable, it seems to have received no recognition at all.[23]

The image shows a young boy of about twelve slumped on a slab on a sidewalk near a street curb. His clothing ragged and his own shoes unpolished, he leans on his shoeshine box, his hat nearby. He is thin, hardened beyond his years, with a questioning, brooding look on his dark face. The street before him is dirty, littered with trash and horseshoes, and in the left, not far away, is the ominous architecture of the Tombs—the New York City halls of justice and house of detention. The general tone of the picture is dark, with the only blue sky directly above the prison. A sharp shadow falls across the boy's face.

Figure 50.

GEORGE HENRY YEWELL

The Bootblack (Doing Nothing), 1852. Oil on canvas,
14 × 12 in. Courtesy New-York Historical Society,
New York City.

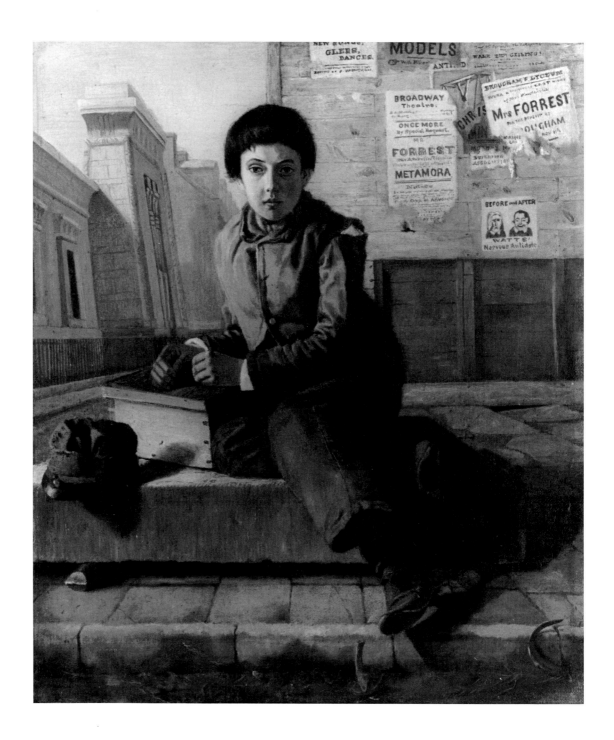

188

Posted on the wall immediately behind this idle bootblack is an array of advertisements. Two are theater posters, one advertising the appearance of Edwin Forrest at the Broadway Theatre in the American play "Metamora" and the other advertising Mrs. Forrest at Brougham's Lyceum in a benefit. Another poster advertises sheet music ("New Songs, Glees, Dances"); yet another urges the passerby to "Walk the Ceiling!" as an "Antidote" and shows a person doing that very thing. Several more signs can be made out: one that advertises "Watts Nervous Antidote," with pictures of a patient before and after (first grumpy and then happy); a fragment that reads "CHRIS" and "MIN"; and parts of posters that read "Building Association" and "Maine Law." At the top of the group, on a separate poster as though to preside over the entire battery of messages, is the large word "MODELS."

Almost all the posters allude to reform movements, ranging from the serious to the silly. Plans for saving the nation were plentiful. Among the platforms for individual and social reform were those, like Watts, that called for tonics; special exercise, such as walking on (or hanging from) the ceiling (others included water cures, and so on); temperance, to which "Maine Law" alludes (Maine's legislature prohibited the sale of all alcohol in 1850, a reform that had a brief life); building associations, aimed at persuading landlords to provide cleaner, larger dwellings for tenants; and the Christian ministry, reaching out in these days to children with its Sunday school movement. Some movements advocated individual moral improvement, others environmental reform. The theater posters allude to the powerful presence in the theaters of lower-class men and boys whose taste ran to rough, lively American actors such as Edwin Forrest in plays like "Metamora" with American subjects, as opposed to English actors and plays, represented by Mrs. Forrest, an Englishwoman. In 1849 the antipathies between supporters of the two schools of acting led to the terrible Astor Place riot, in which twenty-two people died. The theater signs place the painting specifically in the context of American versus English cultural styles, with strong associations between style and class: American acting, like American cities, was brash and vulgar. Making clear the connections among all these fragments is the large sign at the top of the billboard that reads "MODELS." If these diverse urgings to reform are all the models that society has to offer the bootblack, what are his chances? One model is distinctly silly—the advertisement for music and glees, purchases that require resources and leisure well beyond the dreams of the lower classes (an ironic commentary on reforms that aimed simply at "cultural uplift"). The most powerful force in the painting aimed at changing behavior is the prison.[24]

The pictorial language itself is gloomy: the colors are dark and the space is crimped, the picture's low point of view implying the boy's immobility. The pose of the bootblack

bodes ill. Whereas the newsboy in Inman's picture is characteristically on the hustle—at least on his feet—hawking his products to customers in the busy thoroughfares, this bootblack is passive—literally, as Yewell's original title made clear, "Doing Nothing." No jaunty headpiece here; this boy's hat is off, his small potential sovereignty surrendered. He is limited by, almost mired in, the streets. The block the boy sits on is literally and metaphorically a building block. What kind of life will he build? The heavy prison architecture across the left of the painting warns of the restraints with which society will penalize the ultimate desperate act to which doing nothing and thus earning nothing leads—thievery.

If Yewell's audience was nervous about its indictment in the posters in the background, Yewell's title made it clear that the bootblack was asking for trouble by being idle. Unlike European paintings of children begging that aimed to provoke individual sympathy (like the English artist William Daniels's "Two Children Selling Matches," 1851 [art market], and William Frith's "Crossing Sweeper," 1863 [private collection]), Yewell's commentary seems to have been aimed not at the shiftless bootblack, literally a block from prison, but at privileged viewers, who, as in their relationships to images of Yankee farmers, blacks, and women, were exculpated by his presentation.[25]

Pittsburgh artist David Gilmour Blythe made the urban urchin the central interest of his career. His pictures were neither attractive nor optimistic, but neither were they unpopular. Beginning as a portraitist and falling back on portraiture throughout his career (as did most of the artists studied here), by the mid-1850s Blythe had moved into genre painting. He worked a circuit from eastern Ohio through western Pennsylvania and did not maintain a connection to New York beyond a visit there in the years 1837–1840.[26]

In *The News Boys*, about 1848–1852 (fig. 51), one of his earliest forays into genre painting, Blythe took a tack that was to dominate his career. With dark colors and a fluid stroke that binds the atmosphere in a menacing tone, Blythe depicted two newsboys engaged in a transaction that involves jockeying for power in their own world—against each other, not against the representative of another class. Each boy carries a different newspaper, one the *Pittsburgh Daily Dispatch*, the other the *Pittsburgh Commercial Journal*. The boy on the right, taller, older, dressed aggressively, and puffing smoke from a cigar butt with a sneer on his face, would seem to have the advantage over the small fellow on the left. But the younger boy holds his ground; perhaps negotiating a sale or trade, he looks directly into the face of his associate and extends an insistent finger over the stack

Figure 51.
DAVID GILMOUR BLYTHE
The News Boys, ca. 1846–1852. Oil on canvas mounted
on academy board, 29 3/4 × 25 3/4 in. The Carnegie
Museum of Art, Pittsburgh. Gift of Haugh and
Keenan Galleries, 1956.

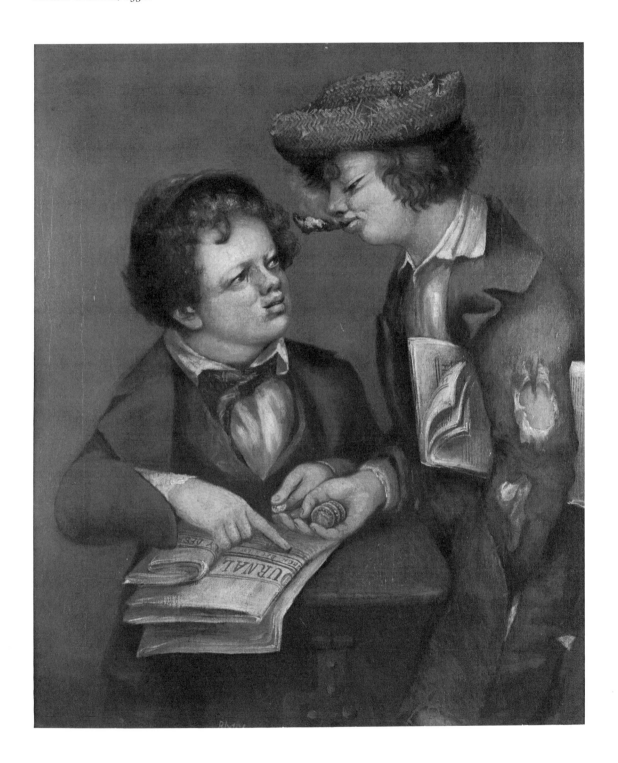

of newspapers. The transaction is reminiscent of the maneuvering of Mount's farmers. But here there is no cheer, no comedy. Mount's American types were good-natured farmers; Blythe's are already members of an underworld.

In the 1850s Pittsburgh could have served as a case study of all that could go wrong in American cities. It was economically depressed, with a continually growing immigrant population for which there was not enough work. The rising anger of workers had led to labor riots and strikes. Because of overcrowded and unsanitary living conditions, epidemics of disease swept through the city in the years 1850–1855, three alone of cholera. Theft and arson were rampant. The city was filthy, layered in soot. Although Pittsburgh was an extreme example of urban squalor, other cities, such as Cincinnati, were also wallowing in industrial dirt and the consequence of inadequate street-cleaning and refuse disposal. In Pittsburgh one found intense doses of the conviction that European immigrants brought degradation: ignorance, poverty, drunkenness, vagrancy, crime, and epidemics. Conditions were so dreadful that the moralist had every reason to preach against urban incitements to evil.[27]

Blythe did attempt a "Popular Street Gallery," but what he painted had by no means the comic dimensions, to say nothing of the uplifting dimensions, of what the New York critic had proposed in 1841 in response to Inman's city type. Drawing heavily in his imagery on prints of degraded peasants by Teniers, Blythe also wrote poetry and letters full of vitriol about money-hungry, socially and morally and politically degraded citizenry. Blythe did not display his city types in an environment patently dominated by the higher classes. Inman's newsboy is part of a luxurious Broadway; Yewell's urban figure poses against posters that convey the purchases and entertainments of those who are well-to-do or straining to be so. In their pictures, the very setting, the very terms of life of the urban types, are those of the higher consuming, moralizing classes. But Blythe depicted his urban subjects in their own social world, one distinct from, closed to, and threatening to, that of the (presumed) viewer.

In picture after picture Blythe stressed not only the separate nature of the world of street types but the threat that this world poses. In his large painting *Street Urchins*, 1856–1860 (pl. 25), for instance, created in dark, sickly yellow and brown, a seemingly numberless crowd of urchins squat on a dirty pier to watch their leader light a firecracker of alarming proportions. From left to right and front to back, these pudgy and pasty-faced, slit-eyed young degenerates, large rolled cigarettes in mouth, crowd together to make their mischief. Not only in tone and crowded figures but in its physical perspective, Blythe's point of view is that of the small criminals. Sullen, mean, and vicious, they are young but also ageless. They are among the future citizens of the Republic.

In the twenty or so pictures that Blythe did of urchins in the 1850s, only *The News Boys* shows members of that class engaged in enterprise. Typically the urchins are not just socially useless but socially alarming. They amuse themselves violently, as in *Street Urchins;* even if the activity is superficially innocuous, as in *Playing Marbles* (National Museum of American Art, Smithsonian Institution) or such eating scenes as *Boy Eating Bread* (1857–1859, Warner Collection), the urchins are so unhealthy and mean in appearance so as to make the activity subversive. Whereas Inman's *News Boy* had provided justification for a comic as well as sentimental—and optimistic—reading of the street child, Blythe's promised nothing but pessimism.[28]

In no image is this clearer than in his *Firecracker,* 1856 (fig. 52), in which the urchin holds schoolbooks on a slate under one arm. Slit-eyed and involved in his task, the boy calmly ignites a firecracker from a cigar he is smoking. He stands alone against a lurid background. Every aspect of the painting should have led a viewer of 1856 to dismal thoughts. And by 1856 Pittsburghers themselves had embarked on a number of reforms calculated to solve the very problems that Blythe was pointing out; they instituted public education, juvenile homes, prisons, and charity. Yet Blythe's painting suggests the futility of such reforms. Firecrackers were a tool of sporadic violence, arson, and riots. The schoolbooks and slate, worn with carelessness and age, point to the failure of society's attempts to mold this boy. The lurid background suggests the industrial and arson-ridden city (Pittsburgh had endured a dreadful fire in 1851 that was presumed to have been set by idle and malicious youths), whether Pittsburgh or elsewhere. And the boy's solitude points to the unchecked power, the unmediated alienation, of such members of the population. The picture forecasts a bleak future, for the urchin, for the city, and for the Republic.[29]

What led Blythe to visions so unrelieved by hope? Did he expect his paintings to be reforming instruments? Creating an impact quite different from Inman's and Yewell's work—those paintings themselves distinct from one another—Blythe's urchins seem to have been the didactic vehicles of a preaching about the character of the population as a whole. Calvinistic in his own moral standards and sympathetic to the Know-Nothings, who organized in the 1850s to vilify Catholics and all immigrant groups, Blythe was persuaded that the polity was degenerating in genetic stock, in politics and other manifestations of judgment, and in manners. The body politic, he fumed, comprised three classes: the "washed, unwashed, and unterrified."[30]

In fewer group scenes of any period is Blythe's contempt for his cast of characters more obvious than in his *Post Office,* about 1860 (fig. 53). In this image Blythe focused on the "general delivery" window of the Pittsburgh post office (there was also a "gentle-

Figure 52.
DAVID GILMOUR BLYTHE
The Firecracker (2), 1856. Oil on canvas, 27 × 22 in.
The Duquesne Club, Pittsburgh.

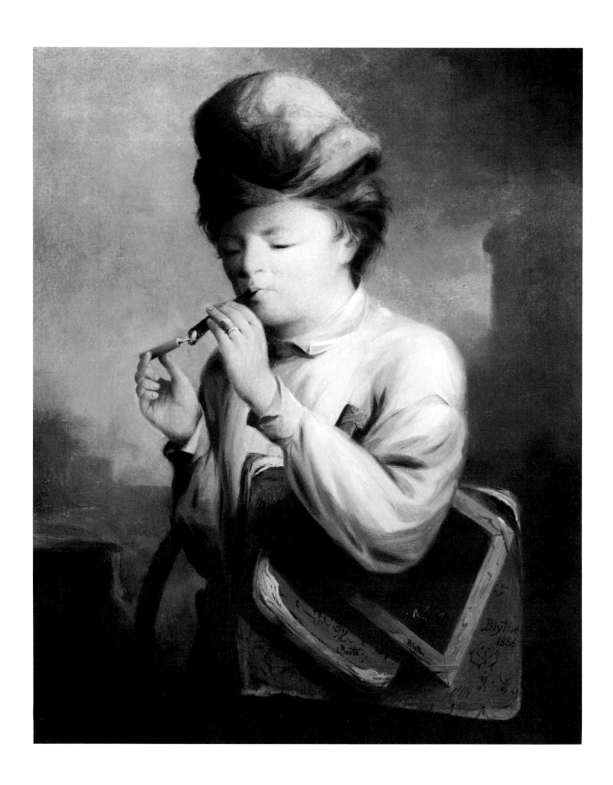

194

Figure 53.

DAVID GILMOUR BLYTHE

The Post Office, 1859–1863. Oil on canvas, 24 × 20 in.
The Carnegie Museum of Art, Pittsburgh. Purchase,
1942.

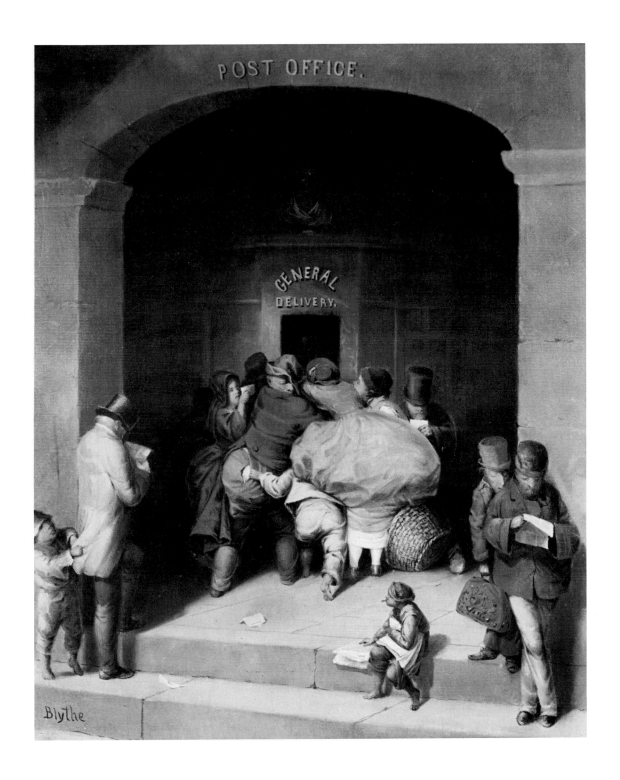

men's window"). Jostling shoving, and pushing, all trying to fit into the same space at the window, are seven or eight figures, men and women. The women are by no means off to the side, as they had been in such earlier paintings as Woodville's *War News from Mexico*, 1848, and Bingham's *Verdict of the People*, 1853–1854. In Blythe's work the women are right in the middle of the urban confusion. They are fewer in number than the men, but they are integral to the scene. One woman is dressed modestly, the other in the latest outrageously billowing skirt; two men are in soft, almost formless hats, another wears a beaver top hat. A short barefooted creature pushes in under the group and picks the pocket of one of the men (as the man's trousers are obviously of unusual construction, with an open fly running up the back, the gesture may be obscene). To the left of this bunch and in the foreground of the painting, a tall figure standing at the portal reads a newspaper and another barefooted street fellow picks his pocket. To the right, a bearded man in a close-fitting cap reads his newspaper while behind him a traveler reads over his shoulder. Seated on the step is a tiny, monkeylike figure chewing on a cigar, newspapers under his arm and at his side. The scene is painted in dirty browns, grays, and yellows, the billowing pink dress of the woman (who is crowding as vigorously as the men) the only light touch. Presiding over the window is a classical bust that evokes the discrepancy between the high expectations of the Founding Fathers and the present social level.

Just why did Blythe's patrons buy his work? He exhibited his paintings in his dealer's store window, where they were regularly seen, commented on in the press, and purchased. Perhaps the most important question about Blythe, in fact, is the relation between his location, his subjects, and his success. Surely no artist in New York (to say nothing of Boston or Philadelphia) could have sustained a career with the subject matter that kept Blythe in paints and lodging. Yet Blythe's patrons in Pittsburgh included such successful citizens as educators, merchants, attorneys, and even wealthy industrialists. Was there a receptivity in Pittsburgh to his images of urban despair because of some peculiarities in the philanthropic class there? Were Blythe's patrons adjusted to the ugliness of the city because of its early industrialization? Or did they find in his work a confirmation of why they were successful: that they had not yielded to improvidence; that they deserved their success just as these urchins deserved their failure. Perhaps because Blythe had an audience that not only tolerated his eccentricities but actually bought his works we can speculate that these Pittsburgh patrons, unlike New York viewers had no idealized notions about the "proper functions of art."

Seven *Inspired from the Higher Classes*

In 1861, when the Civil War broke out, genre painting as a national enterprise had dropped to a low ebb. Woodville, who had enjoyed a flurry of popularity about 1850, was dead; Bingham had gone to Düsseldorf to study, having long since run through his repertory of Western subjects and given up exhibiting in New York after the collapse of the American Art-Union in 1852; Lilly Martin Spencer had found New York too discouraging and had moved to Newark; Burr had abandoned painting for writing and publishing. Only Edmonds was continuing to produce with a kind of indefatigability.

Genre painting had simply failed to meet the needs of new viewers in new times. Mount's amused assessment of the body politic that he perfected in the 1830s appealed to the self-made, nationalistic, even boyish men of New York City who enjoyed the puns, stories, and jokes of a democratic culture riddled with contradictions precisely because they felt themselves to be above these contradictions. Succeeding genre painters of the Western citizenry, of black types, and of women, images that were taken up and peddled to widespread audiences through art unions, alluded to impulses and fantasies that swept over the northeastern seaboard and then yielded to problems that in turn were themselves rapidly overtaken. By the 1850s it was only too obvious that the contradictions Mount had identified might well swamp and even imperil the society. With new degrees of moral earnestness, citizens urged not only that life was too serious for puns and light-heartedness but that art was, too.

In 1851, for instance, W. Alfred Jones considered himself to be reviving Mount's reputation by purging such pungent earlier works as *Farmers Bargaining* and *Farmers Nooning* of their social criticism. "There is nothing of the town life in his pictures," Jones told readers. "All are imbued with feeling of the country—its freshness, its foliage, its sweet airs and soul-calming secret recesses. His best works are, in a word, humorous pastorals, with sweetness and fine-tempered satire (where there is any at all); no bitterness, no moral obliquity or personal deformity impair their effect; they present a picture of country life, at once satisfactory for its truth and agreeable in its aspect and general features." By 1855, when the idealist art journal the *Crayon* began publication, there was no doubt that of national subjects, landscape painting would have the most dependable "soul-calming secret recesses." And by then many claimed that American art should not be 197

national at all. As European paintings and prints flooded American exhibition spaces, local topics came to seem immature, and American artists crude and unaccomplished in comparison with French, German, and English painters. Soon Henry Tuckerman was to assert the superiority of cosmopolitan taste for international works with the comment that "such representations . . . of border life and history as Bingham made popular, though boasting no special grasp or refinement in execution, fostered a taste for primitive scenes and subjects which accounts for the interest once excited in cities and still prevalent at the West in such pictures as *The Jolly Flat-Boatman*." In the superior city of New York, younger artists turned from art unions as sources of support and developed elaborate studios through which they could entertain elite patrons and market their works through social cachet. The spread of lithography and the rise of chromolithography in New York and elsewhere developed audiences for imagery that were composed of increasingly diverse segments and tastes. As though the verbal and visual production of types over the previous fifty years had simply not occurred, the *Cosmopolitan Art Journal* even urged that genre painting had no real basis in the society. In 1860, it intoned: "Genre painters, in this country, are an impossibility, if we consider exposition of *stereotyped* local life and manners as necessary material for this class of artists. As a people the Americans have not lived long enough in one spot to gain strongly local as well as national peculiarities. We are made up of everybody from everywhere."[1]

Almost no comment more fully reveals these sea changes even before the Civil War than one that brings us back to Woodville, with whom we began. In 1858, a writer complained to the *Cosmopolitan Art Journal* that *War News from Mexico* was an example of a deplorable low-life scene. "Why . . . do we introduce these into our constant presence through engravings, 'ornamenting' our parlor and library walls?" the writer argued. "We are very inconsistent; and while we chide our children for every approach to low-taste, we still hold up for their admiration the vulgar and vicious engraving." Rather than low life, the correspondent urged, viewers need to be presented with engravings of "scenes fresh from Nature's great portfolio, embodying the beauty and spirit of her being for our study; or let us have 'deeds heroic,' where man is exercising his noblest mind; or give us the ideal, clad in the graces of the imagination's best powers," or, even, as a kind of concession, "reproduce for us home and its dear joys—woman in her true character of angel purity and love—children in their character of graces." If "lessons of life are to be taught," this critic concluded, "let them be good and pure lessons."[2]

After the Civil War, the dramatic changes in the art world implicated in the production of genre painting completed a sequence that had threatened the undertaking as

early as 1840. Although New York was even more firmly the center of exhibition and patronage, by 1866 the interests of both painters and buyers had turned to Europe, especially France, where looser styles disadvantageous to the narrative qualities of genre painting were setting the pace for painting across the Continent and, before long, on the American side of the Atlantic as well. With the cultivation of cultural cosmopolitanism, elite American critics and patrons labeled native topics retrograde and naive, even the landscape so recently held in such high esteem. The new viewers—descendants of the socially ambitious and typically urban patrons of the 1830s—wanted art that was beautiful and universal, and neither quality was compatible with the social types in a stratified democracy. By 1880, the idealized figure was to reign as the most significant vehicle of beauty, taste, and artistic tradition. Genre painting was from an earlier world, an immature past the memories of which, as Earl Shinn had pronounced in 1877 about Mount's *Bargaining for a Horse*, "[come] over the fancy like some forgotten jest."[3]

The connections of these artistic values to cultural change seem fairly clear. The types that had been created and played on with so much energy between the Revolution and the Civil War lost their function as social relations in the culture changed drastically. There were on the one hand more distinct groups than before (increasing numbers of immigrant groups, the presence of a vocal working class and a permanent underclass, and middle-class women who slowly assumed education, professional, and political power) and on the other a hierarchicalization of social class and group interests that rendered the personal distances in antebellum America pale by comparison. The amassing of large fortunes, the rise of professionalism, the development of bureaucracy in business and government, and the dispersal of political power across a vast nation made the polity at once more complex and less reducible to abstractions. Society that during the antebellum years had seemed to be driven by political and economic conflicts between regions quickly became a vertically organized system, with increasing power assumed by groups who struggled for secure places on the ladders of power. Ambitious patrons proposed no longer to sponsor a national art but to lead the way in buying works and establishing collections that would place them—and by implications "their" America—in the pantheon of world culture. For this dominant group at least, images about national discourse receded in favor of images about aesthetic experience.

This transformation was a clear indication that certain types of cultural power were now beyond contest. Setting the standards for the art display at the National Sanitary Fair of 1864, for instance, the Reverend Bellows informed his colleagues: "[The art] must be Universal; enlisting all sympathies, from the highest to the lowest—democratic,

Figure 54.

THOMAS WATERMAN WOOD

The American Farmer, 1874. Oil on canvas,
24 × 18 1/4 in. New York State Historical Association,
Cooperstown.

without being vulgar; elegant, without being exclusive; fashionable, without being frivo-lous; popular, without being mediocre. In short, it must be inspired from the higher classes, but animate, include, and win the sympathies and interest of all classes."[4]

As the undertaking became a weaker and weaker part of the artistic scene, the tensions that genre painting had first identified and embodied shifted onto different planes. Until about 1880, the rural child (especially the boy), under the brush of Winslow Homer, Eastman Johnson, and John George Brown, played out Americans' identification of them-selves as rural, or recently rural, but the innocent boy in pictures fulfilled none of the social function of the calculating Yankee farmer. Johnson's and Homer's scenes of idyllic boyhoods not only avoided but might even be claimed to have denied the tensions of public life. Although during the war and in the first years of Reconstruction these artists gave some of their images punning titles—such ironic speech and its implied common audience lending a particular pungency to their images—the social assumptions on which this practice rested were soon as outmoded as the deployment of the Yankee farmer as a national type.[5] The farmer virtually disappeared from imagery, showing up only as an older and socially impotent figure in such works as Thomas Waterman Wood's *American Farmer*, 1874 (fig. 54). And whereas few older figures had appeared in genre painting before the war, afterward grandparents, sometimes singly, began to be depicted frequently. The frank sentiment in such images perhaps endeared them to a few mem-bers of the newly sophisticated audience as well as to the mass audience, but the conde-scension of sentiment contrasted revealingly to the charged ambiguity of meaning of genre types before the war. Such images as Thomas Hicks's *There's No Place Like Home*, 1877 (Schweitzer Gallery, New York), and Thomas Oertel's *Visiting Grandma*, 1865 (New-York Historical Society), pointed to the newly tenuous relationship of the older parent to the social world, and perhaps also reminded viewers that a generational holdover was the only remaining continuity with the past. The appearance of blacksmiths and scissors grinders, typically older men, as in Eastman Johnson's *Blacksmith Shop*, 1863 (fig. 55), suggests the waning of these activities in community life; moreover, the craftsmen were pleasant (and perhaps wishful) substitutions for members of the assertive late-century working classes.

The transformation in the late century of the types of women and African-Americans is somewhat more complicated. In the hopeful years of Reconstruction, Homer painted the most caricature-free images of blacks of the century, putting before relatively silent viewers his own argument for altered social relations. After Reconstruction had failed, artists such as William Aiken Walker recreated an "everyday" life that never was: Walker depicted blacks as stereotypical happy slaves on antebellum Southern plantations for

viewers who wanted to maintain the old racial hierarchies even to the extent of rewriting the past. Women appeared in new guises. Genre painters before 1865 had generally ignored young girls, but afterward adolescent girls began to appear in abundance. As suggested by Seymour Joseph Guy's *Making a Train*, 1867 (Philadelphia Museum of Art), which shows a young girl in the dreamy onset of puberty fantasizing about wearing a wedding gown, women were much more directly depicted as objects, their biology the possession of future husbands and of viewers. As the century wore on, images of women in middle-class and elegant leisure pursuits portrayed them as symbols of domestic culture.

In genre painting in the antebellum United States, public culture was the issue; after the war, class hierarchies having been established beyond question, domestic culture was the point of tension.

The one continuation from the early genre painting to the imagery of late in the century was the type of the Western trapper or hunter. First developed by Deas and Ranney, and then simplified by Tait for mass production, the figure became a prototype for the revered cowboys of Frederic Remington and Charles Russell, and later for the Western male adventurer in twentieth-century films, videos, and advertising. As recent cultural analysts have explained it, the conflicts embodied in this type are those of definitions of masculinity, out of which emerge the world of social relations that includes politics, economic behavior, and domestic relations.

Thus a cultural practice that began by examining the character of the sovereign, by definition a white man, survives most explicitly in our time in rehearsals of the character of the male, no longer by definition sovereign.

Notes

INTRODUCTION

1. Thus I have replaced earlier art historians' use of the consensus model of American history with a conflictual model that emphasizes citizens' differences and conflicts. Works in the theory of culture that influenced the evolution of my thinking, and my translation of it into this art-historical study, include sociologists' and anthropologists' formulations of the way that cultural systems work, literary theorists' focus on the relations between language and reality, neo-Marxists' assertions of the nuanced relations between the economic conditions of life, artistic production, and mass communication, and feminist and gender historians' study of dominant groups' assignment of difference and otherness to groups within a culture. Most fundamental have been the following: Raymond Williams, *The Sociology of Culture* (New York: Schocken Books, 1982); Clifford Geertz, *The Interpretation of Cultures* (New York: Basic Books, 1973), and *Local Knowledge* (New York: Basic Books, 1983); Fredric Jameson, *The Political Unconscious: Narrative as a Socially Symbolic Act* (Ithaca: Cornell University Press, 1981); Stanley Fish, *Is There a Text in This Class? The Authority of Interpretive Communities* (Cambridge: Harvard University Press, 1980); and Robert Darnton, *The Great Cat Massacre and Other Episodes in French Cultural History* (New York: Basic Books, 1984). A succinct, provocative discussion of the relation of this thinking to the social history of art, the undertaking to which this study is most closely allied, is Janet Wolff, *The Social Production of Art* (New York: New York University Press, 1984). Of broader focus but also invaluable are Howard S. Becker, *Art Worlds* (Berkeley: University of California Press, 1982), and Vera L. Zolberg, *Constructing a Sociology of the Arts* (Cambridge: Cambridge University Press, 1990).

2. A recent study that thoughtfully considers many of these issues is Mary Cowling, *The Artist as Anthropologist: The Representation of Type and Character in Victorian Art* (Cambridge: Cambridge University Press, 1989).

3. For surveys of genre painting in other periods, see G. Briganti et al., *The Bamboccianti: The Painters of Everyday Life in Seventeenth-Century Rome* (Rome: Ugo Bozzi Editore, 1983); Francis Haskell, *Patrons and Painters: A Study in the Relations between Italian Art and Society in the Age of the Baroque* (London: Chatto and Windus, 1963); Peter C. Sutton, *Masters of Seventeenth-Century Dutch Genre Painting* (Philadelphia: Philadelphia Museum of Art, 1984); Christopher Brown, *Scenes of Everyday Life: Dutch Genre Paintings of the Seventeenth Century* (London: Faber and Faber, 1984); Simon Schama, *The Embarrassment of Riches: An Interpretation of Dutch Culture in the Golden Age* (Berkeley: University of California Press, 1988); Josephine Gear, *Masters or Servants? A Study of Selected English Painters and Their Patrons of the Late Eighteenth and Early Nineteenth Centuries* (New York: Garland, 1977); Lionel Lambourne, *An Introduction to "Victorian" Genre Painting from Wilkie to Frith* (Owings Mills, Md.: Stemmer House, 1982); Kenneth Bendiner, *An Introduction to Victorian Painting* (New Haven and London: Yale University Press, 1985); Geraldine Norman, *Biedermeier Painting, 1815–1848: Reality Observed in Genre, Portraiture, and Landscape* (New York: Thames and Hudson, 1987); and Gabriel Weisberg, *The Realist Tradition: French Painting and Drawing, 1830–1900* (Bloomington: Indiana University Press, for the Cleveland Museum of Art, 1980). Genre painting dropped out of artistic practice in the early twentieth century with the rise of abstraction. Its many functions, however, were taken up by film, followed in more recent years by television.

4. The major works in the field are Patricia Hills, *The Painters' America: Rural and Urban Life, 1810–1910* (New York: Praeger, in association with the Whitney Museum of American Art, 1974), and Hermann Warner Williams *Mirror to the American Past:*

A Survey of American Genre Painting, 1750–1900 (Greenwich, Conn.: New York Graphic Society, 1973). Whereas Williams, producing a survey, was eager to publish as many pictures as possible, Hills, approaching her material for an exhibition, anchored the themes of each painting she discussed in the ongoing phenomena of social change. Sarah Burns, *Pastoral Inventions: Rural Life in Nineteenth-Century American Art and Culture* (Philadelphia: Temple University Press, 1989), discusses a number of genre paintings as part of her argument about the ideology of the rural. Earlier and other studies include Lloyd Goodrich, *American Genre: The Social Scene in Paintings and Prints* (New York: Plantin Press for the Whitney Museum of Art, 1935); *Art in New England: New England Genre* (Cambridge: Harvard University Press for the Fogg Art Museum, 1935); and Patricia Hills, *Painting of the American Frontier* (New York: Whitney Museum of Art, 1974). Also important are *Of Time and Place: American Figurative Art from the Corcoran Gallery* (Washington, D.C.: Smithsonian Institution Traveling Exhibition Service and the Corcoran Gallery of Art, 1981), with essays by Edward J. Nygren and Peter C. Marzio; Joshua Taylor, *America as Art* (Washington, D.C.: National Collection of Fine Arts, Smithsonian Institution Press, 1976); and Linda Ayres, "The American Figure: Genre Paintings and Sculpture," in *An American Perspective: Nineteenth-Century Art from the Collection of Jo Ann and Julian Ganz, Jr.* (Washington, D.C.: National Gallery of Art, 1981). Most recently, the Amon Carter Museum organized the exhibition and accompanying catalog *American Frontier Life: Genre Paintings and Prints, 1830–61* (New York: Abbeville Press for the Amon Carter Museum, 1987).

5. Many of these historians' works I cite in the notes. I list here the names of those whose findings and assumptions have been most influential: Thomas Bender, Paul Boyer, Nancy Cott, Carl Degler, Michael Kammen, Carroll Smith-Rosenberg, Christine Stansell, Jane Tompkins, and Sean Wilentz. In addition, I have found invaluable in formulating my own study the work of art historians John Barrell, Anne Bermingham, Albert Boime, Linda Nochlin, and Griselda Pollock.

6. Always, of course, the art historian wonders what paintings have been lost, or what paintings known to be lost looked like, their absence reminding us of the contingencies on which our structures of interpretation rest.

CHAPTER 1:
ORDERING THE BODY POLITIC

1. This work is discussed in greater detail in chapters 4 and 5. On Woodville, see Francis Grubar, "Richard Caton Woodville: An American Artist, 1825–1855" (Ph.D. diss., Johns Hopkins University, 1966), and *Richard Caton Woodville: An Early American Genre Painter* (Washington, D.C.: Corcoran Gallery of Art, 1967); Bryan Wolf, "All the World's a Code: Art and Ideology in Nineteenth-Century American Painting," *Art Journal* 44 (Winter 1984): 328–337.

2. On Washington Allston, see William H. Gerdts and Theodore E. Stebbins, Jr., *"A Man of Genius": The Art of Washington Allston* (Boston: Museum of Fine Arts, 1979). On Fisher, see Fred B. Adelson, "Alvan Fisher (1792–1863): Pioneer in American Landscape Painting" (Ph.D. diss., Columbia University, 1982). On Guy, see Stiles Tuttle Colwill, *Francis Guy, 1760–1820* (Baltimore: Museum and Library of Maryland History, Maryland Historical Society, 1981).

3. See Milo M. Naeve, *John Lewis Krimmel: An Artist in Federal America* (Newark: University of Delaware Press, 1987) (the study was completed in 1955 but not published for thirty years), and the long review of Naeve's study by William T. Oedel, "Krimmel at the Crossroads," *Winterthur Portfolio* 23:4 (1988): 273–281, in which Odell alludes to the many artists working during these early years as occasional genre painters. On Krimmel and the theme of drunkenness, see Janet Marstine, "John Lewis Krimmel: America's First Painter of Temperance Themes," *Rutgers Art Review* 10 (1989): 111–134. The quotation identifying Krimmel as Hogarthian is from *Port Folio* 7 (1812): 24.

4. I have compiled these generalizations from many sources. Travel accounts have proven invaluable, first, those by European visitors: J. Hector St. John de Crevecoeur, *Letters from an American Farmer* (1782; rpt. New York: Penguin Books, 1981); Basil Hall, *Travels in North America in the Years 1827 and*

Columbia University Press, 1925). The most lyrical treatment of typing is that of Constance Rourke, *American Humor: A Study of the National Character* (New York: Harcourt, Brace, 1931), a formulation that is generously supported by primary sources and which, therefore, mine most resembles. Other studies besides Rourke's also consider issues of typing under the rubric of humor or national character. For overviews of the issues in studying national character, see David E. Stannard, "American Historians and the Idea of National Character: Some Problems and Prospects," *American Quarterly* 23 (May 1971): 202–220; Orrin E. Klapp, *Heroes, Villains, and Fools: The Changing American Character* (Englewood Cliffs, N.J.: Prentice-Hall, 1962); Benjamin T. Spencer, *The Quest for Nationality: An American Literary Campaign* (Syracuse, N.Y.: Syracuse University Press, 1957). A continuingly persuasive study of "American national character" is William R. Taylor, *Cavalier and Yankee: The Old South and American National Character* (1961; rpt. Cambridge: Harvard University Press, 1979). A recent provocative discussion of these issues is Joshua Taylor, "The American Cousin," in *America as Art* (Washington, D.C.: National Collection of Fine Arts, Smithsonian Institution, 1976). Taylor distinguishes between an informal and colloquial typing and a "highly literary mythology," as do I, but he gives equal weight and cultural significance to both. I do not.

12. In 1830, 90 percent of Americans lived in rural areas, and 75 percent were engaged in agricultural pursuits; see Clarence H. Danhof, *Change in Agriculture: The Northern United States, 1820–1870* (Cambridge: Harvard University Press, 1969), 6.

13. On theater in the United States, see Arthur Hobson Quinn, *A History of the American Drama from the Beginning to the Civil War*, 2d ed. (New York: Appleton-Century-Crofts, 1943), and Richard Moody, ed., *Dramas from the American Theatre, 1762–1909* (New York: World, 1966). I have drawn my generalizations about the denigration of farmers from extensive reading of humorous almanacs, caricatures, periodicals, and the agrarian press, as described below.

14. *Knickerbocker* 8 (August 1836): 210–211. On agrarian practice and rhetoric in general, see Richard H. Abbott, "The Agricultural Press Views the Yeoman: 1819–1859," *Agricultural History* 42

(January 1968): 35–48; Paul W. Gates, *The Farmers Age: Agriculture, 1815–1860* (New York: Holt, Rinehart, and Winston, 1960); Louis H. Douglas, ed., *Agrarianism in American History,* (Lexington, Mass.: D. C. Heath, 1969); Albert L. Demaree, *The American Agricultural Press, 1819–1860* (1941; rpt. Philadelphia: Porcupine Press, 1974); and Clarence H. Danhof, *Change in Agriculture: The Northern United States, 1820–1870* (Cambridge: Harvard University Press, 1969).

15. An early example of the conceptualization of the nation as a farm is in Francis Hopkinson's *Pretty Story* (1774; rpt. Freeport, N.Y.: Books for Libraries Press, 1969); Hopkinson tells the story of the Revolution in terms of an Old Farm presided over by a tyrannical father and a New Farm settled by his children when they pulled away from the family. Caricatures showing the nation as a farm include "Andrew Resolute, Uncle Sam's Faithful Teamster, Taking the Produce of the Farms to Another Storehouse, and Giving Uncle Sam His Reasons for So Doing," by M. Williams in 1832 (refers to Andrew Jackson's removal of deposits from the Bank of the United States), and "Coming to Terms," 1848, in which presidential candidate Zachary Taylor is pictured applying to "Jonathan" to lease his "farm" for four years, by H. R. Robinson, 1848. Both images are in the Library of Congress, Prints and Photographs Collection. The *Long-Island Democrat* noted sardonically on Aug. 2, 1837, that Daniel Webster was "passing himself off as a farmer" in order to be elected. Abraham Lincoln, of course, used the image of the farmer masterfully.

16. Primary sources include such almanacs, both comic and serious, as *The American, Finn's Comic Almanac, Finn's Comic Sketch Book, The American Comic Annual, The Old Farmer's Almanac,* and many more that are in the extensive collection of the Library of Congress; and such biographies as George "Handel" Hill, *Scenes from the Life of an Actor* (New York: Garrett, 1853); Northall, ed., *Life and Recollections of Yankee Hill;* and Falconbridge (Jonathan F. Kelly), *Dan Marble; A Biographical Sketch of That Famous and Diverting Humorist* (New York: DeWitt and Davenport, 1851). For secondary sources, see Francis Hodge, *Yankee Theatre: The Image of America on the Stage, 1825–1850* (Austin: University of Texas Press, 1964); Taylor, *Cavalier and Yankee;* Blair, *Native Amer-*

ican Humor; Tandy, *Crackerbox Philosophers;* and Rourke, *American Humor.* Winifred Morgan, in *An American Icon: Brother Jonathan and American Identity* (Newark: University of Delaware Press; London: Associated University Presses, 1988), deals with the figure Jonathan as a national type. Morgan ignores the regional and class antagonisms embedded in the type and thus the ideology that underlay the various regional manifestations of Jonathan. James Fenimore Cooper notes in *Notions of the Americans,* 1:55, that outside the United States all Americans referred to themselves as Yankees, for in that context the term indicated American "enterprise, skill, or reputation"; but when Americans used the term within the country, they meant it as a regional "reproach."

17. Seba Smith, *The Life and Writings of Major Jack Downing, of Downingville, Away Down East in the State of Maine* (Boston: Lilly, Wait, Colman, and Holden, 1833). Later collections of the Downing stories were Smith, *May-Day in New York, or House Hunting and Moving; Illustrated and Explained in Letters to Aunt Keziah* (New York: Burgess, Stringer, 1845), and Smith, *My Thirty Years out of the Senate* (New York: Oaksmith, 1859). For a study of Smith, see Alan R. Miller, "America's First Political Satirist: Seba Smith of Maine," *Journalism Quarterly* 47 (Autumn 1970): 488–492.

18. See Blair, *Native American Humor,* 21, n. 1.

19. *Museum* 26 (January–June 1835): 27. In 1821, Timothy Dwight analyzed the problem with peddling: "All the evils, which are attendant upon the bartering of small wares, are incident to this, and every other mode of traffic of the same general nature. Many of the young men, employed [as peddlers], part, at an early period with both modesty, and principle. Their sobriety is exchanged for cunning, their honesty for imposition; and their decent behavior for coarse impudence. Mere wanderers, accustomed to no order, control, or worship; and directed solely to the acquisition of petty gains; they soon fasten upon this object; and forget every other, of a superior nature. The only source of their pleasure or their reputation is gain; and that, however small, or however acquired, secures both. No course of life tends more rapidly, or more effectually, to eradicate every moral feeling" (*Travels in New England and New York,* 4 vols. [1821; rpt. Cambridge:

Belknap Press of Harvard University Press, 1969], 2:53–55). On the stories of Haliburton, who as a Canadian was also an outsider, see Reginald E. Watters and Walter S. Avis, eds., *The Sam Slick Anthology* (Toronto: Clarke, Irwin, 1969).

20. James Kirke Paulding's *Dutchman's Fireside* (New York: J. and J. Harper, 1831) was a considerably later work that embodied the Dutchman. Also drawing on the Dutch culture were Saint Nicholas paintings, popular in the 1830s. See Lauretta Dimmick, "Robert Weir's *Saint Nicholas:* A Knickerbocker Icon," *Art Bulletin* 66:3 (1984): 465–483.

21. Even though John Neal chose the Southern aristocrat as one of the three national types (along with the Yankee and the frontiersman) in his novel *Downeaster,* 1831, general discourse did not give long life to that triumvirate. Southerners themselves, many from comfortable families, struggled to idealize what they perceived as the disreputable character of the lower-class Southwestern yeoman by envisioning a new breed of Southerner that would somehow emerge from the old Cavaliers, or aristocracy. Crucial in this development was the Southern plantation novel, of which John Pendleton Kennedy, *Swallow Barn, or A Sojourn in the Old Dominion* (Philadelphia: Carey and Lea, 1832), was the prime early example. See Taylor, *Cavalier and Yankee,* and Shields McIlwaine, *The Southern Poor-White from Lubberland to Tobacco Road* (Norman: University of Oklahoma Press, 1939). Not only did the Southerner not appear in genre painting, but there was little genre painting at all in the South before the Civil War. See Bruce W. Chambers, *Art and Artists of the South: The Robert P. Coggins Collection* (Columbia: University of South Carolina Press, 1984); Jessie Poesch, *Painting in the South, 1564–1980* (Richmond: Virginia Museum of Fine Arts, 1983); and Poesch, *The Art of the Old South: Painting, Sculpture, Architecture, and the Products of Craftsmen, 1560–1860* (New York: Alfred A. Knopf, 1983).

22. Johnson J. Hooper created the "Adventures of Simon Suggs," published individually in newspapers and then collected in book form in 1845 as *Some Adventures of Captain Simon Suggs, Late of the Tallapoosa Volunteers, Together with Taking the Census and Other Alabama sketches by a Country Editor* (Philadelphia: Carey and Hart, 1846). Other writers who characterized the same citizenry in stories included Augustus

Baldwin Longstreet, *Georgia Scenes: Characters, Incidents, &c. in the First Half Century of the Republic by a Native Georgian* (Augusta, Ga.: S. R. Sentinel Office, 1835); Thomas Bangs Thorpe, *The Mysteries of the Backwoods, or Sketches of the Southwest* (Philadelphia: Carey and Hart, 1846); Thorpe, *The Hive of the Bee-Hunter: A Repository of Sketches Including Peculiar American Character, Scenery, and Rural Sports* (New York: Appleton, 1854); Joseph M. Field, *The Drama in Pokerville* (Philadelphia: Carey and Hart, 1847); John S. Robb, *Streaks of Squatter Life, and Far-West Scenes: A Series of Humorous Sketches Descriptive of Incidents and Characters in the Wild West* (Philadelphia: Carey and Hart, 1847); William Trotter Porter, *The Big Bear of Arkansas and Other Sketches Illustrative of Characters and Incidents in the South and South-West* (Philadelphia: Carey and Hart, 1845); William T. Porter, ed., *A Quarter Race in Kentucky and Other Sketches, Illustrative of Scenes, Characters, and Incidents throughout "The Universal Yankee Nation"* (Philadelphia: T. B. Peterson and Brothers, 1854); and Joseph G. Baldwin, *Flush Times of Alabama and Mississippi: A Series of Sketches* (New York: Appleton, 1853). On Porter, see Norris Wilson Yates, *William T. Porter and the Spirit of the Times: A Study of the Big Bear School of Humour* (Baton Rouge: Louisiana State University Press, 1957). A recent article that discusses the social circumstances that bolstered the popularity of these types is Elliott J. Gorn, "'Gouge and Bite, Pull Hair, and Scratch': The Social Significance of Fighting in the Southern Backcountry," *American Historical Review* 90:1 (1985): 18–43. I also learned a great deal from Michael Fellman, "Alligator Men and Card-sharpers: Deadly Southwestern Humor," *Huntington Library Quarterly* 49 (Autumn 1986): 307–323. The quotation is from "Yeomen of Mississippi," *The Southwest,* vol. 2 (New York: Harper and Brothers, 1835), 170–172.

23. See Arthur K. Moore, *The Frontier Mind: A Cultural Analysis of the Kentucky Frontiersman* (Lexington: University of Kentucky Press, 1957). Among primary sources, my generalizations have been drawn from Timothy Flint, *Recollections of the Last Ten Years* (Boston: Cummings, Hillard, 1826); James Hall, *Legends of the West* (Philadelphia, H. Hall, 1832), *Harpe's Head: A Legend of Kentucky* (Philadelphia: Key and Biddle, 1833), *Tales of the Border* (Philadelphia: H. Hall, 1835), and *The Wilderness*

and the Warpath, (New York: Wiley and Putnam, 1846); John A. McClung, *Sketches of Western Adventure* (Maysville, Ky.: L. Collins, 1832); and John L. McConnel, *Western Characters, or Types of Border Life* (New York: Redfield, 1853). For secondary sources, see William H. Venable, *Beginnings of Literary Culture in the Ohio Valley* (Cincinnati: Robert Clarke, 1891); Ralph L. Rusk, *The Literature of the Middle-Western Frontier,* 1925 (Westport, Conn.: Greenwood Press, 1975); and Edwin Fussell, *Frontier: American Literature and the American West* (Princeton, N.J.: Princeton University Press, 1965).

24. Toward mid-century, when the balance of regional power had definitely tipped westward, and Western types were *almost* an Eastern "us," Boone became a natural man who was also a gentleman. On Western historical figures who quickly became legendary types, see Walter Blair and Franklin J. Meine, *Mike Fink: King of Mississippi Keelboatmen* (1933; rpt. Westport, Conn.: Greenwood Press, 1971); Franklin J. Meine, *The Crockett Almanacs Nashville Series 1835–1838* (Chicago: Caxton Club, 1955); Michael A. Lofaro, ed., *Davy Crockett: The Man, the Legend, the Legacy, 1786–1986* (Knoxville: University of Tennessee Press, 1985); James Kirke Paulding, *The Lion of the West: A Farce in Two Acts*, ed. James N. Tidwell (1830; rpt. Stanford: Stanford University Press, 1954); and, for a general discussion of Southwestern and Western humor, Yates, *William T. Porter and the Spirit of the Times.*

25. Early literary works that developed blacks as types include James Kirke Paulding, *The Diverting History of John Bull and Brother Jonathan* (New York: Inskeep and Bradford, 1812); Paulding, *The Backwoodsman* (Philadelphia: M. Thomas, 1818); and John Neal's *Brother Jonathan, or the New Englanders* (Edinburgh: N. Blackwood, 1825). For recent discussions, see Henry Louis Gates, Jr., and Guy C. McElroy in Guy C. McElroy, *Facing History: The Black Image in American Art, 1710–1940* (Washington, D.C.: Bedford Arts Publishers in association with Corcoran Gallery of Art, 1990).

26. See Blair, *Native American Humor;* Nancy Cott, *The Bonds of Womanhood: "Woman's Sphere" in New England, 1780–1835* (New Haven and London: Yale University Press, 1977).

27. The best discussion of this character is in Taylor, "American Cousin," 55–67.

28. James Kirke Paulding, *Letters from the South*, vol. 2 (New York: Harper and Brothers, 1835): 260, quoted in Jean Yellin, *The Intricate Knot: Black Figures in American Literature, 1776–1863* (New York: New York University Press, 1972), 32.

29. Article XII, *North American Review* 15 (July 1822): 252, quoted in Taylor, *Cavalier and Yankee*, 20–21.

30. Primary sources on New York City, in addition to contemporary journals and newspapers, include Bayrd Still, *Mirror for Gotham: New York as Seen by Contemporaries from Dutch Days to the Present* (New York: New York University Press, 1956); George Foster, *New York in Slices* (New York: H. Graham, 1849); and Foster, *New York by Gas-Light* (New York: Dewitt and Davenport, 1850). My thinking on New York City has also been shaped by Douglas T. Miller, *Jacksonian Aristocracy: Class and Democracy in New York, 1830–1960* (New York: Columbia University Press, 1967); Amy Bridges, *A City in the Republic: Antebellum New York and the Origins of Machine Politics* (New York: Columbia University Press, 1984); Christine Stansell, *City of Women: Sex and Class in New York, 1789–1860* (Urbana: University of Illinois Press, 1987); Sean Wilentz, *Chants Democratic: New York City and the Rise of the American Working Class, 1788–1850* (New York: Oxford University Press, 1984); Andrew B. Myers, *The Knickerbocker Tradition: Washington Irving's New York* (Tarrytown, N.Y.: Sleepy Hollow Restorations, 1974); and Thomas Bender, *New York Intellect: A History of Intellectual Life in New York City, from 1750 to the Beginnings of Our Own Time* (New York: Alfred A. Knopf, 1987). On artists and writers in New York City, see John Paul Pritchard, *Literary Wise Men of Gotham: Criticism in New York, 1815–1860* (Baton Rouge: Louisiana State University Press, 1963); James T. Callow, *Kindred Spirits: Knickerbocker Writers and American Artists, 1807–1855* (Chapel Hill: University of North Carolina Press, 1967); John Stafford, *The Literary Criticism of "Young America": A Study in the Relationship of Politics and Literature, 1837–1850* (Berkeley: University of California Press, 1952); and Perry Miller, *The Raven and the Whale: The War of Words and Wits in the Era of Poe and Melville* (New York: Harcourt, Brace, and World, 1956).

31. Prominent New York journals included Samuel Woodworth and George L. Morris's, *New-York Mirror*, founded in 1825, and Lewis Gaylord Clark's *Knickerbocker*, founded in 1833. In earlier years, Boston and then Philadelphia had been looked to as major artistic centers, and throughout the antebellum years they continued to function as regional centers with varying success. See Ronald Story, "Class and Culture in Boston: The Athenaeum, 1807–1860," *American Quarterly* 27 (May 1975): 178–199.

32. Allan Nevins, ed., *The Diary of Philip Hone, 1828–1851*, 2 vols. (New York: Dodd, Mead, 1927), 1:261 (May 22, 1837).

CHAPTER 2:
AN IMAGE OF PURE YANKEEISM

1. In my assessment of political and social issues during the late 1820s, the 1830s, and into the 1840s, I have relied for a contemporary point of view (in addition to newspapers and journals of the period) on Jabez D. Hammond, *History of Political Parties in the State of New York*, 4th ed., 2 vols. (Cooperstown, N.Y.: H. and E. Phinney, 1846), and for recent studies, Douglas T. Miller, *Jacksonian Aristocracy: Class and Democracy in New York, 1830–1860* (New York: Oxford University Press, 1967); Edward Pessen, *Jacksonian America: Society, Personality, and Politics* (Homewood, Ill.: Dorsey Press, 1969); Edward Pessen, ed., *New Perspectives on Jacksonian Parties and Politics* (Boston: Allyn and Bacon, 1969); Arthur M. Schlesinger, Jr., ed., *History of the United States Political Parties*, vol. 1: *1789–1860: From Factions to Parties* (New York: Chelsea House, 1973); Schlesinger, ed., *History of American Presidential Elections, 1789–1968*, 4 vols. (New York: Chelsea House, 1971); Daniel Walker Howe, *The Political Culture of the American Whigs* (Chicago: University of Chicago Press, 1979); Thomas Brown, *Politics and Statesmanship: Essays on the American Whig Party* (New York: Columbia University Press, 1985); Richard McCormick, *The Second American Party System: Party Formation in the Jacksonian Era* (Chapel Hill: University of North Carolina Press, 1966); and Anne Norton, *Alternative Americas: A Reading of Antebellum Political Culture* (Chicago: University of Chicago Press, 1986).

2. On Mount, see Alfred Frankenstein, *William Sidney Mount* (New York: Harry N. Abrams, 1975),

composed of selected primary materials. David Cassedy and Gail Shrott, *William Sidney Mount: Annotated Bibliography and Listings of Archival Holdings of the Museums at Stony Brook* (Stony Brook, N.Y.: Museums at Stony Brook, 1983), is an essential compilation, and their *William Sidney Mount: Works in the Collection of the Museums at Stony Brook* (Stony Brook, N.Y.: Museums at Stony Brook, 1983), is invaluable. The most important recent work is *Catching the Tune: Music and William Sidney Mount* (Stony Brook, N.Y.: Museums at Stony Brook, 1984).

3. On Wilkie, see William J. Chiego, *Sir David Wilkie of Scotland (1785–1841)* (Raleigh: North Carolina Museum of Art, 1987). On George Morland, an English artist whose prints enjoyed a large circulation, see David Winter, "George Morland (1763–1804)" (Ph.D. diss., Stanford University, 1977). Also of interest are John Barrell, *The Dark Side of the Landscape: The Rural Poor in English Painting, 1730–1840* (Cambridge: Cambridge University Press, 1980), and Mary Webster, *Francis Wheatley* (London: Paul Mellon Foundation for British Art, Routledge and Kegan Paul, 1970). During the years before Mount took up genre painting, he painted seven works with historical or literary subjects.

4. Krimmel's work was lithographed by Childs and Lehman in the mid-1830s. Mount seems to have seen the watercolor on a trip to Philadelphia in 1829. On other pictorial influences, not only for *Rustic Dance* but for Mount's later genre images, see Donald Keyes, "The Sources for William Sidney Mount's Earliest Genre Paintings," *Art Quarterly* 32 (1969): 258–268, and Catherine Hoover, "The Influence of David Wilkie's Prints on the Genre Paintings of William Sidney Mount," *American Art Journal* 13:3 (1981): 4–33. In his review of Frankenstein's monograph, "William Sidney Mount Reconsidered," *American Art Review* 4 (August 1977): 117–128, Keyes was the first scholar to urge the untenability of Frankenstein's position that Mount's work had no narrative or symbolic content. The praise for *Rustic Dance* at the Mechanics' Institute Fair in New York is quoted by Mount in his autobiographical notes, January 1854, cited by Frankenstein, *Mount*, 25.

5. *New-York Mirror*, May 30, 1835, 379; *American Monthly Magazine* 5 (July 1835): 393; *New-York Mirror*, June 17, 1837, 407; *New-York Mirror*, May 30, 1835, 379.

6. On political caricature see Nancy R. Davison, "E. C. Clay: American Political Caricaturist of the Jacksonian Era" (Ph.D. diss., University of Michigan, 1980); also Davison, "E. C. Clay and the American Political Caricature Business," in David Tatham, ed., *Prints and Printmakers of New York State, 1825–1940* (Syracuse: Syracuse University Press, 1986), 91–110; Allan Nevins and Frank Weitenkampf, *A Century of Political Cartoons: Caricature in the United States from 1800 to 1900* (New York: Charles Scribner's Sons, 1944); Stefan Lorant, *The Presidency: A Pictorial History of Presidential Elections from Washington to Truman* (New York: Macmillan, 1951); Stephen Hess and Milton Kaplan, *The Ungentlemanly Art: A History of American Political Cartoons* (New York: Macmillan, 1968); and Mark M. Lipper, *Comic Caricatures in Early American Newspapers as Indicators of the National Character* (Ph.D. diss., Southern Illinois University at Carbondale, 1973). Examples of politicians literally fighting include *Set To Between Old Hickory and Bully Nick*, 1834, published by A. Imbert, about conflict over the U.S. Bank (Library of Congress), and "Set-to between the Champion Old Tip and the Swell Dutchman of Kinderhook," 1836, published by H. R. Robinson, about the presidential election (fig. 15); an example of card playing is *All Fours—Important State of the Game—The Knave About to be Lost*, 1836, published by Robinson, with Van Buren and Harrison gambling for the presidency (Library of Congress); and of billiards, *Grand Match between the Kinderhook Poney and the Ohio Ploughman*, 1836, published by Robinson, another take-off on the presidential contest (Library of Congress). For surveys of graphic humor in the United States, see William Murrell, *A History of American Graphic Humor, 1747–1865* (New York: Whitney Museum of American Art, 1938), and *American Printmaking before 1876: Fact, Fiction, and Fantasy* (Washington, D.C.: Library of Congress, 1975).

7. In November 1824, a year before he died unexpectedly, Hawkins produced at the Chatham Theatre his musical comedy *The Saw Mill, or A Yankee Trick*, with Yankee characters and themes that built on a Yankee tradition; followers dominated the popular theater for over a decade. Hawkins was also involved in productions that anticipated minstrelsy. See Vera Brodsky Lawrence, "Micah Hawkins, the Pied Piper of Catherine Slip," *New-York Historical So-*

ciety Quarterly 62 (April 1978): 138–165, and Peter G. Buckley, "The Place to Make an Artist Work: Micah Hawkins and William Sidney Mount in New York City," in *Catching the Tune: Music and William Sidney Mount* (Stony Brook, N.Y.: Museums at Stony Brook, 1984), 22–39. In 1824, while Johnston was acting in New York, Mount's uncle commissioned him to do the etchings for his own comic story of a dancing master, and then to illustrate the cover for one of his songs. On Johnston, see David Tatham, *A Note about David Claypoole Johnston with a Check List of His Book Illustrations* (Syracuse, N.Y.: Syracuse University Press, 1970); Tatham, "David Claypoole Johnston's *Militia Muster*," *American Art Journal* 19:2 (1987): 4–15; and Tatham, "D. C. Johnston's Pictorialization of Vernacular Humor in Jacksonian America," in Peter Benes, ed., *American Speech: 1600–Present* (Boston: Boston University Scholarly Publications, 1985), 107–119. The Johnston "pictorializations" are, respectively, in the American Antiquarian Society; *Scraps*, vol. 1 (1829), pl. 3; and *American Comic Almanac* (1833), 16. For points of comparison across the Atlantic, the following are important: M. Dorothy George, *Hogarth to Cruikshank: Social Change in Graphic Satire* (London: Penguin Press, 1967); Ronald Paulson, comp. and ed., *Hogarth's Graphic Works*, rev. ed., 2 vols. (New Haven: Yale University Press, 1970), and *Rowlandson: A New Interpretation* (New York: Oxford University Press, 1972); Judith Wechsler, *A Human Comedy: Physiognomy and Caricature in Nineteenth-Century Paris* (Chicago: University of Chicago Press, 1982); Beatrice Farwell, *French Popular Lithographic Imagery, 1815–1870*, vol. 3 (Chicago: University of Chicago Press, 1981); and Roger B. Henkel, *Comedy and Culture: England, 1820–1900* (Princeton, N.J.: Princeton University Press, 1980).

8. Review in the *New York Transcript*, Jan. 6, 1835, of *Scraps* #6. The publications had a fairly large circulation: *Scraps* #7: *Phrenology*, 1837, was printed in 1837 with three thousand copies by Dutton and Wentworth, Boston, according to Malcolm Johnson, *David Claypoole Johnston: American Graphic Humorist, 1798–1865* (Lunenberg, Vt.: Stinehour Press, 1970), 8.

9. The painting was first exhibited as *Farmer's Bargaining;* the apostrophe seems to tie the bargaining explicitly to the yeoman (or yeomen; usage of the apostrophe during this period was careless). Al-

though there is no indication of such a possibility in the reviews, Mount's earlier painting *Long Island Farmer Husking Corn*, 1834 (Museums at Stony Brook), may well have been a witty essay that brought together Seba Smith's Downing characters, the vernacular *cornhusking*, with which Jack Downing meant getting down to political business, and Mount's own "locals," Long Islanders: when an engraving after the painting appeared in the *Wintergreen for 1844*, the farmer was identified as Jack Downing's "Uncle Joshua." Although the farmers in *Bargaining for a Horse* seem dressed in an extraordinary manner for their activity, the costumes are not unusual. European visitors often commented on the anxious "republican" sameness with which Americans dressed. As models for the composition of *Farmers Bargaining*, Mount may have relied on Wilkie's *Errand Boy* (see David Cassedy and Gail Schott, *William Sidney Mount: Works in the Collection of the Museums at Stony Brook* [Stony Brook, N.Y.: Museums at Stony Brook, 1983], 18) or Morland's *Reckoning*, both in circulation as prints. From this point, I shall allude to composition models only when thematic matters are involved, as my interest is to demonstrate cultural issues at stake in the imagery. I take it for granted that artists constructed pictures from visual sources.

10. The earliest usage of *horsetrading* in the political sense that William A. Craigie, *A Dictionary of American English on Historical Principles*, 4 vols. (Chicago: University of Chicago Press, 1938–1944), was able to find was by Timothy Flint, in his *Recollections*, 64. Americans apparently used *trade* indefatigably, whereas the English used *deal*, and thus shady politicking in England was "horsedealing." By the late 1830s *horsetrading* was used regularly in American journals and newspapers.

11. *Jockey* had a long history in British usage meaning a (dishonest) horsedealer, and *to jockey* was to swindle or cheat. See the *Oxford English Dictionary*, and, for American usage, Craigie, *Dictionary of American English*. In American English, a jockey was very early a *sharper* or *knave*. Although Mount chose not to incorporate into the painting the visual clue of one of the bargainers wearing a jockey cap, one reviewer identified the younger man as a jockey anyway. Interpreting the painting as a battle between an aggressor and a defender, this critic wrote of "the insinuating good nature and shrewdness of the jockey,

in contrast with the plain, downright honesty and good sense of the farmer." Setaucket Scrapbook, 40, newspaper not identified. (The Setauket Scrapbook is Mount's collection of usually unsourced newspaper reviews, a copy of which is at the Museums at Stony Brook; it is essential for scholarship on this artist.) *Horseshedding* is explained in James Fenimore Cooper, *Redskins* (New York: Burgess and Stringer, 1846), xiv, as "private [political] discussions that were held between pairs under what is called the 'horse-shedding' process." The Museums at Stony Brook label Mount's sketches "Studies for Coming to the Point," a painting of 1855 that slightly recast *Farmers Bargaining*, as discussed below. I believe they are studies for the original painting.

12. *Shaving*, of course, was derived from *note-shaving*, an economic practice always to the disadvantage of one party. A favorite expression of the period was "pigeons go to the shavers to be plucked," a colloquial celebration of the gains to be made at the expense of the unwary. For a contemporary use of both expressions, see Asa Greene, *A Glance at New York* (New York: Asa Greene, 1837), 239, 242. Some of these vernacularisms are puns, which as wordplay were ubiquitous in American journals of the antebellum period. Washington Irving, among others, was a relentless punster. See William L. Hedges, *Washington Irving: An American Study, 1802–1832* (Baltimore: Johns Hopkins University Press, 1965). For Henry Thoreau's interest in the pun, see Michael West, "Scatology and Eschatology: The Heroic Dimensions of Thoreau's Wordplay," *Publications of the Modern Language Association* 89:5 (1974): 1043–1064. Tocqueville explained the phenomenon as by "giving double meanings to one word, democratic peoples often make both the old and the new signification ambiguous [so that] the phrase is left to wander free" (*Democracy in America* [1835; rpt. New York: Harper and Row, 1966], 448). James Russell Lowell, also devoted to the practice, considered the implications of the pun in *The Function of the Poet and Other Essays* (Boston: Houghton Mifflin, 1920). A contemporary English collection is Hugh Rowley, *Puniana: or, Thoughts Wise and Other-Wise* (London: John Camden Hotten, 1867). Contemporary with Mount's use of wordplay in American imagery, of course, was the French fascination with the pun *poire* or *pear* that Charles Philipon invented in 1830

to describe the shape (and, because the word also means fat-head, the intellectual capability) of Louis-Philippe. On the cultural implications of the enormous popularity of the pun on both sides of the Atlantic during the nineteenth century, see Walter Redfern, *Puns* (Oxford: Basil Blackwell, 1984). An earlier study of the importance of the vernacular in American discourse is Richard Bridgman, *The Colloquial Style in America* (New York: Oxford University Press, 1966). More recently David Reynolds, in *Beneath the American Renaissance: The Subversive Imagination in the Age of Emerson and Melville* (New York: Alfred A. Knopf, 1988), has considered the pun and other wordplay as forms of subversion. Interest in the American vernacular began very early: the first lists of vernacular expressions were associated with the stage, and one was compiled as early as 1815. In the first edition of Webster's *American Dictionary of the English Language*, 1828, of the 38,000 words in the dictionary, 5,000 were those that Webster claimed had meanings only in American usage. Later dictionaries include James O. Halliwell-Phillips, *A Dictionary of Archaisms and Provincialisms, Containing Words Now Obsolete in England, All of Which are Familiar and in Common Use in America* (London: J.R. Smith, 1847); John Russell Bartlett, *Dictionary of Americanisms* (New York: Bartlett and Welford, 1848); and Alfred L. Elwyn, *Glossary of Supposed Americanisms* (Philadelphia: Lippincott, 1859). Those in this century that provide help in identifying the meanings of the colloquialisms include (in addition to Craigie, *Dictionary of American English*) M. M. Matthews, *The Beginnings of American English* (Chicago: University of Chicago Press, 1931).

13. Setaucket Scrapbook, 5, and quoted in Richard J. Koke et al., *American Landscape and Genre Paintings in the New-York Historical Society: A Catalogue of the Collection, Including Historical, Narrative, and Marine Art*, 3 vols. (Boston: G. K. Hall, 1982), 2:396; Setaucket Scrapbook, 3; Setaucket Scrapbook, 3.

14. On Reed, see Wayne Craven, "Luman Reed, Patron: His Collection and Gallery," *American Art Journal* 12:2 (1980): 40–59, and Alan Wallach, "Thomas Cole and the Aristocracy," *Arts Magazine* 56 (November 1981): 94–106. Reed's letters, many of them to Hackett and to Mount, are at the New-York Historical Society. Reed's paintings collection, which became an American collection after his dis-

covery that New York dealers were selling him fake Old Masters, is discussed in Maybelle Mann, "The New-York Gallery of Fine Arts: A Source of Refinement," *American Art Journal* 11:1 (1979): 76–86. The "new era" quotation is in Frankenstein, *Mount*, 70. Reed identified Mount's humor with that of the Jack Downing stories, associating the narrative of *Farmers Bargaining* with the Jack Downing story that appeared in the *New York Gazette* on Oct. 28, 1835, in which Aunt Nabby interrupts Joshua at his whittling-accompanied argument to come to dinner (letter of Oct. 29, 1835; a passage from the Downing story was printed in the catalog of the Reed collection in 1844). For a discussion of amiable relationships between artists, writers, and patrons during the period, including the Sketch Club, to which Reed belonged and in which Mount occasionally participated, see James T. Callow, *Kindred Spirits: Knickerbocker Writers and American Artists, 1807–1855* (Chapel Hill: University of North Carolina Press, 1967); for patronage, see Lillian B. Miller, *Patrons and Patriotism: The Encouragement of the Fine Arts in the United States, 1790–1860* (New York: G. Braziller, 1966), and Neil Harris, *The Artist in American Society: The Formative Years, 1790–1860* (Chicago: University of Chicago Press, 1966).

15. On gift books, see Ralph Thompson, *American Literary Annuals and Gift Books, 1825–1865* (New York: H. H. Wilson, 1936); David S. Lovejoy, "American Painting in the Early Nineteenth-Century Gift Books," *American Quarterly* 7:4 (1955): 345–361; Benjamin Rowland, Jr., "Popular Romanticism: Art and the Gift Books," *Art Quarterly* 20 (Winter 1957): 364–381; and Fred B. Adelson, "Art under Cover: American Gift-Book Illustrations," *Antiques* 125:3 (1984): 646–653. A gift book, according to a confident critic of the period, "softens the asperities of life, and assists the cultivation of the humanities" (Burton's *Gentleman's Magazine* 1 [October 1837]: 278). A small engraving of *Bargaining for a Horse*, by Joseph Andrews, appeared in *The Gift for 1840* opposite p. 256, with no accompanying story. Mount did not like the quality of the engraving and complained about it in a letter to Carey in 1839 (Frankenstein, *Mount*, 25). The painting was later engraved by the American Art-Union and distributed to members in 1851; see below.

16. For other discussions of the painting, see Ka-

ren Adams, "The Black Image in the Paintings of William Sidney Mount," *American Art Journal* 7:2 (1975): 42–59; Guy C. McElroy, *Facing History: The Black Image in American Art, 1710–1940* (Washington, D.C.: Bedford Arts for the Corcoran Gallery of Art, 1990), 20; and Albert Boime, *The Art of Exclusion: Representing Blacks in the Nineteenth Century* (Washington, D.C.: Smithsonian Institution Press, 1990), 93–95. As Adams points out, the posture of the sleeping black man is close to that of the Hellenistic Barbarini faun, a cast of which was in the National Academy of Design.

17. The first wave of abolitionists, in societies created to urge the end of English involvement in the slave trade, were active in the late eighteenth century; they achieved their goals in 1833. For studies of the second wave, directed at the practice of slavery, see Gerald Sorin, *The New York Abolitionists: A Case Study of Political Radicalism* (Westport, Conn.: Greenwood Press, 1971); Merton L. Dillon, *The Abolitionists: The Growth of a Dissenting Minority* (DeKalb: Northern Illinois University Press, 1974); and Thomas F. Harwood, "British Evangelical Abolitionism and American Churches in the 1830s," *Journal of Southern History* 28:3 (1962): 287–306. For the quotation from the *Long Island Democrat*, see the Oct. 21, 1835, issue. The widely read *Niles Register* reported almost daily in 1834 and 1835 on the dangers of abolition. For the Jackson quotation, see Leonard L. Richards, *Gentlemen of Property and Standing: Anti-Abolition Mobs in Jacksonian America* (New York: Oxford University Press, 1970), 51. For the general mood of hysteria, see David Brion Davis, *The Slave Power Conspiracy and the Paranoid Style* (Baton Rouge: Louisiana State University Press, 1969).

18. Many of the American reformers were Presbyterian, and one of the most prominent Presbyterians was indeed foreign: George Thompson, financed by the Scottish Emancipation Society, traveled an explosive lecture circuit in the United States from September 1834 to November 1835. See C. Duncan Rice, "The Anti-Slavery Mission of George Thompson to the United States, 1834–35," *Journal of American Studies* 2 (April 1968): 13–31, and Harwood, "British Evangelical Abolitionism," 301. Thompson was alluded to as "Mr. Foreigner Thompson" by future president John Tyler in a speech of August 1835 denouncing abolitionist activities (Richards,

Gentlemen of Property and Standing, 57); the *Niles Register* accused Thompson of "foreign interference" on Sept. 27, 1834, and alluded to him as a "foreign emissary" on Nov. 1, 1834. Caricatures include *Reply to Bobalition of Slavery,* a broadside in heavy dialect featuring a conversation between "Scipio and Cato, Sambo and Phillis," n.d. (Library of Congress), and "Grand Celebrashun ob de Bobalition of African Slavery!" 1835 (Library of Congress). Newspaper editor Horace Greeley supported abolition in his *Tribune;* Clay's caricature of 1840, "Race between Bennett and Greeley for the Post Office Stakes" (Library of Congress), depicts Greeley in a tam-o'-shanter and kilts, a reference both to his heritage and to his stand on emancipation; the bag he carries is labeled "black mail" and two blacks stand on the left, carrying signs that read "Emancipation" and "Tribune." In another demonstration of the symbol's potency, President Lincoln wore a tam-o'-shanter when he disembarked the train in Washington, D.C., after his election.

19. Mount's earlier patron, Luman Reed, had died a shockingly early death soon after his delight with Mount's *Bargaining for a Horse.* The quotation is in Jonathan Sturges to William Sidney Mount, Dec. 14, 1837 (New-York Historical Society). In a later communication between Sturges and Mount, Sturges used "in the same line" to allude to Mount's clever founding of an image on the vernacular; see below.

20. *New-York Mirror,* June 17, 1837, 407; Setauket Scrapbook, 11.

21. The painting was engraved in 1842 as a small frontispiece of the association's *Transactions;* the next year the directors commissioned Alfred Jones to engrave a large print of the painting for their 1,450 national members. On the American Art-Union, see Mary Bartlett Cowdrey, *American Academy of Fine Arts and American Art-Union, 1816–1852,* 2 vols. (New York: New-York Historical Society, 1953); Maybelle Mann, *The American Art-Union* (Otisville, N.Y.: ALM Associates, 1977); and Jay Cantor, "Prints and the American Art-Union," in John D. Morse, ed., *Prints in and of America to 1850* (Charlottesville: University Press of Virginia, 1970), 297–326. Mount was to have a roller-coaster relationship with the Art-Union. In 1844 he wrote to George Pope Morris protesting his treatment by the Committee on Management when he had brought in a painting to sell

to them: "I have never sold but two pictures to the Art-Union and was beat down in my price on one of those. . . . The Art-Union does not give orders this year, but intends to buy pictures at *low* prices to grind the *Artist* down" (Frankenstein, *Mount,* 234). By 1847, however, Mount praised the Art-Union as appearing "to be on the right road" (Frankenstein, *Mount,* 42). *Godey's Lady's Book* published an engraving of the work by Joseph N. Gimbrede in July 1845.

22. *United States Magazine and Democratic Review* 1:1 (1837): 2. Certainly it is also significant that writers during these years, most prominently Hawthorne, worked in the trope of allegory. Readers were not unaccustomed to "double meanings."

23. In addition to these two paintings, he showed *The Courtship, or Winding Up* (private collection) (a theme discussed in chapter 5); the previous year, he had exhibited, besides *Farmers Bargaining, The Truant Gamblers (Undutiful Boys),* 1836 (New-York Historical Society), also commissioned by Reed.

24. George Foster, in *New York by Gaslight* (New York: Dewitt and Davenport, 1850), 43, registers his strong disapproval of this phenomenon. "It is true that there is a lot of poultry hanging about the dark and unfurnished room, and lying heaped up at the far end of the long deal table that runs through the apartment like a tailor's shopboard. But the real business of the players, who crowd around this table, is the betting on numbers and buying chances, which is carried on pretty extensively, considering the means of those principally engaged in it. We know an intellectual and gifted man who night after night neglects his wife and children to visit this miserable hole and lose his earnings . . . Attempts have been made to break up this and other establishments somewhat similar—but [these attempts fail because proprietors protest that] it is 'only for a little poultry'—'just by way of passing the evening'—and thus ends the investigation, while the game goes on brisker than ever." A "poultry-dealer" was, then, a gambler. Also see Craigie, *Dictionary of American English.*

25. *Niles Register,* May 9, 1835, quoting the *New York Evening Star;* Allan Nevins, ed., *The Diary of Philip Hone, 1828–1851,* 2 vols. (New York: Dodd, Mead, 1927), 1:203 (Mar. 8, 1836); *Niles Register,* May 9, 1835, Apr. 9, 1836.

26. The only sketch for this work shows a large

tavern with nineteen figures; for the painting, Mount thinned out his crowd and gave the goose center stage. "Goose imagery," both verbal and visual, was prominent in the culture. In disapproval of the mission of abolitionist and women's rights campaigner Frances ("Fanny") Wright, then touring the country, in 1829 the Philadelphia caricaturist James Akin drew *A Downright Gabbler, or A Goose That Deserves To Be Hissed* (Library of Congress), depicting her as goose-faced. In Smith's *Jack Downing* (Boston: Lilly, Wait, Colman, and Holden, 1833), Jack finds himself in a tight spot and rues that "if something isn't done pretty soon, it'll be gone goose with us" (42). Frost's story in *The Gift for 1842* (Philadelphia: Carey and Hart, 1841), 250–261, opens in the 1820s when a countryman comes into a tavern where two Harvard students have joined the crowd. When the countryman raffles a goose that he can't "bargain," or trade, the students throw in their lot and both lose. One learns his lesson but the other is fired with "a taste for speculation." Years pass, the students become lawyers and then family men, and they meet again in early 1837. Predictably, the one has been prudent over the years, but the other has been deeply involved in speculation, the latest of which is a venture on lots in Brooklyn. His careful friend warns him, "I would not risk 20 cents on such a venture." "Why," the gambler replies, "that is just the price of our old raffle tickets." "Just so," says the prudent one, "and you are raffling for a goose." The story ends predictably, with the speculator losing his fortune, plunging his family into ruin, and learning his lesson too late. In 1849, reformer Foster harped on this inevitable outcome of the Bowery raffles. "As to the poultry," he told his readers, "we seldom hear of any body bringing much of it away with him . . . every one who goes [to the raffles] is very likely to turn out a 'gone goose.'" Annual editors typically chose the images that they wished to reproduce and then commissioned writers to compliment them with texts; thus the texts that were published in gift books and periodicals to accompany engravings are superb evidence of the cultural associations of images. I make this point emphatically because Mount's biographer Frankenstein so insistently disavowed such connections.

27. For Strong, see *The Diary of George Templeton Strong* (New York: Macmillan, 1952), Apr. 26, 1837.

Mount himself alluded to it as "The Raffle" until correspondence in the 1850s when he also called it "Raffling for a Goose." See, for instance, June 14 and May 27, 1953 (Frankenstein, *Mount*, 267, 302). In 1852, after Brevoort died, the dealers Williams and Stevens put the painting up for sale as "Raffling for a Goose."

28. George S. Hellman, ed., *Letters of Henry Brevoort to Washington Irving*, vol. 2 (New York: G. P. Putnam's Sons, 1916), 93 (July 28, 1832). Brevoort paid Mount fifty dollars more than they had agreed on for the painting (Frankenstein, *Mount*, 469).

29. The year 1836 saw the highest number of caricatures yet produced—fifty during the year, thirty-seven in New York alone. Typically they lampooned Jackson, as Clay's *Political Barbecue*, published by H. R. Robinson (Library of Congress), in which the president is a pig roasting on a spit being turned by his political opponents.

30. New Yorkers were not flattering about Long Islanders either. A critic for the *New-York Mirror*, for instance, advised that Mount would be better off sticking with "domestick, comick, or rural scenes, than if his time and talents were thrown away on [portraits of] muffin-faces" (May 30, 1835): 379.

31. The painting was not exhibited at the National Academy of Design until 1843, when it was called *Artist Showing His Work*. Mount may well have kept the painting in his studio because E. L. Carey bought it to be engraved and published in *The Gift for 1840* (Philadelphia: Carey and Hart, 1839). The engraving, by A. Lawson, was presented as "The Painter's Study," opposite p. 208; it emphasizes the gap-tooth of the visitor, and Apollo has a clear smirk on his face. In a short autobiography, Mount described the painting as "Artist showing his own work," which suggests the distinction he made between portraiture, painted to the demands of others, and "pictures," or genre scenes that sprang from his own wit (Frankenstein, *Mount*, 29). Tantalizingly, the painting on the easel is about the size of *Farmers Bargaining*—one wonders if the work is an invocation of the memory of Reed, who had died suddenly in 1836—and the cart whip was also a prop carried by Charles Hackett in his stage impersonations of a "real" Yankee; see Francis Hodge, *Yankee Theatre: The Image of America on the Stage, 1825–1850* (Austin: University of Texas Press, 1964), 96. For a recent interpretation of the signifi-

cance of this painting, see William T. Oedel and Todd S. Gernes, "The Painter's Triumph: William Sidney Mount and the Formation of a Middle-Class Art," *Winterthur Portfolio* 23:2/3 (1988): 111–127.

32. Setauket Scrapbook, 3, 5. *New-York Mirror,* July 7, 1838, 15, in which the critic took great pains to distinguish Mount's simple technique from the careful, detailed work of Wilkie; for this writer, at least, Mount's simplicity was part of his virtue. *New-York Mirror,* June 17, 1837, 407.

33. William Dunlap, "On the Influence of the Arts of Design: And the True Modes of Encouraging and Perfecting Them," *American Monthly Magazine* 7 (February 1836): 113–123. On government support, see *United States Magazine and Democratic Gazette* 3:11 (1838): 253, 256. During this era of nationalist assessment of the United States as a potentially artistic culture, early hopeful accounts included Dunlap, *History of the Rise and Progress of the Arts of Design in the United States,* 2 vols. (1834; rpt., 3 vols., New York: Dover Press, 1964); Samuel Knapp, *Lectures on American Literature* (New York: E. Bliss, 1829). For the history of the founding of journals during the period see Frank Luther Mott, *A History of American Magazines, 1741–1850* (Cambridge: Harvard University Press, 1966). Recent surveys of the content and tone of art criticism during the antebellum period are William H. Gerdts, "The American 'Discourses': A Survey of Lectures and Writings on American Art, 1770–1858," *American Art Journal* 15:3 (1983): 61–79, and Anne Farmer Meservey, "The Role of Art in American Life: Critics' Views on Native Art and Literature, 1830–1865," *American Art Journal* 10:1 (1978): 73–89.

34. On Inman, see William H. Gerdts, *The Art of Henry Inman* (Washington, D.C.: Smithsonian Institution Press for the National Portrait Gallery, 1987), 73–74, and on Sully, Monroe H. Fabian, *Mr. Sully, Portrait Painter* (Washington, D.C.: National Portrait Gallery, 1983). Typical titles suggesting idealized childhood by now-unknown artists at the academy exhibition in 1834 were J. Whitehorne, "Boy and Hobby Horse"; F. S. Agate, "The Old Oaken Bucket"; C. Mayr, "Portrait of a Child in Bed"; and J. H. Shegog, "The Torn Hat—Portrait of Boy and Dog." Inman, Browere, Durand, John Gadsby Chapman, Samuel F. B. Morse, and others painted scenes from Irving. During the same period, Inman, William Dunlap, Thomas Cole, and numerous others took inspiration from Cooper's Leatherstocking novels. On Irving and art, see Jules David Prown, "Washington Irving's Interest in Art and His Influence upon American Painting" (M.A. thesis, University of Delaware, 1956). See also Christopher Kent Wilson, "John Quidor's *The Return of Rip Van Winkle* at the National Gallery of Art: The Interpretation of an American Myth," *American Art Journal* 19:4 (1987): 23–45, and Chad Mandeles, "A New Look at John Quidor's Leatherstocking Paintings," *American Art Journal* 12:3 (1980): 65–74.

35. For an invaluable discussion of the goals of history painting during these years, see William H. Truettner, "The Art of History: American Exploration and Discovery Scenes, 1840–1860," *American Art Journal* 14:1 (1982): 4–31. William H. Gerdts and Mark Thistlethwaite, in *Grand Illusions: History Painting in America* (Fort Worth, Texas: Amon Carter Museum, 1988), in contrast to Truettner, make few connections between paintings and contemporary politics and ideology. The response to Weir is in *New-York Mirror,* May 22, 1841, 167.

36. The contents and thus the proportions of exhibitions can be traced in exhibition catalogs and summaries, such as Mary Bartlett Cowdrey, *American Academy of Fine Arts and American Art-Union, 1816–1852,* 2 vols. (New York: New-York Historical Society, 1953), and *National Academy of Design Exhibition Record, 1826–1860,* 2 vols. (New York: New-York Historical Society, 1943); Robert F. Perkins, Jr., and William J. Gaven III, *The Boston Athenaeum Art Exhibition Index, 1827–1874* (Boston: Library of the Boston Athenaeum, 1980); and Anna Rutledge, *Pennsylvania Academy of the Fine Arts, 1807–1870: Cumulative Record of Exhibition Catalogues* (Philadelphia: American Philosophical Society, 1955), and *Index to American Art Exhibition Catalogues: From the Beginning through the 1876 Centennial Year* (Boston: G. K. Hall, 1986). Houston Mifflin, "The Fine Arts in America and Its Peculiar Incentives to Their Cultivation," *Knickerbocker Magazine* 2 (1833): 34. Mount was interested in landscape and visited Thomas Cole in 1834 on a trip to the Catskills. Cole's essay is found in the *American Monthly Magazine* 7 (January 1836): 1–13, quotation on pp. 1–2. Ironically, however, Cole's *Course of Empire,* which he finished in 1836, pointed to essentially the same cul-

tural phenomenon of cultural decay as Mount's *Farmer's Bargaining* but did not receive a congratulatory review.

37. Frederick Marryat, *A Diary in America: With Remarks on Its Institution* (1839; rpt. New York: Alfred A. Knopf, 1962): 77.

38. *Transactions of the American Art-Union*, 1839, 12. On the depression, see Samuel Rezneck, "The Social History of an American Depression, 1837–1843," *American Historical Review* 40:4 (1935): 662–687. Isaac S. Lyon, *Recollections of an Old Cartman* (Newark, N.J.: Daily Journal Office, 1872), 60.

39. David C. Johnston, among other American wits, renewed popular delight in this pun in his *Aurora Borealis, or Flashes of Wit; Calculated to Drown Dull Care and Eradicate the Blue Devils* (Boston, New York, and Philadelphia: The Editor of the Galaxy of Wit, 1831). One speaker reported that he had shot thirty-three hares before breakfast. "Sir," his respondent replied, "then you must have been firing at a *wig*" (6).

40. Davis was director of the New York branch of the Second Bank of the United States and a close friend of Nicholas Biddle. His Jack Downing letters are distinguishable from Smith's because they are signed "J. Downing, Major." Begun in June 1833, they were subsequently published as *Letters of J. Downing, Major, Downingville Militia, Second Brigade, to His Old Friend, Mr. Dwight of the New York 'Daily Advertiser'* (New York: Harper and Brothers, 1834). Davis also published, in 1834, *The Life of Andrew Jackson, President of the United States* (Philadelphia: T. K. Greenbank, 1834), illustrated with satirical woodcuts. The review of *Boys Trapping* is in Setauket Scrapbook, 9.

41. The image was later made into a color lithograph with that title by W. Schaus and Goupil, 1850. In 1844 E. W. Carey in Philadelphia commissioned a second version of the scene, this one called *Trap Sprung;* engraved by J. I. Pease, it was published in *The Gift for 1845*. Mount having painted the first image of "rabbit trapping" for Davis, at which point it presumably disappeared from public access, Carey may have wished to spread the enjoyment of the idea, much as he had with *Farmers Bargaining*, especially in his careful transformation of the title in his publication into *Bargaining for a Horse*.

42. Fundamental to my work in conceiving this project was the essay by Joseph B. Hudson, Jr., "Banks, Politics, Hard Cider, and Paint: The Political Origins of William Sidney Mount's 'Cider Making,'" *Metropolitan Museum Journal* 10 (1975): 107–118.

43. The story of this campaign is told in Robert Gray Gunderson, *The Log-Cabin Campaign* (Lexington: University of Kentucky Press, 1957).

44. The story is quoted in Stuart P. Feld, "In the Midst of 'High Vintage,'" *Metropolitan Museum of Art Bulletin*, n.s., 25 (April 1967): 300–304.

45. A master of colloquial wit, Mount alluded to the bunker in a letter of Oct. 15, 1848, to a fellow Democrat, in which he attacked the collusion between the Barnburners (radical Democrats, so called because they would "burn the barn" to get rid of the rats) and the Whigs in election strategy; he coined *Barnbunkers* to express his contempt for this faction in the party. The fact that Harrison had died only a few days before the exhibition in which *Cider Making* was displayed was a sad irony, but the painting itself was not a comment on Harrison.

46. *Knickerbocker* 18 (July 1841): 87; the critic added that the color was "harsh and disagreeable" (*Arcturus* 2 [June 1841]: 61–62. Mount's brother is quoted on p. 292 in Feld, "Midst of 'High Vintage'"). Setauket Scrapbook, 12; *New-York Mirror*, May 22, 1841, 167.

47. Two of the most intriguing of these later images are *California News*, 1850 (Museums at Stony Brook), and *Herald in the Country*, 1853 (Museums at Stony Brook).

48. The painting was reviewed approvingly in *Knickerbocker* 23 (June 1844): 597, although not as a work following in the humorous line of Mount. H. Nichols B. Clark, in *Francis W. Edmonds: American Master in the Dutch Tradition* (Washington, D.C.: Smithsonian Institution Press, for the Amon Carter Museum, 1988), 76, discusses this painting as a tribute to heroes in general. However, I think that the figure of Napoleon on the peddler's tray alludes to the disparaging identification by Democratic opposition of Andrew Jackson as a tyrant. Aside from the title of this painting, associated with Edmonds's preparation for the work is additional evidence that several New York artists besides Mount were eager to explore the pun and other verbal ambiguities. In 1841, when the members of the Sketch Club put

their efforts to the topic "The Trying Hour," Edmonds, just back from France, drew Napoleon standing on the deck of his ship (the form he was to incorporate into *The Image Peddler*); Asher B. Durand sketched a woman kneeling in tears over the bier of a child; and Mount depicted a woman rendering fat in a large kettle over a fire (a now-obsolete meaning of *to try*) (Clark, *Edmonds*, 25). Another artist who tried Mount's colloquial approach was the portraitist Thomas Hicks, who created the small painting *Calculating* in 1844 (Museum of Fine Arts, Boston). With the onslaught of the depression, Mount had abandoned economic issues, but Hicks, a socially well-heeled New York portraitist, could not resist the opportunity to laugh at the well-storied fondness for calculation of the Yankee farmer. He depicted his farmer busy "reckoning" on a slate or tablet in a barn that has been swept clean of even a blade of straw. Besides the jug and the dog, the objects in the barn—the draped table on the left, the chair on which the farmer calculates, and the stool on the right, also draped—seem to have been transported from a house. The reckoning farmer has been "cleaned out" by the depression; yet, even with an empty barn—and presumably no home—he maintains his identity as a calculator. Edmonds, always alert to pictorial ideas, made Hicks's subtle humor blatant in his imitation of this painting in 1861, in which a man sits in an empty house, not even calculating; the work is entitled *Hard Times (Out of Work and Nothing to Do)* (Albrecht Art Museum, Saint Joseph, Mo.), pictured in Clark, *Edmonds*, 139. In another example of pictorial humor, the irrepressible D. C. Johnston, perhaps keeping an eye on Mount's success, created a drawing, etching, and painting in 1845 on the theme *Wide Awake—Sound Asleep* (private collection) that is an amused attack on the discrepancies between lazy and *wide-awake* (a colloquialism for looking out for the "main chance") citizens. Johnston depicted the street in front of a shipping firm, where one worker is busy, a second is dozing, and a youngster is painting a smiling face on the bald head of the sleeper. The firm is called "Marker and Sleeper"; other verbal jokes include the address on one of the boxes: to "I Brow in Philadelphia."

49. In his second version of the painting, dated 1852, Durrie painted a rooster, symbol of the Democratic party, on the ledge of the open window. The obvious reading was that it had plenty to crow about. Durrie exhibited neither painting in New York. Critics would not brook imitation of Mount that was too close. In 1847, for instance, Otis A. Bullard exhibited *Trading Horses* at the National Academy of Design (now lost), and a critic criticized him harshly: "A palpable and absurd imitation of Mount. We notice this gross attempt to rob Mount of his identity, because we have observed that all this artist's attempts at composition have been evidently borrowed from the same source" (*Literary World*, May 1, 1847, 304).

50. Two of the unsuccessful pictures in 1840 were subjects of rural children (*Boy Hoeing Corn* and *The Blackberry Girls*) and a third was a treatment of a procrastinating bachelor whose house had burned down; see *Knickerbocker* 16 (July 1840): 82. Apparently, Mount needed the corroboration of a patron to be witty. On the Sturges request, see Frankenstein, *Mount*, 99. What Sturges got next was *Scene in a Long Island Farm-Yard (Ringing the Pig)*. *Knickerbocker* 18 (June 1842): 590, admitted that the work had "much of the humor and point of this artist" but that Mount hadn't handled his coloring well at all, that in fact he ought to go abroad to achieve "a more thorough acquaintance with the mechanical part of the art." In 1851 Sturges was to write to Mount that, with Mount's painting for him *Who'll Turn the Grindstone*, they were "likely to have a chance to go down to posterity, clinging to Dr. Franklin's skirts. . . . I shall be most happy to take a 'Turn at your Grind stone.' The fact is I have been waiting so long, to get a 'turn,' that I can hardly wait for you to get here with it. I have no doubt it will be of the *real grit*, such as usually comes from your quarry" (Frankenstein, *Mount*, 100).

51. *Knickerbocker* 24 (July 1844): 75. On "Woodman," see Frankenstein, *Mount*, 142. The MS for the Jonathan series is in the New-York Historical Society and printed in Frankenstein, *Mount*, 130–132.

52. Charles Lanman, *Letters from a Landscape Painter* (Boston: James Munroe, 1845), 244.

53. He then went on to make his own pun by noting that the country seats of wealthier Long Islanders were ornamented with "far fetched" (that is, European and idealistic) pictures. Setauket Scrapbook, 6.

54. Brevoort to Irving, Oct. 18, 1843, *Letters*, 132–133.

CHAPTER 3: FROM THE OUTER VERGE OF OUR CIVILIZATION

1. Major secondary works on which I have drawn, in addition to a wide range of contemporary periodicals, include Henry Nash Smith, *The Virgin Land: The American West as Symbol and Myth* (Cambridge: Harvard University Press, 1950); Richard Slotkin, *Regeneration through Violence: The Mythology of the American Frontier, 1600–1860* (Middletown, Conn.: Wesleyan University Press, 1973), and *The Fatal Environment: The Myth of the Frontier in the Age of Industrialization, 1800–1890* (Middletown, Conn.: Wesleyan University Press, 1985); Patricia Nelson Limerick, *The Legacy of Conquest: The Unbroken Past of the American West* (New York: W. W. Norton, 1987); and Richard Wade, *The Urban Frontier: Pioneer Life in Early Pittsburgh, Cincinnati, Lexington, Louisville, and St. Louis* (Chicago: University of Chicago Press, 1964).

2. For European attitudes, see Hugh Honour, *The New Golden Land: European Images of America from the Discoveries to the Present Time* (New York: Pantheon, 1975), and Ray Allen Billington, *Land of Savagery/Land of Promise: The European Image of the American Frontier in the Nineteenth Century* (Norman: University of Oklahoma Press, 1981). Slotkin, in *Regeneration of Violence*, analyzes the assessments of the West by Americans in different regions, citing among other rich evidence the variants in the Daniel Boone stories. Also see Walter Prescott Webb, *The Great Plains* (New York: Grosset and Dunlap, 1953), and G. Malcolm Lewis, "The Great Plains Region and Its Image of Flatness," *Journal of the West* 6 (January 1967): 11–26. For Bryant, see *Knickerbocker* 2 (December 1833): 410; Washington Irving, *A Tour on the Prairies* [1835], ed. John Francis McDermott (Norman: University of Oklahoma Press, 1956), 175–176; Thoreau, *Journal*, 14 vols. (New York: Dover, 1962), 2:171.

3. James Hall, *Sketches of History, Life, and Manners in the West* (Philadelphia: Harrison Hall, 1835), 21. See also Earl Pomeroy, "Toward a Reorientation of Western History: Continuity and Environment,"

Mississippi Valley Historical Review 41:4 (1955): 579–600, who proposes an alternative to the frontier thesis of Frederick Jackson Turner.

4. Catlin, *Travels in North America* (London: published by author, 1841), 32.

5. Among the most cynical about Westerners was the Englishman Basil Hall, who traveled on the Mississippi and Ohio rivers in 1827 and 1828 with a camera lucida, translated his images into etchings, and issued them as *Forty Etchings from Sketches Made with the Camera Lucida in North America in 1827 and 1828* (Edinburgh: Cadell; London: Simpkin and Marshall, and Moon, Boys and Graves, 1829) at the same time that he published his dyspeptic *Travels in North America* (Philadelphia: Carey, Lea, and Carey, 1829). Including an Indian, boys, backwoodsmen, steamboat captain, boatman, and plantation overseer, Hall's types projected indolence, self-satisfaction, lack of conspicuous intelligence, and suspicious ambiguity of moral character, all qualities that dominated his travelogue. *Illinois Monthly Magazine* 1:1 (1830): 3; *Western Monthly Review* 2 (November 1828): 366.

6. On Manifest Destiny, see Albert K. Weinberg, *Manifest Destiny: A Study of Nationalist Expansionism in American History* (1935; rpt. Chicago: Quadrangle, 1963), and Frederick Merk, *Manifest Destiny and Mission in American History: A Reinterpretation* (1963; rpt. New York: Vintage, 1966). For an extended discussion of the anxiety about maleness during this period, see David Leverenz, *Manhood and the American Renaissance* (Ithaca: Cornell University Press, 1989).

7. For a survey of prints of Westerners, see Bernard Reilly, Jr., "The Prints of Life in the West, 1840–1860," in Ron Tyler et al., *American Frontier Life: Early Western Painting and Prints* (New York: Abbeville Press, for the Amon Carter Museum, 1987), 167–192. This book, and the exhibition it accompanied, have been invaluable. Production of the Crockett almanacs, devised and printed by entrepreneurs in Philadelphia and New York beginning in 1835, became a virtual industry in the late 1830s after Crockett's death at the Alamo. See Franklin Julius Meine, *The Crockett Almanacks* (Chicago: Caxton Club, 1955).

8. For scholarship on Quidor and paintings of Cooper's Leatherstocking, see chapter 2, note 34.

9. Some of Miller's images also featured the

French and half-French, half-Indian trappers of the early fur trade, who were a race apart as well—said to be warm-hearted, childlike, and irresponsible. Catlin exhibited his Indian Gallery in 1837 and again in 1839; Miller exhibited oil paintings made from his watercolor sketches in Baltimore and at the Apollo Gallery in New York in 1839. See Herman J. Viola, "The American Indian Genre Paintings of Catlin, Stanley, Wimar, Eastman, and Miller," in Tyler et al., *American Frontier Life,* 131–165. On Miller, see Ron Tyler, ed., with a Catalogue Raisonné by Karen Dewees Reynolds and William R. Johnston, *Alfred Jacob Miller: Artist on the Oregon Trail* (Fort Worth, Texas: Amon Carter Museum, 1982). On Catlin, see William Truettner, *The Natural Man Observed: A Study of Catlin's Indian Gallery* (Washington, D.C.: Smithsonian Institution Press, 1979). Other enterprises to paint portraits of the Indian included those of Charles Bird King and James Otto Lewis, begun in the 1820s and 1830s. In 1832 Swiss artist Karl Bodmer accompanied the Austrian naturalist and explorer Prince Maximilian of Wied-Neuwied on a Western expedition; his watercolors served as the basis for aquatints that appear in Maximilian's *Travels in the Interior of North America.* In the 1840s and later, illustrator F. O. C. Darley popularized the Indian as both romantic and fierce; Christine Anne Hahler, *"Illustrated by Darley": An Exhibition of Original Drawings by the American Book Illustrator Felix Octavious Carr Darley (1822–1888)* (Wilmington: Delaware Art Museum, 1978). On the relationship between whites and Native Americans, see Roy Harvey Pearce, *Savagism and Civilization: A Study of the Indian and the American Mind* (Baltimore: Johns Hopkins University Press, 1967); Robert F. Berkhofer, Jr., *The White Man's Indian: The Image of the American Indian from Columbus to the Present* (New York: Alfred A. Knopf, 1978); and Robert M. Utley, *The Indian Frontier of the American West, 1846–1890* (Albuquerque: University of New Mexico Press, 1984).

10. For earlier studies of Western images, see Patricia Hills, *The American Frontier: Images and Myths* (New York: Whitney Museum of American Art, 1973), and Dawn Glanz, *How the West Was Drawn: American Art and the Settling of the Frontier* (Ann Arbor, Mich.: UMI Research Press, 1982). I am espe-

cially indebted to Glanz; though I have not followed her formulation, her gathering and analysis of so large a body of material has been most helpful in my research.

11. For the most recent scholarship on Deas, see Carol Clark, "Charles Deas," in Tyler et al., *American Frontier Life,* 51–78.

12. The image of a man on horseback is reminiscent of similar works of French officers by French artists during the earlier part of the century, such as those by Théodore Géricault. Deas's New York audiences had seen trappers in the paintings of Alfred Jacob Miller as part of the motley assemblage of Indians and adventurers in the far West, but Deas was the first artist to present the trapper alone for examination. Moreover, Miller's trappers, active in the northern Rockies, were generally assumed to be French or half-French; those of Deas, by contrast, who plied their trade in the lower Rockies, Anglo-Saxon. Although a few of Miller's images presented trappers in dramatic situations, such as fleeing Indians, most showed trappers relaxing—enjoying the company of Indians in work, social occasions, and domestic arrangements. One of his most popular paintings, *The Trapper's Bride,* a romantic image that celebrated the exoticism (and purity) of the Indian maiden, at once echoed Delacroix's fascination with exotic women, picked up European fantasies about the virtuous savage tribes, and hinted at theories popular earlier in the century that intermarriage would slowly raise the Indian to the level of white civilization. This picture by Miller, and others in which he depicted trappers and Indians, was not so much about the social territory into which the nation would expand as about an idyllic, exotic land that had existed primarily in the past.

13. Deas painted *voyageurs,* by definition French, in the company of their families, as had Miller, for Americans believed the essence of the French trapper to be his desire for comfortable domesticity.

14. On the trapper, see LeRoy R. Hafen, ed., *Mountain Men and the Fur Traders of the Far West* (Lincoln: University of Nebraska Press, 1982); Ray Allen Billington, *The Far Western Frontier, 1830–1860* (New York: Harper and Row, 1956), esp. 41–68; William H. Goetzmann, *Exploration and Empire: The Explorer and the Scientist in the Winning of the American*

West (New York: Alfred A. Knopf, 1966); and Goetz-mann, "Lords at the Creation: The Mountain Men and the World," *The Mountain Man* (Cody, Wyo.: Buffalo Bill Historical Center, 1978), 9–31. Although the story of various fur companies is complex, the earlier trappers were generally associated with the British Hudson's Bay Company and the American Fur Company, and the second wave with the Rocky Mountain Fur Company, founded in 1830 by trappers. See Goetzmann, "Lords at the Creation," for a detailed chronology.

15. Timothy Flint, *The Shoshonee Valley: A Romance*, 2 vols. (Cincinnati: E. H. Flint, 1830), 1:20–22; J. M. Peck, *A New Guide for Emigrants to the West* (Boston: Gould, Kendall, and Lincoln, 1836), 127.

16. Quoted in Goetzmann, "Lords at the Creation," 26. Washington Irving, *The Adventures of Captain Bonneville* (1837; rpt. Norman: University of Oklahoma Press, 1961), 11.

17. James Madison Cutts, *The Conquest of California and New Mexico* (Philadelphia: Carey and Hart, 1847), 165–167, quoted in Smith, *Virgin Land*, 84–85, who notes that this description was reprinted in *The Rough and Ready Annual; or Military Souvenir* (New York: D. Appleton, 1848), 153–168.

18. According to this critic, Asher B. Durand's landscape *The Passing Shower* was the universal favorite at the exhibition; right behind it were Deas's *Long Jakes* and Charles E. Weir's *Compositor Setting Type* (now lost). Because compositors were identified with the working classes (and sometimes women did such work), the juxtaposition of these two paintings as favorites is thought-provoking indeed (*Broadway Journal*, Jan. 4, 1845, 13).

19. *New York Illustrated Magazine* (July 1846): 169–174. Herbert often wrote in the gothic mode of Edgar Allan Poe.

20. Charles Averill, in *Kit Carson: The Prince of the Gold Hunters* (Boston: G. H. Williams, 1849), describes a painting of Carson: "A man on horseback, in the dress of a western hunter, equipped like a trapper of the prairies; his tall and strongly knit framed drawn up, erect and lithe as the pine tree of his own forests; his broad, sun-burnt face developing a countenance, on which a life of danger and hardship had set its weather-beaten seal, and placed in boldest relief the unerring signs of a nature which

for reckless daring and most indomitable hardihood, could know scarce a human superior." Only the details in the background vary from Deas's image, but they suggest a painting discussed below, by Ranney, *The Trapper's Last Shot:* "Far in the background of the painting, rolled the waving grass of a boundless prairie; amid the silent wilderness of which towered the noble figure of the hunter-horseman, half Indian, half whiteman in appearance, with rifle, horse and dog for his sole companions, in all that dreary waste; though to the right a yelling pack of wolves were seen upon his track, and on his left the thick, black smoke, in curling wreaths, proclaimed the prairie fire, while in the clear, gray eye that looked from the thrilling picture forth, there seemed to glance a look of proud indifference to all, and the conscious confidence of ennobling self-reliance!" (Averill, *Kit Carson*, 44–45, quoted in Smith, *Virgin Land*, 88–89).

21. Other Western adventure stories were Emerson Bennett's *Prairie Flower, or Adventures in the Far West* (Cincinnati: Stratton and Barnard, 1849), and Averill's *Kit Carson* of the same year, Bennett's *Border Rover* (Philadelphia: T. B. Peterson and Brothers, 1857), Mayne Reid's *Hunters' Feast; or, Conversations around the Campfire* (New York: De Witt and Davenport, 1856), and weekly offerings in Gleason and Ballou's *Flag of Our Union* and the *New York Ledger*. See Smith, *Virgin Land*, 87–89; Jules Zanger, "The Frontiersman in Popular Fiction, 1820–1860," in John F. McDermott, ed., *The Frontier Re-Examined* (Urbana: University of Illinois Press, 1967); and Frederic Hudson, *Journalism in the U.S. from 1690 to 1872* (New York: Harper, 1873), 587–589. On Parkman, see Leverenz, *Manhood*, 217–226.

22. On exhibition by late summer 1845 at the Art-Union, this startling image, which drew crowds of viewers and widespread notice in the press, was snapped up for his own collection by the organization's treasurer, George Austen.

23. Reviews are found in *Broadway Journal*, Sept. 13, 1845, 154–155, and *AngloAmerican*, Sept. 6, 1845, 474. Herbert, in *New York Illustrated Magazine* 2 (1846): 289–294. *Democratic Review*, January 1847, reprinted in the *St. Louis Weekly Reveille*, Feb. 8, 1847, 1163. In 1847 owner George Austen exhibited *Death Struggle* at the Boston Athenaeum under the

considerably more sedate, less inflammatory title *Contest for a Beaver*.

24. For illustrations of Deas's images of Indians, see Tyler et al., *American Frontier Life*, 59 (*Sioux Playing Ball*) and 63 (*A Group of Sioux*).

25. Years later, the artist Worthington Whitredge, who had been a student in the 1840s, reminisced that the American Art-Union had given genre painting its distinctive chance. "That class of work generally known as 'genre,' the most natural and expressive way of recording the manners and custom of a people, had been almost entirely neglected. It was the Union that gave impetus to this class of work, not so much by merely buying them . . . as by the encouragement it gave to native art, and the consequent spur to the artists to look for subjects at their own doors" ("The American Art-Union," *Magazine of History* 8 [February 1908]: 66).

26. For a general account of these journals, and their publishers' and writers' ambitions, see Frank Luther Mott, *A History of American Magazines, 1741–1850* (Cambridge: Harvard University Press, 1966). *Knickerbocker* 32 (November 1848): 446. The American Art-Union formed a model for many subsequent ventures, including the New England Art-Union, the Western Art-Union (headquartered in Cincinnati), the Philadelphia Art-Union, and even the California Art Union, which lasted only one year and is discussed in Raymond L. Wilson, "Painters of California's Silver Era," *American Art Journal* 16:4 (1984): 73. On exhibitions at the American Art-Union, see *Literary World*, Nov. 25, 1848, 853.

27. In fact, Mount had a difficult relationship with the American Art-Union, apparently because he had already secured patronage and reception identified with a particular social group. See chapter 2.

28. *Broadway Journal*, Apr. 11, 1845, 254. *Literary World*, July 3, 1847, 517.

29. On Ranney, see Linda Ayres, "William Ranney," in Tyler et al., *American Frontier Life*, 79–108. In the years of the controversial Mexican War, Ranney painted historical images of the Revolution and the life of George Washington that provided points of comparison with contemporary politics; some of these images seem to conflate history and genre painting. Henry Tuckerman described Ranney's studio in *Book of the Artists: American Artist Life* (New York: G. P. Putnam and Son, 1867), 431–432.

30. Before *The Trapper's Last Shot*, Ranney probed such motifs as trappers roping wild horses and pioneers dealing with prairie fire, stampede, and family death, constructions that promoted the West as an arena of natural wonders and dangers subject to control by the properly skilled male. He apparently based *The Trapper's Last Shot* on Deas's *Last Shot* (now lost), which had been exhibited at the American Art-Union in 1847; see Francis S. Grubar, "Ranney's *The Trapper's Last Shot*," *American Art Journal* 2:1 (1970): 92–99. He painted two versions of the work, selling the first to the Western Art-Union in Cincinnati and making a second for exhibition in New York, for which he sharpened the separation of foreground from background, raised the horizon line, delineated the approaching Indians, and heightened the alarmed expression on the trapper's face; Currier and Ives made a lithograph of the painting in the mid-1850s (illustrated in Tyler et al., *American Frontier Life*, 190). The adjective *Western* in the name of the Western Art-Union by no means implied that it invited specifically Western topics. In fact, the institution emulated East Coast taste in landscape and in European imports. New York *Daily Tribune*, June 21, 1851, 6. The American Art-Union bought twenty-seven paintings by Ranney.

31. Other paintings include *The Trappers*, 1856 (Joslyn Art Museum), and *The Pipe of Friendship*, 1857–1859 (finished by William S. Mount, Newark Art Museum), which is illustrated in Ayres, "William Ranney." During these years Ranney also had success with scenes of Easterners hunting, in which men or a man and a boy hunted birds, as *Duck Shooting*, 1850 (Corcoran Gallery of Art).

32. On Tait, see Warder H. Cadbury and Henry F. Marsh, *Arthur Fitzwilliam Tait, Artist in the Adirondacks: An Account of His Career . . . [and] a Checklist of His Works* (Newark: University of Delaware Press, 1986), and Warder H. Cadbury, "Arthur F. Tait," 109–129, in Tyler et al., *American Frontier Life*. Cadbury stresses that only eleven of these images are distinctively different topics (that is, they are not variations); eight were lithographed by Currier or Currier and Ives. After the Civil War, Tait painted animals and birds. In the context of his entire career, western or hunting subjects are few; they show him as sensitive to the market from the moment of his arrival in the United States.

33. Nathaniel Currier snapped up the image for a lithograph, and this was to be Tait's procedure for all his Western works.

34. New York *Herald,* Feb. 17, 1852, quoted in Cadbury, "Tait," in Tyler et al., *American Frontier Life,* 114; *Literary World,* May 1, 1852, 316.

35. And thus Deas and Ranney created few pictures of Western overland emigration, which involved families, and Tait did none at all. Deas's *Prairie Fire,* 1847, exhibited in Saint Louis, and Ranney's work on the same motif, exhibited in 1848 at the American Art-Union as *The Stampede* (now *Prairie Fire,* 1848, private collection), both emphasized the heroism of the male pioneer in protecting the families from the raging fire. Deas sold *Oregon Pioneers* (now lost) to the American Art-Union in 1846, and Ranney painted *Advice on the Prairie,* 1853 (private collection), in which an earnest-looking trapper gives a family gathered around a campfire advice about the journey ahead; he began but did not finish a work called *The Pioneers* (about 1850–57, private collection), showing families consulting in a circle of wagons. The *Bulletin* of the American Art-Union complained in 1850 that no artists were representing the migration of families on the overland trail (August 1851). There were actually a few such works, including Charles Christian Nahl's *Crossing the Plains,* 1856 (Stanford Art Museum), a painting that was not exhibited in New York; James Henry Beard's *North Carolina Emigrants,* 1845 (art market); and Saint Louis artist James Wilkins's *Leaving the Old Homestead,* 1854 (Missouri Historical Society, Saint Louis), an image not sent East. The best-known today of such images is Bingham's *Emigration of Daniel Boone,* 1851–1852 (Washington University Art Gallery, Saint Louis), which was not exhibited in New York either.

36. The indispensable reference on Bingham is E. Maurice Bloch, *The Paintings of George Caleb Bingham: A Catalogue Raisonné* (Columbia: University of Missouri Press, 1986). Nancy Rash, *The Painting and Politics of George Caleb Bingham* (New Haven and London: Yale University Press, 1991), studies the artist's work as responses to local and national political issues, an approach that complements my own but does not question the social assumptions of genre painting. For the most recent general study of Bingham, see *George Caleb Bingham* (New York: Harry N.

Abrams, for the Saint Louis Art Museum, 1990). See also E. Maurice Bloch, *George Caleb Bingham: The Evolution of an Artist,* 2 vols. (Berkeley: University of California Press, 1967); John Francis McDermott, *George Caleb Bingham: River Portraitist* (Norman: University of Oklahoma Press, 1959); Ron Tyler, "George Caleb Bingham, The Native Talent," in Tyler et al., *American Frontier Life,* 25–49; Robert F. Westervelt, "The Whig Painter of Missouri: George Caleb Bingham," *American Art Journal* 2:1 (1970): 46–53; John Demos, "George Caleb Bingham: The Artist as Social Historian," *American Quarterly* 17:2, pt. 1 (1965): 218–228.

37. Nancy Rash, in "George Caleb Bingham's *Lighter Relieving a Steamboat Aground,*" *Smithsonian Studies in American Art* 2:2 (1988): 17–31, considers some of these issues in relation to one of Bingham's paintings.

38. Perhaps inspired by Deas's pictures of French fur traders, which he exhibited in Saint Louis, Bingham began his New York career with *French Trader and His Half-Breed Son* (later renamed *Fur Traders Descending the Missouri,* 1845, Metropolitan Museum of Art), a tribute to the older generations of fur traders, whom neither Northeasterners nor Westerners saw as fully American. Although the American Art-Union bought Bingham's painting, and the Art-Union's patronage was crucial in his career in New York, there was virtually no critical journal commentary on his work for several years. On the rivermen, see Leland D. Baldwin, *The Keelboat Age on Western Waters* (Pittsburgh: University of Pittsburgh Press, 1941); Louis C. Hunter, *Steamboats on the Western Rivers: An Economic and Technological History* (New York: Octagon, 1969); and Emerson W. Gould, *Fifty Years on the Mississippi; or Gould's History of River Navigation* (Saint Louis: Nixon-Jones, 1889).

39. Edmund Flagg, *The Far West; or, A Tour Beyond the Mountains* (New York: Harper and Brothers), 1:30; Hall, *Sketches of History, Life, and Manners,* 2:72.

40. Peck, *New Guide for Emigrants,* 128. Peck quoted Hall in the middle of his description: "proverbially lawless at every town and landing, and indulged with out restraint in every species of dissipation, debauchery and excess," but then contradicted Hall's implications. For an analysis that has influenced my broader generalizations about the boatman and

other Western figures, see Carroll Smith-Rosenberg, "Davey Crockett as Trickster: Pornography, Liminality and Symbolic Inversion in Victorian America," *Journal of Contemporary History* 17 (April 1982): 325–350.

41. Bingham's painting contrasts in every way to other images of flatboats, such as an unidentified artist's *Rafting Downstream,* about 1840–1850 (Indiana University Art Museum), and William Baldwin's *Merry Raftsmen,* 1844 (Amon Carter Museum), in which young boys are playing on the raft, a violinist in their midst.

42. Something of the same spirit is conveyed in the popular song "The Jolly Raftsman" (copyrighted in 1844 by C. H. Keith, Boston); see H. Dichter, *Handbook of American Sheet Music* (Philadelphia: H. Dichter, 1951), #1614.

43. The American Art-Union bought the painting in late 1846, and the directors decided to have it engraved for subscribers; thus it was not distributed until 1847, by which time the Art-Union had also bought *Raftsman Playing Cards,* in which Bingham carried out the same pictorial strategy, placing his figures in a triangular grouping and splaying his scene with peaceful color and light. The Art-Union exhibited *Jolly Flatboatman* and *Raftsmen Playing Cards* as its first offerings in the group of paintings to be distributed in 1847. *Literary World,* Oct. 23, 1847, 277. The identity of the other painting, the one as "yet unpurchased," is unclear. Ironically, it was Bingham's classicism that brought him to the attention of museum curators and art historians in the 1930s, long before anyone became interested in Deas or Ranney.

44. Saint Louis *Missouri Republican,* Nov. 27, 1847, quoted in McDermott, *Bingham,* 62.

45. These pictures include *Boatmen on the Missouri,* 1846 (Fine Arts Museums of San Francisco); *The Jolly Flatboatmen,* 1846 (Manoogian Collection, on loan to the National Gallery of Art); *Lighter Relieving a Steamboat Aground,* 1846–1847 (The White House); *Raftsmen Playing Cards,* 1847 (Saint Louis Art Museum); *St. Louis Wharf,* 1849 (now lost); *The Wood Yard,* 1849 (now lost); *Raftsmen on the Ohio,* 1849 (now lost); *Watching the Cargo,* 1849 (State Historical Society of Missouri, Columbia); *A Boatman,* 1849 (now lost); *The Wood-Boat,* 1850 (Saint Louis Art Museum); *Mississippi Boatman,* 1850 (private collection);

In a Quandary, or *Mississippi Raftmen at Cards,* 1851 (Henry E. Huntington Library and Art Collections). He took up the theme again in 1854 with two paintings called *Woodboatmen on a River* or *Watching the Cargo by Night* (Museum of Western Art, Denver; and Amon Carter Museum, with the specific title *Western Boatmen Ashore by Night*); in 1857, *Jolly Flatboatmen in Port* (Saint Louis Art Museum); and in 1877–1878, *The Jolly Flatboatmen* (2) (Terra Museum of American Art).

46. *Bulletin of the American Art-Union* 2 (1849): 10.

47. *Home Journal,* Oct. 28, 1848, 2.

48. Huntington's exhibit included such titles as *Communion of the Sick, Mercy's Dream, Christians and Children, Henry VIII,* and *Lady Jane Grey in the Tower.* Willis quotation in *Home Journal,* Oct. 28, 1848, 2.

49. For a study of the implications of the Gold Rush in California and national history, see Kevin Starr, *Americans and the California Dream, 1850–1915* (New York: Oxford University Press, 1973). On Nahl, see Moreland L. Stevens, *Charles Christian Nahl: Artist of the Gold Rush, 1818–1878* (Sacramento: E. B. Crocker Art Gallery, 1976). Many of Nahl's illustrations for California periodicals were copied in the East, especially in *Gleason's Pictorial Drawing-Room Companion.* On early painting in California, see Jeanne Van Nostrand, *The First Hundred Years of Painting in California, 1775–1875* (San Francisco: John Howell, 1980); Raymond L. Wilson, "Painters of California's Silver Era," *American Art Journal* 16:4 (1984): 71–92; and Ellen Schwartz, *Nineteenth-Century San Francisco Art Exhibition Catalogues: A Descriptive Checklist and Index* (Davis: University Library, University of California, Davis, 1981). For the Hunt quotation, see "California, Oregon and Washington," *Journal of the American Geological Society* 1 (May 1859): 146, quoted in Mott, *History of American Magazines,* 2:120.

50. The theme of the election and its accompanying activities had been attempted by few other American artists, although of course it had a notable precedent in Hogarth's election series in the mid-eighteenth century, which was distributed extensively as engravings, and in Wilkie's *Village Politicians,* also engraved. Among American works are Krimmel's election scenes in early nineteenth-century Philadelphia, pictures by John C. Hagen called "The Politicians" and "The Stump Candi-

date," exhibited at the National Academy of Design in 1839 and 1841 (now both lost), a painting by Manuel J. De Franca called "The Red-Hot Politician," exhibited at the Apollo Association in 1838 and 1839 (now lost), Clonney's *Politicians in a Country Bar,* 1844 (New York State Historical Association), Woodville's *Politics in the Oyster House,* 1848 (Walters Art Gallery), and Alfred J. Miller's *Election Scene, Catonsville, Baltimore County,* about 1860 (Corcoran Gallery of Art). On Bingham's election scenes and his politics, see Barbara S. Groseclose, "Painting, Politics, and George Caleb Bingham," *American Art Journal* 10:2 (1978): 4–19, and Gail E. Husch, "George Caleb Bingham's *The County Election:* Whig Tribute to the Will of the People," *American Art Journal* 19:4 (1987): 4–22. On politics in Missouri, see John Vollmer Mering, *The Whig Party in Missouri* (Columbia: University of Missouri Press, 1967).

51. Phrenological distinctions about the relationship of forehead development, jaw prominence, and the placement of eyes to intelligence and moral fiber were common in descriptions of human beings throughout the period. See J. G. Spurzheim, *Phrenology, in Connection with the Study of Physiognomy* (Boston: Marsh, Capen and Lyon, 1833); Arthur Wrobel, "Orthodoxy and Respectability in Nineteenth-Century Phrenology," *Journal of Popular Culture* 9:1 (1975): 38–50; and John D. Davies, *Phrenology, Fad and Science: A Nineteenth-Century American Crusade* (New Haven: Yale University Press, 1955); Mary Cowling, in *The Artist as Anthropologist: The Representation of Type and Character in Victorian Art* (Cambridge: Cambridge University Press, 1989), applies the theories to the work of Victorian genre painters, especially William Frith.

52. The two other paintings are *Stump Speaker,* 1853, and *Verdict of the People,* 1854 (both at the Boatman's National Bank, Saint Louis). Bingham's first large painting on the election theme was *Stump Speaking,* 1847, now lost and known only through a daguerreotype. When Bingham exhibited the painting at the American Art-Union, the *Literary World,* perhaps overwhelmed by the sheer evidence of a proliferating western population of ordinary people, damned it with the comment that the picture "makes one's eyes ache to look at it" (June 3, 1848, 350–351).

53. That Bingham meant the cider barrel to be a symbol he makes clear in his letter of Dec. 12, 1853,

about the next picture in the series, *Stump Speaking.* Certainly his experience as a candidate in 1846, in which he won and then experienced legislative reversal of a very close decision (discussed below), would have suggested that a coin toss determined at least some outcomes.

54. For example, a tribute by the *Home Journal* (Nov. 18, 1848) quoting the *Commercial Advertiser* praised American "republican institutions" with as much enthusiasm as the anecdote in the Saint Joseph *Gazette* (Nov. 17, 1852) about an "hindependent voter" ridiculed the ignorant voter for insisting that as a "sovereign" he had the right to vote twice—once for each party. For the announcement of Bingham's exhibition, see Saint Joseph *Gazette:* "George C. Bingham, the Missouri artist is now on his way to this city, for the purpose of securing subscribers for his celebrated painting—the County Election. He has the painting with him, which he exhibits gratis" (Nov. 17, 1852).

55. Baltimore *American,* June 18, 1852, quoted in McDermott, *Bingham,* 95.

56. As is discussed below, several years later he tried Eastern venues for all three images as a unit.

57. *Weekly Missouri Statesman* (Columbia), Oct. 31, 1851, quoted in McDermott, *Bingham,* 91. Also favorable were the *Daily Missouri Republican* and the Cincinnati *Western Journal,* Nov. 7, 1851, 145, quoted in Bloch, *Bingham: Evolution of an Artist,* 144.

58. Reprinted in the Columbia *Missouri Statesman,* Jan. 9, 1852, and elsewhere; quoted in McDermott, *Bingham,* 92.

59. April 6, 1853, quoted in McDermott, *Bingham,* 97–98.

60. Lexington *Kentucky Statesman,* June 1, 1853; quoted in McDermott, *Bingham,* 99–100.

61. Bingham to Rollins, Nov. 2, 1846, in C. B. Rollins, ed., "Letters of George Caleb Bingham to James S. Rollins, Pt. 1: May 6, 1837–July 5, 1853," *Missouri Historical Review* 32:1 (1937): 15. Bingham later gladhanded so successfully that he was briefly considered as a candidate for governor in 1848 and then won the race he did enter, triumphing over his previous opponent for the legislature from Saline County. Over the next twenty years he was an influential Whig speaker, wangled for consular appointments, and won election as the sheriff of Kansas City.

62. Bingham to Rollins, Dec. 12, 1853, "Letters, Pt. 2: October 3, 1853–August 10, 1856," *Missouri Historical Review* 32:2 (1938): 171.

63. He wrote to Goupil that "my *County Election* has excited more interest than any of my previous productions, and my friends, here, propose to raise a sum which will enable me to publish it, in superior style, upon a large scale" (Jan. 31, 1852, in Archives of American Art, Smithsonian Institution). Rollins to A. Warner, Jan. 11, 1852, American Art-Union Correspondence in New-York Historical Society.

64. Bingham to Sartain, Oct. 4, 1852, Archives of American Art, Smithsonian Institution. Quoted in George R. Brooks, "George Caleb Bingham and 'The County Election,'" Missouri Historical Society *Bulletin* 21 (October 1964): 39. These were *Stump Speaker*, and then to "*cap the clymax*" of the series, *Verdict of the People* in 1854 (letter to Rollins from New York, May 17, 1854, "Letters, Pt. 2," 179–182). The crowd that has gathered to hear the results of a very close election is the largest assemblage of Western types that Bingham had gathered: it includes merchants, farm-types, peddlers, a black man, an Indian man, boys, and women (who look on from a hotel balcony). Tallies of votes for the candidates are 1406 and 1410. Although Bingham claimed to feel affection for the body politic, this work is the most ambiguous of the three. The shadow of an official on the porch shows his nose to be exaggeratedly long, and citizens are variously calculating, drunken, arguing, and celebrating—all under the aegis of the brightly waving American flag in the distance. The painting is perhaps too full of diversity; *County Election* remains the best work of the three.

65. *Daily Picayune*, Mar. 18, 1853, suppl., 1, quoted in Bloch, *Paintings of Bingham*, 143, and Tyler, "Bingham," 45. Bingham sanguinely pronounced his own sense of his importance in 1871: "The humorous productions of Mount and others as seen in the 'bargaining for a horse' 'The Jolly flat Boatmen' and 'County Election,' assure us that our social and political characteristics as daily and annually exhibited will not be lost in the lapse of time for want of an Art record rendering them full justice" (Bingham to Rollins, June 19, 1871, in "Letters of George Caleb Bingham to James S. Rollins, Pt. 5," *Missouri Historical Review* 33:1 [1938]: 72); *Western Journal* 7 (November 1851): 145, quoted in Bloch, *Bingham:*

Evolution of an Artist, 144; Bingham to Rollins, Philadelphia, Nov. 23, 1853, in "Letters, Pt. 2," 170.

66. Nov. 23, 1853, in "Letters, Pt. 2," 169.

67. "Rambles in the Far West," *Knickerbocker Gallery* (New York: S. Hueston, 1855), 147.

68. These lithographs included *The Prairie Hunt: "One Rubbed Out!"* 1852, hand-colored lithograph; *A Check: "Keep Your Distance,"* 1852, hand-colored lithograph, both produced by Currier; Currier and Ives: *The Last War-Whoop* and *The Pursuit*, both 1856; *Life on the Prairie: The Trapper's Defense, "Fire Fight Fire,"* and *Life on the Prairie: The Buffalo Hunt*, both 1862. Currier and Ives produced thirty-eight prints after Tait, all but four presenting scenes of hunting and life in the West. These carried forward scenes first developed by Catlin and Bodmer.

CHAPTER 4:
STANDING OUTSIDE THE DOOR

1. For recent studies of the evolution of attitudes and imagery about blacks in Europe and the United States, see Hugh Honour, *The Image of the Black in Western Art*, vol. 4: *From the American Revolution to World War I: Part 1, Slaves and Liberators; Part 2, Black Models and White Myths* (Cambridge: Harvard University Press, 1989); James Walvin, *Black and White: The Negro and English Society, 1555–1945* (London: Penguin Press, 1973); David Dabydeen, *Hogarth's Blacks: Images of Blacks in Eighteenth-Century English Art* (Mundelstrup, Denmark, and Kingston-upon-Thames: Dangaroo, 1985); George M. Fredrickson, *The Black Image in the White Mind: The Debate on Afro-American Character and Destiny, 1817–1914* (Middletown, Conn.: Wesleyan University Press, 1971); Albert Boime, *The Art of Exclusion: Representing Blacks in the Nineteenth Century* (Washington, D.C.: Smithsonian Institution Press, 1990); Sidney Kaplan, *Portrayal of the Negro in American Art* (Brunswick, Maine: Bowdoin College, 1967); Ellwood Parry, *The Image of the Indian and the Black Man in American Art, 1590–1900* (New York: George Braziller, 1974); and Guy C. McElroy, *Facing History: The Black Image in American Art, 1710–1940* (San Francisco: Bedford Arts, for the Corcoran Gallery of Art, 1990). For studies of the political, economic, and social circumstances of blacks in the United States, see Leon F.

Litwack, *North of Slavery: The Negro in the Free States, 1790–1860* (Chicago: University of Chicago Press, 1961); Edgar J. McManus, *A History of Negro Slavery in New York* (Syracuse, N.Y.: Syracuse University Press, 1966), and *Black Bondage in the North* (Syracuse, N.Y.: Syracuse University Press, 1973); Ira Berlin, *Slaves without Masters: The Free Negro in the Antebellum South* (New York: Pantheon Books, 1974), and "The Structure of the Free Negro Caste in the Antebellum United States," *Journal of Social History* 9 (Spring 1976): 297–318; Eugene Berwanger, *The Frontier against Slavery: Western Anti-Negro Prejudice and the Slavery Extension Controversy* (Urbana: University of Illinois Press, 1967); and P. J. Staudenraus, *The African Colonization Movement, 1816–1865* (New York: Columbia University Press, 1961).

2. Harriet Martineau, *Society in America*, vol. 2 (Paris: Baudry's European Library, 1837), 73.

3. For Hammett, see David M. Streifford, "The American Colonization Society: An Application of Republican Ideology to Early Antebellum Reform," *Journal of Southern History* 45:2 (1979): 216, quoting American Colonization Society, *Sixteenth Annual Report*, 1833; Paulding, *Slavery in the United States* (New York, 1836), 176, quoted in Jean Yellin, *The Intricate Knot: Black Figures in American Literature, 1776–1863* (New York: New York University Press, 1972), 43.

4. In New York, every person who was a slave before July 4, 1799, was freed as of July 4, 1827, although until 1841 nonresidents could enter the state with their slaves. The phrase "Long Island nigger" was frequently employed by New Yorkers into the middle of the nineteenth century to invoke the liveried domestic servant, and thus to express contempt for blacks as well as for the class of white entrepreneurs (the "new men") who bought estates on Long Island, put their servants in livery, and gave themselves airs. McManus, *Black Bondage*, 185, and McManus, *Negro Slavery in New York*, 46; see also Gabriel Furman, *Antiquities of Long Island* (1874; rpt. Port Washington, N.Y.: Ira J. Friedman, 1968), 222ff. See Roi Ottley and William J. Weatherby, *The Negro in New York: An Informal Social History, 1626–1940* (New York: Praeger, 1969), 1–91, on blacks and the crafts. McManus, *Black Bondage*, 195, and Fredrickson, *Black Image in the White Mind*, 41, 90, discuss the anti-black atmosphere in New York City. On Douglass, see McManus, *Black Bondage*, 185.

5. For studies of minstrelsy and related issues of black music and dance, see Carl Wittke, *Tambo and Bones: A History of the American Minstrel Stage* (1930; rpt. Westport, Conn.: Greenwood Press, 1968); Hans Nathan, *Dan Emmett and the Rise of Early Negro Minstrelsy* (Norman: University of Oklahoma Press, 1962); Robert C. Toll, *Blacking Up: The Minstrel Show in Nineteenth-Century America* (New York: Oxford University Press, 1974); Lynne Fauley Emery, *Black Dance in the United States from 1619 to 1970* (Palo Alto, Calif.: National Press Books, 1972): Sam Dennison, *Scandalize My Name: Black Imagery in American Popular Music* (New York: Garland, 1982); Lizzetta Lefalle-Collins and Leonard Simons, *The Portrayal of the Black Musician in American Art* (Los Angeles: California Afro-American Museum, 1987); and A. Saxton, "Blackface Minstrelsy and Jacksonian Ideology," *American Quarterly* 27 (March 1975): 3–28.

6. Exceptions to these generalizations are Christian Mayr, *Kitchen Ball and White Sulphur Springs*, 1838, and Eastman Johnson, *Negro Life at the South, or Old Kentucky Home*, 1859, both discussed below. In addition, there is *Plantation Burial*, 1860 (Historic New Orleans Collection), by John Androbus, an English immigrant to New Orleans, who apparently planned a series of twelve scenes "representing Southern life and nature." *Plantation Burial* is solely about blacks; the other projected works are unknown. See Honour, *Image of the Black*, vol. 4, pt. 1, 214–217.

7. In the 1880s and later, Southern genre painter William Aiken Walker specialized in scenes of blacks during the "happy plantation days."

8. As Honour points out, there were precedents for "Life in ———" series in England and France, most recently *Life in London*, 1820–1821, illustrated by George and Robert Cruikshank. In the United States, Edward C. Clay was the prominent caricaturist of urban free blacks, in 1828 in his lithographed series *Life in Philadelphia* and in 1830, *Life in New York*. Fueling these ugly satires were middle-class whites' complaints that economically comfortable urban free blacks did not "know their place"; for a specific instance, see John Fanning Watson, *Annals of Philadelphia . . .* (Philadelphia and New York: E. L. Carey and A. Hart, 1830), 479. For a general discussion of American prints in the antebellum years, see *American Printmaking before 1876:*

Fact, Fiction, and Fantasy (Washington, D.C.: Library of Congress, 1975).

9. Russian visitor Pavel Petrovich Svinin, in Philadelphia from 1811 to 1813 as secretary to the Russian consul general, made numerous watercolors of the United States for a travel book and in a number of them caricatured blacks as America's "lower orders." See Abbott Gleason, "Pavel Svinin," in *Abroad in America: Visitors to the New Nation, 1776–1914,* ed. Marc Pachter and Frances Wein (Washington, D.C.: National Portrait Gallery, 1976). Also of interest is Scots artist William T. Russell Smith, *Baptism in Virginia,* 1836, in Bruce W. Chambers, *Art and Artists of the South: The Robert P. Coggins Collection* (Columbia: University of South Carolina Press, 1984), 16. On Krimmel, see Milo Merle Naeve, *John Lewis Krimmel: An Artist in Federal America* (Newark: University of Delaware Press, 1987); the later election scenes are two large watercolors in the Historical Society of Pennsylvania. On Guy, see Stiles Tuttle Colwill, *Francis Guy, 1760–1820* (Baltimore: Museum and Library of Maryland History, 1981).

10. For an earlier discussion of Mount's paintings of blacks, see Karen M. Adams, "The Black Image in the Paintings of William Sidney Mount," *American Art Journal* 7:2 (1975): 42–59.

11. Mount's other works in the early 1830s with an African-American on the sidelines include *The Breakdown,* 1835 (Art Institute of Chicago), and *Schoolboys Quarreling,* 1834 (Museums at Stony Brook), both of which construct the overlapping yet distinct social worlds of white and black.

12. On the calculated silence of journals, see, e.g., *New-Yorker,* Nov. 14, 1835.

13. Clonney immigrated to New York from England at the outset of his career. For biographical, historiographic, and stylistic treatment of Clonney, see Lucretia H. Giese, "James Goodwyn Clonney (1812–1867): American Genre Painter," *American Art Journal* 11:4 (1979): 4–31. Dennison, in *Scandalize My Name,* demonstrates that popular songs about blacks also contained references to current political issues.

14. Clonney was not the only person to use this motif in art. The song "Nigger on the Wood Pile," published in Boston in 1845 as part of *Kendall's Clarinet Instruction Book,* was attributed to the minstrel Dan Emmet; see Nathan, *Emmett and the Rise of Negro Minstrelsy,* 340. A use of it in visual caricature is the anti-Lincoln political cartoon "The Nigger in the Woodpile!" H. R. Robinson, 1860 (Library of Congress).

15. Since Southerners and Northerners alike used the term *dark* to refer obliquely to slavery, the large dark horse that the black boy rides suggests the slavery interest represented by the Democratic candidate, Southerner James K. Polk. It may well also be that the term *dark horse* was used early in this campaign to convey Polk's candidacy; Polk was certainly the first dark horse to be nominated in a party convention. On *corn,* Jack Downing in Smith, *Jack Downing,* 1833, describes the meeting of the Maine legislature as a great cornhusking, 75; and Yankee actor George Handel Hill writes of "acknowledging the corn," meaning to confess to exaggeration, in Northall, *Life of Hill,* 131. For a quick reference to the ubiquity of other expressions involving *corn,* see the variety of contemporary usages and occurrences listed in Craigie from the 1830s.

16. Clonney's study "Rabbit Catchers" (Museum of Fine Arts, Boston) clearly links his conception for *Trapping* to that of Mount's two works on the colloquialism. The catalog of the Art-Union alerted viewers with the explanation "A Negro boy has taken a hare from the trap, which a white boy is setting afresh. The faces express great gratification." The motif of fence-sitting was common in political caricature, as in the satire on presidential candidate Martin Van Buren's straits in "Settin' on a Rail," 1837, H. R. Robinson (Library of Congress). The witticism about *Waking Up* is in *Home Journal,* Apr. 16, 1851, 3. Currier and Ives picked up Clonney's version of the motif of a sleeping black man in his *Waking Up* with their lithograph *Holidays in the Country: Troublesome Flies,* in 1855, an image more broadly condemnatory in that the black man is asleep in the workplace. Clonney's most tendentious painting involving fishing is *What a Catch,* 1855 (art market). In this picture are two sets of black and white men, paired off in separate fishing boats, who compare catches. The pair in one boat has caught all the fish, while the men on the other boat have caught only a bottle. In considering the allusions here, the functioning of each white man seems linked to black assistance. That in 1855 one side has come up with everything, the other with nothing but the

humiliation of an empty bottle suggests an allusion to the Kansas-Nebraska Act of 1854, in which the slave interests defeated those with antislavery convictions by overturning earlier agreements about free Western territories.

17. That Clonney exhibited the painting in 1844 at the National Academy of Design and in 1845 at the American Art-Union again suggests the broad appeal of his topics and humor. A watercolor for *The Political Argument* at the New York State Historical Association, Cooperstown, reveals that Clonney had originally conceived the chair on which the younger man drapes his coat to be country style. Perhaps his conversion of it to an old-fashioned Queen Anne in the painting was meant to heighten the contrast between young and old, contrived and direct, urban and rural, which intensified political disagreements. For a favorable response to the painting, see *Knickerbocker* 23 (June 1844): 596.

18. For a linking of Clonney to Mount, see *Knickerbocker* 29 (June 1847): 572. A prominent disjunction between Mount's sketch of a black figure and the final version in the painting is the black for *California News*, 1850, the sketch for which, along with Mount's other sketches, is at the Museums at Stony Brook. The assessment of Clonney's style as "sharp and hard" is in *Literary World*, Nov. 6, 1847, 330.

19. Mayr painted other images of the blacks at White Sulphur Springs, including *Jack in the Kitchen, at White Sulphur Springs,* but they seem to be lost. Although Mayr may not have felt the need to caricature, he clearly felt condescension toward his black subjects. He jovially told English visitor Marryat, who visited the springs while Mayr was there, that he had included in *Kitchen Ball* "all the well-known colored people in the place" but had left one man out of the band of musicians. When Marryat asked why, Mayr, apparently infected with the widespread fondness for punning, responded, "Why, sir, I could not put him in; it was impossible; he never *plays in tune . . .* he would spoil the *harmony* of my whole picture!" (Frederick Marryat, *A Diary in America: With Remarks on Its Institutions,* ed. Sidney Jackman [New York: Alfred A. Knopf, 1962], 236). For accounts of the culture of the spring resorts, see Perceval Reniers, *The Springs of Virginia* (Chapel Hill: University of North Carolina Press, 1941).

20. On the implications of this international re-

form in American society, see Clifford S. Griffin, *Their Brothers' Keepers: Moral Stewardship in the United States, 1800–1865* (New Brunswick, N.J.: Rutgers University Press, 1960). For its specific relation to antislavery convictions, see Russel B. Nye, *William Lloyd Garrison and the Humanitarian Reformers* (Boston: Little, Brown, 1955); Aileen S. Kraditor, *Means and Ends in American Abolitionism: Garrison and His Critics on Strategy and Tactics, 1834–1850* (New York: Pantheon, 1969); Fredrickson, *Black Image in the White Mind,* esp. 97–129 on "romantic racialism"; and Merton L. Dillon, *The Abolitionists: The Growth of a Dissenting Minority* (New York: W. W. Norton, 1974), esp. 141–169. Orville Dewey, *A Discourse on Slavery and the Annexation of Texas* (New York: 1844), 10, quoted in Fredrickson, *Black Image in the White Mind,* 102. Alexander Kinmont, *Twelve Lectures on the Natural History of Man* (Cincinnati: U. P. James, 1839), 198, 218, quoted in Fredrickson, *Black Image in the White Mind,* 105. James Russell Lowell, *Anti-Slavery Papers,* 2 vols. (Boston and New York: Houghton Mifflin, 1902), 1:21–22, quoted in Fredrickson, *Black Image in the White Mind,* 108. The powerful painting *The Slave Ship,* 1840 (Museum of Fine Arts, Boston), by J. M. W. Turner, exhibited the year that the British and Foreign Anti-Slavery Society first met in London, may be seen in this context of international reform.

21. Theodore Weld, *American Slavery as It Is: The Testimony of a Thousand Witnesses* (New York: American Anti-Slavery Society, 1839); John W. Blassingame, ed., *Slave Testimony: Two Centuries of Letters, Speeches, Interviews, and Autobiographies* (Baton Rouge: Louisiana State University Press, 1977). In 1841, members of the Artists Fund Society refused to exhibit Nathaniel Jocelyn's portrait of Cinque in Philadelphia, even though Jocelyn had been invited to send his painting down. A letter stated that it was "contrary to usage to display works of the character, believing that under the excitement of the times, it might prove injurious both to the proprietors and the institution." A writer in the *Pennsylvania Freeman* claimed that "Cinque is a NEGRO and the negro-haters of the north and the negro-stealers of the south, will not tolerate the picture of a negro in a picture gallery." The sponsor of the picture concluded that "a black man had no right to be a hero." See Honour, *Image of the Black,* vol. 4, pt. 1, 161, cit-

ing Eleanor Alexander, "A Portrait of Cinque," *Connecticut Historical Society Bulletin* 49 : 1 (1984): 31–51.

22. See Sam Dennison, *Scandalize My Name*, esp. 163–165, and, more broadly, his chapter in the same work, "Abolition Movement versus Minstrelsy," 157–186. On Powers, see Vivien M. Green, "Hiram Powers's *Greek Slave:* Emblem of Freedom," *American Art Journal* 14 : 4 (1982): 31–39.

23. Mount's uncle, Micah Hawkins, engraved a long epitaph on Clapp's tombstone that celebrated the violinist's accomplishment on his instrument and his humility and piety. "Anthony, though indigent, was most content, Though of a race despis'd, deserv'd he much respect: in his deportment modest and polite, Forever faithfully performing in life's drama the eccentrick part assign'd him by his Maker. . . . Upon the Violin, few play'd as Toney play'd, His artless music was a language universal, and in its Effect—most Irresistible!" (*Catching the Tune: Music and William Sidney Mount* [Stony Brook, N.Y.: Museums at Stony Brook, 1984], 13).

24. Mount wrote Charles Lanman in 1847 that his own childhood experience had gone into the painting as well; in Mount's childhood, a black man named Hector had taught him to spear flatfish and eels. The estate belonged to the patron's uncle Selah B. Strong. The painting was exhibited the year after Mount's portrait of the patron, George Washington Strong, a man that his son, the diarist George Templeton Strong, irreverently referred to as "the Generalissimo" (*Diary*, Apr. 30, 1844, 29).

25. *Knickerbocker* 27 (June 1846): 556; *Morris's National Press*, May 23, 1846, 4. We do not know what the patron thought of the work. It also seems possible that *Eel Spearing* or *Recollections* suggested, as my colleague Ann Abrams pointed out, an idyllic happier time, before talk of abolition, when maternal blacks cared for young boys and stayed close to the "safe" shore.

26. Both works are based on the composition *Dancing in the Barn* (Museums at Stony Brook) that Mount had first worked out in 1831. In that earlier work, he had placed a young man and a girl dancing in a barn interior to the music of a fiddler who sits near the open door. In *Dance of the Haymakers*, the first new work, Mount presented a neatly clothed black boy, nearer childhood than adulthood and thus offering little of the social and economic threat

of the black adult, gaily beating time on the outside barn door as farmhands dance on the inside. Patron Charles M. Leupp, a merchant and collector who belonged to the Sketch Club, had ordered the painting, perhaps even suggesting the topic. *Haymakers* was Mount's first critical success after *Cider Making;* the critic for the *Broadway Journal* exclaimed enthusiastically, "What a delight to pass from a picture like [H. Peters Gray's] "Cupid Begging for his Arrows" [now lost] to this scene of real life and jollity" (*Broadway Journal,* May 17, 1845, 306). After the success of *Dance of the Haymakers,* Leupp's mother-in-law, Mrs. Gideon Lee, commissioned Mount to paint *The Force of Music*.

27. *Literary World,* June 5, 1847, 419.

28. Setauket Scrapbook, 22.

29. Advertisement, Mount archives, Museums at Stony Brook, claiming to quote a reviewer for the *Providence Journal*. In changing the title of Mount's image for a lithograph, Goupil and Vibert carried out a similar strategy in 1849 with *Dance of the Haymakers*. They changed Mount's title to *Music is Contagious,* redirecting the focus of the painting from the dancers to the black boy. If the point of the painting is that "music is contagious," then the work means not only that the figures in the painting share an emotional world but that that commonality is considerably more important to the painting than the dancers' merry-making.

30. *Bulletin of the American Art-Union* 2 : 2 (1849): 9–10.

31. This hardening of opinion, which the heated response to the Wilmot Proviso of 1849 had signaled (the proposed legislation that slavery not be legal in territories gained from Mexico), is discussed in Alfred N. Hunt, *Haiti's Influence on Antebellum America: Slumbering Volcano in the Caribbean* (Baton Rouge: Louisiana State University Press, 1988), 154ff., and Fredrickson, *Black Image in the White Mind*, 130–164. See also Jane H. Pease and William H. Pease, "Confrontation and Abolition in the 1850s," *Journal of American History* 58 (March 1972): 923–937.

32. George Fitzhugh, *Reply to Dr. Dewey's Address Delivered at the Elm Tree* (Charleston, S.C., 1852), 22–23, cited in Hunt, *Haiti's Influence*, 138. Jean Fagan Yellin, "Caps and Chains: Hiram Powers' Statue of 'Liberty,'" *American Quarterly* 38 : 5 (1986): 798–826. Maurice Agulhon, *Marianne into Battle:*

Republican Imagery and Symbolism in France, 1789–1880 (New York: Cambridge University Press, 1981), discusses the symbolism of the liberty cap in France.

33. Mount's musician series includes the following lithographs of blacks as musicians or as listeners, issued by Goupil: *The Power of Music,* 1848; *Music Is Contagious,* 1849; *Just in Tune,* 1850 (here, the violinist is white); *Right and Left,* 1852; *Banjo Player,* 1857; and *Bones Player,* 1857. All are in the collection of the Museums at Stony Brook.

34. For correspondence about Mount's discussions with Schaus, see Alfred Frankenstein, *William Sidney Mount* (New York: Harry N. Abrams, 1975), 162. The other potential objects were a squirrel and a duck.

35. The comparison to Lessing is from *Sunday Courier,* Feb. 9, 1851, as pasted in the Setauket Scrapbook, 25; the *Harper's* critic is quoted in Boime, *Art of Exclusion,* 90 (quotation on African Adonis); *Sunday Courier,* Feb. 9, 1851, in Setauket Scrapbook, 25.

36. Edward P. Buffet, "William Sidney Mount, A Biography," *Port Jefferson Times,* Dec. 1, 1923–June 12, 1934, clippings in Archives of American Art, Smithsonian Institution. Scholarship on painting and exhibition practices in the South is so recently underway that generalizations about Southern "art worlds" can only be hazarded. See Jessie Poesch, *The Art of the Old South: Painting, Sculpture, Architecture, and the Products of Craftsmen, 1560–1860* (New York: Alfred A. Knopf, 1983), and *Painting in the South: 1564–1950* (Richmond: Virginia Museum of Fine Arts, 1983); and Chambers, *Art and Artists of the South.* For the quotation on Mount, see W. Alfred Jones, "A Sketch of the Life and Character of William S. Mount," *American Whig Review* 14 (August 1851): 124.

37. On Johnson, see Patricia Hills, *Eastman Johnson* (New York: Clarkson N. Potter, in association with the Whitney Museum of American Art, 1972), and *The Genre Painting of Eastman Johnson: The Sources and Development of His Style and Themes* (1973; rpt. New York: Garland, 1977).

38. This type of comparison, always flattering to the happy conditions in plantation slavery and derogatory of worker conditions in factories, can be found much earlier in English caricature, as in the ironically titled *The Happy Free Labourers of En-*gland / The Wretched Slaves in the West Indies, 1833; see Honour, *Image of the Black,* vol. 4, pt. 1, 149. Another image vitiating slavery and impugning industrialization is "The Horrors of Slavery in black and white," by R. L. Hinsdale in the American periodical the *Lantern,* February 7, 1852, 46. The black side shows a happy dance in front of a fireplace; the white side shows a seamstress, warming her fingers over a candle. A sign reading "shirt manufactory cheap" makes her position clear.

39. In the Southern urban environment in which Johnson painted the picture—Washington, D.C., on F Street (N.W.) between Thirteenth and Fourteenth streets, where his parents lived—it was common to find white masters and black slaves living side by side. See Richard Wade, *Slavery in the Cities: The South, 1820–1860* (New York: Oxford University Press, 1964), 55–79, 275–277; Berlin, *Slaves without Masters,* 251–258.

40. *Cosmopolitan Art Journal,* June 1859, quoted in Richard J. Koke et al., *American Landscape and Genre Paintings in the New-York Historical Society: A Catalogue of the Collection, Including Historical, Narrative, and Marine Art,* 3 vols. (Boston: G. K. Hall, 1982), 2:234.

41. "National Academy of Design: Second Notice," *Crayon* 6 (June 1859): 191.

42. There were, however, prints about Stowe's novel, which included an auction scene. See, e.g., James F. O'Gorman, "War, Slavery, and Intemperance in the Book Illustrations of Hammatt Billings," *Imprint* 10:1 (1985): 2–10. Thomas Satterwhite Noble, a Southerner, painted slave auctions after the Civil War; sympathetic to black humanity, Noble apparently deemed his pictures to be a celebration of the demise of the auction. See Albert Boime, *Thomas Couture and the Eclectic Vision* (New Haven and London: Yale University Press, 1980), 580–589. Moreover, the Inventory of American Paintings lists Margaret M. Pullman, *Old Slave Market, Baltimore, Md.,* about 1850; Taylor, *American Slave Market,* painted after Hammett Billings's engraving of the slave auction in *Uncle Tom's Cabin* for the illustrated edition, and another image by an unknown artist that may also be a copy of the Billings illustration.

43. Crowe painted a second image from his sketches, *After the Sale: Slaves Going South* (Chicago Historical Society), apparently 1862. Not exhibited in the United States, when Crowe's *Slave Auction in*

Richmond was exhibited in the Royal Academy in London, it was hailed as evidence of the "appalling guilt of that accursed system" and as an image that would advance Crowe's reputation as an artist. "Exhibition of the Royal Academy," *Art-Journal*, n.s., 7 (1861): 165, quoted in Honour, *Image of the Black*, vol. 4, pt. 1, 206. Another image that served the enthusiasm for reform was the English artist Richard Ansdell, *Hunted Slaves*, about 1861, illustrated in Susan Casteras, *Virtue Rewarded: Victorian Paintings from the Forbes Magazine Collection* (Louisville, Ky.: J. B. Speed Art Museum, 1988), 44.

44. Its hard style and coloring suggesting a German artist, the painting embodies certain motifs in *Uncle Tom's Cabin:* the degenerate overseer Simon Legree, for instance, could well be evoked by the whip-bearing man on the left. The clothing styles as well as the prominence of facial hair on the men suggest a date near 1860; I thank Claudia Kidwell, National Museum of American History, Smithsonian Institution, for this suggestion.

45. It is curious that although American painters would not touch the slave auction as a subject, the popular sculptor John Rogers did. Composing a small group of four figures, a white auctioneer, a proud black man, and a grief-stricken black mother with her child, Rogers put the sculpture on the market in New York in late 1859, soon after John Brown's execution. Rogers learned to his dismay that the piece absolutely would not sell and that its presence in his sales room caused a falling-off of his other sales. Moreover, as he noted ruefully later, "*The Slave Auction* tells such a strong story that none of the stores will receive it to sell for fear of offending their Southern customers" (David H. Wallace, *John Rogers: The People's Sculptor* [Middletown, Conn.: Wesleyan University Press, 1967], 82).

46. Koke, *American Landscape and Genre Paintings*, 2:232.

47. Henry Tuckerman, *Book of the Artists: American Artist Life* (New York: G. P. Putnam and Son, 1867), 468. The image of a banjo at Petersburg calls to mind Homer's painting *Defiance: Inviting a Shot before Petersburg*, 1864 (Detroit Institute of Arts), in which a grinning black banjo player is positioned right behind the embankment controlled by the Confederate troops.

48. The painting continues to be interpreted in these two distinct ways. Johnson created at least two other works based on his groupings in *Negro Life at the South: Southern Courtship* (the two lovers), 1859 (private collection), and *Confidence and Admiration* (the banjo player and the young listener), n.d. (present location unknown). Other images of blacks by Johnson include *The Freedom Ring*, 1860 (Hallmark Cards, Kansas City, Mo.); *Washington's Kitchen at Mount Vernon;* the pictures *The Chimney Corner*, 1863 (Munson-Williams-Proctor Institute), and *The Lord Is My Shepherd*, about 1863 (National Museum of American Art).

49. For the pressure on Mount not to paint blacks, see Frankenstein, *Mount*, 164. On *The Negro Politically Dead*, see letter of Monday, Dec. 9, 1867, in Frankenstein, *Mount*, 440.

CHAPTER 5:
FULL OF HOME LOVE AND SIMPLICITY

1. Because I am writing about the paintings of whites for whites, when I use the term *women*, I mean white women unless I specify otherwise. With the exception of Mount in his *Eel Spearing at Setauket*, 1845, American painters made few images of African-American women, although caricaturists Edward C. Clay and others occasionally included urban black women in their satires. My formulation of this chapter has been strongly influenced by the following important studies: Laura Mulvey, "Visual Pleasure and Narrative Cinema," *Screen* 16:3 (1975): 6–18; Carl N. Degler, *At Odds: Women and the Family in America from the Revolution to the Present* (New York: Oxford University Press, 1980); Griselda Pollock and Rozsika Parker, *Old Mistresses: Women, Art, and Ideology* (New York: Pantheon, 1981); Elizabeth Fox-Genovese, "Placing Women's History in History," *New Left Review* 133 (May–June 1982): 5–29; Griselda Pollock, "Women, Art, and Ideology: Questions for Feminist Art Historians," *Woman's Art Journal* 4:1 (1983): 39–47, and *Vision and Difference: Femininity, Feminism and Histories of Art* (London: Routledge, 1988); Joan W. Scott, "Gender: A Useful Category of Historical Analysis," *American Historical Review* (December 1986): 1053–1075; and Linda Nochlin, *Women, Art, and Power and Other Essays* (New York: Harper and Row, 1988).

2. In few pictures was a woman essential to Bingham's theme. On *Captured by Indians*, 1848 (Saint Louis Art Museum), in which a white captive women with her child on her lap looks piously to heaven as her captors sleep or sit guard, see Elizabeth Johns, "Bingham: The 'Missouri Artist' as 'Artist,'" in Michael Shapiro et al., *George Caleb Bingham* (New York: Abrams, for the Saint Louis Art Museum, 1990), 118–123. Another image in which women are present is his *Emigration of Daniel Boone*, 1851 (Washington University Gallery of Art), in which the company that Boone brings through the Cumberland Gap includes his wife and grown daughter. In both these images, women were essential to Bingham's point, just as in all his other paintings, women are not.

3. In only one image of the West does a young woman serve as an alluring beneficiary of male heroism: in Deas's *Prairie Fire*, 1847 (private collection), a dashing trapper carries off his young bride through a raging fire. In a few other images, women are part of the cast of characters of the overwhelmingly male group who ride across the prairies on wagons.

4. An earlier reading of the banner as "Freedom for Kansas" is now agreed to have been incorrect. See Barbara Groseclose, "The 'Missouri Artist' as Historian," in Shapiro et al., *George Caleb Bingham*, 79–83, and 185 n. 37.

5. See Carol Duncan, "Happy Mothers and Other New Ideas in French Art," *Art Bulletin* 55:10 (1973): 570–583. For a study of some of the implications of these paintings for audiences, see Michael Fried, *Absorption and Theatricality: Painting and the Beholder in the Age of Diderot* (Berkeley: University of California Press, 1980). On the situation in England, see Helene E. Roberts, "Marriage, Redundancy, or Sin: The Painter's View of Women in the First Twenty-Five Years of Victoria's Reign," in Martha Vicinus, *Suffer and Be Still: Women in the Victorian Age* (Bloomington: Indiana University Press, 1972), 45–76; and Susan Casteras, *The Substance or the Shadow: Images of Victorian Womanhood* (New Haven: Yale Center for British Art, 1982), and *Images of Victorian Womanhood in English Art* (Rutherford, N.J.: Fairleigh Dickinson University Press, 1987).

6. Edmonds is an exception to this generalization. Attempting first one motif and then another, and responsive throughout his career to seventeenth-century prototypes, Edmonds did not give his career the kind of topical or literally "typical" definition that most of his contemporaries did. Nichols B. Clark, in *Francis W. Edmonds: American Master in the Dutch Tradition* (Washington, D.C.: Smithsonian Institution Press, for the Amon Carter Museum, 1988), interprets the artist's career as an attempt to elevate (from my point of view, to dehistoricize) daily life by associating it with seventeenth-century Dutch painting.

7. The studies I have drawn on for these generalizations include Barbara Welter, "The Cult of True Womanhood: 1820–1860," *American Quarterly* 18:2, pt. 1 (1966): 151–174; Gerda Lerner, "The Lady and the Mill Girl: Changes in the Status of Women in the Age of Jackson, 1800–1840" *American Studies* 10:1 (1969): 5–15, and as revised in 1979 in Nancy F. Cott and Elizabeth H. Pleck, eds., *A Heritage of Her Own: Toward a New Social History of American Women* (New York: Simon and Schuster, 1979), 182–196; Kathryn Kish Sklar, *Catharine Beecher: A Study in American Domesticity* (New Haven and London: Yale University Press, 1973); G. J. Barker-Benfield, *The Horrors of the Half-Known Life: Male Attitudes toward Women and Sexuality in Nineteenth-Century America* (New York: Harper and Row, 1976); Nancy F. Cott, *The Bonds of Womanhood: "Woman's Sphere" in New England, 1780–1835* (New Haven and London: Yale University Press, 1977); Carroll Smith-Rosenberg, "Beauty, the Beast, and the Militant Woman: A Case Study in Sex Roles and Social Stress in Jacksonian America," in Cott and Fleck, eds., *Heritage of Her Own*, 197–221; Barbara L. Epstein, *The Politics of Domesticity: Women, Evangelism, and Temperance in Nineteenth-Century America* (Middletown, Conn.: Wesleyan University Press, 1981); Carroll Smith Rosenberg, *Religion and the Rise of the American City: The New York City Mission Movement, 1812–1870* (Ithaca: Cornell University Press, 1971), and *Disorderly Conduct: Visions of Gender in Victorian America* (New York: Alfred A. Knopf, 1985); and Lee M. Edwards, *Domestic Bliss: Family Life in American Painting, 1840–1910* (Yonkers, N.Y.: Hudson River Museum, 1986). For studies of English emphasis on domesticity, see Walter E. Houghton, *The Victorian Frame of Mind, 1830–1870!* (New Haven: Yale University Press, 1957); Leonore Davidoff and Cath-

erine Hall, *Family Fortunes: Men and Women of the English Middle Class, 1780–1850* (Chicago: University of Chicago Press, 1987); and Casteras, *Substance or Shadow,* and *Images of Victorian Womanhood.* For a review of several studies of domesticity that analyzes the conflicting assumptions that underlie such investigations, see Judith Newton, "*Family Fortunes:* 'New History' and 'New Historicism,'" *Radical History Review* 43 (Winter 1989): 5–22.

8. Harriet Martineau, *Society in America,* 3 vols. (1837; rpt. New York: AMS Press, 1966), 3: 105–106.

9. For a recent discussion of these ideas, see Barker-Benfield, *Horrors of the Half-Known Life.* Among the evidence of this separation by gender was the establishment in the period of differential wages by gender for activities from piece work in manufacturing to school teaching.

10. Lerner argues that "the cult of the lady in an egalitarian society serve[d] as a means of preserving class distinctions" ("Lady and Mill Girl," 191). Elizabeth Fox-Genovese, in "Placing Women's History in History," argues that the bourgeoisie was consolidated as a class in the United States at the expense of the rights and freedoms of women. More recently, Scott stated unequivocally that "the concept of class in the nineteenth century depended on gender for its articulation" ("Gender: A Useful Category," 1073). Studies that have contributed to my formulations about urbanism and women include Karen Halttunen, *Confidence Men and Painted Women: A Study of Middle-Class Culture in America, 1830–1870* (New Haven and London: Yale University Press, 1982); Lois W. Banner, *American Beauty* (Chicago: University of Chicago Press, 1983); Valerie Steele, *Fashion and Eroticism: Ideals of Feminine Beauty from the Victorian Era to the Jazz Age* (New York: Oxford University Press, 1985); and Christine Stansell, *City of Women: Sex and Class in New York, 1789–1860* (Urbana: University of Illinois Press, 1987).

11. In fact, the motif of women sharing intimacy with other women was common in English painting as well as in American cultural practice. For a discussion of women's social relations as a world they created to be both within and apart from the requirements of domesticity, see Carroll Smith-Rosenberg, "The Female World of Love and Ritual: Relations between Women in Nineteenth-Century

America," *Signs* 1:1 (1975): 1–30. On manners, see Arthur M. Schlesinger, Sr., *Learning How to Behave: A Historical Study of American Etiquette Books* (New York: Macmillan, 1946).

12. I am grateful to Claudia Kidwell of the Costume Department, National Museum of American History, Smithsonian Institution, for discussing with me the implications of costume in this and other pictures. For general surveys of costume, see Ruth Turner Wilcox, *Five Centuries of American Costume* (New York: Charles Scribner's Sons, 1963), and Estelle Ansley Worrell, *Early American Costume* (Harrisburg, Pa.: Stackpole Books, 1975).

13. Although I discuss white men here, the applicability of these categories to Eastman Johnson's *Old Kentucky Home* is stunning. The African-American males are represented by Johnson in three roles: as children, as suitor, and as banjo-player. This would suggest that the anxiety level in white society about black masculinity was high indeed.

14. Alexis de Tocqueville, *Democracy in America* (1835; rpt. New York: Harper and Row, 1966), 568–569. James Fenimore Cooper also addresses this issue in *Notions of the Americans,* 2 vols. (Philadelphia: Carey, Lea and Carey, 1828), 1:27. See Sarah Burns, "Yankee Romance: The Comic Courtship Scene in Nineteenth-Century American Art," *American Art Journal* 18:4 (1986): 51–75.

15. What might have spurred Mount to try the theme was that in 1834, a purported Ostade "courtship" was exhibited in New York to genial approval by *American Monthly Magazine* 2 (1834): 281. As Peter Buckley points out in "The Place to Make an Artist Work: Micah Hawkins and William Sidney Mount in New York City," in *Catching the Tune: Music and William Sidney Mount* (Stony Brook, N.Y.: Museums at Stony Brook, 1984), 34, this subject has an almost exact correspondence to a scene in the drama *Forest Rose,* 1826, the encounter between Harriet and the two rivals for her affection, Jonathan and the city slicker Bellamy. Although *The Sportsman's Last Visit* was reviewed favorably in *Knickerbocker* 5 (June 1835): 555, no one bought it.

16. Before Mount left the courtship theme, he tried another twist on the topic. Inspired by the success of his pun in *Farmers Bargaining,* he painted a scene in 1837 in which a young woman in a simple rustic interior is entertaining one suitor, a rural type

rather than the confidence man increasingly popular in literature. The farmer's whittled stick on the floor beside him, he is talking enthusiastically while he helps her "wind up" a ball of yarn. But she gives her full attention to the yarn project. Delighted critics caught Mount's joke and told their readers that the young woman was in fact "winding up" the suit, making this the unsuccessful suitor's last visit. *New-York Mirror,* June 17, 1837, 407.

17. Those who would lampoon Harrison, however, took aim at his country pretensions. Working the deep vein of misogyny in the culture, caricaturists dressed Harrison in a frilly apron and woman's droopy-brimmed hat to illustrate the nickname by which opponents alluded to his age and punctilious habits, "Granny Harrison."

18. Edmonds followed the motif of courtship in many paintings throughout his career, many of them on literary themes.

19. In the history of images, the picniclike *fête galante* had a long tradition, of which the images of Watteau are an excellent example. See Roxana Barry, *Land of Plenty: Nineteenth-Century American Picnic and Harvest Scenes* (Katonah, N.Y.: Katonah Gallery, 1982). Another early picnic image is Durand's *Dance of the Haymakers,* 1851 (private collection), in which an urban couple stands to the side of the image watching the rustics cavort. Typically, landscape rather than genre painters undertook the motif of the picnic, linking their claims that nature had a special, moralizing influence on human beings with those of advocates for women's special nature who claimed the beneficent influence of women over men.

20. I thank Donald Keyes for his help on Matteson, on whom he has done much research. On the cultural implications of men's dress at mid-century, see Lois Banner, "Men," in *American Beauty,* 226–248.

21. April 26, 1845. The painting was engraved by S. A. Schoff for the *Columbian Magazine* 8 (July 1847): frontispiece (Library of Congress); reproduced in Carl Bode, *American Life in the 1840s* (Garden City, N.Y.: Anchor, 1967), plate 22.

22. On Thompson, see Lee M. Edwards, "The Life and Career of Jerome Thompson," *American Art Journal* 14:4 (1982): 4–30, and Donelson Hoopes, "Jerome B. Thompson's Pastoral America," *American*

Art and Antiques 1:1 (1978): 92–99. Thompson's picnic pictures include *A Pic Nick,* about 1855 (Museum of Fine Arts, Boston); *Pick Nick near Mount Mansfield, Vermont,* 1857 (Fine Arts Museums of San Francisco), exhibited, according to Edwards, as *Recreation (A Picnic Scene in Vermont);* and *The Belated Party on Mansfield Mountain,* 1858 (Metropolitan Museum of Art).

23. The radical questioning of the domestic male that took place in women's novels seems not to have taken place in domestic imagery. The imagery, after all, was the product of an urban male-dominated commercial enterprise, run by men who had wives at home. In contrast, as Mary Kelley discusses in *Private Woman, Public Stage: Literary Domesticity in Nineteenth-Century America* (New York: Oxford University Press, 1984), women wrote novels with female characters at the center of the social world. In these works though men were never on the periphery, they played roles that embodied subversions of their domination in real life. This visual and verbal discrepancy points to several factors: the considerably larger participation of women in the production of literature, the commercial sponsorship of that work because women formed so significant a proportion of the readership, and the much greater flexibility of verbal discourse than visual in transforming received traditions, which may have received additional enhancement because of the verbal rather than visual orientation of most Americans. *Married,* Sarony and Major, 1848 (Smithsonian Institution), is illustrated in Bode, *American Life in the 1840s,* plate 6.

24. *Cosmopolitan Art Journal,* June 1857, 127, 129. Engraved in 1856 for the 25,000 members of the Cosmopolitan Art Association, *Apple Gathering* was chromolithographed in 1866 by A. H. Ritchie.

25. For essays that treat the child as a separate type in American art, see Jadviga M. Da Costa Nunes, "The Naughty Child in Nineteenth-Century American Art," *Journal of American Studies* 21:2 (1987): 225–247; Sarah Burns, "Barefoot Boys and Other Country Children: Sentiment and Ideology in Nineteenth-Century American Art," *American Art Journal* 20:1 (1988): 25–50; and Burns, *Pastoral Inventions: Rural Life in Nineteenth-Century American Art and Culture* (Philadelphia: Temple University Press, 1989). Studies of childhood in America, with "natu-

ral" attention to male childhood, are numerous. I have drawn most on Bernard Wishy, *The Child and the Republic: The Dawn of Modern American Child Nurture* (Philadelphia: University of Pennsylvania Press, 1968); Michael Gordon, ed., *The American Family in Social Historical Perspective* (New York: St. Martin's Press, 1978); Joseph Kett, *Rites of Passage: Adolescence in America, 1790 to the Present* (New York: Basic Books, 1977); and the several essays in Marylynn Stevens Heininger et al., *A Century of Childhood, 1820–1920* (Rochester, N.Y.: Margaret Woodbury Strong Museum, 1984). Primary documents during the period are virtually uncountable. A good source for the running dialogue about children is the periodical *Godey's Lady's Book*. Others are Lydia Sigourney, *Letters to Mothers* (Hartford, Conn.: Hudson and Skinner, 1838); Heman Humphrey, *Domestic Education* (Amherst, Mass.: J. S. and C. Adams, 1840); and Lydia Maria Child, *The Mothers Book* (New York: C. S. Francis, 1844).

26. John Neal, "Children—What Are They?" *Godey's Lady's Book* 29 (October 1849): 260–262; "The American Ideal Woman," *Putnam's* 2:11 (1853): 531.

27. *Godey's Lady's Book* 12 (June 1832): 268; J. M. Van Cott, "City Article: Barry Case," *Arcturus* 1 (February 1841): 185.

28. The scene is set on a street recognizable earlier this century to residents of Catskill, New York, where Browere lived for much of his career (Archives, New York State Historical Association, Cooperstown). That Browere named the store "McCormick's" suggests another bias involved in the high jinks—that against Irish immigrants—and thus possibly links women with immigrants as the derided classes.

29. Mount painted *The Truant Gamblers (Undutiful Boys)* (New-York Historical Society) for Luman Reed in the same commission in which he created *Bargaining for a Horse*. The pair thus seem to have illustrated two stages of the male sovereign's interests; "harmless" gambling and neglect of duty lead to "harmless" bargaining and neglect of production.

30. The schoolmaster was enjoyed by a writer for the *Literary World* as an allusion to "Geoffrey Crayon," the teacher that Washington Irving invented to parody New England uprightness (May 10, 1851, 380). *Tribune*, Apr. 26, 1845. *Morris' Na-*

tional Press, June 20, 1846. Clark, *Edmonds*, reproduces Edmonds's preliminary study for the painting, which seems to show that the scene in the schoolroom, with the schoolmaster's back turned, is anything but orderly.

31. In yet another painting about women as mothers (but one in which women are mean), Tompkins Matteson's *Caught in the Act*, about 1860 (Vassar College Art Gallery), again placed the boy in the context of women. In the picture, either the mother or a sister (and conceivably a maid) has caught the boy just as he has dropped a jar of preserves in the act of snitching it from the cupboard. As she pinches his ear, he grimaces in pain.

32. See Julian Treuherz, *Hard Times: Social Realism in Victorian Art* (London and Mt. Kisco, N.Y.: Lund Humphries and Moyer Bell, in association with Manchester City Art Galleries, 1987), and Susan P. Casteras and Ronald Parkinson, eds., *Richard Redgrave* (New Haven and London: Yale University Press, 1988). The English-born artist James T. Peele exhibited such English-influenced topics as "The Poor Seamstress" at the National Academy, in apparently uninfluential step with the themes discussed in T. J. Edelstein, "They Sang 'The Song of the Shirt': The Visual Iconography of the Seamstress," *Victorian Studies* 23 (Winter 1980): 183–210.

33. Burr seems to have tried almost every topic that came to mind; in 1842, for example, he exhibited *Washing Day*, *The Justice's Court*, and *Morning of a Training Day* (presumably about a militia expedition). Many of the motifs of Burr's *Intelligence Office* are found in prints after Redgrave, especially *The Reduced Gentleman's Daughter*, 1840, illustrated in Casteras and Parkinson, eds., *Richard Redgrave*, 16. That the dress of the would-be domestics in Burr's image marks them not only as lower class but as risque is suggested in Stansell, *City of Women*, 94, who quotes Foster's description of Bowery fashions as loud and uncoordinated, with the head immodestly uncovered, in *New York by Gas-Light*, 107–108.

34. Another image that points to class divisions is James Cafferty's *Side Walks of New York*, 1859, also called *Rich Girl, Poor Girl* (New-York Historical Society).

35. One possible exception to the generalizations about insiders would be any genre pictures that

might yet come to light by such black portraitists as Joshua Johnston.

36. The major scholarship on Spencer is Robin Bolton-Smith and William H. Truettner, *Lilly Martin Spencer, 1822–1902: The Joys of Sentiment* (Washington, D.C.: Smithsonian Institution Press for the National Collection of Fine Arts, 1973). While in Cincinnati, Spencer received other encouragement in 1847 from the newly established Western Art-Union, which, like other regional art unions, modeled itself on the American Art-Union in New York.

37. Bolton-Smith and Truettner, *Joys of Sentiment,* 30–31.

38. Henriette A. Hadry, "Mrs. Lilly M. Spencer," *Sartain's Union Magazine of Literature and Art* 9:2 (1851): 152; Frances Dana Gage, "Mrs. L. M. Spencer, the Artist," in unidentified Saint Louis newspaper, about 1854–1857, quoted in Bolton-Smith and Truettner, *Joys of Sentiment,* 76; Frankenstein's verse is quoted in ibid., 45; *Literary World,* May 1, 1852, 316. I omitted in this last quotation the *Literary World*'s complaint against her "grinning 'niggers,'" a reference to her two condescending lithographs of black children playing "dress-up," *Height of Fashion* and *Power of Fashion,* which, like her other works, reveal her to have calculated her audience very knowledgeably.

39. For lithographer and engraver, see Bolton-Smith and Truettner, *Joys of Sentiment,* 167. They make much of the possibility that the model for *Shake Hands?* was Spencer's cook, implying that the picture is therefore one of a servant in the kitchen. I argue, however, that the meaning of a picture is never necessarily attached to its mechanical origins. The recommendation of Spencer's contribution is in *Cosmopolitan Art Journal,* September 1857, 165, quoted in Bolton-Smith and Truettner, *Joys of Sentiment,* 42.

40. Bolton-Smith and Truettner, *Joys of Sentiment,* 172–173, cite Mrs. Trollope's comment, in 1830, that many Cincinnati gentlemen did family grocery shopping. Just how widespread the practice was in New York some twenty-five years later is not clear. The point of this picture seems to be the husband's clumsiness. *Knickerbocker* 47 (May 1856): 547; *Crayon* 3 (May 1856): 146.

41. See Kelley, *Private Woman, Public Stage,* and Nina Baym, *Woman's Fiction: A Guide to Novels by and about Women in America, 1820–1870* (Ithaca: Cornell University Press, 1978). On "lips as sweet as molasses," see Walter Blair, *Native American Humor, 1800–1900* (New York: American Book Company, 1937), 21.

42. Although whether the negotiations between Spencer and the Cosmopolitan Art Association specified the precise qualities of the images is not clear, I suspect that they did not. *Cosmopolitan Art Journal,* November 1856, 50. The painting was advertised in the Catalogue of Premiums, p. 63, no. 73, as *Kiss Me If You Dare.* Just how attractive audiences found these innuendoes in title and activity is made clear by a description of another Spencer painting, now lost, with similar motifs. The *Cosmopolitan Art Journal* advertised Spencer's *How Tempting!* 1857, to its readers by describing the work as showing a young maiden sitting with "coquettish ease" and holding in her left hand "a plate, heaped up with fruit, deliciously ripe. With her right hand she holds up a couple of bunches of grapes, so exquisitely done as to lead the beholder to think they *are* grapes. . . . With these, and her own rosy beauty, she is tantalizing the visitor. . . . On a side table are melons, dish of apples, etc., painted to the very life. In the back-ground, to the right, is a parlor, of which we have a glimpse through an open door. . . . The language of the whole is provocative of a glow under the waistcoat." The sexual overtones of this last phrase, "a glow under the waistcoat," cannot be mistaken; such alternative encomiums as "a warmth in the heart" were commonplaces in enthusiastic criticism at the time. *Cosmopolitan Art Journal,* September 1857, 165, quoted in Bolton-Smith and Truettner, *Joys of Sentiment,* 145.

43. *Cosmopolitan Art Journal,* November 1856, 50.

44. Bolton-Smith and Truettner, *Joys of Sentiment,* 152.

45. *Cosmopolitan Art Journal Supplement, Catalogue of Premiums,* December 1860, 191. I take the phrase "cultural work" from Jane Tompkins, *Sensational Designs: The Cultural Work of American Fiction, 1790–1860* (New York: Oxford University Press, 1985), from which I have learned a great deal.

46. For Spencer's images of motherhood, see Bolton-Smith and Truettner, *Joys of Sentiment,* 154–155; other paintings include *Come to Mama,* 1858 (private collection), and related pictures are *Listen-*

ing to Father's Watch, 1857 (Currier Gallery of Art), and *Fi Fo Fum,* 1858 (private collection). Although by the mid-1850s critics were complaining about the flooding of exhibitions with images of motherhood, stating emphatically that the Madonna was *de trop,* many of the paintings seem to have been by Europeans rather than Americans.

CHAPTER 6: THE WASHED, THE
UNWASHED, AND THE UNTERRIFIED

1. The deaths in 1850 of Calhoun and in 1852 of Webster and Clay, national and sectional leaders who had been powerful in earlier days, was perceived as the symbol of a major turning point in the nation's history.

2. Sources for these population figures are Edward K. Spann, *The New Metropolis: New York City, 1840–1857* (New York: Columbia University Press, 1981), 23–26; Philip M. Hosay, *The Challenge of Urban Poverty* (New York: Arno Press, 1980), 11–12; and Paul Boyer, *Urban Masses and Moral Order in America, 1820–1920* (Cambridge: Harvard University Press, 1978), 3–4, 67–68.

3. I have been especially influenced in this interpretation by Thomas Bender, *Toward an Urban Vision: Ideas and Institutions in Nineteenth-Century America* (Lexington: University Press of Kentucky, 1975). A very recent study is Stuart M. Blumin, *The Emergence of the Middle Class: Social Experience in the American City, 1760–1900* (London: Cambridge University Press, 1989).

4. See Boyer, *Urban Masses,* 73; Todd, *Moral Influence, Dangers, and Duties, Connected with Great Cities* (Northampton, Mass.: J. H. Butler, 1844), 79–80. For other early diagnoses of the evils of the city, see John H. Griscom, *The Sanitary Condition of the Laboring Population of New York* (New York: Harper and Brothers, 1845); George G. Foster, *New York by Gaslight,* 1849, and *New York in Slices,* 1850; and George Lippard, *The Empire City; or, New York by Night and Day: Its Aristocracy and Its Dollars* (New York: Stringer and Townsend, 1850), and *New York: Its Upper Ten and Lower Million* (Cincinnati: H. M. Rulison, 1853). For recent studies of the city and its problems, see Edward K. Spann, *The New Metropolis: New York City,*

1840–1857 (New York: Columbia University Press, 1981); Carroll Smith-Rosenberg, *Religion and the Rise of the American City: The New York City Mission Movement, 1812–1870* (Ithaca: Cornell University Press, 1971); Philip M. Hosay, *The Challenge of Urban Poverty: Charity Reformers in New York City, 1835–1890* (New York: Arno Press, 1980); Charles N. Glaab, *The American City: A Documentary History* (Homewood, Ill.: Dorsey Press, 1963); and Clifford S. Griffin, *Their Brothers' Keepers: Moral Stewardship in the United States, 1800–1865* (New Brunswick, N.J.: Rutgers University Press, 1960). For points of comparison in England, see H. J. Dyos and Michael Wolff, eds., *The Victorian City: Images and Realities* (London: Routledge and Kegan Paul, 1976), and Ira Bruce Nadel and F. S. Schwarzbach, eds., *Victorian Artists and the City: A Collection of Critical Essays* (Elmsford, N.Y.: Pergamon Press, 1980).

5. In the early 1840s in the United States, following in the "street cries" tradition, Italian immigrant Nicolino Calyo made watercolors of and then lithographed street vendors. In the 1850s, a few artists occasionally painted images of vendors and other "curious" city types who provided local color; these included Francis W. Edmonds and Charles Blauvelt in New York, William E. Winner in Philadelphia, Thomas Waterman Wood in Baltimore, and David G. Blythe in Pittsburgh; for Blythe, see below. For examples of comic urban types, see Bernard Reilly: "Comic Drawing in New York in the 1850s," in *Prints and Printmakers of New York State, 1825–1940,* ed. David Tatham (Syracuse, N.Y.: Syracuse University Press, 1986), 158. For a discussion of the character of Mose, with illustrations, see Joshua Taylor, *America as Art,* 64–67. A type long associated with ports, and one important in English typing of the more exotic "lower orders" as well as in American literature, is the sailor, who (perhaps because of the prominence of agrarian ideology) never achieved importance in American visual imagery. Moreover, American doctors, lawyers, and judges did not come in for ridicule in prints as did their European counterparts; I believe the explanation for this singularity lies in these new men's hegemony in cultural patronage in the United States.

6. The first genre artist to have a Southern, albeit border-state upbringing—he began his career

with medieval and other Romantic subjects like the cavalier—that were congenial to popular Southern literature and ideology, and were also popular in Düsseldorf. On Woodville, see Francis Grubar, "Richard Caton Woodville: An American Artist, 1825–1855" (Ph.D. diss., Johns Hopkins University, 1966), and *Richard Caton Woodville: An Early American Genre Painter* (Washington, D.C.: Corcoran Gallery of Art, 1967).

7. The only images in which Mount used a confined interior in picturing the (male) polity are *The Raffle* and *The Long Story*, both 1837 (Corcoran Gallery of Art).

8. A painting much like this one in theme is *Waiting for the Stage*, 1851 (Corcoran Gallery of Art); in this image, too, one man is about to be "taken" by a confident gambler who seems to have an assistant, a man in dark glasses reading a newspaper called "The Spy" and standing conspicuously where he can see both men's cards.

9. *Literary World*, Nov. 30, 1850, 432; Dec. 13, 1851, 47.

10. Brevoort to Irving, in *Letters of Henry Brevoort to Washington Irving*, vol. 2, ed. George S. Hellman (New York: G. P. Putnam's Sons, 1916), 132–133. A few Baltimore patrons encouraged Woodville as well as the American Art-Union, which bought *The Card Players*, 1846 (Detroit Institute of Arts), in 1847 and *Young '48 and Old '76* (Walters Art Gallery) in 1849. George Austen, director of the Art-Union, owned *War News from Mexico* and *The Cavalier's Return*, 1847 (New-York Historical Society). Director Abraham Cozzens bought *Barroom Scene*, 1835 (now *The Breakdown*, Art Institute of Chicago), in 1845.

11. Population statistics are from Hosay, *Challenge of Urban Poverty*, 12; Spann, *New Metropolis*, 23; Channing cited in Boyer, *Urban Masses*, 56. For immigrants, see Robert Ernst, *Immigrant Life in New York City, 1825–1863* (New York: King's Crown Press, 1949); David Ward, *Cities and Immigrants: A Geography of Change in Nineteenth-Century America* (New York: Oxford University Press, 1971); and John Bodnar, *The Transplanted: A History of Immigrants in Urban America* (New York, 1985).

12. See, e.g., François Bonvin, *The Young Savoyard*, 1845 (Boulogne-sur-Mer, Musée Municipal), in Gabriel P. Weisberg, *The Realist Tradition: French Painting and Drawing, 1830–1900* (Cleveland: Cleveland Museum of Art, 1980), 43, fig. 1, and Weisberg, *Social Concern and the Worker: French Prints, 1830–1910* (Salt Lake City: University of Utah Museum of Fine Arts, 1973).

13. Willis quoted in Christine Stansell, *City of Women: Sex and Class in New York, 1789–1860* (Urbana: University of Illinois Press, 1987), 74. On the poor near City Hall, see *Arcturus* 1 (April 1841): 309. In another example, in 1847 Robert Carter had written in *Life in New York*, "Pause at the bedside of that dying old man, and if honest now, he will tell you of sin that paved his walk to this end of town" (quoted in Hosay, *Challenge of Urban Poverty*, 14). For self-righteousness in hatred of the lower classes, see Griffin, *Their Brothers' Keepers*.

14. Spann, *New Metropolis*, 262, 263; Robert W. Lynn and Elliott Wright, *The Big Little School: Sunday Child of American Protestantism* (New York: Harper and Row, 1971), 33, quoted in Boyer, *Urban Masses*, 80. On children and urban poverty, see David Nasaw, *Children of the City: At Work and at Play* (Garden City, N.Y.: Anchor Press and Doubleday, 1985); Robert M. Mennel, *Thorns and Thistles: Juvenile Delinquents in the United States, 1825–1940* (Hanover, N.H.: University Press of New England, 1973); and Joseph M. Hawes, *Children in Urban Society: Juvenile Delinquency in Nineteenth-Century America* (New York: Oxford University Press, 1971).

15. The topic did appear in illustrations and prints. In painting, Edmonds is an interesting case. He painted *Italian Mendicants* (now lost), exhibited at the National Academy of Design in 1842, which was reviewed by the *Knickerbocker*, "There is a brightness and clearness in the whole picture perfectly in keeping with the subject; for Italy with all her wretchedness still wears a cheerful aspect, and her mendicants, though begging with a doleful countenance at one moment, are the next dancing with light hearts and lively steps to a mountaineer's pipe" (cited in Nichols B. Clark, *Francis W. Edmonds: American Master in the Dutch Tradition* [Washington, D.C.: Smithsonian Institution Press, for the Amon Carter Museum, 1988], 71). Edmonds's *Miser and the Beggar Woman*, exhibited in 1844, also called *The Beggar's Petition*, was praised by the *New York Tribune*, Apr. 25, 1844, as "a poem full of heart-moving pa-

thos, tenderness and nature." The *Knickerbocker* articulated Edmonds's point: "A spirited and faithful representation of the cold indifference to the wants of others, displayed in the miser's disposition. . . . The female supplicating in behalf of the distressed is graceful in attitude, and admirably contrasted with the hoarding miser" ("The Fine Arts" [June 1844]: 597). Charles M. Leupp bought the work. Edmonds's scenes of poverty did not survive.

16. Neal, "Pennings and Pencillings, In and About Town," *United States Magazine and Democratic Review* 61 (July 1843): 91. Strong first appears in the City Directory in 1820 as a grocer; by 1843 he listed himself as a "commercial merchant," and by 1846, as a "manufacturer." When he wrote "Limnings in the Thoroughfares, The News-Man and Newsboy," for the *Knickerbocker* 15 (February 1840): 138–144, he was perhaps expressing the conservatism of middle age.

17. One of the first traceable pictures of a newsboy exhibited was that by Edmonds, *The Penny Paper*, in 1839; Charles Lanman, in *Letters from a Landscape Painter* (Boston: James Munroe, 1845), 240, referred to the works as *Newspaper Boy*, saying it pictured "a large room thronged with men, women, and children, into the midst of whom a ragged boy has entered to sell his Sunday morning papers." Edmonds wrote that he had worked a great deal on it, finding the groups of people very difficult (Clark, *Edmonds*, 49).

18. The hotel was noted by the *Knickerbocker* 60 (July 1852): 91; it was near Vesey Street, where Inman then lived.

19. *New-York Mirror*, May 22, 1841, 167.

20. *Arcturus* 2 (June 1841): 6; "Billy Snub the Newsboy," *The Gift* (Philadelphia: Carey and Hart, 1843): 59–84. Smith's wife, Elizabeth Oakes Smith, later wrote the novel *The Newsboy*, praising her fictional character Bob as having "that innate dignity of soul which neither crown nor scepter could augment" (*The News-Boy* [New York: J. C. Derby, 1854], 8, 9).

21. Exceptions are William Page's *Young Merchants*, 1842 (Pennsylvania Academy of the Fine Arts), in which two street children who are the picture of rosy middle-class health and polite composure sell newspapers and strawberries near New

York City Hall. When this picture was engraved for *The Gift* in 1844, Seba Smith wrote another confident tale of regeneration. In this one, however, the children are country people, whose families were ruined financially; they went to the city to work, saved enough money to buy the boy's family's farm back, married each other, and returned to the farm. Other images of the "happy street child" include William Ranney's scrubbed and contented *Match Boy*, 1845 (private collection), a notable contrast to English depictions of the type and a topic to which Ranney never returned after he took up the Western trapper; William LeClear's healthy *Buffalo Newsboy* of 1853 (Albright-Knox Art Gallery, Buffalo) (LeClear was Inman's student); and the chromolithograph of William Winner's *Newsboy*, 1853, a transposition of a farm lad into the city, right out of one of Mount's trapping paintings except without the capacity for mischief. On LeClear, see *The Wayward Muse: A Historical Survey of Painting in Buffalo* (Buffalo, N.Y.: Albright-Knox Gallery, 1987).

22. *Arcturus* 2 (June 1841): 60.

23. Born in Havre de Grace, Maryland, Yewell grew up in Iowa City, Iowa. See entry on Yewell in Richard J. Koke et al., *American Landscape and Genre Paintings in the New-York Historical Society: A Catalogue of the Collection, Including Historical, Narrative, and Marine Art*, vol. 3 (Boston: G. K. Hall, 1982). Yewell occasionally did other such works; they, too, were not reviewed and all of them are now apparently lost. They were exhibited at the National Academy of Design as follows: "The Poetry of Laziness," #182, 1853; "Too Poor to Play," #136, 1854; "Self Defense," #103, 1855; and "Country Boy in a Studio," #282, 1856. Just when the title "Doing Nothing" was changed to *The Bootblack* is not clear.

24. Of interest to some viewers who noted the drama posters may have been the fact that the actor Forrest was then divorcing his (English) wife, and thus, like the popular theater audiences, was rejecting aristocratic connections.

25. Another complex image of an urban street child is James Cafferty's *Newsboy Selling New-York Herald* (private collection), which presents similar themes: the city as a mixture of privilege and deprivation, the youngster as determined and (therefore) successful. Like Yewell, Cafferty had tried

socially sensitive images early in his career, which included one image that represented inequities between women on the urban street, *The Sidewalks of New York*, 1859 (New-York Historical Society), also called "Rich Girl, Poor Girl" and "The Encounter." See David Stewart Hull, *James Henry Cafferty, N.A.* (New York: New-York Historical Society, 1986).

26. See Bruce W. Chambers, *The World of David Gilmour Blythe* (Washington, D.C.: Smithsonian Institution Press, for the National Collection of Fine Arts, 1980). Always on the entrepreneurial look-out, Blythe also tried a panorama, but the business went broke. Chambers suggests that Blythe may have been in New York in 1852.

27. George Thurston, *Pittsburgh as It is* (Pittsburgh: W. S. Haven, 1857); Michael F. Holt, *Forging a Majority; The Formation of the Republican Party in Pittsburgh, 1848–1860* (New Haven and London: Yale University Press, 1969), and Richard Wade, *The Urban Frontier: Pioneer Life in Early Pittsburgh, Cincinnati, Lexington, Louisville, and St. Louis* (Chicago: University of Chicago Press, 1964).

28. Blythe also painted *A Match Seller*, about 1859 (North Carolina Museum of Art), that approaches European images in its despair.

29. Blythe's pictures were typically exhibited in the store window of his dealer, Gillespie's, where they were seen and commented on in the press and by patrons. The sense of bleakness was crucial to his works; he made it explicit in *The Firecracker*. Blythe signed the work on all the boy's school things—signing the slate "Blythe," the larger book "Blythe, 1856" (with a stick character below the signature), and the smaller book "Boots," the name under which he published his reform poetry. Blythe thus identifies himself as the boy. Like the boy, like the firecracker, and like the social disorder that they represent, Blythe's urging for reform will be ignored.

30. Chambers, *Blythe*, 170. On the Know-Nothings, see Ira B. Leonard and Robert D. Parmet, *American Nativism, 1830–1860* (New York: Van Nostrand and Reinhold, 1971).

CHAPTER 7: INSPIRED FROM THE HIGHER CLASSES

1. W. Alfred Jones, *Characters and Criticism* (New York: I. Y. Westervelt, 1857), 288; Henry Tuckerman, *Book of the Artists: American Artist Life* (New York: G. P. Putnam and Son, 1867), 494. Peter C. Marzio, *The Democratic Art: Pictures for a Nineteenth-Century America* (Boston: David R. Godine, 1979). *Cosmopolitan Art Journal*, December 1860, 166–167. Such young painters as Francis Blackwell Mayer, working in Baltimore, and John Ehninger, in New York, tried genre scenes in the 1850s but soon went on to more promising topics. Mayer's *Labor and Leisure*, 1858 (Corcoran Gallery of Art), which he exhibited only in Washington, D.C., is the closest to a genre scene from a Southern point of view; most interesting is that Mayer presents a scene of class differences, the implications of which he clearly disapproves. A blacksmith and his helper shoe the horse of an aristocratic young man who lounges against the door of their workshed accompanied by his whippet. Ehninger's *Yankee Peddler* (Newark Museum), exhibited in New York in 1853, elicited the comment that the Yankee subject was "hackneyed" and that the artist should take "a higher range" of subject. *Knickerbocker* 48 (July 1856): 38.

2. *Cosmopolitan Art Journal*, March–June 1858, 144.

3. Richard J. Koke et al., *American Landscape and Genre Paintings in the New-York Historical Society: A Catalogue of the Collection, Including Historical, Narrative, and Marine Art*, 3 vols. (Boston: G. K. Hall, 1982), 2:402.

4. United States Sanitary Commission, *A Record of the Metropolitan Fair in the Aid of the United States Sanitary Commission, Held at New York, in April, 1864* (New York, 1867), 2.

5. Examples of such pictures include Winslow Homer's *On the Bright Side*, 1865 (Fine Arts Museums of San Francisco), and Eastman Johnson's *Corn Husking*, 1860 (Everson Museum, Syracuse), in which notes of the campaign rivalry between Lincoln and Hamlin are drawn on the barn door.

Index

Page numbers in italics refer to illustrations.

Abolitionists, 33–36, 101, 106, 116. *See also* Slavery

Advice on the Prairie (Ranney), 225 n. 35

African-Americans, 1, 137, 160, 197; in Homer's works, 201–202; in Guy's works, 4; in Krimmel's works, 6; in Mount's works, 25, 33–35, 37; as "other," 11, 178; role of, in genre painting, 100–136 passim; stereotypical images of, 19–20, 141, 157

All Talk and No Work (Edmonds), 123

Allston, Washington, 3, 45

Amalgamation, 106, *107. See also* African-Americans; Slavery

American Art-Union, 75–77, 224 n. 25; and Bingham, 82, 87, 88, 89, 97; and Clonney, 110, 113; demise of, 94, 149, 197; and Edmonds, 156; and Mount, 37, 55; as patron, 90; and Spencer, 161, 162; and Woodville, 180, 181

American Farmer, The (Wood), *200,* 201

Amistad incident, 116

Androbus, John, 229 n. 6

Apple Gathering (Thompson), 148–151, 159, 168, *pl. 19*

Apollo Association. *See* American Art-Union

Arcturus (Democratic journal), 53, 153, 187

Astor Place riot, 189

Backwoodsman, 17. *See also* Frontiersman

Baltimore, 94, 122

Baltimore American, 94

Bargaining for a Horse [*Farmers Bargaining*] (Mount), 28–33, 36, 38, 45, 46, 47, 53, 55, 57, 77, 78, 110, 137, 138, 142, 146, 179, 196, 199, *pl. 3;* studies for, 29, *30,* 31

Barlow, Joel, 10

Beard, James Henry, 225 n. 35

Benton, Senator Thomas Hart, 83, 94

Biddle, Nicholas, 51

Bingham, George Caleb, 131, 175, 197; and election scenes, 91–99; and images of the West, 82–89, 102, 103, 137, 147, 176, 179; and images of women, 138, 164

Birch, Thomas, 4

Birch, William, 4

Blacks. *See* African-Americans

Blacksmith Shop, The (Johnson), 201, *202*

Blair, Francis Preston, 52

Blythe, David Gilmour, 190–196

Boone, Daniel, 18, 62

Boone's First View of Kentucky (Ranney), 80

Bootblack, The [*Doing Nothing*] (Yewell), 187, *188,* 189–190

Boston, 3, 21, 91, 176, 196

Bostonians, 22, 28, 102

Boy Eating Bread (Blythe), 193

Boyhood, images of, 151–157, 201

Boys Hustling Coppers (Mount), 58

Brace, Charles Loring, 186

Breckenridge, Henry Hugh, 10

Brevoort, Henry, 41, 59, 181

Broadway Journal, 69, 77

Browere, Augustus, 44, 153, 163, 174

Brown, John George, 201

Bryant, William Cullen, 22, 60

Buffalo Newsboy (LeClear), 242 n. 21

Burr, William Henry, 157–160, 197

Butler, Samuel, 75

Cafferty, James, 238 n. 34, 242 n. 25

Calculating (Hicks), 220 n. 48

California, 90–91

California News (Mount), 219 n. 47

Captured by Indians (Bingham), 236 n. 2

Card Players (Woodville), 179, 180, *pl. 22*

Carey, Edward L., 32, 40, 186

Carson, Kit, 69, 70

Catching Rabbits [*Boys Trapping*] (Mount), 47, *49,* 50, 57, 110, 137, 154

Catlin, George, 61, 63, 66, 75, 80

Caught in the Act (Matteson), 238 n. 31

Channing, William Ellery, 182

Children, images of, 163, 170–175, 183–184

Christ Raising the Daughter of Jairus (Mount), 24

Cider Making (Mount), 50–54, 57, 77, 94, 138, 146, 154, *pl. 5*
City and the Country Beaux, The (Edmonds), 146–147, *pl. 17*
Civil War: and Bingham, 98; depiction of women after, 175; and end of genre painting, xi, 197, 198; and images of African-Americans, 103; and Johnson's works, 127, 134, 135
Clay, Edward C., 26, 34, *35*, 46, *47*, 63, *64*, 107
Clonney, James, 53, 157, 174, 175, 178; and images of African-Americans, 108–15, 122, 123
Cole, Thomas, 32, 44, 45, 218 n. 36
Coming to the Point (Mount), studies for: *29, 30,* 31
Compromise of *1850,* 55–57, 110, 122, 124
Cooper, James Fenimore, xv, 18, 22, 44, 63, 75
Corn Husking Frolic (Fisher), 4, 5
Cosmopolitan Art Association, 14, 162, 164, 168, 174
Cosmopolitan Art Journal, 151, 164, 170, 198
County Election (Bingham), 92–98, 137, *pl. 10*
Courier and Enquirer, 34
Courtship, 143–151
Courtship, or Winding Up (Mount), 216 n. 23
Crawford, Thomas, 123
Crayon, 197
Crockett, Davy, 11, 18, 62, 63, *65,* 147
Crossing the Plains (Nahl), 225 n. 35
Crowe, Eyre, 132–133
Cruikshank, George, 27
Cushing, Caleb, 52

Dance in a Country Tavern (Krimmel), 25, 105
Dance of the Haymakers (Mount), 119
Daniels, William, 190
Davis, Charles August, 50
Deas, Charles, 80, 142, 178, 185; compared to Bingham, 83, 85, 87, 92, 94; and images of the West, 66–78, 102, 103, 147, 163, 179, 203
Death Struggle, The (Deas), 73, *74,* 75, 77, 78, *79,* 85
Defiance: Inviting a Shot before Petersburg (Homer), 234 n. 47
Delaroche, Paul, 90
Democratic party: and *Arcturus,* 153; and Bingham, 96; images of, 46, *47, 48,* 49–58; in Jacksonian era, 24, 26; and slavery, 102
Disagreeable Surprise (Mount), 155
Douglass, Frederick, 102

Doughty, Thomas, 45
Downeaster, 15, 16
Downing, Jack, 15, 26, 32, 50, 62
Dunlap, William, 43
Durand, Asher B., 44
Durrie, George Henry, 55
Düsseldorf, 178, 197
Düsseldorf art union, 90
Dutchmen (in U.S.), 16, 44

Edmonds, Francis W., 59, 75, 103, 161, 175, 179, 181, 197; and images of African-Americans, 123; and images of masculinity, 146–147; and images of motherhood, 155–157, 159, 174; and images of women, 138, 164; and Mount, 54–55, 66
Eel Spearing at Setauket (Mount), 118–119, 131, *pl. 13*
Ehninger, John, 243 n. 1
Election Scene, Catonsville, Baltimore County (Miller), 227 n. 50
Emerson, Ralph Waldo, 24, 131
Emigrants, 68
Emigration of Daniel Boone (Bingham), 225 n. 35
European visitors, 8, 61

Farmers: in Bingham's works, 92–93; and class distinctions, 98–99; as depicted in images, 103, 160, 179; disappear from imagery, 201; in Mount's works, 28–42, 50–57, 84; and nation as farm, 208 n. 15; as type, 12–14, 16
Farmers Nooning (Mount), 33–38, 77, 107, 111, 114, 120, 137, 197, *pl. 4;* study for, 36, *37*
Femininity. *See* Women
Fink, Mike, 19
Firecracker (Blythe), 193, *194*
Fisher, Alvan, 4, 5, 140
Flint, Timothy, 67–68
Fourth of July in Centre Square (Krimmel), 4, 6, 7
Frankenstein, John, 162
Frémont, John Charles, 64, 69
Frontiersman: images of, 60–82 passim, 99, 141; as type, 17–19

Gage, Frances, 162, 173
Genre painting: definition of, xi-xiv, 2–3; Dutch and Flemish, xi, 2, 3, 24, 131, 138, 164; English, xi, 2, 3, 24, 139, 143, 157, 182; French, xi, 2, 131, 139, 157, 182–183; German, 2, 139, 143, 182

Gift, The, 32, 155, 186
Gillray, James, 27
Gilmor, Robert, 113
Glance at New York (Baker), 20
"Go-ahead," 10, 11, 23, 65
Godey's Lady's Book, 37, 148, 149, 152, 175
Good Breakfast, The (Clonney), 157
Goupil and Vibert, 90, 121, 123
Gray, Henry Peters, 90
Greek Slave, The (Powers), 90, 116, *117*, 133
Greuze, Jean-Baptiste, 4, 174
Guy, Francis, 4, 104, 140
Guy, Seymour, 202

Hackett, James, 32
Haiti, 123
Haliburton, Thomas Chandler, 15
Halt on the Prairie (Ranney), 79–80
Happy Family (Sartain), 149, *150*
Harper's Monthly Magazine, 125
Harrison, William Henry, 50–51
Hawkins, Micah, 24, 27
Hawthorne, Nathaniel, 38
Herald in the Country (Mount), 219 n. 47
Herbert, William Henry, 70, 75
Hicks, Thomas, 201, 220 n. 48
History painting, 3, 24, 44–45
Hogarth, 6–7, 27, 92–93, 138
Homer, Winslow, 201, 243 n. 5
Hone, Philip, 9, 39, 182
Horsetrades, 26, 29, 49
Huntington, Daniel, 90, 187

Illinois Monthly Magazine, 62
Image Peddler (Edmonds), 54, 55, 138
In the Cornfield (Clonney), 110, *111*
In the Woodshed (Clonney), 108, *109*
Inman, Henry, 44, 59, 63, 184–187, 192
Intelligence Office, The (Burr), 157, *159*, 160
Irish, 19, 94, 95, 176
Irving, Washington, 32, 41, 44, 59, 79; on New
 Yorkers, 14, 16; as source of images, 75, 154; on
 the West, 60, 68–69

Jackson, Andrew, 14, 18, 26, 53, 54, 57, 60
Jefferson, Thomas, 9, 13
Johnson, Eastman, 127–131, 201–202, 243 n. 5

Johnston, David Claypoole, 27, 28, 29, 32, 63
Jolly Flatboatmen, The (Bingham), 84–87, 137, 198,
 pl. 9
Jonathan (yeoman type), 14, 41
Jones, W. Alfred, 127, 197
Josselyn, Lewis, 51

Kansas-Nebraska Act (*1854*), 111–113, 127, 138
Kendall, Amos, 52
Kentuckians, 12, 18, 21, 63
Kentucky Statesman, 96
King, Charles Bird, 4
Kiss Me and You'll Kiss the 'Lasses (Spencer), 168, *169*,
 170
Kitchen Ball at White Sulphur Springs (Mayr), 114,
 127, 131, *pl. 12*
Knickerbocker, 14, 73, 76, 77, 118, 165
Know-Nothings, 193
Krimmel, John Lewis, 4–7, 25; and images of Af-
 rican-Americans, 104, 105, 114, 131; and images
 of women, 140

Labor and Leisure (Mayer), 243 n. 1
Landscape painting, xiv, 3, 45, 161
Lanman, Charles, 58
Last War-Whoop, The (Tait), 99
LeClear, William, 242 n. 21
Leslie, Charles Robert, 44, 161
Lessing, Carl Friedrich, 90, 125
Leupp, Charles, 114
Life of a Hunter, The: A Tight Fix (Tait), 81, *82*
Literary World, 76, 81, 85, 120, 163, 180
Little Navigator, The (Spencer), *171*, 172–174
Little Sunshade, The (Spencer), *172*, 173–174
Long Islanders, 25, 41–42, 58–59
Long Island Democrat, 34
Long Jakes (Deas), 66–73, 75, 78, 79, 80, 85, 91, 131,
 142, 179, 185, *pl. 6*; engravings of, *71*, *72*
Long Story, The (Mount), 42
Longfellow, Henry Wadsworth, 116
Longstreet, Augustus Baldwin, 38
Louisville Daily Times, 95
Lowell, James Russell, 115
Lucky Throw (Mount), 123, *126*

Making a Train (Guy), 202
Manifest Destiny, 62

Marryat, Frederick, 46

Martineau, Harriet, 100–101, 141

Masculinity, 142, 144–147, 170; and images of African-American men, 236 n. 13; and Western male type, 62, 68–73, 77–82, 84, 86, 90, 203

Matteson, Tompkins, 147, 155

Mayer, Francis Blackwell, 243 n. 1

Mayr, Christian, 114, 127

Melville, Herman, 123

Mercy's Dream (Huntington), 187

Mexican War, 66, 70, 75, 116, 180

Miller, Alfred Jacob, 63, 80, 226 n. 222

Minstrelsy, 20, 103, 123

Missouri, 82, 83, 94

Missouri Compromise, 127

Morland, George, 25, 139

Morris's National Press, 119

Mose the Fireman, 20, 178

Mother's Watch (Clonney), 157, *158*

Mount, Henry, 24

Mount, William Sidney, 67, 80, 89, 93, 96, 163, 175, 178, 181, 185; and images of African-Americans, 101, 105–108, 113, 115–127, 135–136; and images of courtship, 142–146; and images of women, 137, 138, 154; and images of Yankee farmer, 24–59, 63, 64, 66, 84, 103, 176; and patronage and criticism, 75, 76, 77, 197

Mowatt, Ann, 177

Mrs. McCormick's General Store (Browere), 153, *154*

Mulready, William, 139

Musicians (Mount), 233 n. 33

Nahl, Charles Christian, 91

National Academy of Design (NAD), 22, 45, 76, 90, 123, 160; and Clonney, 113; and Mount, 31, 57; and Spencer, 162, 165

Native Americans, xv, 83, 99; in Deas's works, 73, 75, 78–79; in Herbert's works, 75; as image of the West, 63

Neagle, John, 4

Neal, John, 152

Negro Life at the South (Johnson), 127–135, *pl. 15*

Negro Politically Dead, The (Mount), 136

New Englanders, 11, 14, 15, 16, 17, 23

New Orleans Daily Picayune, 98

NewScholar, The (Edmonds), 155, *156,* 159

New York: and Bingham, 87–91, 94; and Blythe, 196; as center of art world, 101–102; dominance of, 7, 22–23; Dutch in, 16; in Guy's works, 4, 104; and images of urban types, 182–190; impact of growth in, 176–179; and Leatherstocking, 18; and Mayr, 114; and Mount, 96, 101–102, 105; and Spencer, 161

New York American, 51

New York Daily Advertiser, 50

New York Daily Tribune, 79

New York Herald, 31, 80

New Yorkers, 90, 176; and Clonney, 114; and conception of frontiersmen, 17; and conception of Yankees, 15; as cultural brokers, 22–23, 46, 103; and Johnson, 130; and Mount, 25; and Spencer, 163; and Woodville, 180

News Boys, The (Blythe), 190, *191,* 192, 193

Newsboy, The (Inman), 184–186, 192, *pl. 24*

Newton, Gilbert Stuart, 44

Niles Register, 39–40

Nothing Else to Do (Spencer), 173

Oertel, Thomas, 201

Old Kentucky Home (Johnson). See *Negro Life at the South*

On the Bright Side (Homer), 243 n. 5

Otis, Bass, 4

Page, William, 242 n. 21

Painter's Triumph (Mount), 42, *43,* 137

Painting, literary, 44, 75, 161; defined, xv

Panic of *1837,* 46, 67

Parkman, Francis, 73

Paulding, James Kirke, 21, 101

Peddler, image of, 15, 21, 209 n. 19

Philadelphia, 4–7, 75, 82, 91, 176, 196

Philadelphians, 22, 37, 63, 102

Pictorial puns, 28. See also Vernacular speech

Pittsburgh, 190–196

Playing Marbles (Blythe), 193

Poe, Edgar Allan, 22, 38, 182

Political caricature, 22, 26, 34–35, 41, 46, 47, 48

Politicians in a Country Bar (Clonney), 113, *pl. 11*

Politics in an Oyster House (Woodville), 179, *pl. 23*

Polk, James K., 64

Polling, The (Hogarth), 92, *93*

Poor Author and Rich Bookseller, The (Allston), 4

Post Office (Blythe), 193, *195,* 196

Power of Music, The (Mount), 119–123, *pl. 14*
Powers, Hiram, 90, 116, *117*, 123
Prairie Fire (Ranney), 225 n. 35, 236 n. 3
Prairie Hunter, The—One Rubbed Out! (Tait), 80, *81,*
Prints, 123, 198; and American Art-Union, 76, 97;
 anti-abolitionist, 106, 128; of Bingham's work,
 97–98; of Davy Crockett, 63–65; of Deas's work,
 70–72; by Johnston, 27–28; of Mount's work,
 32–33; of Spencer's work, 164, 173–175; by Tait,
 99; of Thompson's work, 149, 150, 155; of urban
 lower class, 20, 115, 177–178. *See also* Political
 caricature
Prospectors: as type, 91
Pursuit, The (Tait), 99, *pl. 8*
Putnam's, 152

Quakers: as type, 19
Quidor, John, 63
Quilting Frolic (Krimmel), 104, *105*

Raffling for the Goose [*The Raffle*] (Mount), 38, *39,*
 40–41, 77, 137
Raftsmen Playing Cards (Bingham), 85, *86*
Ranney, William, 88, 178; compared to Bingham,
 82, 85, 87, 88, 92, 94; and images of the West,
 78–80, 102, 103, 163, 203
Redgrave, Richard, 157
Reed, Luman, 32, 36, 55, 58
Reform movements, 115, 189
Remington, Frederic, 99, 203
Retreat, The (Ranney), 79, 80
Reynolds, Joshua, 3
Ringing the Pig (Mount), 57, 220 n. 50
Rivermen, images of, 83–88, 98–99, 103, 179
Rollins, James, 97, 98
Rowlandson, Thomas, 27
Russell, Charles, 99, 203
Rustic Dance after a Sleigh Ride (Mount), 24–25, 35,
 105–106, 120, 142, 144, 154, *pl. 2*

Sailor's Wedding (Woodville), 123, *124*
Saint Louis: and Bingham; critics in, 95; and Deas,
 75; as trade center, 86
Saint Louis Evening Intelligencer, 95
Sarony, Napoleon, 149
Sartain, John, 98, 149, 150
Sartain's Union Magazine of Literature and Art, 162

Schauss, William, 123, 124
Scheffer, Ary, 90
Schoolboys Quarreling (Mount), 154
Scott, Sir Walter, 44, 70
Settling the Bill (Durrie), 56, 57
Seward, William, 50–52
Shake Hands? (Spencer), 164, 168, 170, *pl. 20*
Shakespeare, William, 44, 161
Slave Auction in Richmond, Virginia (Crowe),
 132–134, *pl. 16*
Slave auctions, 132–134, 233 n. 42, 234 n. 45
Slave Market (unidentified artist), *133*, 134
Slavery, 19, 33–38, 59; images of, 100–136 passim,
 117, 129, 133
Smith, Seba, 14, 26, 32, 50
Smollett, Tobias, 44
South. *See* Southerners
Southerners, 11, 15, 23; and Mexican War, 180; and
 slavery, 102, 106, 127–128, 132; stereotypes of,
 16–17, 209 n. 21; and Whig politics, 52. *See also*
 African-Americans; Slavery
Southwesterners, 17, 38, 182
"Sovereigns," 140, 203; in Bingham's works, 92–94;
 in Clonney's works, 113; definition of, 10; in Mid-
 west, 83; in Mount's works, 29, 31, 41; as type, 13;
 in Woodville's works, 179–180
Sovereignty, defined, 9
Speculation, land, 39–40
Spencer, Lilly Martin, 176, 178, 197; and images of
 children, 171–175; and images of women, 140,
 160–170
Sportsman's Last Visit, The (Mount), 144, *145*, 146
Squatters, The (Bingham), 87, *89*, 138
Sterne, Lawrence, 44
Stowe, Harriet Beecher, 122
Street Urchins (Blythe), 192, *pl. 25*
Strong, George D., 185
Strong, George Templeton, 40
Stump Orator (Bingham), 92
Sturges, Jonathan, 36, 57, 113
Sugaring Off (Matteson), 147–148, *pl. 18*
Sully, Thomas, 4, 44, 161

Tait, Arthur F., 80–82, 99, 203
Taylor, Zachary, 180
Teniers, David the Younger, 138, 192
Terborch, Gerard, 138

Texas, 59, 66, 78, 110, 116
Thackeray, William, 132
Theater, 102. *See also* Yankee theater
There's No Place Like Home (Hicks), 201
This Little Pig Went to Market (Spencer), 174–175, *pl. 21*
Thompson, Jerome, 147, 155, 168
Thoreau, Henry David, 60, 62
Thoughts of Liberia: Emancipation (White), 123, *125*
Tocqueville, Alexis de, 9, 10, 79, 141
Trappers: images of, 66–82 passim, 90, 92, 94, 99, 103, 141, 179, 203
Trappers (Clonney), 110
Trapper's Bride, The (Miller), 222 n. 12
Trapper's Last Shot, The (Ranney), 78–80, 85, 90, *pl. 7*
Trollope, Frances, 11
Truant Gamblers, The (Mount), 58, 155
Tuckerman, Henry, 134–135, 198
Tyler, John, 51, 66
Tyler, Royall, 13
Typing, xii-xiii, xv-xvi, 2, 7–10, 11–12, 21

Uncle Tom's Cabin, 122, 127
United States Bank, 26
United States Magazine and Democratic Review, 24, 38
Urban types, 20, 115, 157, 176–196 passim, 240 n. 5

Van Buren, Martin, 46, 186
Verdict of the People, The (Bingham), 138, *139*, 196
Vernacular speech, 15, 16, 18, 100; as social currency, 21; use by Clonney, 108–110; use by Durrie, 55–57; use by Edmonds, 54–55; use by Mount, 27–28, 29, 31, 35, 40, 41, 46–50, 51–54, 124
Village Politicans (Wilkie), 226 n. 50
Virginians, 16, 21
Visiting Grandma (Oertel), 201

Waiting for the Stage (Woodville), 241 n. 8
Waking Up (Clonney), 110, *112*
Walker, William Aiken, 201
War News from Mexico (Woodville), 1, 121–122, 138, 180, 196, 198, *pl. 1*
Washington, D.C., 82
Washington, George, 54, 180

Watts, G. F., 157
Webb, James Watson, 34
Webber, Charles W., 73
Weed, Thurlow, 50–52
Weir, John F., 45
West, the, 18, 59; images of, 60–99 passim
Western Art Union, 90
Western Journal, 98
Western Monthly Magazine, 62
Westerners: and Bingham, 160–161, 179; images of, 60–99 passim, 137, 147; stereotypes of, 12, 16, 17–19, 23, 103, 178, 183, 197
Wheatley, Francis, 139
Whig party, 46–58, 96, 108; images of, *47, 48*
Which Way Shall We Go? (Clonney), 110
White, Edwin, 123
Whittier, John Greenleaf, 116
Who'll Turn the Grindstone? (Mount), 220 n. 50
"Wide-awake," 9, 29
Wilkie, David, 24, 25, 32, 138, 139
Wilkins, James, 225 n. 35
Willis, Nathaniel P., 90, 183
Winter Scene in Brooklyn (Guy), 4, *6*, 104–105
Women: images of, 25, 60–99 passim, 178, 201–202 (post-Civil War); as "other," 11; stereotypes of, 19–20, 197
Wood Boat, The (Bingham), 87, *88*
Woodville, Richard Caton: and images of African-Americans, 121–123, 131; and images of everyday life, 1, 198; and images of politics, 178–182; and images of women, 138
Wordsworth, William, 121
Wright, Fanny, 52, 138

Yankee: images of, 24–42 passim, 46–59 passim, 84, 146; as regional type, 12, 14–16, 18, 19, 183, 201
Yankee Peddler (Ehninger), 243 n. 1
Yankee theater, 15, 26
Yeoman: images of, 25–59 passim, 113, 146; as ideal citizen, 12–14, 16
Yewell, George Henry, 187, 192
Young '48 and Old '76 (Woodville), 180, *181*
Young Husband, The: First Marketing (Spencer), 165, *166*
Young Merchants (Page), 242 n. 21
Young Wife, The: First Stew (Spencer), 165, *167*